The Dedalus Book of Polish Fantasy

edited & translated by Wiesiek Powaga

Dedalus/Hippocrene

Eastern Arts
Board Funded

Dedalus would like to thank the M.B. Grabowski Fund and The Eastern Arts Board for their assistance in producing this translation.

Published in the UK by Dedalus Ltd, Langford Lodge, St. Judith's Lane, Sawtry, Cambs, PE17 5XE

ISBN 1 873982 90 9

Published in the United States by Hippocrene Books Inc, 171 Madison Avenue, New York, NY 10016

Distributed in Australia & New Zealand by Peribo Pty Ltd, 58 Beaumont Road, Mount Kuring-gai N.S.W. 2080

Distributed in Canada by Marginal Distribution, Unit 102, 277 George Street North, Peterborough, Ontario, KJ9 3G9

First published by Dedalus in 1996
Selection, introduction & translation copyright © 1996 Wiesiek Powaga
Individual stories still in copyright are copyright of their respective authors

Printed in Finland by Wsoy
Typeset by Datix International Limited, Bungay, Suffolk

ACKNOWLEDGMENTS

Now that after a long and weary flight the Polish Fantasy has finally reached the shores of reality I would like to offer my thanks to those who helped it on its way. My thanks are due: to the publisher for his patience and understanding; to Steve Gove for smoothing out the rough edges and David Bird for roughing it with Malczewski; to Adam Czerniawski, Beryl Ranwell, George Hyde and all the people connected with the British Centre for Literary Translation, for their hospitality which made my stay in Norwich such a memorable occasion; to Stefania Kossowska and the Polish Citizens' Committee for Refugees for their help in replacing the computer stolen with the text of the book; to Nick Lane for his encouragement and friendship.

I would also like to express my gratitude for the permission to include the following stories to: Jacek Dukaj for *The Golden Galley,* Rita Gombrowicz for *Dinner at Countess Kotłubay's*, Marek S. Huberath for *The Greater Punishment,* Maria Iwaszkiewicz for *Mother Joanna of the Angels,* Sławomir Mrożek, Diogenes Verlag AG Zürich and Tanja Howarth Literary Agency for *Co-existence* (*Koegzystencja* Copyright © 1992 by Diogenes Verlag AG Zürich), Andrzej Szczypiorski for *The Lady with the Medallion* (Copyright © 1995 by Diogenes Verlag AG Zürich) and Wiktor Woroszylski for *The White Worms.*

I dedicate this book to my son in the hope that scary though it may be, it will strengthen his Polish spirit.

<div align="right">Wiesiek Powaga</div>

THE DEDALUS BOOK OF POLISH FANTASY

Contents:

INTRODUCTION

Dialogue with the Devil

Officially, the devil arrived in Poland in 966. For the Polish pagan tribes sandwiched between the two rival spheres of influence – Rome and Byzantium – the conversion to Christianity was a political manoeuvre aimed at consolidating the new fledgling state, and an argument against the eastward expansion of the German Roman Empire. It took place at the time of great ideological turmoil in Christendom, caused by the anxiously awaited first millennium, and with it the arrival of the Antichrist. Amidst the panic and rumours of the impending end of the world, the until then dim and vague figure of Satan was suddenly brought into a much sharper focus. It was then that Satan and his ilk became part of the dogma of the Catholic Faith and an irreducible part of the world. In these circumstances the arrival of the devil together with the rest of the Christian inventory played a crucial role in shaping the character of the new religion. In effect, Polish Catholicism, operating on the edges of Rome's influence, developed a highly conservative and combative spirit, while the dangers to which it was exposed both as a religion and as a national institution easily acquired demonic dimensions.

This fusion of Catholic and national ideologies was further strengthened over the last two hundred years when the very essence of Polish nationhood has been under almost permanent threat. It first came to the fore during the Romantic age when the partitioned Poland disappeared from the map of Europe, especially in the messianic doctrine of Poland as the Christ of Europe crucified for the freedom of other nations. Now, the parallels with Poland's most recent history are obvious (at least to the Poles), and it is not surprising that yet

another generation tapped into this rich vein of national mythology to reflect on their current predicament, the more so in view of the rapidly growing influence of the Church rising from Communist persecution.

In choosing the stories for this anthology I tried to do justice to the devil and various strands of tradition which account for his presence in Polish fantastic fiction. I wanted to present the English language reader with some of the historical and cultural background of his exploits in a repertoire of roles and guises in which he is familiar to the Poles: from the personification of pure malice in Barszczewski's *Head Full of Screaming Hair* and the omnipotent Prince of Darkness in Dukaj's *Golden Galley*, to the patriotic hero in Woroszylski's *White Worms*; from the seductive temptresses in Miciński's *Infernal Rose* and Szczypiorski's *Lady with the Medallion* to the pitiful, though proud, individual entangled in the sticky web of human affairs in Makuszyński's *Gentleman with a Goatee*.

Polish tradition abounds in stories about the devil, which were collected when the interest in the native folklore was first awakened during the Romantic era. These stories filtered into the literature from the rich and ethnically diverse traditions – Lithuanian, Ukrainian, Bielorussian – which comprised Polish culture at the time. This folklore was full of pagan devils and demons. They could be dangerous and nasty, like vampires (*upiory*) of all kinds and shapes, such as *strzygi* – the bloodsucking demons in the shape of an owl, *zmory* which literally took their victims' breath away, or child demons wreaking revenge on the living for their shortened lives.

The proliferation of the devil was duly reflected in his varying social status: from a wicked though feeble-minded rustic creature easily outwitted by the God-fearing and commonsense peasant to the mysterious inn-keeper; from the figure of a shabby nobleman to the powerful magnate. Later, in the 19th century during the first period of industrialisation, he was also the lame owner of mills and plants, whose hellish machinery helped him in making his great

fortune. At the same time, everything that was different signi-
fied the presence of the Evil One, and just as in Holland the
devil paraded in Spanish dress, in Eastern Prussia and Bielo-
russia as a Polish nobleman, in Poland he was often spotted
dressed after German fashion, while the words *heretic* or *luter*
became in everyday parlance synonymous with the devil.

No account of the Polish devil could omit the legendary
figure of Mr Twardowski, the Polish Faust, whose dealings
with the devil are the subject of numerous folk-tales, poems
and novels, of which Siemiński's *Shadow of Queen Barbara* is
an example. The legend of Mr Twardowski shows him some-
times as a clever Polish nobleman who outwitted the devil,
sometimes as a magician who, like Faust, sold his soul to the
devil in return for magic power and knowledge; there are
even Twardowski's magic mirror and his magic book. Al-
though neither probably belonged to him, both are genuine
artefacts connected with the magic arts flourishing in Poland
in the 15-16th centuries, particularly in Kraków where the
Yagellonian University had a department of magic teaching
astrology, alchemy and other assorted secret arts. There are
grounds to assume that Twardowski was a historical figure, a
German rather than a Pole, a fellow-magician and the con-
temporary of the celebrated Dr Faust, who, it is said, won his
magic spurs at the Kraków Academy. But only in the late
19th century was the legend of Mr Twardowski connected
with a historical character, and in Siemiński's story, based
also on a historical event, another, darker persona of the magi-
cian emerged: that of a dangerous, malevolent and scheming
evil-doer.

Of course, apart from the devil whose pervasive presence
in Polish literature owes much to the Catholic and Romantic
traditions, there are other themes common to the European
literary heritage. For instance Grabiński's atmospheric stories,
Mirandola's *Strange Street* or Reymont's *Vampire* are examples
of the fantastic fiction of a more classical turn, springing
from the fascination with the paranormal and the occult
widespread in Europe at the beginning of the century.
Jasieński's *Legs of Isolda Morgan*, a potent mixture of turbid

decadence and revolutionary rhetoric, belongs to yet another tradition of the futurist avant-garde of the 1920s, while the stories of Gombrowicz and Schulz, with their motifs of the outsider and small town life that blur the distinction between reality and fantasy, echo the legacy of surrealism. On the other hand, there are stories which rework the classic themes and set them in the Polish context. Such for instance is Iwaszkiewicz's *Mother Joanna of the Angels* in which the well known story of the possessed nuns of Loudun is transferred to 17th century Poland and recounted as a subtle psychological study of love and madness. Here, apart from exploring Christian concepts of love, sacrifice and devotion, Iwaszkiewicz confronts them with the Jewish tradition in a powerful clash of two cultures living side by side, sharing so much of their spiritual heritage, yet unable to unite against the common enemy of evil. The portrait of the magnificent figure of Reb Isze from Zabłódów brings to mind the famous Jewish mystic and cabalist Löwy (Juda) ben Bezalel, the creator of the Golem, later the chief rabbi of Poland.

Under the Communist rule, which itself could be taken for a grotesque nightmare if it were not so real, literature, just like everyone else, had to accommodate itself to the watchful presence of Big Brother. The stories of Andrzej Bursa and Sławomir Mrożek in this anthology brilliantly evoke the reality of living in close proximity to evil, where the danger of moral compromise is practically unavoidable.

All those traditions came to fruition in the post-communist Poland with an unprecedented popularity of fantastic fiction. The striking feature of the writing in the wake of liberalisation from Communism was that it was not so much interested in developing the visions of a bright new world – here the lack of faith in social order based on the rational scientific progress was particularly manifest – but in a return to the universal theme of Good versus Evil, particularly in their transcendental yet concrete manifestations, such as the Messiah and Satan. The latest generation is represented here by two young writers: Jacek Dukaj and Marek S. Huberath. Dukaj's brilliant *Golden Galley* unveils a futuristic vision

of the world policed by the omnipotent organisation of the Blessed Legions that looks like KGB and the Society of Jesus rolled into one. It is a world of institutionalised cynicism and total spiritual desolation where the Blessed Legionaires, who have all the earthly powers and more at their disposal, are engaged in a futile attempt to avert the end of the world. It contains one of the most striking images of Satanic might in Polish contemporary fiction. Huberath, in his oppressive *Greater Punishment*, reminiscent of Flann O'Brien's *The Third Policeman*, depicts Hell drawing on the last fifty years of Polish history whose haunting images seem just as inescapable as damnation itself. Both stories belong to the popular category of religious fantastic fiction, but occupy two ends of the spectrum encompassed by the genre. While Dukaj's pessimism seems to be irrevocable, or at least deeply distrustful of the inherited bankrupt values, Huberath, despite his grim view of human nature, remains firmly within the sphere of Catholic tradition.

In this selection of Polish fantastic fiction I have tried to show it in the light that sets it apart in the history of the genre. For while it belongs to European fantasy, it is also very much a part of the time-honoured tradition in Polish literature which throughout its turbulent history has often served as a vehicle to convey, and come to terms with, the oppressive and officially unmentionable aspects of the nation's fate. Stranded between West and East, forever suspended between damnation and redemption, Satan and the Messiah, Polish fantastic stories possess a unique and distinctive voice.

CO-EXISTENCE

by Sławomir Mrożek

On his return, the vicar found the devil at home. The devil, sporting a red jockey-cap, was sitting at the table, looking at the human being – in this case the vicar – with concentrated attention. For in contrast with human beings, the devil is never absent-minded. He is not divided between good and evil, but wholly devoted to evil and free from deliberation, which means he is perfectly focused, always, in every situation.

It happened at dusk, when the vicar returned from his everyday parish duties. He saw the devil and he sighed like a woodcutter who after a whole day of felling pine trees in the woods finds that in the meantime an oak tree has grown in his room.

He knew however, both from experience and education, that the devil's existence is constant, that is, it is not subject to fluctuations, to ebbs and flows, to expansion and dissipation, to the rhythm of work and leisure, of dreaming and waking. So, he was not as surprised as the woodcutter would have been, only – and here the simile with the woodcutter is fully appropriate – he felt doubly tired.

"What do you want?"

It was a curt, rather unwelcoming question.

"As a matter of fact, nothing. I simply am," answered the devil. The vicar brought to mind all the interpretations of devilishness, all the speculations on the nature of the devil, and all the exorcisms. As a matter of routine, he went through various procedures for exorcising the devil, trying out this and that, looking for one that would fit the situation. But there were too many of them, and after a day's work he felt so tired that in the end he could not decide on any. He

was about to say "All right, be then" but he stopped himself, for such an acceptance of the existence of evil would be rather improper.

"I understand," said the devil. "But don't worry, I'll leave you in peace too. I won't tempt you, I won't spin any webs of intrigue or deception. I'll just sit here, that's all."

"Of course he's lying," thought the priest. "Lying is in his nature. I should throw him out. If he wants to sit and do nothing, why in my home? Why not somewhere else? But let me take my shoes off first and put my slippers on. If only I were younger . . . I'm not as quick as I used to be."

He took off his shoes, put his slippers on and made tea. All the while he was observing the devil from the corner of his eye. But the devil kept his word. He was silent, sitting modestly at the table; he didn't even take off his cap, which indicated that he was not going to make himself at home, and didn't display any of the activities or entrepreneurial spirit for which he is famous.

The vicar had his tea and, not so much out of interest but to gain time, he picked up a book on some inconsequential topic. Alas, precisely because of that, his eyelids, which he was struggling to keep open anyway, had now grown even heavier and he couldn't keep them up. Resurfacing from his nap into half-sleep, he could still see the devil sitting politely at the table, but as if from a distance. "Strange thing, he doesn't bother me. He should want something from me, and even if he doesn't want anything now, the suspicion that it's only a pretence – at least that should bother me. You can't be too careful with the devil. I'll show him what's what, but later. I have to have some rest first."

"Are you still here?" he asked when he woke up from his nap. The devil only nodded. He was, obviously and too self-evidently for it to require verbal confirmation. He was still sitting quietly, as in a waiting-room, that is as if he had no business in the room he was in, still in that grotesque red jockey-cap of his. "He's not pushy, though," thought the vicar. "And even if he is plotting something there will be enough time to put an end to it. Besides . . ." Here the vicar

embarked on a course of reasoning that was to calm his stirring conscience: "If he is here, it means he is not somewhere else. He doesn't bother me, I can keep an eye on him here. And as long as he is here, he cannot do any harm to anyone else, not being where he actually is not. In the end it's better to have him here than to send him away, that is somewhere where God knows what trouble he would stir up. So, let him be, for if anyone is the loser here, it's him."

And so he settled to sleep for good and thus spent his first night with the devil; for when the vicar woke up at dawn, the devil was still sitting at the table, still in his foolish red cap, consistent as ever. The devil doesn't get tired and so he doesn't need rest. The priest was surprised that despite the devil's presence he had slept well, deeply and without nightmares.

When the vicar was leaving the vicarage, the devil followed him to the door with his eyes but without moving from his place. He greeted the vicar the same way when the latter returned home in the evening. The devil behaved like a faithful well-trained dog, with one difference only, and a favourable one in comparison with a dog, that he required no attention or looking after. The vicar remembered his resolution from the day before, namely to throw the devil out, but at the same time he also remembered the arguments that had stopped him from doing so there and then. "He doesn't bother me, so I won't bother him. While he is with me, he is harmless. If he has to be, let him be idle. It's better that he sits here, where he does me no harm, than that he goes away and harms other people. And if he tries anything with me, I'll show him an exorcism or two."

But the devil didn't try. He avoided any, even the slightest conflict with his host. All he needed was a place at the table. If he wasn't asked he didn't talk, and the vicar wasn't asking him anything. Peace for peace. It may strike one as strange, but the vicar didn't take advantage of this opportunity to find out something about his adversary by way of direct and civil conversation. Was he trying to keep clear of any discussion, bearing in mind that one should not discuss anything

with the devil? Probably, yes. He knew the devil was only waiting for the occasion. That was the reason the vicar had wanted to send him away in the first place, for he was afraid that the devil had come only to ensnare him in conversation. And then he let him stay only because the devil remained silent. So he was careful not to start what the devil did not. But on the other hand, the priest was no longer young and his curiosity was not so keen any more, especially given the effort he would have to make to satisfy it. He would not have made this effort even if the above considerations had not applied. He always returned home tired, always found the devil in his place, and they never talked to each other. The priest went to bed, the devil stayed awake. And so things settled down between them.

One day a bishop visited the parish. He found the church in excellent state, the cure of souls exemplary. The vicar's hard work from dawn to dusk was not in vain; after all that was why he was returning home so tired that he couldn't even be bothered with the devil.

"We should like very much to see the vicarage too," said the bishop at the end of his visit.

The vicar remembered what sort of guest the bishop would meet in his house and he panicked. Convinced that it was the end of everything, certain of unavoidable scandal, of utter shame and complete disaster, cursing under his breath both the devil and his own foolhardiness — why didn't he throw the devil out on the first day? why did he procrastinate? what was he waiting for? — he opened the door. And wasn't he surprised, and relieved, when he found there was no one there? The devil had disappeared. The vicar couldn't help feeling grateful to the devil, though he knew that such a feeling was in the highest degree imprudent, humiliating and undignified. The devil though he was, when the need arose he had behaved with decency, friendliness even.

The bishop looked around and was just about to praise the humble, eremitic dwelling when he noticed the red jockey-cap which the devil had left on the table. He turned his eyes

questioningly on the vicar, for it seemed to him odd that a virtuous custodian of the faith should parade in such frivolous headgear, bringing disrepute to the holy ministry. Odd and unbefitting.

"It's a . . . it's my nephew. He visits me sometimes," lied the vicar. Had he said the cap belonged to him, he would have lied too.

The bishop nodded his head with understanding and expressed his general approval. He left the parish, still very pleased. When the vicar was finally alone, the devil came out of the wardrobe where he had hidden. He walked up to the priest, his ugly visage contorted in a sickening smile of triumph.

"My dear uncle!" he cried with joy, and opened his arms.

THE LADY WITH THE MEDALLION

by Andrzej Szczypiorski

Please, can't you understand? There was nothing extra-ordinary about her. After all, we're both grown-ups, men of the world, each with his own burden of intimate experience. Let's simply say she was sexy; I hope the word means something to you . . .

She had a slender yet shapely figure; the face thoughtful, without a hint of frivolity. The eyes rather cool. Passing such a woman on the street a man might study her figure, her face, her style and come to the conclusion that she is not an easy conquest, but would certainly be worth the effort. Such women avoid casual friendships. One does not meet them in cafés or on lonely walks in fashionable resorts. They are never alone. They are always accompanied by a mature, hand-some man with a sporty air – greying hair, corduroy trousers, thick pullover, a pipe. You know the type, don't you?

She, on the other hand, elegance itself, so refined, if a touch old-fashioned. The fragrant body, the skin lightly tanned by good mountain sunshine, the long, calm hands which bring to mind old portraits of cardinals . . . Come to think of it, she also radiated an aura of purple and gold, like a burning renaissance palace. Beautiful? No, she was not beauti-ful. Her face was rather oval, I'd say thin. Very expressive eyes – gold set in black. If there was anything of truly classical beauty in that face it was the nose. Charmingly formed, like a face on a rococo cameo. Her wrists were unusually thin and her hands had the supple slenderness of a flower on a stem. No, she didn't wear any jewellery. This type of woman shuns such ostentation. She wore only that medallion with its fantastic effigy, the one which you don't seem to be able to fit into your theory . . . For me, luckily, this medallion is the

main evidence of her existence. Without it I would have no choice but to accept the conclusion that I am mentally ill . . . Really, it's utterly absurd to maintain that finding it was just a coincidence. Have you ever seen anything like it? Haven't your laboratories proved themselves completely helpless in dealing with this lump of metal? Finally, don't you yourself, inspector – a level-headed and reasonable man though you are – aren't you struck by the peculiar mystery of this object which instead of sitting in your files with all your evidence keeps being sent from one laboratory to another? All right, back to the story. So, as you know, I arrived in N. where I was impatiently awaited. I was to give a series of talks about contemporary cinema. I am no expert but since we have this tradition of intellectual discussions on popular topics, competence is less appreciated than effortless brilliance. I arrived in N. by plane. I had a good flight; lovely, end of May weather. Here on the coast, it was still rather cool and when I got off the plane I felt a light breeze on my face. I like that – the moist scent of infinity, you understand . . .

I stayed at a small hotel, in the old part of town. In N., as everywhere in the country, there is a terrible shortage of hotels – you probably know more about it than I do – and the organisers must have performed miracles to book me into such a nicely furnished, charming room, one with windows opening onto a delightful view of the Old Town. In the hotel restaurant, which was somewhat empty despite its excellent reputation, I had lunch before my first lecture. Pardon? No, I never drink. I've said that many times before. That's why it was so striking. When I was choosing from the menu I was overcome by the irresistible desire for a small glass of vodka. I was really surprised. But I succumbed to this innocent fancy.

After lunch I went to my lecture. It was to take place in a very beautiful, elegantly furnished public library with a magnificent oak staircase, richly carved banisters – you know the interior anyway. A well-dressed, cultured audience filled the lecture room; there were old prints on the walls, a small collection of arms and a few portraits blackened with age, a

beamed ceiling . . . In a word, the atmosphere of a spiritual feast.

As I sat in a comfortable armchair, facing the auditorium, I suddenly felt ill at ease. It was quite unbelievable, what with my audacity and experience. Difficult to say what it was, really . . . At any rate, I said to one of the ladies who were looking after me, an obliging lady in a beige dress, that I felt rather hot and thirsty. She greeted my confession almost with joy, certain that I had stage-fright and proud that I had shared such an intimate secret with her. The windows were flung open and a cup of coffee and some mineral water appeared on the table by my side. The lady in beige, maternal and coquettish at the same time, handed me a glass.

Well, I was neither hot nor thirsty. But how was I to tell the gentle ladies something so preposterous – that I felt oppressed by an unpleasant smell in the room? From the moment I seated myself in that armchair, my nostrils were fiercely assaulted by a noxious stench, the bitter-sweet odour of a rotting corpse, which made me want to retch. I looked at the faces of my audience and came to the conclusion that I must be imagining it. I got a grip on myself. The smell was still there but I put on a brave face and started my lecture. The minutes passed, filled with the gentle hum of the city flowing into the room through the open windows. The foul smell disappeared but I began to feel a certain restless tension rising slowly within me. I was supposed to be talking about Jean-Luc Godard but I could not concentrate on the content of my lecture. I was growing more and more distracted, filled with an inexplicable feeling of expectation. The air seemed to be charged with electricity, like in a stuffy, unaired room before a storm. I drank some water. The kind lady in beige gave me an anxious look. I noticed it, but suddenly my gaze wandered deeper into the room, towards the windows. I met the eyes of that woman. She was looking at me attentively, insistently. In the soft light of the room I saw her big eyes, like two golden bees, still and yet alive, incredibly alive. It was an unsettling moment. As I took my eyes off the bees, for a

second it seemed to me that I could clearly hear their buzzing around my head. I picked up the thread of my talk again, and again the library filled with my voice, steady if somewhat monotonous. But it didn't last for long. After a while, almost automatically, as if independently of my will, my eyes returned to that woman, drawn to a medallion on her long neck. I also noticed that the lady was not alone . . . Next to her sat a man, very handsome, with a strange expression on his noble face. I wouldn't have noticed him at all but for his eyes, fastened on his companion. There was so much suffering in those eyes, so much despair and resignation! The woman seemed to be completely oblivious to his presence, as if he did not exist. Her whole body was turned towards me, her whole being concentrated in the golden, velvety gaze which was almost caressing my face. And again, I smelt briefly that terrible odour. When it passed, a wave of penetrating cold swept over me and then a wave of heat, just as if I had been dropped into the waters of the Arctic and immediately afterwards exposed to the burning winds of the desert . . . I thought there was something wrong with me, I must have been taken ill, caught a cold. Or maybe it was the vodka? I carried on talking, confusedly, about Antonioni and his conception of unrequited love. It sounded, I suspect, rather unimpressive. I continued with my talk, quickening the tempo to finish as soon as possible and return to the hotel; I did not feel safe in this room. But it was not to be. When I'd finished, a lively discussion took place. People spoke but I can't remember what they were saying. My thoughts were full of the woman and her companion. She was still looking at me, stubbornly, not taking her eyes off me. There was something shameless in her behaviour, but nobody noticed, except for me and that gentleman who, all this time, had been looking at her with despair. Suddenly, something extraordinary happened. I got up from my armchair, raised my hand in a commanding gesture and interrupting some old fellow I said:

"Stop this idiotic drivel! I've had enough! I'm going back to the hotel."

It became silent, like in a church at communion time. The kind lady in beige went pale, her eyelids fluttered. I knew she was struggling but finally her sense of duty prevailed, for she formed her lips into an uncertain smile and addressed the audience with some conventional words of apology, explaining that I was tired and unwell. I cut her short and, suddenly, I found a wild joy in ridiculing and humiliating her.

"Will you stop this nonsense!?" I shouted. "I'm in excellent form but you all simply bore me . . . You in particular, with your intellectual chatter."

I saw how she clasped her hands and squeezed them till her knuckles went white. That only fired me up.

"Oh, please go on, faint . . . What will the local busybodies make of it? 'Frustrated old spinster faints in the arms of a famous film director!'"

Again, silence fell for a moment and everybody looked at me as if I was standing in front of them naked. And then the quiet, even peal of that woman's laughter resounded throughout the room. She got up and clapped her hands. Nobody looked at her; it was as if they were unaware of her presence or her laughter. The lady in beige said very quietly:

"You will be kind enough to leave our meeting."

"With pleasure," I answered brutally. I left immediately; nobody saw me out. When I reached the stairs I heard a great hubbub of voices erupting in the library.

On the street I came to my senses. "Good God!" I kept saying to myself, "something terrible has happened . . ." I walked hurriedly towards the sea, which in N. breaks into the city unexpectedly among the houses and old baroque palaces. A gentle breeze caressed my face. I was devastated. Imagine my situation, inspector – such a scandal! I arrive in town preceded by my reputation as an intellectual and an academic, a man of the world and every inch a gentleman. I have friends in the artistic circles here who think of me, and rightly so, as a sober-minded and serious man. And then, suddenly, without any rhyme or reason, I behave like a complete hooligan, a churl. I asked myself, what the devil had got into me? For a moment I felt elated, then very weak,

and finally I was overcome by shame . . . I came to the conclusion I had to do something immediately, invent some excuse, offer some justification. So, I had to make myself ill – not with anything minor, but with a serious nervous disorder. After all, I have a sensitive, artistic nature, these are hard times, requiring constant mental effort, I've been working hard of late, exhausted my reserves, so it must be a nervous breakdown. It was not completely convincing, but it sounded reasonable. This was it then – an illness. I was so taken by the idea that I decided to go and see a doctor at once and ask for his advice. I felt completely crushed by my madness. I couldn't establish where, all of a sudden, this crazy idea had come from, and how such a pitiful incident could have happened at all. I also thought that I should send the nice lady in beige some flowers and a card full of entreaties and profuse apologies; but, of course, I didn't know her address. I wandered aimlessly around the streets, turning left, then right, speculating frantically, full of growing shame and horror, feeling more and more helpless.

Suddenly, I found myself in front of the restaurant "The Dancing Salmon", right in the centre of the town. I gave up the idea of seeing a doctor. The mood of almost serene recklessness returned. Simply, in some inexplicable way, I forgot about the incident in the library.

On entering I found myself in a big, spacious room. It was early evening, the end of May, still the low season in a town which from the beginning of summer attracts thousands of tourists and sea-bathers. The restaurant was therefore nearly empty, with just a few tables taken by the guests. The electric light was already switched on but it was mixed with gentle sunlight flooding into the room through the wide windows on the street side. To the few passers-by the interior might look like a huge aquarium, as the strained light of the chandeliers, reflected in the greenish colour of the walls and furniture, created an illusion of shimmering, seductive depth.

A distinct if unobtrusive smell of cooking hung in the air, and as I walked across the luxurious carpet in search of a table I passed a bar full of appetising *hors d'oeuvres*. At the

other end of the room I was struck by a peculiar sight. High on the wall, above the music stands of a dance orchestra, hung an enormous painting depicting life at the bottom of the sea. At first sight the thing was quite ordinary, even though executed with a certain talent, but it made a depressing impression on me. Among the tangled dark green seaweed and slimy, brown stones the artist had placed marine creatures of all shapes and sizes – livid algae, silvery starfish, an octopus in shades of purple and gold, strange, unfamiliar creatures of oblong shapes and colours, all tangled up in some passionate whirl which touched my heart with cold fear. To tell the truth, this feeling was not unjustified. You know of course, inspector, the Venetian delicacy *frutta di mare*. On a plate it looks quite innocuous. But imagine all those oddities spread out on a wall six metres by three . . . ! Even Potter's famous still-lives – those crystal goblets filled with fine wines, roast turkeys, peeled lemons on which, here and there, glistens a drop of juice – even they would look monstrous in such dimensions. Just imagine, ten square metres of beefsteak! What I saw was an entire wall of creatures which looked far less appetising. I sat with my back to the picture but still felt uneasy, like a man who is aware of a huge spider crawling about behind him. A waiter appeared. When he handed me a menu I said that that work of art on the wall didn't look very inviting.

"Why not?" he asked with a smile. "It's just an ordinary sea view."

"You mean under-sea view," I corrected him.

"Well, no . . . I think not," he said and walked away.

As he was speaking, while he still stood at my side, I looked behind me, at the wall. And indeed what I saw was the greenish surface of the sea spreading far and wide, gently ruffled but calm. Further in the background loomed the outlines of the shore, hills with patches of sunshine, an empty beach painted with a thick yellow line. It was all quite subtle and evocative, but as I stared at the painting with growing amazement I began to see emerging out of the greenish waters the shapes of algae, starfish, octopuses, all that slimy

23

eddying mass of marine fauna and flora. Almost impercept-
ibly, and yet so obviously, the land, the hills and beach were
disappearing in front of my eyes while the contours of the
horrible creatures assumed more and more definite shapes
and colours. Something strange was happening to me once
more. I shut my eyes tightly and when I opened them again
all I saw was the indescribably dark depths of the sea, torn
here and there by flashes of silver, gold and purple emanating
from the terrifying animal forms. Believe me, inspector, it
was unbearable! I turned my head away, ready to get up and
leave immediately to see the nearest doctor.

Just then I saw that couple again. They were sitting at a
nearby table, in silence, like two strangers. She was looking at
me, the way she had looked at me in the library. He was
looking at her with the same expression of hopelessness and
despair. This time I found a different quality in the woman's
eyes and that discovery sent shivers all over my body. Those
two golden bees in the crystal chandeliers' light seemed both
sensual and aggressive. There was something enticing in the
woman's gaze, which was melancholy and at the same time
victorious, the way a woman looks at her lover. It was unbear-
able and yet utterly charming. This kind of gaze is the sole
privilege of a man. Only we can lay bare a woman's emotion
in this way – in a theatre foyer, at a restaurant table, strolling
in a park. And here this woman, quiet and dignified on the
surface, was now giving me a brazen look of naked desire,
here, in broad daylight, in the presence of other people, in the
glare of the chandeliers and the setting sun. It was amazing,
magnificent, delicious and unbearable.

At that moment, just as before in the library, an unpleasant
smell, at first faint then simply disgusting, overpowered my
nostrils. I looked around, uncertain, trying to trace its source,
but nothing I could see might explain it. The waiter
appeared, bowed and asked for my order. I answered rather
brusquely that there was a strange smell in the room, which
was surprising in an establishment which enjoyed such an
excellent reputation. He sniffed like a hunting dog, looked
around, and then at me.

"Forgive me, sir, but everything seems to be in order . . ."

"Rubbish," I cut him short. The smile vanished from his face, he became cold and distant.

"Will you be ordering, sir?" he asked.

"*Bouillon*, Vienna schnitzel with vegetables and coffee to follow . . ."

He left me immediately.

I was strangely incensed, irritated by the tone of his voice, the expression on his face and the strutting step with which he was crossing the soft carpet. I gave the couple at the nearby table another look. The man was sitting still, as if holding his breath, staring at the woman's face, or rather, at her profile, for she was looking at me, more and more intently and sensuously. When our eyes met a faint quiver ran through her face, her lips opened up gently and I saw her smile. It was an extraordinary smile; never had I been so moved. Her face radiated a kind of intoxicating charm — maternal, soothing and at the same time animal. So must the Phoenician Astarte, mother of the world, symbol of fertility, rapture, motherhood and sex, Astarte Protective and Riotous, have smiled on her followers.

I saw her teeth — beautiful, gleaming white teeth — which might have indicated merely good health but seemed to me the predatory, strong teeth of a beast, made for rapacious kisses. I was experiencing a strange mixture of fear and desire such as I had never known before. I smiled politely in return, full of gallantry and respect, inclining my head slightly, giving to understand that I would be honoured to make her acquaintance. The man seemed to pay no attention to our silent communication, his despairing eyes fixed on his companion's profile.

I was excited; thoughts ran through my head like a herd of frightened horses. My first impulse was to get up and walk to the other table but I restrained myself, or rather, I was restrained by her forceful, golden eyes which seemed to draw from the rest of her body that wonderful, tender and exciting warmth.

Have you ever, my dear inspector, experienced a feeling of

overpowering desire for a strange, unknown woman? Do you know the feeling, when a man is ready to commit any folly and won't shrink from murder or making a fool of himself just to take a woman in his arms? Are you familiar with this fascination, this obsession, even fury, when you will do anything to make your dream come true? Your head is full of rational thoughts, suddenly you become aware of all your duties and commitments, all your principles gain the strength of steel, only to break down and release with greater force that destructive power which will crush everything standing between you and the satisfaction of your desire. In one brief moment this woman became to me dearer than anything in the world, though, of course, I was aware that the moment would pass. It's maddeningly exciting, that first step on the path to hell. In moments like these you are perfectly aware that the desire which possesses you is as light as a puff of smoke, it's enough to make the decision – not a difficult one, in fact rather a trivial one – to get up and leave, stroll along a crowded street, visit a café, or a cinema, or simply return to your hotel room, lie down in comfort and read a book. In other words it's enough to do something very simple, something which requires no effort, struggle or sacrifice and you can free yourself immediately from all temptation. But precisely because it is so obvious and easy you take the risk, you challenge Fate repeating to yourself stubbornly that there is still time to prolong this test of strength. For then, every man feels his own power, convinced that he controls events and recklessly feeds the fire of temptation which gives us all such pleasure.

With every second the decision, at first easy and simple, becomes more and more difficult to make. We sink in inertia and reverie as in quicksand, our bodies grow heavier and heavier, our hearts beat faster and faster and our minds are feverishly building an intricate construction of justification and excuse to withstand the weight of what is about to happen . . . It makes me realise now that in such moments people who are truly happy can, after all, control events. A man who is awaited at home by a devoted, loving woman

and is satisfied and free of the suffering brought by unsatisfied desires, such a man can, without too much difficulty, find his way out of this maze. Loving, and being loved, he understands the full meaning of fidelity and the price of such a conquest. Everybody measures the world with his own yardstick and a happy man who loves and is loved thinks that only equally sublime feelings can, or rather should, accompany his every amorous adventure. The moment he realises this such a man gets up from the table, crosses the soft carpet and goes out into the street, and away into the world. But I? I, with my insatiable need for warmth and hope? You have to take into account, inspector, that I have never truly loved any woman; I have pursued them with a certain stubbornness and taken them with a touch of anger and bitterness, convinced from the start that even though I was driven by hope, in the end I would be disappointed. The untiring seeker after love, whom women always accused of selfishness, a slave to my own sensitivity and imagination, searching for a goddess or at least for a lover skilled in love-making, I, who nevertheless invariably ended up with trivial women, common like sand, those babbling featherbrains or frigid Brigits, spoilt kittens or melancholic princesses, all equally sentimental, awaiting a miracle, starved of warmth, support, strength, tolerance and the devil knows what else . . . The worst were the lonely ones, beautiful and independent, but still capricious, who treated an affair like an adventure, or, on the contrary, built up towering expectations against which any man would look like a dwarf.

Perhaps this is why I treated the presence of the man at the table as reassuring. She was not a lonely, single woman. I could therefore afford another challenge without the risk of getting entangled in a moral dilemma.

Naturally, then, in the restaurant, all my thoughts ran through my head in a violent and disorderly manner. I felt something was happening to me, that here was the beginning of a rare and delightful adventure, even though I knew all along it had only a temporary character. If you think, inspector, that I was building my future on the smile and the gaze

of that woman you're very wrong. And if you think that I felt any hostility towards that man you're wrong again. It was quite the opposite. With every minute he seemed to me more and more friendly, a handy prop in the game I was about to begin. Please understand my situation. I'm single, earning good money, my professional position is very secure. Men like me are afraid of liaisons with single women, who tend to be possessive; they are a threat to our freedom. In a word, I'm an excellent catch. Please, look at my past, the most intimate details of my life. I've always avoided single women like the plague. All my affairs and flirtations have invariably been triangular. Love of geometry it may be called. To be the third, that's my motto. When terminating such a relationship I wasn't leaving a wrecked marriage behind, but the opposite, a newly cemented union. I think this must be counted as a good deed, though I've never tried to turn pleasure into a virtue.

And so, even then, in the restaurant, I treated the presence of that man as a propitious circumstance. Naturally, I intended to get rid of him, but in a tactful and gentlemanly manner. What's more, I felt sorry for him. Surely, you can understand that? She was causing him pain. That heart-rending look in his eyes seemed to me almost like an accusation. I felt a sense of male solidarity growing within me. "My beautiful lady," I thought to myself with cruel satisfaction, "you will pay me back for him. You will not turn me into such a despairing wreck, oh no." This thought excited me and intensified my desire to possess her. I decided to conquer and humiliate her, and in this way make her pay for the pain suffered by the other man . . . I felt very close to him and for a moment I wanted to call out: "You can count on me, my unhappy friend!"

At that moment my schnitzel was served.

I tucked in with gusto. But then, again, I experienced an unpleasant sensation. The dish seemed repulsive to me. The moist, whitish meat on the plate gave off a foul smell, its taste was nauseating and filled me with strange fear. I called a waiter and when he appeared I launched into a feverish and

28

rude complaint about being served meat which was off and badly prepared. I was speaking in a raised voice, very upset and aggressive. What's worse I had a feeling that those sea creatures were moving noiselessly behind my back, that they had slipped off the wall and were crawling towards me. A sort of moist coldness was spilling down my neck. I sprang up from the table, heard the soft sound of the falling chair and saw a look of surprise in the eyes of the waiter. Next to him stood the headwaiter, a balding man with dark hair, ruddy cheeks and big fleshy lips which looked like liver chops past their best. The headwaiter was talking to me in an agitated manner, explaining and apologising, his eyes running between my face and the plate like a pair of little black spiders. Suddenly he picked up the fork, poked it into my food, put a bit of meat into his mouth and started to chew, carefully, conscientiously, his moist, round lips moving rhythmically, parting for a moment to reveal his tongue. It was disgusting, disgusting beyond words. All this amidst the all-pervasive putrid stench, as if the whole restaurant were a decomposing corpse, as if the waiter, the headwaiter, and even myself, were dead bodies: livid, gangrenous and swollen with the pressure of death . . . For a second I caught sight of the woman's eyes. She was laughing gaily, the golden bees were buzzing above our tables, her face was almost happy, full of life, the only face with human colour, without that glaucous sheen and cadaverous paleness. The man at her side seemed to me particularly terrifying – bloated, practically green, fetid, dripping with the deathly venom of his rotting body . . .

It was a terrible moment. On the verge of losing my senses I pushed the headwaiter away with a force that made him reel backwards, and fled towards the door; banging my head on the door-frame was painful but at that moment it seemed like a blessing to me. I ran out into the street and kept running blindly through the crowd of passers-by. Suddenly, my sense of reality returned; I could feel a gentle breeze on my face, a pimply youth stood next to me, smiling derisively. I found myself in the big square of N.'s Old Town, surrounded by delightful, baroque houses. You know yourself, inspector,

that it's quite a distance from "The Dancing Salmon", a good ten minutes' walk. I must have run, but I have no recollection of it, not a crumb of memory left.

I was breathing with difficulty, slowly regaining my balance. Looking around I realised it was already evening, the sky was dark blue, with just a few clouds, and a playful breeze was blowing from the sea. The moving cars had their lights on, brightly coloured neon signs glowed above the shops and the first few windows were lit up in the dusk. It was a normal May evening in a big seaside town. Nothing extraordinary was going on. The air was fresh if slightly damp, with a mixture of salt, car fumes and the smell of the flowers sold all day on the market square. The passing women were charming, the men smiled. Someone was playing a transistor radio, the sound of a fog-horn reached me from the port. I decided to go and see a doctor without further delay. And then I saw . . . It was horrible, unbelievable. On the square, if you remember, there is a neat, well-lit newspaper kiosk. I was standing right next to it and just as I decided to go and see a doctor my eyes were arrested by the covers of the illustrated magazines on the display . . . That's right, that's exactly what I am going to tell you, about this damned issue of the *Weekly Mirror* from the 10th of May. And you can tell me a million times that it was an hallucination and I will answer you a million times that I had this magazine in my hand, that I felt its glossy cover with my fingers and smelt the smell of its fresh print . . . No, it's not the issue you are showing me now! A hundred times no! You can think what you like, I know I can't win anyway, there's no hope for me, but I tell you again and again, being in full possession of my mental faculties and fully responsible for my actions, as your doctors confirm, that the issue of the *Weekly Mirror* I bought from the kiosk in the square had a different cover. It had a photograph in a black frame. That's right, the photograph of that man. It was him, I swear it was him, and I'll swear to it on the gallows! That sad, tense face, the eyes looking at something outside the frame, probably at her, that woman. The photo was framed by a thick, black line. And below there were a few words to

30

the effect that this outstanding inventor, the pride of the electronic industry, the "constructor of thinking machines" had taken his life in mysterious circumstances. Inside there was an insipid, cheap, sentimental note about the man with a comment that the only explanation of his mysterious suicide was a tragic love affair.

That's the truth, my dear inspector. The only truth about these terrible facts in which I got entangled through the machinations of some destructive, evil, infernal power . . .

I cannot help it if it sounds fantastic. Everything here is fantastic from beginning to end. You can cut my head off, but I will not change a single word of my testimony.

No, I can't explain these facts. I'm not even going to try. I know what happened to me. If you don't dare to put a name to it it's your business . . . Let your people examine this medallion carefully, each atom separately. That's where the answer to the problem lies . . .

The rest you know. You must know it all by heart. I'm giving my evidence for the umpteenth time without changing a word. That is surprising, isn't it? If a man lies, if he is fantasising, it may happen, it even must happen, that certain details will be changed. But in my story, you will agree, there is a perfectly rational description of every event! Well, there it is . . . There is something terrifying in it . . . Yes, naturally I returned to my hotel. As I walked I read in the light of the street-lamps this amazing article, growing more and more convinced that what I had just experienced was no hallucination but reality – inexplicable, mysterious but therefore all the more exciting and interesting. I decided that immediately after my return to the hotel I should get in touch with my friend, a professor at the local polytechnic, who was mentioned in the obituary as the friend, teacher and mentor of the "sadly departed". I decided to give the professor a precise, minute by minute account of the whole afternoon. He is a remarkable man with a highly logical mind and extraordinary intelligence. Who else but he, I thought then, should be able to help me in finding a rational explanation of those strange events. I assure you that from

the moment I bought the *Weekly Mirror* I was convinced that what was happening to me was real.

The paper was tangible proof that it hadn't been an hallucination, that I hadn't fallen victim to my untameable imagination or, indeed, to mental illness. What's more, and I have mentioned this before, the man selling the newspapers spoke to me briefly about the death of the famous scientist. So, there was another man who held in his hand a copy of the *Weekly Mirror* from the 10th of May ... I don't care about your insistence that there is no such man, that for years the papers in that kiosk have been sold by an old lady, well known locally. I don't live in N., I came here to give a series of talks, and I know few people in this town ... I declare again that the man who sold me the magazine was about thirty, with a long, pale face, lightly freckled with light red hair. He wore a flannel shirt with rolled-up sleeves, and on his right forearm he had a very peculiar, unusual tattoo, to be exact, the same as the painting on the wall in "The Dancing Salmon". I know, you claim that the painting depicts a coastline but you're wrong. If you want to see exactly what the painting on that horrible wall is like, find the man from the kiosk. You'll find an identical picture on his right forearm ...

OK, I'll stick to the story. So, I was walking quickly towards my hotel. After a few minutes I was there. In reception the wall-lights shone brightly. I was handed the keys to my room. The receptionist was just looking through the *Weekly Mirror* – and I don't care that he emphatically denies it now. Someone who can corroborate my story certainly exists. I went upstairs. Walking up the stairs I smelt for a moment that dreadful, penetrating rotten stench, but I did not think about it much. I was determined to phone the professor at once and to unravel this mysterious story with his help.

The door to my room was slightly open. As I approached it I knew well whom I would find inside. I did not feel any surprise. It all seemed perfectly natural, obvious ... With the *Weekly Mirror* in my hand I pushed the door open.

She was sitting in the armchair looking at me with a joyful

gleam in her eyes. I came in and carefully closed the door. For a long while we remained silent. I felt I was lost but decided to go ahead and meet my destiny. She was beautiful and desirable above everything in the world. The medallion on her neck shone with a bewitching radiance . . .

"Where is he?" I asked after a while, pointing at the man's photo on the cover.

"He left," she answered.

Those were the only words I heard her say. Her voice was astonishing, unearthly. When she said these words the whole room filled with the sound of an organ playing. Yes, that's right, an organ playing . . . That's the only thing we agree upon, isn't it? Just at that time an organ concert was taking place in the nearby church of St. Roch, a famous virtuoso was playing Bach's fugues and toccatas. This helped you to establish the exact time . . . My God, who would have thought that my life would hang on a string of a few notes by J.S.Bach? This is the toughest nut to crack: the whole thing didn't last more than half an hour. Thirty stupid minutes from the moment I ran out of "The Dancing Salmon" till the moment when, allegedly, a cry was heard in my hotel room . . . It's nonsense, of course. I cannot prove anything, but I do know that she was with me the whole night, till dawn. The sound of organ music filled the room till the sun rose on the eastern side of the sky. These are the facts and you can keep repeating that I was arrested at 9 p.m. till kingdom come for all I care. You've got a statement from one of your men, someone read it to me. It's quite comforting. When he came into the room I was standing by the open window. I said: "What a bracing morning. How lovely the sunrise is above the city! . . ." He states in his report, if I remember correctly: "I heard him say it and I came to the window and indeed it seemed to me that there really was a sunrise. I said something like: 'I must be drunk.' And the sergeant behind me said: 'But corporal, you're teetotal!' and I confirmed that I was but I still saw the rising sun and I got scared . . ." This corporal of yours added later that he must have been imagining it, but that's nonsense, it's a desperate search for a

rational explanation to this whole story which is constantly slipping from our grasp . . .

Yes, of course . . . I'll stick to the story.

Well, she was in the room. When I closed the door she came up to me and put her arms around my neck. She kissed me on the mouth in such a way that I was close to losing my senses, but at the same time aware that here was the moment I had longed for.

We spent the whole night amidst the sounds of organ music. Neither of us uttered a word. She was astonishingly inventive in the way she made love. My God, for a night like that any man would gladly pay with his life.

When the morning came I got up and walked over to the window. I opened it wide, ravished by the sight of the sun rising above the city. Just then your men entered the room. They claimed the door wasn't closed but left ajar. On my bed lay the man. Dead. Apparently, he was strangled in some peculiar manner which can't be fully explained by your doctors. You state yourself you couldn't find anything which would indicate how it was done. Let me ask you two questions then . . .

How had that man been strangled? And from where had this mysterious medallion made of the metal of unknown origin and properties come? I know very well where you can find the answers to these questions, and many others raised by my story.

Dear inspector, do you think that in this age of electronics and *cinema verité*, that Hell has ceased to exist?

THE GREATER PUNISHMENT

by Marek S. Huberath

Rud was trying to lie still, though the pain had lost its piercing sharpness and changed into a pulsating heat, only sometimes reminding him of the steel objects with which they had tortured him. He was almost sure they had left some of their instruments buried in the wounds. He could not get up; the strong straps were still fastened around his hands, feet and neck. He was also trying to lie still because the sheet stuck to his back and any sudden movements would tear off the dried up scabs.

He lay, waiting for the next interrogation. It was all right now; they had stopped beating him. Only the lamp shone straight into his eyes with an unbearable glare. Because of it he had swollen and itching eyelids. Each glance caused a shooting pain and brought tears to his eyes. He wished he could keep his eyes closed for ever, but after each interrogation they were always forcing him to read lengthy statements which he then had to sign. Now he kept his eyes tightly shut to give them at least that much protection. He was afraid he would go blind, and suspected that this was precisely what they wanted. The regular flashes of the lamp, powerful like the flash of a camera, penetrated the eyelids. He saw them as sudden eruptions of red, and those particularly strong ones as slow-motion explosions of whiteness spreading through the black. The eyelids burned, especially when he was blinking, but he preferred this to the blinding flash of the light.

He lay, thinking that he would rather be dead. Every move meant pain. The throbbing in the wounded flesh indicated the desperate efforts of his body to cope with the injuries. He almost felt the forces of his organism fighting the infections and internal bleedings, as life struggled to return to the

damaged tissue. He did not even try to guess the extent of the damage. He knew that his fingernails were pulled out; he saw that. He was convinced that they had smashed his jaw. He suspected they had knocked out many of his teeth, for he remembered spitting them out. His whole body must have been one big wound; it was frightening to think what he looked like. The thing he feared most was the return of his tormentors. His every nerve strained to detect the slightest indication – a noise, the vibration of the floor – signalling their return. He knew he was under "normal procedure" and that he had to go through all its stages. The Interrogators had used that phrase in his presence several times.

Before, they used to visit him regularly. Rud would turn his head to see the face of the electric clock hanging on the wall. That was how he knew when they would be back, and in this way he had breathing space. But they caught on to it and began to visit him at different times, or maybe they had simply changed the timetable. Now it didn't matter anyway: during one of the interrogations the blood squirted out as far as the clock and the cleaning lady, washing the room with a hose, wiped the clock with a wet rag; the mechanism stopped. Water must have got inside and caused a short circuit. They took the clock for repair and on the wall there remained only a lighter patch with two hooks and an electric wire hanging between them.

The lamp started flashing at regular intervals. It always meant that someone was coming down the corridor. He was overcome by an animal fear. His body grew taut, as if trying to break out of the fetters, instinctively shrinking from the expected tortures. Soon he heard the steps in the corridor. The grating noise of the key in the rusty lock caused a physiological reaction – Rud wetted himself. It was accompanied by a terrible pain in his burnt and massacred genitals.

The steps resounded in Rud's head like a hammer. He tensed again in expectation of the first blow. He wanted to confess everything, he wanted to shout out his readiness, but the swollen lips did not want to move and the broken jaw responded to his efforts with a shooting pain.

"He stinks like a skunk. Pissed himself. It's like a pigsty here," he heard a voice. "We'll have to report Blicyna. She's doing sod all, that bloody woman."

Rud wanted to protest that it was not her fault but his own weakness, but the words could not pass the barrier of his crushed lips. He knew that Blicyna, the cleaning lady, would take her revenge for the report. She would be deliberately hosing his tortured body with disinfectant, for longer than necessary, setting the stream to the maximum force, tearing and salting the wounds. She would also, as if accidentally, push and pull the lying Rud, knowing well that it would cause him pain. She would, as if unintentionally, catch his broken fingers with the rag or prod his skin, burnt with cigarettes, with the end of the broomstick.

When there were no reports on her from the Interrogator, Blicyna was less cruel; she did not bother, hurrying to other things. There was always a report when Rud defecated under himself, and they were more or less regular as Rud never left the table for interrogations, or even between them.

Despite that, Rud greeted Blicyna's visits with relief. They meant that the interrogation was over. And when she tormented him no more than was her custom, he was almost happy. The most wonderful moment was when she covered his bruised body with a sheet.

The lamp ceased to flash and the darkness returned under his eyelids. He tried to open his eyes but they were stuck with pus. Through his broken nose, filled with clotted blood, he smelt the odour of cheap tobacco.

"Milankiewicz, dreaming's over! Wake up!" Someone pulled at the sheet, tearing off tens of scabs at the same time.

Rud only groaned; the pain flashed in his head like lightning. Someone pulled off the sheet completely. Rud jerked in his straps.

"There, there, it's all right now," the voice sounded different from the usual barking of the helpers or the persistent questioning of the Interrogators; there was no threat in it. Rud was crying. He expected something worse to happen at

any moment. The tears at last forced their way through the dried up pus and rolled down his temples.

"Ah, you can't open your eyes . . . Why don't you say so, Milankiewicz? . . ." It was the same, somewhat sleepy voice.

But I do, I do, I would . . . Rud wanted to shout it out, his heart overflowing with willingness to co-operate with the Interrogator.

"Now, wait a moment," said the officer and walked to the glass medicine-cabinet where he picked up some eye-drops.

Rud felt an excruciating pain, as if someone had stuck a screwdriver in his eyeball and kept twisting it. Then the pain stopped. He could open his eyes now.

He saw before him a brutish, as if distended face belonging to the Interrogator Neuheufel. He did not have his helpers with him. Neuheufel participated in all the interrogations. He was neither better nor worse than the others. Only once, furious, he had pushed a pencil into Rud's left ear and burst the membrane. Sometimes, though rarely, he would burn the skin between his fingers with a cigarette.

Now Rud was struck by the change in the Interrogator's appearance. Instead of a fiery pentagram, his hat bore a blue one. The hat also had a blue, rather than the usual blood-red rim. The lapels on his uniform were of a similar colour.

"You're in Heaven, Milankiewicz. Greater Punishment is over. I managed to arrange for an early release, without the last two sessions," said Neuheufel, at the same time loosening the straps restraining Rud.

Rud only groaned.

"Get up. I'll take you to the Medical now." Neuheufel was helping Rud who hissed every time the Interrogator's rubber-gloved hands crushed the scabs on his shoulders. Each move was painful; lying still too. Rud could not bear the pressure on his bruised, festering buttocks but did not know how to tell Neuheufel, who kindly, though firmly, supported him in a sitting position.

Neuheufel pushed a lit cigarette between Rud's mashed, swollen lips.

"Have a drag," he said. "Can you manage a walk?"

The smoke scoured his aching throat. His lips burnt unbearably. Irritated by the cigarette, the chafed lip burst and a thin trickle of blood rolled down his chin. He started coughing, gasping for air. Each cough caused a paroxysm of pain in his battered guts.

"Oh, Milankiewicz, pull your socks up," muttered the dissatisfied Neuheufel. "A young man like you . . . and such a jelly."

Rud's sight was still too weak to judge properly the state he was in. He only noticed that his right shin, broken during one of the interrogations, had healed crooked. His body was covered in scabs. He could not tell one wound from another.

Neuheufel helped him to get up. Rud's limbs were not numb. Perhaps it was thanks to the various chemicals injected into his veins after each interrogation. He could not stand straight, his left leg was shorter, he was trying not to lean on the broken toes or the battered heels. The only remaining support was the outer edges of his feet.

Neuheufel threw over Rud a grey, sleeveless prison shirt. Apparently, the regulations forbade leading naked prisoners through the corridors. The shirt had a big fiery pentagram on its back and a ten-digit registration number. Rud could never remember it.

"Follow me. But don't embarrass me and don't shit yourself on the way, Milankiewicz," said Neuheufel. He opened the door and walked out into the corridor.

Hissing with pain and limping on his injured feet, Rud hobbled after him. Neuheufel's polished boots flashed in front of his eyes. He could not keep up with the Interrogator's springy gait.

"You're in no great hurry, Milankiewicz. I see I shouldn't have bothered with that early release. You don't even want to shift your arse from the Interrogation Room, do you?" said Neuheufel without turning his head, as he walked on.

Unable to deny it, Rud began to cry. The accusation that he was being ungrateful hurt like a match being pushed under his fingernail.

"No . . . no . . . I simply can't walk any faster," he mumbled out his first words.

They stopped in front of a lift. Neuheufel ceremoniously pressed a big, blue button.

"You'll go to the very top, Milankiewicz. Aren't you pleased?" He chuckled and lightly slapped Rud on the back. His back was one big messy wound full of pus.

The Medical Committee was already waiting for him. The uniformed nurse led him to the middle of the room and to the small plinth standing opposite a huge mirror. On the left stood a table covered with a green cloth. One of the doctors sat in front of an ancient typewriter. On a little plate there were doughnuts, and around it stood glasses of freshly brewed coffee. The green cloth was generously sprinkled with icing sugar from the doughnuts.

The committee consisted of four female doctors. They all wore field-caps, and white coats over their uniforms. Rud noticed that all of them had blue pentagrams on their caps and none wore the fiery sign. He sighed with relief.

The doctors were healthy, rosy-cheeked, of unidentifiable age. They all wore heavy make-up. The one who had the role of typist was correcting her manicure with brightly coloured nail varnish. The room was filled with the intense smell of acetone mixed with the fragrance of coffee and cheap perfume.

The sight of so many women, bursting with health and aggressive sexuality, overwhelmed him. In the Interrogation Room he had long lost the sense of time. Now he could not remember when he last saw a woman.

One of the doctors, arguably the most beautiful of them all, with flaming hair, strong rouge on her cheek bones and cherry lipstick on her lips, watched Rud with interest. Her colleague sitting next to her unbuttoned her white coat and uniform to her waist, constantly moving and stroking her breasts. Between her hand and the material he caught glimpses of her smooth skin. Ignoring Rud, she was discussing with her neighbour the problem of looking after breasts and their firmness. In the end she took them out even further and, pretending she was screening them from Rud's

eyes, she showed her colleague the nipple, boasting of its perfect roundness and colour, it being apparently the result of long massage and a specially prepared ointment. Rud's head was swimming. " Angels . . ." he thought, enraptured.

The fourth doctor listened to the talk while nibbling at a fresh doughnut sprinkled with icing sugar and quietly slurping the coffee.

"At last, they've sent someone sensible from downstairs," said the cherry-lipped one, picking up a file. "Normally they send us shrivelled up grandads, swollen fatties or aborted foetuses. Ho, ho, ho," she showed her surprise, leafing through the file, "what a womaniser. So many women . . ." She grew silent, absorbed in reading the documentation. "Hm," she said and looked at Rud with interest. A light, sensuous smile lent her somewhat aggressive beauty a hint of charm.

"So, your name is Rudolf Milankiewicz?" she asked after a period of meaningful silence.

"Ruder, not Rudolf," he corrected her. "My father was an immigrant."

"I don't mind. Take your clothes off."

Before the surprised Rud could react, two female Guardians stripped him of his prison shirt. In the mirror in front of him he saw the terrifying ruin of his body. The ghastly puffed up face with hardly visible slits for eyes; the broken nose; the lips deformed and swollen out of all proportion; the horribly emaciated limbs, covered with dry blood, sweat and dirt; the open wounds and the grotesquely bent right leg that was never set properly; the ears hanging in shreds.

Only after a while, as if waiting for Rud to examine himself in detail, the doctors burst out laughing.

"But men usually have something else there, not scraps like that," cracked the one who was doing her fingernails, and the rest cackled.

"Is he a man at all?"

"He's worse than a grandad or a cardiac!"

"What a wreck!"

41

Flushed and animated, the doctors were shouting one over the other, almost overflowing with feminine sexuality.

"Well, we'll see what we can do for him," said the beautiful one and came closer.

"Our boys did a right job on him," she said after a while, prodding the remains of Rud's genitals with the pencil. "Torn up and burnt shreds, now infected and full of pus," she said. "Point one: fit for complete removal."

"They were connecting electrodes, pulling with little hooks . . ." mumbled Rud.

"Correct. That's why the skin is charred," she answered. "But no worries. We'll fix you with a pretty little pipe. You'll piss without pain."

Rud's heart fluttered like a caged bird.

"Can you feel anything?" she asked, for a change sinking the pencil in the huge, rotting wound stretching from his collar-bone to the top of his shoulder. She had to push it deep before Rud hissed with pain. She deliberated for a long time over his leg, but in the end came to the conclusion that the bone was rotting and the leg would have to be amputated below the knee.

The slow thumping of the ancient typewriter was sealing the fate of his wretched body. The typist kept making mistakes, swore and complained that the typing was ruining her nail-varnish.

The doctor spent even more time over his face.

"I think the ears can be just as well altogether removed. There's hardly anything left of them anyway. The nose . . ." she hesitated, "the nose could go too." She must have suddenly felt pity for Rud, for she added: "You are a tricky case. There's very little healthy skin left on you that we can use for grafts."

"They were beating me till the skin burst," he said. "Poured acid into my armpits . . ."

"Stop moaning, Milankiewicz," she barked at him and her beautiful face hardened unexpectedly into the expression he used to see on Neuheufel's face. "It's a normal procedure for interrogations. You didn't get there without a reason."

And then she changed her tone again.

"I can make you the ears but then there won't be enough for the piss-pipe," she said more kindly. "I'll make you a little hole, like a girl's, but you'll have to wee-wee squatting."

"Maybe we should turn him into a girl altogether," giggled the one who was playing with her breast. "We'll make him a little hole and breasts stuffed with sponge and then we'll have enough skin to make him a pretty little face."

"No . . . No, you can't. I object," protested Rud violently.

"If you object to the operation we won't treat you at all, Milankiewicz," said the beautiful one firmly. "You are free to choose. With rotting genitals and that wound on your shoulder you won't last long. Ten days at the most. There are already the beginnings of a general infection."

Rud shuddered.

"Your consent to all operations and amputations is the condition of your treatment. You have absolute freedom of choice. Here you are, choose."

She waited a little while for his answer. Rud went numb with fear.

"We won't change him into a woman. The documents state he is a man so he'll have to stay a man. It all has to tally."

"We can cut the leg above the knee and then we'll have more skin to repair the face," mused the one eating the doughnuts.

"Waste of the joint," the beautiful doctor thought aloud. "I don't think it's damaged. It will be easier to fix the artificial leg."

"There aren't any short ones in stock, I think," the doughnut eater was not giving up, licking the sweet icing off her lips. "Only the long ones, full size."

"But the artificial limb is fitted to the leg, to the stump, not the other way round," Rud dared to suggest.

"Don't interfere, Milankiewicz," barked the one playing with her breast, and aimed the large nipple at him like a gun. "You look a ruin as it is. Six inches won't make any difference to you. It would be nice if our industry were to

43

produce artificial legs made to measure for each of you, wouldn't it? Well, I can tell you that you wouldn't be able to afford one, it would cost so much. Haven't you ever heard of mass production?"

Rud stopped interfering in the discussion of his body. He did not protest any more. He was, after all, in Heaven.

Before the operation he was put in hospital to heal his open wounds. The unbearable itching of the skin, caused by the thick gel spread all over his body, drove him crazy. Hopping like a madman, Rud would wander restlessly among the bunk beds in the crowded ward, which in turn made other patients mad at him. Some of them, those from the upper beds, would punish him by pouring over him tea or the remains of their soup. One of them even burnt the skin on Rud's head with hot milk. He lost the rest of his hair then. Other patients, who still remembered what they had been through themselves, were kinder. Generally they were weak, wrinkled old men tired of life, who were afraid of the limping but physically stronger Rud.

The pre-operation treatment also included daily pumping out of the stomach, which was making his insides tie themselves in knots; and daily enemas.

"They probably want to rupture the constrictor muscle," commented Tony the epileptic. "Then they'll make you an artificial arse-hole on your belly. To prevent you stinking of shit all the time. They do it to everyone. With you, they must have forgotten to blast your arse during the interrogations. Did they connect the air-compressor to your arse-hole?"

"No."

"There you are. It bursts your gut."

Tony's hands, covered with flowery patches, with big, knotty, rheumatic joints, trembled uncontrollably as he was trying to roll a cigarette. The precious tobacco, fine as dust, was spilling all over the floor. Rud tried to help him with his stiff, broken fingers. Three of them had new shoots of finger-nails growing back.

Rud's new ears, fitted in place of the old ones, which had

been torn to shreds during the interrogations, were shapeless and devoid of their characteristic dents and folds, and had white hairs growing on them. They must have used the skin from his forearms. These were the only hair on his head. His skull was bald and shiny.

"The nurses and orderlies are so rough and brutal," remarked Rud.

"Just routine," answered Tony. "It's routine that on the men's wards they employ only female doctors and on the women's wards only men. The same rule applies to the nurses, orderlies and the rest of the personnel."

"How do you know that?"

"I spoke to the patients on the women's ward."

Rud was so surprised that he added: "You're not allowed to have any contact with women before an operation. Only after an operation. Even in Heaven you have to dose the freedom sensibly: gradually. Otherwise you'll go out of your mind; too much joy."

The surface wounds were healing although, or maybe because the nurses tore them off so frequently, always changing the dressings quickly, if not violently, pulling at the dried up gauze. They cut the dead tissue out of the wounds, and several times, accidentally, cut the living flesh with it. It was the more unpleasant for Rud since he didn't want to lose even those miserable remains of his genitals.

He madly feared the operation. He observed with terror as the zigzag line tracing the daily record of his temperature headed inevitably for the purple, vertical line marking the date set for the operation.

He feared those moments when someone else would be deciding the fate of his body without him being able to influence the process. He feared that they would turn him into a woman, for a joke. He often examined his leg trying to guess at which point the doctors had decided to cut it. The leg didn't hurt. The skin was healing smoothly. Only the shin had a grotesque, crooked shape from the badly set bone. Nevertheless, he could walk, though with a pronounced limp. He also feared they would cut off his inactive fingers.

Looking into a small, fly-blown mirror hanging above the sink, he tried to imagine what he would look like with a hole instead of a nose. He still had a nose, although most of it was covered by a weeping scab and the nostrils were hanging in shreds. But it was his.

After the operation, they had brought Rud back to the ward. He was bandaged from top to toe, and as a precaution a small screen was installed around his head to prevent him from seeing the rest of his body.

The first hours were a nightmare. The ether made him vomit, to which his cut and sewn up flesh answered with terrible pain. Every move, every attempt to clear his throat, caused pain. The patients sailed through the ward looking him up. When Rud could speak again he asked Galahar, who was just leaning over him, to check how far they had cut his right leg. Old Galahar lifted the sheets with his walking stick.

"It looks as if you're in one piece, with both legs. They've wrapped you up from top to toe with holes for your eyes, your mouth and your nostrils. But, you see . . . when they cut someone's leg off, the artificial leg is also bandaged up so you can't see it. It's their kind of medical ethics – not to cause undue anxiety in the patient. Try and move this leg."

Rud could move neither his leg nor his hand. The only movement he was capable of was rolling his head from left to right, and even that only to a limited extent.

"I can hit your toes with my stick, maybe you'll feel the pain," suggested Galahar.

"It won't help," Tony joined in. "He won't be able to differentiate the pain. A cut off limb hurts as if it was still there and as if it hurt all over, even though it's not there. They could cut off his arms and legs and he wouldn't be able to test it that way."

"Aaa!" Rud jerked with fear and groaned, paying with pain for the hasty movement.

"So what's left?" Rud forced the question out of himself when he managed to stifle the sobbing, and when the pain had returned to its normal level.

"The uncertainty," quipped Tony.

Soon the screen was taken away. Now it would be set up around his head only for changing the dressing or removing the stitches. They said it was to save him unnecessary stress. Lying passively, he would try to guess, in vain, what they were doing, and what they had done to his body. The only indication was the changing intensity of the pain coming from different places during the course of the treatment. The treatments were always carried out by one of the doctors who had examined him earlier. He remembered them all very well. He did not know their names with the exception of the redhead – the beautiful one – whom the patients called Panfilova.

The doctors changing the dressings often tormented him with silly jokes. The one who had been playing with her breast, claimed they had managed to turn him into a pretty girl with a very attractive bust; even she was envious. She only complained that his hips were too narrow, but they would soon fatten him up, take some fat from his belly and pad out his thighs and buttocks. All this she said half-jokingly and Rud had no way of knowing the truth. He was still afraid but in time he started growing indifferent. Fear, if not accompanied by pain, turns into a habit.

Once he gathered his courage and asked Panfilova how high they had cut his leg.

She looked at him searchingly.

"You'll be surprised when you see it," she said and gave him a hard, almost friendly, slap on the face.

Another time, Neuheufel paid him a visit. Rud shivered seeing him again. He could not help it. Neuheufel made him answer hundreds of questions from a lengthy questionnaire. He was sitting on the edge of the bed, filling in page after page, smoking like a chimney. Rud could not stand the smell of tobacco and after Neuheufel's visit he vomited.

They could not keep him wrapped up in bandages forever; some day the uncertainty would have to end. When that day came, they took all the bandages off in one go and he was

allowed to walk straight away. Rud examined his body suspiciously and asked for a mirror. His body didn't look too bad, in fact it looked far better than he had anticipated.

They had not cut off his right leg. It was straight and the same length as the left. More important, he could urinate without too much pain. They had reconstructed his nose quite well. It was soft like a boxer's nose, but could have been worse. The ears were also where they should be, though ugly, badly shaped and too big. The hole on his shoulder remained but it had healed. His body was covered with fresh red scars and patches of pink skin, which looked like thin blotting paper, and which had freshly grown over the burns and where they had taken the skin for plastic surgery. He was given a special talc to sprinkle over these areas to avoid chafes and new wounds. He could bend all his fingers, though some of them moved only with difficulty. Most of the fingernails had begun growing anew.

"Why? Why have I had to live in uncertainty?" he asked Panfilova, putting back on his grey hospital gown with a blue pentagram and his registration number.

"The transition from Punishment has to be gradual, it's better for the mind this way," she answered. "And besides, we don't want patients to nurture unfounded hopes. An operation can be unsuccessful . . . That's why the initial examinations always suggest the least optimistic outcome. We have to avoid disappointing the patient. What would you say if I'd promised you that I could save your leg and you'd woken up without it?"

Rud didn't answer. Panfilova was throwing the bandages into the bin. She was working on her own; there were not many nurses on the afternoon shift. She looked tired. She had no make-up on. Her face looked pale because of it, but younger. She had a delicate net of wrinkles around her eyes. It was a completely different Panfilova from the one he had grown used to, though equally, or maybe even more beautiful. He wanted to ask her if she was not ill but thought it might have been a hangover and did not dare.

"And what will happen to me now?"

"The same as to everybody," she shrugged her shoulders. "They'll transfer you to the Adaptation Centre. You have to recover internally. The process is gradual. The same rule applies as with operations."

The Adaptation Centre occupied a wide area surrounded on one side by grey hills and on the other by a sickly little wood. The blue-grey sky, unseen for so long, took his breath away.

The Centre consisted of barracks standing in rows and built of black, rotten timber. Along the rows of barracks ran narrow streets trodden out in clay. When it was dry they were covered with dust, when it rained they turned into mud. Then there was a little factory employing people from the outside, who arrived by a train weaving its way through the hills; there were also a number of administrative buildings. The zone, with fences and sentry-boxes, was located on the side near the wood. The adaptation to Heaven should be gradual and so, for the sake of the inmates' mental health, their release into freedom was also gradual. One of the administrative buildings housed a small crematorium where all the hospital's refuse – used bandages, excretions, offal – were burnt. On windless days, thick smoke floated through the streets, irritating the throat. Those who, like Rud, were brought here by the lift from below, joked that the crematorium was fuelled by the unfortunate ones who failed to adapt to Heaven; but it was not true.

The barrack where Rud lived was exactly the same as the others: through the middle ran a dark corridor, with electric wires from which hung speckled light-bulbs surrounded by buzzing flies. The corridor was filled with the stale odour of timber rotting in the damp warmth. On each side was a row of warped doors leading to the wards. The door was always padlocked when everybody had left the ward. In such cases the orderly of the ward – usually an old, decrepit man – took the key with him. It was inconvenient.

At the end of the corridor was a toilet; two cubicles. In each there was a board with a hole in it; below, the cesspool

49

and a swarm of fat, obstinate blue-bottle flies. The instructions stated that the seat should always be sprayed on both sides with a strong insecticide, as underneath often sat venomous spiders. People said that there were a few cases of bites, when the swollen victims had to be hospitalised. But more often than not, the aerosol was missing from the shelf made of a small rough plank. Thus there were only two toilets per barrack and every morning in front of them gathered a long, stinking queue. The stink was coming from the incontinent ones. Everyone crowded in, ignoring the stink, for even though in each ward there was a sink, urinating into it was strictly forbidden under the threat of extension of Greater Punishment; this was threat enough.

The wash-room was outside, adjoining the barracks' wall. It was a long metal trough with a row of taps. In the morning, before everybody left for work, all the taps were in constant use. The water pressure diminished in each tap towards the end of the pipe. As a rule, the strongest always positioned themselves at the taps with the highest pressure.

The shower was also located outside, fenced with a sheet of corrugated iron screening the body from calves to mid-shoulder. It was used rarely, for the water was ice-cold, as in the sink taps. The water was so cold it made hands numb and red. The regulations demanded that the hands be washed twice a day, and a bath taken every two days; those found with dirty hands, feet or ears were deprived of their ration of cigarettes or chocolate ersatz. Everybody therefore washed and took their showers according to the regulations, but no more often.

One half of the barrack, the one further from the toilet, was taken by the Un-born. Rud didn't like the Un-born. He thought they considered themselves better than the others. Even in the barracks they occupied the parts where it stank less.

He had seen an Un-born for the first time on the lawn outside the barrack. He had expected to see a tiny, dainty creature but the Un-born was quite big, the size of an ordinary new-born baby, ugly with a strange watery, limpid

complexion. Later, someone told Rud that there were also Un-born who were eight months old.

Rud looked at him. He noted the delicate skin which seemed almost too soft, the barely drawn fingernails, the big, grey-blue eyes without eyelashes, and the tender transparent ears. The Un-born was looking back at Rud with an unexpectedly strong, insistent, almost hypnotic stare. Rud averted his eyes. It was difficult to withstand the gaze of the Un-born. Both wore the same sort of grey linen jackets and trousers. Both had the blue pentagrams and registration numbers on their backs. Their jackets, of the same cut, were simple but practical. The Un-born's shoes were a miniature copy of Rud's camp issue clogs – healthy, airy, with wooden soles.

"What tiny feet," thought Rud.

"Beat it, mate. Get out of my way," thundered in Rud's head. The Un-born, with their undeveloped speech organs, used that strange, direct method of communication. Rud obediently stepped off the path. The Un-born toddled past him in mincing little steps with faint thumps of his wooden heels.

On the ward, apart from Rud, there were only old men; some of them very old, gaga. The wooden beds had no top bunks; there was no way any of the old men could climb the ladder. Half the ward, those who slept on the window side, were in the care of Interrogator Neuheufel. He was their guardian and protector. The rest were looked after by Lieutenant Holzbucher, who hardly ever visited the barrack.

Neuheufel managed to get all those in his charge out from below before the full completion of Greater Punishment. At least that was what they said; and so did he. Sometimes Neuheufel would bring some liver sausage or brawn from the canteen. He would take these treasures, wrapped up in soggy brown paper, out of the pocket of his uniform and put them on the table, which someone would hasten to wipe obligingly with their sleeve. They would all surround the table, watching devoutly his hands unwrapping the precious gift. Holzbucher's flock went green with envy watching the rationing ceremony from their bunks. Neuheufel shared out the meat according to work input and progress in

re-socialisation. Those who in his eyes didn't deserve it would walk away from the table dejected, while the rest relished the gift. Neuheufel tended to favour Rud and his portions of brawn were always the biggest.

"These rotting grandads piss me off," he confided once to Rud, "but what can I do? They only send that sort these days. Sometimes they do a round up on the other side and then we have crowds. Women, children, old and young. Whatever you fancy. You can work yourself stupid, there's so much of it.

"But I like work," he looked at Rud searchingly, "it's better than doing nothing, like now . . . But maybe something will turn up soon. At the moment there are only grandads. Very rarely someone young, from an accident, like you, Milankiewicz."

That was how Rud learned that he had got there as the result of an accident.

Neuheufel's casually dropped remark began to germinate in Rud's mind during the sleepless nights. At the first appropriate occasion he returned to that conversation. He asked directly why he had ended up with Greater Punishment.

"I wonder myself," stated Neuheufel colouring the graphs in his report. "You have to be a right bastard to get Greater Punishment. You don't look it Milankiewicz."

Rud had expected a different answer, he wanted an explanation. For many days he fruitlessly rummaged through his memory. Almost fruitlessly. There was one thing that kept coming back.

Neuheufel's face grimaced in a strange expression, his eyes bulged, so greedily was he awaiting Rud's words. He thought that Neuheufel was trying to help him, as if by concentrating so hard himself he might help Rud remember the right reason.

"There was really only one thing. It was about a girl," he started with hesitation, but as he spoke the words began to flow more easily. "She worked a till at a department store.

Petite, slim, with a good figure, unpretentious, only her face was really beautiful."

"The rest was ugly?" asked the interrogator.

"Well, no, but her face was really unusual. Everything was beautiful on that face: the eyebrows, the eyelashes, the peach complexion and the same sort of down on her cheeks. Her nose was perhaps a little too prominent. She had searching eyes, vivid, blue-green. I'll never forget her eyes. And blonde hair. Excellent combination. Later, I found out that the hair was bleached. But it didn't matter all that much . . . Always that blush . . . The lipstick was unnecessary, too."

Neuheufel was listening patiently.

"And the funny little biceps, and the dark hair on her forearms. She was very embarrassed about those hairy arms and when it got warmer she would shave them. Then the hair would grow back even thicker," Rud was responding to his own thoughts.

"I began to visit that shop," he continued after a moment of silence, "and then the affair followed its natural course. When I first chatted her up I was sure of the result. Several times I caught her eyes and the eyes can tell you almost anything. That searching look in her blue-green eyes. Water has that colour sometimes."

Neuheufel slurped mightily from a three-pint metal tankard. Then he spat out a tea-leaf.

"See no reason for Greater Punishment," he stated with an innocent face, if Neuheufel's face could ever assume that kind of expression.

"It's because . . ." Rud stammered, blushing, "it's because later we did the usual."

"The usual?" Neuheufel was mercilessly curious.

"Well, you know . . . We even lived together. Then I had to leave; I began to study," Rud stammered out.

Neuheufel watched Rud's face closely, while his own slowly crumpled into the familiar smile.

"And she was pregnant. She even followed me. To the place where I was studying. But by then I was interested in

53

someone else," Rud was tortuously squeezing out of himself one sentence, then another.

"Did she give birth?"

"I don't think so. That is, I'm sure she didn't." Rud was sweating with the effort. The confession was bringing him no relief.

"I'll check your file, Milankiewicz. We'll see what we can do about this." Neuheufel's tone of voice was official. "What was her name?"

"Dianna. Dianna Felden. Strange spelling of the name."

Neuheufel nodded and turned to the window. He didn't want Rud to see him laugh.

On Rud's ward arrived Tony, the old epileptic of shiny bald head covered with red freckles and trembling hands with cauliflowery growths, whom Rud had met in the hospital.

As Rud's convalescence progressed, the time spent on rehabilitation exercises was cut shorter and shorter. He hated those obligatory tortures. First he had to soak his hands, feet or his entire body in a hot solution of salt and then rough, well-muscled, female masseurs would break his stiff joints to make them usable again. He could not stand their cynical comments. Apparently, he was making a surprisingly good recovery, though to him it seemed rather different. The scars had paled and the pink, paper-like skin had grown thicker, whiter and less irritable.

Because Rud had now a little more time, Neuheufel offered him some work. It earned him additional rations for cigarettes and better food. Rud did not smoke but with cigarettes he could buy almost anything, they were a common barter.

His job was at the railway depot, unloading new residents who arrived from the other side. The old steam engine, wheezing with the effort, pushed several cattle wagons down the track. The greasy face of the engine-driver, wearing a military hat with the red pentagram, would look out from the cockpit; transports from the other side were dealt with by the functionaries working below.

The task of Rud's brigade was to unload the transport.

The leader wore a hat with the blue pentagram and a black police truncheon, but he was never forced to use it, for everybody worked with a will. In fact there was more willing than work. For some time now, the transports had been rare and relatively small. Before, there were periods when the track was crowded with wagons, the brigades worked day and night and still could not keep up with the unloading. There had been many young men on the transport then and the last time when the volume of transports had peaked, there were also the old. The leaders' truncheons had been used then, though the day rates were higher and they paid overtime for night shifts.

Small, dark-skinned Jose remembered those days. He was smoking a strong roll-up. His registration number was very low, almost half Rud's. Jose was a rebel or a guerrilla fighter. He didn't remember exactly, or didn't want to say.

"They used to come in herds, in stripy pyjamas," he said, reminiscing. "Once, one of them, skinny as a coat-hanger, with sunken, burning eyes, stops in front of me, fixes those flaming peepers on me and he says: 'There was a ramp there and here is a ramp.' He sniffs the air and he sighs: 'Eli, Eli, and the smoke stinks just the same. Isn't it ironic, brother?' I didn't understand that. And then he walked away, stooped, his shoulder-blades sticking out. I can't forget him. I've never seen him again, though I wanted to talk to the bloke." Jose twitched his flat, coal-black little moustaches, sucked in the rest of the smoke and stamped out the fag-end.

When the seals on the wagons were broken, they saw rows of vats with hermetically sealed lids. Each vat had two little handles. When they were carrying them from the wagons, putting them two at a time on electric trolleys, they could hear water sloshing inside. The work was hard, the vats heavy and the day was exceptionally hot. Rud dripped with sweat. He worked with Jose who, though not very tall, was a strong man. It was much harder for the old men, who puffed and groaned, but the temptation of earning an extra ration of cigarettes was strong enough and the leader had no need to wave his truncheon.

Leader Eckhardt was a tall man with the muscles of a body-builder and the face of an actor in westerns. He used to stroll slowly among the workers, sometimes helping the men when the vat carried by their weak hands was tipping dangerously.

This transport puzzled Rud. He expected people and all that came were big buckets of water. At night, when the tired muscles tingled pleasantly, he fell asleep seeing rows of grey, numbered vats.

The following day was his day off. Neuheufel sat at the desk, preparing another report. Rud was copying for him long columns of figures, drinking coffee with chicory sweetened with saccharine. Neuheufel had real coffee with real sugar. Rud asked him about the mysterious vats.

"It's the Un-born," Neuheufel winced. "They always transport them that way. People pour buckets of them down the loos so we get them in buckets too. Hands, legs, heads, all separate, you understand? Those surgical scoops cut them into bits. Then the girls from the Medical have to put them back together, sew them up. Shitty job. Those little arms, delicate tissue . . ."

"The doctors sew them up?"

"Of course not, there's too much of it. Their nurses do it. If she scraped out one she has to stitch one back, if two – she's doing two."

"Each her own kid?"

"I don't know. I don't think so . . . for practical reasons. It doesn't matter. What matters is that they mustn't mix up the hands of different kids. That would be a mess," he chuckled coarsely.

Neuheufel's white, fat belly covered with thin wisps of hair spilled out from his unbuttoned uniform shirt, bouncing to the rhythm of his giggle. Rud poured his coffee down the sink. He wanted to throw up.

Despite his first, unpleasant impression, Rud had grown to like his job of unloading the transports. He only asked Neuheufel not to send him to work on the transport with the

hermetically closed vats. He was still afraid of them. But when there were other transports the work was pleasant. He liked to watch as the old, frightened faces brightened up on seeing the sun and the blue sky. He would escort those people – meek, humbly stooped, clutching their favourite things – explaining to them they should give up all they had brought with them, as here they wouldn't be able to hang on to anything from the other side. Some of them were persuaded, some not, and he had to take their things away from them by force. Sometimes it caused an unnecessary fracas.

Later, the newly arrived were put in front of the committee that decided who was to be sent for Greater Punishment. Jose claimed that the committee decided nothing, but only administered and sorted out the transports. Except for the complete grannies, Rud felt uncomfortably bashful with the women. Every time, it seemed to him he read in their eyes contempt that he was not a real man, because he had to piss through a special pipe.

Then Fiala joined their team; a young boy, fresh from Greater Punishment. Rud could not bear looking at his face. It was exceptionally badly and clumsily reconstructed. The ears were uneven, one sewn up higher than the other, the nose was too short with huge nostrils, like a monkey's; the skin on his jaw was rough and tubercular. He had many tissue bridges on his neck, an uncountable number of pink weals scarring his face, patches of bald skin on his skull, and horrific skeletal fingers covered with shiny, elastic pink film. Fiala told them that during the interrogation they had enjoyed sprinkling him with petrol and setting him on fire. They had practically burnt all his skin. Apparently it was Neuheufel's idea. Rud found it hard to believe. Fiala could carry nothing in his damaged hands and only escorted the newly arrived, persuading them to relinquish things brought from the other side. Thus the job of wrenching away their possessions had fallen to Rud and he was not pleased with such a helper. Fiala, to the contrary, unexpectedly chose Rud as his confidant.

"The worst was the Medical Committee," he once told

Rud as they sat on the slope by the track, waiting for the engine to pull away the empty wagons. "I wanted the earth to swallow me up," he said blushing with embarrassment, the scars on his face swelling into thick, bloody strings. "They were splitting their sides for half an hour that I had nothing left . . . Shit, how could I have anything left when they'd burnt everything to a cinder – nose, ears, eyelids . . . I'm surprised they didn't blind me."

Rud nodded and spat out his chewed gum. Recently, Neuheufel had been giving him nicotine chewing gum; first to get him used to nicotine, then to make him interested in cigarettes. Neuheufel wanted to make Rud take up smoking so that he would be more interested in the overtime, which was paid in cigarettes.

"It's a normal adaptation procedure. The laughter," he was telling Fiala, "is to make you stronger. Or so they say. Don't worry about it. Have they at least fixed you a piss-pipe?"

"They have."

"Does it hurt when you're taking a piss? If it does report it to the Medical. They'll have to adjust it." Rud lighted a cigarette for Fiala.

"The pipe works all right, except that it drips. All the time. Drop after drop."

"Report it. Let them fix it. No point messing about with them."

For a while they sat in silence. Rud was chewing a new portion of gum, though he didn't like the taste. He remembered how he used to be embarrassed about his little pipe until he learned that the majority were in a similar predicament. Fiala was smoking. At the other ramp a new transport was being unloaded.

"Handsome's carrying a suitcase for a girl again," sneered Fiala with envy. "Landed a plum job, that bloke."

"They say he didn't go through Greater Punishment," said Rud, "so he has no problems."

They were talking about Leader Eckhardt who was busy with the new transport.

★

Neuheufel began to use Rud for help more and more often. Rud had come to the conclusion that he must have been to a school of terribly low standard. Rud had to do his maths homework, mostly simple combinations of the four basic rules of arithmetic. One day he rebelled and said he would rather work unloading the transports.

Neuheufel gave him a resounding, swinging slap on the face. The old men sleeping on the bunks raised their heads.

"You bloody, disgusting, ungrateful bastard!" shouted Neuheufel reproachfully. "So I sacrifice myself for you, get you out of the Punishment three . . . five sessions before the end, even though your behaviour wasn't up to scratch and you weren't at all willing to co-operate! I've been risking my career to make your life easier and now this shit . . . Tfu!" Neuheufel spat on the freshly scrubbed floorboards from the bottom of his "good" heart.

His whole face was burning and the slapped cheek swelled like a pillow; or so it felt. That slap immediately brought back the memory of the tortures during Greater Punishment. It reawakened his dormant fear of Neuheufel. Rud stooped and fawned, feeling crushed inside. He felt that everybody was watching him – the ungrateful sod – with disapproval.

"Won't even say he's sorry," said Neuheufel in a hurt tone of voice. It seemed to Rud that Neuheufel's eyes moistened. Now he felt sorry.

"Sorry," he mumbled. He lowered his eyes and started writing. He was counting very carefully, for Neuheufel's homework was marked very strictly and one mistake disqualified the whole solution. He did not notice as onto the Interrogator's face crept an unpleasant smile of satisfaction. Only the eyes took no part in the smile.

Neuheufel must have had some exams, for he stopped coming around for a few days. Instead, Holzbucher became a frequent visitor. He kicked up a great fuss after finding a book under Tony's pillow. It was a torn, greasy, coverless book printed on yellow paper, a silly, nonsensical detective story; Rud had already read it. Holzbucher shouted that

Tony was damaging his eyes through reading but he did not beat the old man, did not slap him even once. He satisfied himself merely with a ceremonious burning of the book. He put it in Tony's soup bowl and set fire to it with a lighter. The old man stared at the creeping flames as if hypnotised. When the fire spread it added light to his faded eyes.

Because Rud did not have to do Neuheufel's sums now, he worked more at the transports. He had amassed a little fortune in cigarettes and bartered it with the sentry Mykolov for a pair of real boots made of artificial leather. The boots were high, brown and shiny but impractical, as his feet sweated in them and later stank terribly. Because of the boots, others in his brigade started calling him Dandy. The rest of his fortune was stolen; he had wanted to buy himself a pair of army trousers. Still, undeterred, he carried on working.

It was a wonderful, sunny day. Fluffy clouds sailed across the sky, pushed by a cool breeze. The transport consisted almost entirely of the Un-born. Rud worked at the only wagon that contained no vats. An ordinary transport: old men, some cancers, puffing cardiacs.

Quite unexpectedly, out of that grey, indistinct mass, there emerged a figure whose presence seemed to be a complete mistake: a young girl carrying a canvas bag on long straps. Rud was charmed when the wind streamed her unusual, ash-blonde hair. She had a white complexion, and her ears, a light creamy colour whereas most people's are pink, looked as if the layer of fat under her skin was showing through, giving it that exquisite yellow tone. The girl was not exceptionally beautiful. She had a square, prominent jaw and dull blue-green eyes, similar to the fish-eyes of the Un-born. Her beauty was saved by the fact that, despite such a pale, almost white complexion, she had dark eyebrows and eyelashes. She was much shorter then Rud and quite broad in the hips, though her legs were straight and shapely.

She was the first attractive woman Rud had seen for ages. Besides, the wind playing with her long, thick, brushed back hair, set her determined face in a striking frame. There was

also a distance in her eyes, a manifest conviction of her own uniqueness and beauty, which only amplified Rud's impression that he had just beheld complete perfection. Their eyes met for a while and they looked at each other in eloquent silence. When he recalled that meeting later, he realised she might have thought he was a guard making a selection; after all he wore high, military boots.

When he finally came to his senses and stretched out his hand to help her carry the bag, forgetting he was supposed to take it away from her, a strong hand grasped his shoulder. Somebody grabbed him and pushed him aside.

"You, Dandy, fuck off," he heard the resounding voice of Leader Eckhardt. "You've no business here. Piss off to your grandads. Now! Or they'll stray."

Eckhardt's voice vibrated in the air. Rud cringed with shame. His face swelled and burned, worse than when he had caught that slap from Neuheufel. He wanted to disappear, run away, run anywhere. He walked away towards the new arrivals without looking back.

That day Rud was rough. He yanked the bags away from several people. He hit one particularly stubborn old man and trampled his photos.

When doing Neuheufel's homework again, he asked him about Eckhardt. He was writing a long essay, or an extended report, comparing long rows of statistics. It was about the proportions of different age groups among the new arrivals over the last few years. A difficult job; there seemed to be no overall pattern. Besides, he had to be sensitive to the slightest manifestation of thought hatching in Neuheufel's lethargic brain and immediately praise it as if it were a revelation. Otherwise Neuheufel was offended. Anyway, despite Rud's best intentions, Neuheufel still thought him a lying and ungrateful sod. He was particularly piqued when Rud was pointing out his mistakes. He repaid him then with crude and nasty gibes, which Rud had to swallow in silence. On the other hand, he had to correct at least the more obvious mistakes, as he did not want Neuheufel's work to be rejected

or marked too low. He knew – did he not – that he owed Neuheufel the shortening of Greater Punishment.

This time Neuheufel had no need to be spiteful. The work was progressing slowly. Rud, hard as he tried, was unable to spot any historically determined trends in a mass of random figures. He could not guess the wishes of Neuheufel's teachers, whom he did not know. His unruly thoughts were running away from the statistics. Neuheufel loudly slurped tea from a glass with a teaspoon stuck in it, which he was holding back with his finger to prevent it from poking his eye out. Rud asked him about Eckhardt.

"There's a lucky bastard," he said. "A big, handsome, sun-tanned fellow, got through the Punishment undamaged, not a single scar on him . . . No girl can resist him."

Neuheufel giggled.

"It's not quite so . . . He pisses squatting. He's only got a little hole," he said. "Precisely because they'd fixed him with such a handsome mug there was no skin left to repair anything else."

Rud was astonished. He had not expected such an answer.

"So what's he doing with all those girls he chats up?" he asked at last.

"Maybe he practises lesbian love," Neuheufel burst out with laughter, and his trembling massive belly bumped the table and spilt the coffee.

Rud cackled with Neuheufel but then thought that Eckhardt was even more unhappy than he was and, while still laughing, felt a pang of self-contempt. He stopped laughing. Neuheufel noticed it and also grew silent, watching him attentively.

Rud used to go for walks around the barracks. Sometimes he would even venture as far as the women's camp hoping to meet the Pale Stranger again.

"You must have been seeing things," Fiala told him. "Nobody young arrives here in one piece. Never. No exceptions."

Rud was strolling slowly, hands behind his back, stopping now and again to wait for his friend who limped behind.

"Remember that, mate: all the young ones go through the post-mortem," Fiala was mercilessly killing Rud's dream, "and there they slice them into bits to determine the cause of death. Then they sew them up again, any old way, and chuck them in the coffin or the family will complain. The insides are stuffed back without rhyme or reason, anyhow, a slap-dash job. Only old and cut up specimens end up here. And the Un-born of course, torn to shreds by the scooping. There are no other possibilities."

They sat down on a bench made of rough planks by the well. The bench was shaded by a little silver birch. It was a sunny, hot day and Fiala felt the heat, all the more because of his black trousers. He always wore black trousers, for the colour helped to conceal the stinking wet patch on his crotch. He had already been given two dates for corrective operations but each time they were put off at the last moment.

The offensive smell of urine, amplified by the heat and the crushing logic of the argument with which Fiala was destroying his illusions, made Rud want to liberate himself from such unpleasant company. He felt imprisoned. He realised that the Adaptation Centre was in fact nothing but a prison: barbed wire, sentry boxes . . . And behind the wires an ordinary little wood, an ordinary meadow, ordinary hills. Perhaps there he would meet the Pale Stranger again.

"And yet, she was all in one piece – no cuts, no stitches," he insisted. "I'm sure of that, Fiala. It must have been an exception. She was lucky." Rud hoped that his insistence would put Fiala off the conversation and force him to look for other company.

"You can't see it on me because the skin is burnt, but look in the mirror. You'll see on your face all the scars from when they stitched you up after the post-mortem," Fiala would not give up.

"Now I know which scars are from the post-mortem and

which from the Punishment," muttered Rud. The stench of urine was growing more and more intense.

Fiala must have noticed it too. He was increasingly embarrassed. He used some trivial pretext to excuse himself, said goodbye and hobbled off on his burnt feet. After a while Rud also got up from the bench; Fiala had left a wet patch on it.

He was walking along the inner zone. Nobody ever said that coming near the levelled stretch of ground marked with little red flags was forbidden. The sleepy guards were dozing on their towers. Rud looked at the woods beyond the wires. He felt a great urge to get there.

"Why couldn't it be simply Heaven?" he thought. "Why this Adaptation Centre first?" He heard a train whistle coming from the railway track – the new transport had arrived.

Suddenly, he heard a resounding crash. Rud turned his head: one of the sentry towers had collapsed, tearing down the barbed wire as it fell. Over the years the supporting planks had completely rotted through. The guard's nest, knocked up from wooden boards, was lying in the ploughed outer zone. He could hear the screams and groans of the injured guard.

For some reason, the accident attracted no one's attention. "I can escape," thought Rud. The tower had flattened the wires, opening the way out. The guards from the neighbouring towers probably wouldn't shoot either; they could have shot one of their own. Rud stood still, stupefied.

Only after a minute or so, one of the guards woke up from his nap and blew his whistle. The Guardians and more guards appeared. Rud expected them to run around like maniacs but they drifted over, sleepy and lethargic. They could find nobody in the orderly-room and had to send for someone from below. Two stretcher-bearers turned up, the mandatory fiery pentagrams on their hats. It seemed to Rud they blinked, unused to the light. They quickly put the groaning guard, who had apparently broken his leg, on the stretcher and carried him away. Several Un-born huddled together in a small group observing this unusual event. They themselves

were a rare sight; normally they avoided sunlight to protect their sensitive skin. Only on cloudy days, early mornings or evenings, could one see them wandering around in groups, observing everything closely. One had to be careful not to bump into one of those tiny people, though in fact there was little chance of that, since from a distance of several yards they would already be invading the mind of a passer-by, shouting in his head to be careful and not to harm them.

More and more guards and inmates gathered around. The Guardians began to pick volunteers for work. The tower and the wires needed to be mended and someone had to carry new planks. Of course, they did not bother the old and the Un-born. At first, Rud wanted to leave quietly but then thought he had nothing better to do. Back in the barracks there was only another of Neuheufel's essays waiting for his corrections. The very thought that he would have to go through the misery of praising loudly the Interrogator's feeble ideas made him head for the crowd.

"Keep out of it, boy," said the toothless old woman, "or they'll blame it on you . . . They'll be looking for a scapegoat. First they build rubbish and then blame innocent people . . ." She was livening up. She even started waving her walking stick, but soon gave up; it was too heavy for her.

Rud was in no mind to get back. He stood out from the crowd of stooped, withered bodies and was quickly picked out. One of the Interrogators motioned him to come closer. Rud walked up to him.

"We need people to work," said the Interrogator, looking closely at the number on his overalls.

"I wonder if he's already memorised my number," the thought passed through Rud's mind.

"We'll carry the wood. Go and wait there, at the fence."

"Will we go outside the zone?" Rud played dumb.

"No. We'll be dancing on the roofs," snorted the Interrogator. "Do as you're told, Milankiewicz," he added.

Rud froze. How could he know his name? Probably the Interrogators communicated among themselves in the same way as the Un-born, and this one must have already got his

data from the central register. It made sense. Without a word, though pleased, he stepped over the string with the little red rags, crossed the stretch of beaten down ground and joined the selected group. They waited a few more minutes until the required number of people had been found. The Interrogators brought axes and saws.

Rud was overwhelmed with joy when he realised that they were going to the woods for which he longed so much. The prospect of hard physical work was in no way off-putting. He was given an axe set on a long handle. Thus equipped – some with axes, some with saws – they marched in pairs. Deeply moved, Rud walked across the ploughed outer zone, his feet sinking in the soft earth. Everybody marched cheerfully, some even started to whistle.

They were escorted only by one unarmed Interrogator. He introduced himself as Schulz. "Come to think of it, there would be no problem in overpowering him," thought Rud. "One blow with the axe and it's done. We'll have to wait till we get into the wood so they can't see us from the Centre," he was analysing the situation. "Before they register the escape we'll be far away. I'm sure the others are thinking the same thing."

The wood was not far and after fifteen minutes they entered among the first trees. Schulz was marking the trees to be felled. He behaved as if he was not afraid of them.

Then it started: Rud felt an itching inside his nose. He sneezed; once, a second time, a tenth. His nose was dripping like a tap. Rud felt awful. His body became an unbearable place to be in. His head seemed to swell. He could not think. He had never had hay fever before and its symptoms were something new to him. They all suffered the same. Some of them really began to swell up. Schulz hurried them without mercy. They sawed the trunks and then chopped the branches off.

"Come on, get on with it. You'll stay here till we get all the timber we need. Nobody will do it for us," he kept shouting. He was the only one who did not suffer from the allergy. "What do you think?" he sneered, "that those towers

and wires are put up to keep you in? You're wrong! They are to protect you against the outside environment."

After several hours of unendurable work – unendurable because of the raging hay fever – Rud's nose was red and painful. It even bled a couple of times. Schulz gave each of them an anti-histamine pill. He had no more. The pill worked for fifteen minutes and then it started all over again.

After they finished, each pair lifted a prepared log and placed it on their shoulders. Despite the weight they marched briskly, sneezing and swearing, just to make it to the zone. Rud was relieved to find himself back behind the wires. The hay fever disappeared the moment they entered the Centre.

Neuheufel waited till Rud had finished a chapter. The semestral essay was nearly complete. Rud found calculating the correlation between the regions and types and number of people coming to the Centre hard going. The near-incomprehensible equations noted by Neuheufel during his lessons were very dubious: the same data calculated several times always gave different results. Neuheufel didn't seem to notice, greeting each result with the same gloomy face. Rud took it all very seriously and in his mind he already pictured the inevitable row.

He handed Neuheufel a few written pages littered with crossed out and corrected lines and sat behind the table; his tired eyes were watering. The Interrogator read each sentence slowly, as if with difficulty. He moved to the window to see the text better. Rud waited in silence for the usual comments: unimaginative, often meaningless and always laboured out with immense effort; it was the time of loud praises for every feeble idea and discreet corrections of monumental inanities. The silence dragged on. It was the usual ritual. Reading was a hard task for Neuheufel, or at least that was the impression he gave.

This time it was different, however. Neuheufel neatly folded the pages and put them into his map-case.

"He'll be rewriting these five pages for the rest of the evening with his tongue hanging out, and tomorrow he'll

bring them to me as his own ideas and I'll have to correct the spelling mistakes he's made rewriting my text . . ." thought Rud, rubbing his sweating hands.

"Well, all right," said Neuheufel. "It's a bit weak, I'll try to improve it . . . A lot of mistakes."

This was the normal conclusion, but it usually took place after convoluted discussions over each essay, which went on for hours until Neuheufel finally grasped the ideas proposed by Rud. This time it meant there would be no discussion, or that it was postponed. So Rud remained silent.

"I looked through your file," said Neuheufel.

Rud froze.

"It's a big file," Neuheufel carried on. "You've picked up quite a lot on your way."

Rud was listening attentively.

Neuheufel stopped for a moment as if trying to think, but his boorish, as if bloated face assumed an expression of forcefully restrained laughter.

"This Dianna of yours was quite a morsel, wasn't she," started Neuheufel again, still serious. "Such a delightful love dish. Or rather a starter. She's so small," now he was giggling, he could no longer restrain the laughter. "I watched all the cassettes with you and her. Had lots of fire, that woman . . . Where did she learn all that . . . ? Or at her place . . . When she was doing that . . . you remember . . ." he chuckled. "Or when she burnt herself pink in the sun and all that skin was peeling off . . . I still liked her, don't know what you were complaining about," Neuheufel shamelessly ventured to give his own opinion.

Rud grew pale and blushed in turn.

"You were a pretty good rooster too," Neuheufel was slapping his thighs. "But now it's all over, Milankiewicz," he added calming down.

Rud wished he could sink into the ground.

"Great evening," he carried on. "A crate of beer and the video with the two of you. Holzbucher also thinks you were good."

Rud grew angry. What right did this sonofabitch have to

drag out the most intimate details of his life? He was only supposed to find out something about the sentence.

Unexpectedly Neuheufel told him to leave. He said he had almost divulged an official secret.

Furious, Rud ran out of the barrack. Outside, he saw Jose sitting on the bench surrounded by clouds of cigarette smoke.

"Wanna fag, Milankiewicz?" he asked calmly. His voice calmed Rud too.

"No," he said, "but I can passively smoke some of yours."

He sat down next to Jose.

"You ran out as if Neuheufel stuck a propeller up your arse," said Jose and put out a half-finished roll-up. He didn't want to poison his mate.

"Almost. He started telling me the most intimate details of my life. What I did with Dianna. He had it all on video, the bastard."

"That's right. They have everything on video, with all the details. Every situation shot from different angles. From the front, the sides, from behind. Have you seen that sort of thing?"

"No."

"It's as if they stuck a camera up your arse. They showed me my cassettes too, from the service . . ." he stopped abruptly.

"Where do they get it from?"

"They just do. During your life everything is recorded. Having a beer? Three shots. Cuddling a girl? Goes on video straight away. They have everything on video as evidence for Greater Punishment. Not other things, only things that led to the conviction."

"But how did they do it?" Rud wondered. "Once we spent a weekend in Dianna's parents' home, they'd gone away somewhere. We were alone. Even the television was switched off, you know what I mean?"

Jose nodded showing he understood, took out a small packet and began to roll, slowly and carefully, another roll-up. The habit was stronger than friendship.

"The bastard told me everything in such minute detail, as if he were sitting next to us," carried on Rud. "But I shouldn't be saying things like that, he is my benefactor," he tried to mitigate his remarks.

"You're right. These films have such a fine grain you can see a single hair, even the shadow that hair throws on the skin or across other hairs. They see better than you could see yourself at the time. By the way, why did you deny it? They're always right, they're never wrong. If you got Greater Punishment it means you deserved it."

"I wasn't denying anything. Anyway, does it matter?"

"Only that they can check out your documentation. They have no right to look through the videos, unless it's at your request."

"I only asked him to find out why I got Greater Punishment."

"You idiot. They'll never tell you that and thanks to you they had a video session."

Rud stopped listening. Further away stood a kiosk surrounded by wooden tables and benches selling cigarettes and semi-sweet orangeade. Rud didn't like that orangeade: it didn't taste of oranges, it had no fizz – just water with sugar – and often had spiders' webs floating near the bottom of the bottle. Now he was surveying the benches.

"Have you met your Dianna here?" asked Jose from behind a new cloud of smoke.

Rud did not answer. It had not even crossed his mind to look for her. He excused himself and walked, almost ran towards the kiosk. It seemed to him that from a distance he saw a familiar, light patch.

The Pale Stranger was sitting on a bench together with some toothless old women who were sipping the orangeade. She wore the normal uniform: brown shirt, trousers of the same colour and clogs. The way she wore her shirt, the way she crossed her legs and slipped a clog off her shapely foot, lent her coarse camp-issue garb a touch of refinement. She looked at him as if she had been waiting for him, though perhaps with a hint of fear. She might have taken him for one

of the Interrogators, since by now he had acquired a pair of the well-cut green trousers worn by the guards, and an official peaked cap from which he had had to tear off the pentagram. As an inmate he had no right to wear it there, only on his back together with the registration number.

"Hi. I'm glad I've managed to find you again," he said sitting himself, uninvited, on the bench next to her. The toothless old women carried on with their quarrel, lisping so badly he could not tell what it was about.

She made room so he could sit more comfortably.

"What's your name?"

"Maria."

Rud suddenly ran out of chat-up lines. He had some tobacco with him and he could exchange it for something at the kiosk.

"Fancy an orangeade?" he asked.

"Do all Leaders make acquaintance through an orangeade?" she answered with a question. She had a very pale complexion, shadows around her eyes, even premature wrinkles indicating exhaustion. But nowhere – on her face, her neck or her hands – could he see any scars.

"I'm not a Leader."

A shadow fell on both of them. Rud turned his head; Leader Eckhardt had just returned from the kiosk with a bottle of orangeade and two mustard glasses. He stood, eyes blood-shot, with a fury which only served to bring out the manliness of his face. He looked like a wolf.

"You here, Dandy?" he hissed putting the bottle and the glasses on the table. "Beat it."

Undaunted, Rud defiantly opened Eckhardt's bottle, which gave out a faint hiss, and poured the stale water into the glasses. He offered one glass to Maria and ostentatiously took a sip from the other.

"Thanks, Eckhardt," he said. The other was a Leader only during work; now they were equal. "I'll pay you back in tobacco. I know you smoke like a chimney."

"Do you smoke?" he turned to Maria.

"No."

"I'll give you a pound of tobacco for the orangeade," he carried on, "it's a good price . . . Now Eckhardt, leave us alone. You smell of perspiration. If you want to use the toilet, remember the Ladies is just behind the kiosk on the right, not on the left – that's the Gents."

Rud made a couple of mistakes. He underrated his opponent. Eckhardt was maybe slower but he was also taller, heavier and stronger, and sitting, Rud had limited freedom of movement. He hoped that Eckhardt, publicly humiliated, would withdraw of his own accord. He was wrong. He had hardly managed to lift the glass to his mouth when Eckhardt, foaming with rage, pulled out his official truncheon and struck Rud over the head. The spilt orangeade splashed over the surprised women. Maria screamed, terrified. The next whack of Eckhardt's truncheon rendered him unconscious.

Rud found himself back at the hospital. Luckily, his injuries were not serious. This time he had more freedom and could follow the course of treatment. The plastic surgery done on this occasion was successful and even improved his looks. The stitches were so skilfully sewn there was no sign of red scars. He no longer looked like a monster. He also agreed to the cosmetic removal of his three split fingernails. The operation was done without anaesthetic but he had known worse pain. When the fingernails grew back his hands should also regain their normal look. Only two of his fingers were missing their last two joints.

On the whole he was lucky. The enraged Eckhardt might have killed him. Even when Rud was lying on the ground, covered with blood and unconscious, he did not stop beating him. Maria tried to restrain him but he pushed her away, and only her screaming attracted the guards who finally overpowered the attacker. The entire stock of tobacco he had saved and kept in his pocket had disappeared. He did not know if Eckhardt had managed to frisk his pockets or whether he had been robbed in the hospital.

The stay in the hospital turned out to be a generally pleasant experience. The food was excellent: every day a litre

of turnip soup with a proper meaty supplement – a thick slice of liver sausage in which he could sometimes find fragments of print, or a solid cut of faintly putrid brawn. And on top of that a pound of black bread. In the evenings, another quarter of a loaf of bread and a saucer of very sweet beetroot marmalade. He could drink strong, bitter coffee to his heart's content. He could even get it between meals if he took his mug to the kitchen. The big, heavy-breasted cook, Marusia, grumbled but in the end always lifted the lid off a huge pot and with an enormous ladle covered with dried drips poured out the dark, lukewarm liquid. He had to fish out the flies himself; a whirling mass of them was constantly swarming around the pots.

There was always something left from those generous portions and Rud, bartering with others, quickly managed to put away a new stock of tobacco and three packets of chewing gum, which was enough to arrange the transfer to Panfilova. He did not like her as much now when he thought about Maria, but he trusted her. She was an excellent surgeon and Rud's appearance still required a lot of corrections.

When he had managed to save more, he bartered it with a guard for a leather jacket. It was a good deal: the jacket was worn, the leather thin and cracked here and there, but it fitted him perfectly. The obligatory letters ZP, the number and a small, neat pentagram were embroidered by the old ladies from the women's ward, who also carefully stitched up the cracks. They did it in exchange for tobacco and for the flowers from the hospital garden. The stench on the wards was unbearable and the flowers did not help, but at least the old ladies liked looking at them. Keeping flowers on the ward was forbidden and they had to accomplish feats of ingenuity to hide them during the doctors' rounds. Rud could not comprehend this love for dying flowers. He noted however that it didn't diminish with age. And anyway, it was thanks to this love that instead of the grey camp garb he now wore the guard's jacket. He could not leave the hospital's grounds so the exchange took place at the end of the garden,

73

where Rud would sit on a bench, a few metres away from the path used by the healthy. He would sit there also for another reason: he hoped to see Maria passing. He never did, though. He had some chewing gum for her; the nicotine sort, there was no other.

The healthy inmates could sit on that bench too, but they hardly ever did; maybe they were afraid of catching something. That particular day he found an Un-born there, a girl. He sat next to her.

"Sit on the other side and give me some shade. I don't want to get sunburnt again," he heard her voice in his head.

He complied with her request and the little human body was swathed in deep shadow.

"Tell me a story about when you went to school," said the voice in his head. The little girl stared at him with her dark green fish-eyes, sucking her pink, almost transparent finger. Rud noticed the tiny fingernails.

"I don't remember much," he said. "I never liked school. Once, I had a frog in my pocket and it escaped. I shared a desk with a boy who used to catch flies and pull their wings out and then drown them in drops of ink. The wretched flies would go round and round drawing blue circles and lines on the desk. Then he would spear them with a nib. Later, we had biros. It was difficult to stick the flies on a biro. Only our history teacher forbade us to write with biros. He said they weren't proper pens."

"Did the girls spear flies too?"

"No. They were always busy doing sums. They were more serious than the boys, apparently. It changed later."

"They started to spear flies?"

"No, that's not what I meant . . . Once, it was a history lesson, when one of the boys got up to answer a question I stuck about twenty drawing-pins through a page and made a sort of fakir's mat. He sat down and jumped in the air. The teacher gave a long speech and threw me out of the class-room. I was very proud of myself. I wanted to show off before one girl, and I think it worked. During the break I had a fight with that boy. I tore off his collar and he two of my buttons."

"I've got a problem," interrupted the girl.

"What problem?"

"I have to choose my age, which I'll stay in for ever. I can't decide. There's no rush but at some point I'll have to make my mind up."

"It's easy, isn't it?" he said without a moment of hesitation. "Choose the age at which a woman is most beautiful. That is, when you would be most beautiful."

"That's just what I don't like," he heard her answer. "You see, Ruder, when they are most beautiful, that's when they kill us. I don't want to look like that."

He wondered what to say for a while but decided not to continue with the subject.

"How do you know my name?" he asked.

"You're that guard Ruder who was beaten up by another guard and now you're recovering from the attack. Maria told me."

"I'm not a guard, or an Interrogator, or a Leader. I've only bought the guard's clothes because they're nicer than the camp-issue. Tell Maria. Please."

She nodded her disproportionately big head of a foetus.

"I shall," her voice came out from the middle of his brain. "Listen, how about being a little schoolgirl, or an elderly lady: silver hair, glasses, well-preserved figure, lovely hands. It would be nice, wouldn't it?"

"What's your name?" he asked.

"I've chosen Patricia, because it's strange."

"But pretty, nevertheless."

"You see, Ruder, the foulest thing they've done to me is that they deprived me of my childhood. It must be a great time. Everybody I ask tells me such interesting things, even those who complain that they had an unhappy childhood. I'll always look the age I choose, but any one can do it. But others have already lived their lives and they've already looked like that, first they were young, then they were old. With me it's different, strange, artificial, as if I had to become another person . . ."

Rud thought that he too must have chosen the age he

75

was in . . . Only those damn effects of Greater Punishment . . .

She asked him to put her down on the ground. He took her tiny body in his hands. Dressed in the regular, camp-issue jacket, little trousers and miniature clogs, she easily fitted on the palm of his hand. He put his hand on the path so she could safely step out.

"Thank you," he heard in his head.

"Patricia, who sat you on the bench?"

"A nice old man," she explained. "I like sitting on the bench talking to the Born. They tell interesting stories. When I see Maria I'll tell her. Bye, Ruder."

She opened up a tiny parasol which shaded her bald head and toddled off. Rud stretched till his joints cracked.

That bench could be called the Bench of Interesting Meetings. During his trading activities he met so many people. Rud was the only patient on the ward who had no restrictions on his movements. He made good use of it. The whole trade between the patients and the world of the healthy passed through his hands. He was an honest middle-man. From each transaction he would take only a small provision for himself but even with that he managed to amass great quantities of the precious commodities available in the Centre. It came to the point where he did not know what to do with it all. He experienced a strange feeling of possessing everything that it was possible to possess. He could afford anything, any object in the Centre, except a gun. He could even buy a dog from a guard, if he so fancied. Perhaps even a gun, if he dared to risk it. All he was missing was Maria, so that he could impress her with his riches. But for some reason she did not come.

Instead, he met other people. They often crossed the path for a chat. He tried to avoid the really old men. Most of them were gaga and had nothing interesting to say. His dislike for the Un-born had gone, but they too were boring, asking him about different, trivial details of everyday life, about all the things they were barred from experiencing themselves.

There was an Un-born boy, named Albert, who used to wear him out with his questions about skiing. At the first meeting Rud had carelessly mentioned that he used to ski. He only wanted to show off, for in fact he did not remember much. Since then he had to describe to Albert all the kinds of slopes, snow, everything about the equipment and anything remotely connected with skiing. The little one was very quick and immediately thwarted all Rud's attempts at confabulation with the invariable: "Cut the crap, mate. Tell me what it's really like." Albert was a ski fanatic. He was interested in everything to do with skiing. Sometimes he would invent stories about how he skied himself, and he told them to Rud. He would question him afterwards as to whether he had made any material errors and whether he could really ski like that. Rud nodded, occasionally throwing in a detail or two.

But he could not wait to see the Little Brown Riding Hood, as in his thoughts he called Patricia.

One day a young man came up to him, who reminded him of someone; he was only a bit shorter than Rud, and thinner.

"Hi, Ruder. I'm leaving here. I've come to see you and say goodbye," he said.

"Have we met? Remind me." Rud half shut his eyes to see better and to help his memory.

"Never mind, I know you. You didn't want to teach me fishing. You were a good angler and I could be one too."

"But there are no fish here," responded Rud, still unable to remember where he had met him.

The other shrugged his shoulders.

"That's exactly the reason. Now it's too late. Well, ciao Rud. See you around. Perhaps," he added walking away.

"What's your name?" Rud shouted after him.

"Rolf. It won't mean anything to you, I chose the name myself."

Rud followed him with his eyes for a long while. The figure, the look, were very familiar. When next day he was

shaving in front of the mirror he made an amazing discovery: Rolf looked almost like a copy of Rud, maybe a bit thinner, a bit younger. The only difference was the eyes – blue-green, like Dianna's.

Maria still did not come. Once, lazing out on the bench, he spotted the characteristic toddling figure in brown hood and a tiny parasol.

"Patricia!" he called after her.

She turned her hairless face of a foetus, wincing as a gust of bitter-sweet smoke blew over from the crematorium.

"Do you want to sit with me?" he asked her.

"Yes, but not for long. I'm in a hurry," he heard her voice in his brain.

She came closer. He lowered his hand so she could step on it and lifted her like a crumb to the seat of the bench. Then he sat next to her protecting her from the sun, though at first he forgot.

"Where are you hurrying then?" he asked.

"I want to see the new transport. I like watching the new arrivals."

"Watching?" he was surprised. "I've never seen the Un-born watching a transport . . ."

"There's a place where we can wait unnoticed. It's a viewing gallery for the Un-born, though they hardly ever go there . . . It's on the roof of that building where they bring the new arrivals; the gallery is just behind the gutter."

"That's the committee building where they announce who's going for Greater Punishment and who doesn't need to," explained Rud.

"Does the Committee decide?"

"No, the documentation with decisions is already there. The Committee only administers: this one goes there, that one there and so on . . . Piles of paperwork."

"I've never seen when the Un-born arrive," he heard Patricia remark.

"They come in those metal buckets with hermetic clasps," he told her, and immediately regretted it.

"Why do they bring us in buckets?" she asked, as if

automatically, but then added: "I thought they sewed us up somewhere else, before . . ."

"Have you given Maria my message?" he broke the silence.

"Yes."

"What did she say?"

"Maria is rather poor. She wants to save some food to make you a present."

"Food? . . . Present?" He could not comprehend it. "Listen, Patricia, tell Maria that I have enough food. I want to see her, not presents. I can give her whatever she likes. I've got plenty of food, up to here," he raised his hand to his throat.

"I must go. Put me on the path."

"Please, don't forget to tell her that," he called after her. Patricia nodded her little head in the brown hood and walked away towards the Committee building.

Rud started cleaning his fingernails. He had just had more plastic surgery for which he had paid with the food he'd earned. Now his hands had a complete set of fingers, each with a shapely fingernail. "I didn't have better ones even before the Punishment," he stated with pleasure as the black lines changed into white.

Maria came a few days later. When she stopped before him, Rud did not know how to start a conversation. She was so delicate, so feminine, so unsuited to the surroundings.

"Hi," she greeted him and sat down next to him on the bench.

He still could not find his confidence. He noted Maria's grey, unhealthy complexion.

"I couldn't wait to see you," he said at last. "You don't look well."

"I rarely leave the barracks," she answered after a moment's silence.

"Don't you go to work?"

"I don't have to."

"Maria, do you want some food? You don't look well."

She thought for a while.

79

"OK," she said, "I'll take the food. It's never enough. When may I collect it?"

Her voice, full of fear, had a chilling effect on him. "Doesn't she trust me?" he thought.

"Maria, I'm not a guard, nor am I a Leader, and never was," he tried to convince her.

"I know. You told me before." Again that tone and the distrustful face. It began to irritate him: "Can't she trust me, or what?"

"Come tomorrow. I'll give you some food," he told her.

"OK," she said, and quickly left.

The following day Rud gave her four big loaves of black bread, almost his entire stock. He added to it two thick slices of brawn wrapped up in brown paper. She did not want to eat it in his presence and put everything into a big kerchief. She refused the tobacco and chewing gum. He helped her to hoist it over her head and shoulders so that the load was resting on her back and the knot below her neck. Rud was annoyed: he wanted to talk to her and the meeting had turned out to be nothing more than repacking the food. It hurt his pride.

They had several meetings after that; each the same. Altogether they exchanged no more than a hundred words. He suspected she knew how he had been crippled during Greater Punishment, and he managed to come to terms with the fact that their meetings had to be limited to the exchange of goods. He was content with seeing her, catching the fleeting fragrance of her hair, a glimmer in her eyes, watching the way she moved.

Once, he asked about her past.

"Nothing particular," she shrugged her shoulders, "A quiet girl, eighteen quiet years. I was a bit of a loner. Nothing to interest you."

He didn't pursue the subject although soon afterwards he realised that that was precisely the interesting part.

Another time he asked her what she did with the food.

"There's hunger on the barracks," she answered. "Do you know how they damage women during Greater Punish-

ment? How they mutilate them? What state they're in? Literally in shreds. And on top of that they starve them . . ." She stopped abruptly, as if afraid she had said too much.

"I know about Greater Punishment," he said emphatically. "They damage men too."

"Did you take part in the interrogations? . . ." The familiar expression of fear returned to her face.

He turned his head in denial. "I'll never convince this silly girl," he thought.

"Maria, I served Greater Punishment," he stressed, perhaps too anxiously. "I too was released mutilated and crippled."

"It doesn't show."

He realised how difficult it was to convince her, since all the signs of torture had been carefully removed during a series of plastic surgeries. Even his piss-pipe, after several surgical corrections, looked little different from the original. The old scars had faded, and the post-operation scars were so thin and skilfully hidden in the folds of his skin that he could hardly find them himself. Perhaps his teeth might be considered too straight and a touch too white. Perhaps his ears were not ideal, but they were hidden by the long, thick black hair which, after a series of implants, perfectly covered his previously bald head. "In fact my hair is even thicker now than the hair I had towards the end of my stay on the other side . . ." he thought, passing his hand through his hair.

"What's all this rubbish on your head?" he changed the subject and began to comb through the strands of her hair, pulling out straws and dry leaves. She did not object and even moved closer so that he did not have to stretch his hand. But at the same time she grew tense and stiff.

"Where have you picked it up?" he asked, putting all the straws one by one on the palm of her hand.

"The pillow must have a hole," she answered, "or it comes out of the mattress, from the bunk above me. An old lady sleeps there. She coughs all night and every time she has a cough she leaks. In the morning there's always a new, wet patch on the mattress." Maria's voice changed. He noticed that for the first time she was relaxed.

"It never drips but it's always wet through," she said. "She must have a good measure in her eye to know how much she can drink before going to bed . . ."

"She has a measure in her bladder," he joked.

For the first time she laughed.

"Milankiewicz!" Behind them stood Panfilova. "Talking to the healthy is forbidden outside visiting hours. Report to the registry immediately."

It had to be important if Panfilova bothered to inform him personally. He followed her. Once more he turned his head to see Maria walking in the opposite direction, slightly bent under the weight of her bundle. She too turned her head to see him and he caught a glance of her green eyes. Normally dull, now they shone. Her jaw was still a bit too square.

As long as he traded food nobody bothered him. When he started supplying it for free to Maria's mates in the barracks he was released from the hospital. It was a disciplinary removal. He had long recovered and felt fine, but he kept signing up for cosmetic surgery which cost him a lot of liver sausage, bread, tobacco and chewing gum. Someone must have become scared people would start talking and the same day Rud found himself back on the barracks.

Neuheufel was not around. Others, those more active, had gone to work, and there were only old infirm men left on the ward. They lay or squatted on their bunks rocking rhythmically. The ward, unaired since the morning, stank like hell. Most of those left behind were incontinent. By now Rud had forgotten how powerful was that ordinary, everyday barrack smell; in the hospital, he had shared his ward with eight patients.

He could not bear the stink much longer. He went out to the kiosk for a drink of orangeade. He was hoping vaguely to see Maria there.

As usual, there was a lively crowd at the kiosk. The conversations were a garbled torrent of mumbled words issuing from the old toothless mouths. "How do they communicate?" Rud often wondered.

The day was hot. Rud joined the queue behind a fat victim of a heart attack who was perspiring and gasping like a fish. A moment later two terribly emaciated women of over fifty stopped behind him. They were talking with a female Interrogator wearing a hat with the pentagram about the new transports.

The Interrogator was saying that any day they expected huge new transports of different ages: young, old, women, children, but most of all – a lot of young men. Something would be happening at last. Rud watched the wood behind the wires with aversion. The mere memory of the expedition for timber made his nose itch. One of the thin women pulled up her shirt to show the other women a horrific long scar across her back. She said it was from the removal of a kidney tumour.

Someone jumped up from a table and moved towards him.

"Dandy!" the voice roared. "Gotcha, you shit!"

Eckhardt, red with fury, was pushing towards him like an enraged bull.

"You fuckin' shit! So you fancy other people's girlfriends? I'll cure you," Eckhardt took a huge swipe. The queue scattered. The female Interrogator didn't even try to intervene; she was unarmed.

Rud dived under the huge arm which swung at him like the hammer of a bell. He did it so deftly Eckhardt could not stop the blow in time and crashed his fist full swing into the kiosk's wooden wall. The boards rattled. The surprised saleswoman put her head out and started screaming.

Eckhardt grimaced with pain as he clasped his bruised fist. His handsome face, distorted with suffering, seemed less thought-resistant. He waited through the first pain and took another swipe. He did not pull out his truncheon; the last time he had, he was deprived of his position as a Leader and had his food rations cut for a whole month. Rud knew that and was not afraid of the black rubber truncheon behind Eckhardt's belt.

All the time Eckhardt threw insults, cursing Rud, trying to frighten him, and encourage himself. He called him a "bozo

of the infirmary", "a greedy skirt-chaser", "a crab-louse playing a guard" and so on. He also shouted out a litany of less refined invective. Rud would not be provoked and stayed calm. Eckhardt waved his arms like a windmill but his imprecise punches were either missing Rud or were easily parried. Rud did not hit hard, saving his strength for one big slug. A couple of times he checked Eckhardt with perfect left jabs on the chin till the latter's head bounced back. But he was still being forced back by the heavier and stronger, though slower, opponent.

He waited for the right moment until, after one of the countered punches Eckhardt lowered the guard on his chin. This time Rud swung it. The powerful blow stopped Eckhardt dead in his tracks. Half-conscious, he only managed to wave his hand in the air trying limply to connect, before a second, even more powerful blow felled him to the ground.

Hissing with pain, Rud clutched his right fist; he had smashed his knuckles on his opponent's jaw. He only wished Maria could see his victory.

Rud had no unpleasant consequences to face because of the fight with Eckhardt. He was saved by the female Interrogator who had seen how it all started. Her name was Kohlengruber. She was the typist at Rud's first medical examination after the transfer from below.

"I didn't recognise you, Milankiewicz," she said after the preliminary hearing when they stopped for a chat. "Your artificial leg doesn't show at all."

"They didn't cut my leg off," he said.

Kohlengruber reeked of perfume and had long bright red fingernails. Maria cut her fingernails short and never painted them.

"Fancy that." She was surprised. "They managed to save even such a smashed up leg. How economical. Do you know, Milankiewicz, how much you would have had to pay for a new artificial leg? A fortune. You would never pay it back," she answered her own question.

"Crazy woman," he thought. "Lucky she testified with some sense."

84

After a break he had to go back to correcting Neuheufel's essays. He hated the job but dared not refuse. The new confidence he had acquired while in hospital was not enough to tackle Neuheufel. And so he struggled with the messy print-outs of tables. The complicated rules of calculation seemed muddy and unduly complex.

"Not bad, Milankiewicz, you've got back your old looks from before Greater Punishment," said Neuheufel, looking at him closely. "Practically no difference . . . no scars . . . Excellent job."

He pulled out a big, colour photo of Rud from his briefcase.

"Stop staring at the papers, raise your head," he said and carefully compared Rud's face with that on the photo. "Practically the same," he repeated. "The Punishment has left no trace."

"There is one. And an important one," he burst out. "I piss through a stuck-on pipe."

According to an unwritten rule this subject was taboo. Even the oldest of inmates avoided it and pretended there was nothing amiss, despite the big wet patches of urine drying on their trousers. On top of that, some of them stank of the excrement constantly escaping from their artificial recta.

"Have you still got the same pipe?" asked Neuheufel ironically.

"Well, no . . . I've had some plastic surgery," admitted Rud.

"Exactly. And what? What does it look like now? Different from before?"

"It looks good, the same as before the Punishment, but that's not the point . . ." Rud stopped, embarrassed.

"Ha ha ha," laughed Neuheufel. "I'm sure you don't get up to much if you gobble up all that bromine. Marusia puts that shit into coffee with a shovel. What did you think, Milankiewicz?" asked Neuheufel emphatically. "Why does everybody drink coffee here? A fine mess we'd be in if you all started chasing skirt. We won't have it."

Rud was speechless with astonishment. Seeing that he had not convinced him yet, Neuheufel added with emphasis:

"You're a normal, healthy man now and from the medical point of view the treatment of the after-effects of Greater Punishment can be pronounced a complete success. These things are parts of your own body – not grafts or implants. You look exactly the same as when you were thirty, and this age and these looks suit you best. They do, don't they?"

"Yes," answered Rud. He felt wings growing out of his shoulders. "Does this mean that not only my physical looks but my general state have returned to normal?" He was trying to make sure.

"It means exactly what I said."

There was a silence. Rud returned to work. He wanted to see Maria as soon as possible and tell her what he had just heard. He wanted to shout out that he was a healthy man again. He was carefully rewriting long columns of figures and then adding and multiplying them.

"Anyway, your injuries weren't really objective . . ." muttered Neuheufel all of a sudden. "You only felt like that since that was your punishment . . ."

Rud didn't answer. He didn't understand.

"Besides, I thought you'd already figured it out yourself, Milankiewicz," carried on Neuheufel, "since you went completely bonkers about that kid from 971C."

"You mean Maria?" he let it slip.

"I don't like that name," Neuheufel winced. "They shouldn't give it to anyone. And let's say it openly – she's ugly," he added, rummaging through his briefcase. "So pale, her skin grey and transparent, you can see all the fat . . . And her hair . . . Weird colour. In fact, it's no colour at all if she forgets to put her highlights in . . ." Neuheufel carried on with disdain. "And that protruding jaw, she must be a pretty mean character . . . Fishy eyes, dull, no spark in them, kind of torpid, like in a foetus . . . Pale lips, pale nipples . . ." he continued as if remembering the details. "Terrible figure: bum like a chest of drawers, and sort of cracked the wrong way . . . Left tit twice as big as the right, one pointing up, the other

down . . ." Neuheufel let out an obscene cackle, illustrating what he meant with his thumbs.

"You're lying, you filthy swine! Leave her alone!" screamed Rud, and like a cat he threw himself at Neuheufel, aiming for the throat. The chair flew back, papers on the desk scattered. The old men cowered terrified on their bunks.

Neuheufel nonchalantly swung his hand, hitting Rud in mid-air. Rud bounced off like a ball and rolled across the floor. The power of Neuheufel's blow was unbelievable.

"You? Getting at me? At an Interrogator?" he asked. He didn't even raise his voice.

Rud, bruised and aching, picked himself up from the floor which oozed with the stench of urine. He had cut his head on the corner of a wooden bunk.

"Come here, you shit," ordered Neuheufel. "Have a look yourself."

He handed Rud a large sheet of paper. Rud was silent. He looked at a big colour photograph of a naked Maria. It must have been one of those documentation photos Jose had talked about. In the top right corner there was a little pentagram and Maria's number. The photo showed her standing astride, in four shots: front, back and two sides. She was not built well: breasts of unequal size with disproportionately large nipples; wide, ungainly hips. Despite that, Rud looked at the photo with great interest: it was the first time he had seen Maria naked. Her face had something subtly repulsive in it, a sort of half-smile of repressed animal lust.

"Enough," said Neuheufel and took the photo from Rud's hands. "Now you can clean up, Milankiewicz. Pick up the chair and put the papers in order."

The punishment for the attack on Neuheufel was a week's ban on leaving the barracks. It seemed to Rud surprisingly mild.

He spent the week inside in stinking twilight; all that time the offended Neuheufel did not appear. Instead, Holzbucher turned up regularly, telling him to scrub the floor. Rud did

not protest since he had expected something worse, and the floor only gained from the extra attention: it became lighter and did not smell of urine so much.

Only then did he realise that the old men were being starved. During mealtimes they were often left out or were given watery portions of soup from the top of the pot. Those who could not move from their bunks suffered most.

After seven days Holzbucher ignored Rud's presence on the ward and stopped giving him any orders. It meant that the arrest was over. Rud decided to look for Maria. Luckily, he remembered the number of her barrack mentioned by Neuheufel. He put on his guard's jacket, the same sort of trousers, the boots of artificial leather and the military hat. He wanted to look his best. Finding barrack 971C should not be difficult, as each row was clearly marked.

The day was sunny but cool. White cirrus clouds sailed across the sky. It had not rained for a long time and the strong wind drove billows of dust along the camp streets. Rud walked for over an hour before he reached row 971. Only then did he understand what a lucky coincidence that meeting at the kiosk had been. He decided to ask Maria what had made her venture so far away from her barrack that day. He spent another hour looking for Block C, asking the women and female guards on the way. They all looked at him suspiciously, as few men strayed so deep into the female camp, and his guard's uniform made them especially cautious.

As a man, he was not allowed into the women's barracks, so, following the regulations, he asked one of the inmates wandering outside to call out the Curator. A short, corpulent woman with a broad face came out fastening the last buttons on the blouse of her uniform. One of the lenses in her glasses was cracked. Seeing Rud, she adjusted her cap, squeezed it onto a bun of brown hair, and was about to salute him when, noticing the lack of the pentagram on his cap, she realised he was not a guard.

"What do you want?" she snarled, regaining her confidence.

"I want to speak to Maria."

Hearing the name she winced.

"We have a dozen of those here. Which one do you want?" she asked. "What's her surname?"

"I don't know," Rud was confounded. "A young . . ."

"An Un-born?"

"No, young, that is eighteen at most; beautiful."

"Without scars after the post-mortem? Hasn't done Greater Punishment?" she glanced at him keenly.

"I don't know . . ." He was not sure of that either.

"Do you or don't you know who you want to speak to, Milankiewicz?" she asked harshly.

"I want to speak to Maria. I can describe what she looks like . . ."

"There's no need," she interrupted him. "I'm the Curator here and I think I know who you mean. She used to bring stolen food from the hospital, didn't she?"

Rud didn't answer but it was taken as confirmation.

"The food wasn't stolen," he said after a while, realising that his silence might cause further problems for Maria. "I gave it to her."

"Never mind. It doesn't matter now. She's not here any more."

"What do you mean? What have you done to her? Was it because of that food?"

"Calm down, Milankiewicz. We haven't done anything to her. She simply finished her preparation programme."

"Finished . . ." he repeated, as if still trying to understand the word.

The curator shrugged her shoulders.

"Entry to female barracks is forbidden, remember that," she said over her shoulder and disappeared inside.

He tried to get in nevertheless, but it proved impossible. Each attempt was thwarted by some inner resistance: he was sweating and shivering, and could not cross the critical line. "Have they hypnotised me or what . . . ?" he wondered in disbelief. In the end he gave up. Crestfallen, he dragged

himself back, down the dusty road along the barracks made of black rotting boards.

"Ruder!" he heard a shout inside his head.

He stopped and looked around.

"I've been out on a walk for over an hour, but if you put me on the bench it would be nice to have a chat with you," the voice spoke again in his brain. Then he noticed the characteristic tiny figure of Little Brown Riding Hood standing in the shadow of the barrack wall.

"Patricia!" He was pleased to see her.

The little figure climbed onto the palm of his hand. He sat down on the bench and put Patricia next to himself. This time she lay down, curling up into a tiny bundle.

"I'm tired of wandering around. I'll have a bit of rest," she explained.

The Un-born never adopted the foetal position in the presence of the born, trying in this way to emphasise their full human status. That she did curl up like a foetus next to Rud was a sign of great familiarity.

"Tell me what happened to Maria," he began, "I need to see her."

"Sorry, Ruder, Maria is no longer here. She finished her stay in the Centre. She said goodbye to me yesterday."

"And she forgot about me," said Rud in a hollow voice. "She only needed me to get food for her friends."

"Don't be so hard on her," the voice admonished him from inside his own brain. "For the whole week, day after day, she went to your barrack to see you, but you never came out, not once. Two hours getting there, and two back . . . remember."

"She was so close . . ." he was shocked. "I was sitting out my punishment, exactly a week of arrest; today's my first day out. If she'd only come to the window I could have seen her . . ."

"If she'd known you wanted to see her . . ."

"Those bastards!" Rud got angry. "What did they tell her about me? What? That I didn't want to see her?"

"Maria told me that you probably got into trouble for giving her food and had had enough of her."

Rud was silent.

"I'm surprised," he said after a while, "that she could think that. I would've done anything she asked me to. For her . . ."

"You were always so sure of yourself, so firm and confident . . ." carried on Patricia. "You simply said what you wanted of her and she gave it. She was afraid of that. You see, Maria confided in me a lot. She fell in love with you from the start, at very first sight. She fought this feeling because she thought you were a guard, and she didn't want to have anything to do with them. That was why she tried to avoid you at the beginning, though it was beyond her endurance. That's what she told me."

"But I'm not a guard. I've never been a Leader even. I only dress like this because it's nicer than the camp garb."

"Who can tell nowadays. The Interrogators, the guards, the Curators, they all use different methods. She couldn't be sure until you told her yourself."

"I too fell in love with her at first sight. Now it's too late to tell her."

"Who knows? I do know that Maria loved you. And what about you, Ruder? Yesterday Diana, today Maria, tomorrow there may be another girl on the new transport? . . ."

"How can you?" Rud boiled with indignation. "How can you say such a thing? . . . And who are you to judge me in this way?"

"You're right," Patricia lowered her little head, "I'm nobody. I'm just a little girl who wasn't allowed to be born, a foetus cut up by surgical scoops. I've no right to judge people whose hearts suffered in the fight with other people. I'm sure I would be no better."

"I'm sorry, Patricia. I didn't mean to hurt you." Rud felt pity for her. "Neuheufel told me my preparation period is nearing its end. I'm sure I'll leave the Centre soon. I'll find Maria and tell her what I should have told her ages ago."

Patricia was silent.

"You see, I thought she was avoiding me because she knew I was maimed and I didn't want to be pushy. Now I'm normal again and that's what I wanted to tell her."

"What nonsense, Ruder. Anyone returning from Greater Punishment is in the same state."

Rud's face showed utter confusion and surprise.

"And sooner or later everybody returns to the normal state. Those who haven't been through Greater Punishment – like me or her – they know that. There's no need to talk about it; it's normal and it passes. Besides, we can do better: for instance, we can see how such a stitched up, healing face looked before the Punishment and how it will look after."

"So that means that when she saw me for the first time she didn't see that horrible, nightmarish visage but my normal face?"

"I don't know. If she wanted to she could have seen your normal face. I don't know, she didn't say."

They both fell silent.

"You know, those Interrogators use strange methods. Neuheufel, in order to put me off, showed me the registration photos of Maria naked. They were of such good quality that I could see every detail, every fault of her body. You know that she had one breast bigger than the other and very ungainly, sort of broken hips. Yet somehow . . ."

"That's not true," Patricia interrupted him firmly. "Maria's breasts were the same size. I'm sure of that."

"How do you know?"

"I know because I've seen them. I asked her to show me what the breasts of a grown woman look like . . . I needed to know that because before I leave the Centre I have to decide the age of my body."

Rud had difficulty restraining himself from asking what Maria's breasts looked like.

"And also for another reason . . ." the voice that reached his brain was quiet and hesitant, as if Patricia was very embarrassed. "I wanted her to put me to her breast like a baby . . . to see what it's like"

"And?"

"And nothing. It didn't work. The nipple was too big to fit into my mouth."

"And she wasn't that unshapely either, was she? If she had broken hips I would have easily noticed . . . I saw her figure, how she walked, how she moved."

"They must have shown you the photographs of some other girl. Maria didn't mention she had been photographed naked."

"No, the face was hers," he insisted, "though even that face was strange, swollen, unctuous, full of repressed animal lust."

"She wanted to stifle that feeling for you. That's what she was struggling with," said Patricia. "Anyway, what sort of photographs were they?"

"Well, the registration ones, with the pentagram and her registration number."

"Don't let them fool you, Ruder. They don't take such photographs; they've no right to. I think Neuheufel forged them to see your reaction. If they were provocative, showed her sprawling in a porno shot you wouldn't believe them. So he used a more intelligent ruse."

"Do you think he provoked the fight to have an excuse to arrest me and prevent me from seeing Maria?" he asked, more to himself than Patricia. "What a bastard . . . And that's supposed to be Heaven," he sneered.

"Ah, Heaven . . ." sighed Patricia. "I'll be leaving here soon, you know?"

"Really?"

"I want to see my . . . those two who didn't want to be my parents . . . I heard they're still here."

"Do you really want to see them?"

"All the Un-born say that they don't, they swear they'd never see them. But towards the end almost everyone goes to see them . . . Somehow . . . they want to know . . . to see them. Both."

"Will you speak to them?"

"A few words, casually," she shrugged. "I don't want them to guess."

Rud fell silent.

★

93

Rud came to the conclusion that there was no point in arguing with Neuheufel, as it might only delay his meeting with Maria. After all, the Interrogator was his benefactor, to a degree. In the end Rud even brought himself to apologise to Neuheufel for his bad temper. The apologies were accepted with understanding. The uncouth Interrogator, in his own peculiar way, liked his charge. Rud went back to writing essays and solving mathematical problems for Neuheufel. Only now he was more cautious and secretive. Occasionally he shared his food with the old men who could not leave their bunks. He was not doing it out of the good of his heart exactly, but because Maria used to do it.

"You know, Neuheufel, I thought Heaven would be different," he started a conversation with the Interrogator; the doubts had been gnawing at him for too long and in the end he could not bear it. "First of all what I miss here . . ."

"There's nothing you could possibly miss here," snapped Neuheufel. He was in a good mood: his belly full, he sipped strong coffee through his teeth and, as was his way, spat the coffee grounds on the floor. The essay had been given high marks and he was feeling well disposed towards Rud. "Everyone's been here at some point . . . The Galilean too . . . I remember that day very well, though it was so long ago," Neuheufel fell into a reverie. "They brought Him on a Friday after knocking-off time. All the boys ran to see him. The Boss Himself interrogated Him. I couldn't come 'cause I was doing my shift below, but the boys told me later . . . Holzbucher saw it all . . . And then, when he was leaving, that was something, man," Neuheufel, steeped in memories, was talking to Rud as if to a friend, not to his charge. "What a light He gave off, I'm telling you . . . White, white light . . . You could see through the walls. We couldn't get on with our work, had to stop all the interrogations, every single one . . . Then came the thaw, the releases. We had less work; until they started sending us new transports. I interrogated one of those two who came with Him, you know? He's still with us. The other one was released. He came out soon after the Galilean."

"His . . . His . . . He . . . He . . ." repeated Rud, obviously struggling. "Neuheufel, I can't say His name . . ."

"You can't here," said Neuheufel. "No one can."

"But Neuheufel, we're all supposed to praise his name in Heaven," Rud was almost sobbing.

"And who said you were in Heaven, you fool?" Neuheufel's face set in the old familiar expression.

"You did, Neuheufel, in the Interrogation Room, down below," blurted out Rud.

Neuheufel made an indeterminate gesture with his hand.

"Oh," he said, "we say that to everyone. Regular procedure. It's to do with raising the spirits of your charge. Anyway, you felt like you were in Heaven here, didn't you Milankiewicz? It's all right, you're serving Lesser Punishment now."

"Lesser Punishment?"

"For you, Lesser Punishment means humiliation; Greater Punishment pain. You can't go on forever with Greater Punishment or you'd get used to it, and that's not the point. That's why the periods of Greater Punishment have to be broken up with periods of relief – the Lesser Punishment – so that you don't lose the scale of suffering."

"How long is the Punishment?" Rud asked, feeling the fear begin to squeeze his throat.

"It varies. You know that for some it will go on for ever. For some it will end, others get only Lesser Punishment. You see, it's all up to them. I've been observing them for generations: here, they're exactly like they were on the other side, not a wee bit better. When the pain stops, they go back to their old habits. They don't want to change. Look at yourself: the moment the pain was gone you went back to your old wheeling and dealing and skirt-chasing. Had you realised earlier that you'd returned to your normal form you would've no doubt managed to seduce this . . . And you want to get out of here, Milankiewicz?" the Interrogator finished with a question.

"Neuheufel, will I ever get out of here?" sobbed Rud.

"Eh, Milankiewicz! Milankiewicz!" roared Neuheufel,

changing suddenly. "Are you trying to make me divulge an official secret?! Don't ask me, look for the answer in your own heart!"

"You said once that my preparation period was coming to an end, so what will happen to me now?"

"It's no longer any secret," Neuheufel shrugged his shoulders. "You'll be sent back on Greater Punishment. Not for the first time, nor the last."

"How much time have I got left? When are they taking me down below?"

"Tomorrow."

Waterloo, April–May 1990

FATHER FAUST

Tadeusz Miciński

(extract)

The Mithraic Initiation

How mysteriously divine and ecstatic is the power of fire from the alder logs blazing in a fireplace. It awakens in us the ancient Aryan and Sumerian, our knees bend before the god of fire who still lives within us. The oldest and the most profound mass at which Man has ever officiated! The magnetism it spreads throughout the whole of our being introduces a mood of holiness.

The room in which Peter found himself had been created from a few cells of the former monastery by removing the dividing walls, their remaining ribs still visible on the ceiling. It had Gothic, stained-glass windows, some of them covered by a heavy curtain, and many books on the shelves which stretched across the walls from the floor to the ceiling. A huge table was covered with pots of begonias, old books in folio bound in leather, and the entire workshop of a writer and scientist – manuscripts, scalpels, quills and modern pens, amid rows of chemicals, retorts and lamps.

Any free space on the walls was covered by some polar species of moss and a collection of the skins of Javanese boas bearing hypnotic patterns, Cambodian, Peruvian and Maori masks, poisoned krises and Chinese execution swords. Everything bore witness to the host's love of danger and the unfathomable depths, and created an atmosphere suggesting the demonism of Life. The notes accompanying the skins of various animals on display stated that they had all been killed in self-defence.

The books bore imprints dear to the Polish eye – Washington, Irkutsk and Kraków. But there were also books

from Bombay and Tokyo; obviously, the priest must have travelled widely to amass such a collection.

The library was equipped mainly for religious studies. It contained the works of Smith on Chaldaea, Lassen's on India, Cumont's study of paganism, and Tyrrel's and Radliński's on modern religions. There were authors such as Jeremias, Loisy and Chwolson, ancient philosophers like Chrysyppus, Plato, Jamblichus, Heraclitus, Lucian of Samos, and classics of the Middle Ages – Kuzon, Mirandola and Copernicus. Whole walls were taken up by the naturalists – Bill, Darwin, Lyell, Suess, Strasburger, Kerner. Then there were editions of holy books from the East and a few hundred volumes of *Acta Sanctorium* by the Bollandists. One could also find here the works of modern thinkers such as Bergson, Poincaré, Sorel, Simmel and Driesch. Most of the remaining space was occupied by piles of scientific and esoteric periodicals.

Among these wonders, which made Peter's face flush with excitement, he also found "The Life of Jesus" in an excellent Polish translation from the sixteenth century with hand-painted miniatures – the rare edition of *Bibliotheca Fratrum Polonorum*, the literature of Polish emigration, an entire wall of books by Rzewuski, Kraszewski, the great Polish romantics with Norwid, as well as contemporary writers, including those of the Young Poland movement. Only now did he feel the full extent of his longing to reach out, to fulfil his life by his own actions and deeds . . .

He had left school to fight the Russian oppressor and thus, instead of initiating himself into the mysteries of Mendeleyev's chemistry, he would soon himself join the process of chemical decomposition in the moat of some fort, trampled by soldiers' boots. He looked at the open Bible with hatred, took in his hands a volume of Kelsos, the greatest enemy of Christianity, whose attack on the Cross was more devastating than that of Nietzsche in *The Anti-Christ*, and started leafing through the contemptuous accusations against "that ignorant rabble". Then, his eyes stopped at a point of great significance where all the cultures of the world seemed to meet.

"As Plato stated, there is only one road that brings the soul

to Earth and takes it from Earth to Heaven, the one leading through the planets. As the Persian worshippers of Mithras also claimed there are two kinds of heavenly movements: planetary and stellar, and the passage of the soul through them leads through seven tall gates. The first gate is lead, the second tin, the third bronze, the fourth is iron, the fifth is made of alloyed metal, the sixth is silver and the seventh gold. The first is devoted to Chronos whose weight and slowness is that of lead; the second to Aphrodite whose softness and light compares to tin; the third to Zeus with its bronze threshold of death; the fourth to Hermes who, like iron, is good at all kinds of work, pliable and durable; the fifth to Ares who is a dangerous mixture; the sixth to the silver Moon; the seventh signifies the Sun which lends its colour to gold. The reason for such a division, as taught by Persian theosophy, is derived partly from Nature and partly from music."

Peter could not bear to read further, feeling locked behind the lead gate he had reached as a youth and now forbidden to pass through the other gates of life.

The priest had left to prepare a meal for him, and Peter took advantage of his absence to sneak into the other room, where he found a collection of portraits hanging on the walls. His eyes were drawn to one particular painting depicting a strange scene: in a room lit by candle-light and with a table groaning under the weight of food and crystals, stood a beautiful woman holding a rose, while a man, visibly in love with her yet with horror in his eyes, thrust a dagger through her body as if through a ghost . . .

The man, dressed in the splendid uniform of the Papal Guard, had a pale, demonic face. Peter looked closer and it seemed to him that the man bore a strong resemblance to his host, though much younger, with a youthful, proud and sensuous face, and without the terrible scar above his nose.

Further along the wall there were paintings from the 1863 uprising, and a portrait of Colonel Sierakowski with a dedication: "To Father Faust". To his surprise, Peter noticed an open coffin standing in the corner. It was filled with straw

covered with a sheet and had a leather pillow inside. Did he really sleep in it?

Suddenly he heard the priest's steps and, like a schoolboy caught snooping around, his first reaction was to get back to the library; but then he stopped himself. A thought, cold and forbidding like the peaks of the Caucasus above a stormy sea of clouds, returned to his mind and from the chasm of his soul rose a sense of the utter futility of everything.

The priest brought in a pot of hot tea, big glasses, a huge chunk of black bread, radishes, salt and delicious-looking apples.

"Here is the prisoner's Christmas Eve supper," he said. "Allow me to share it with you."

Judging by the appetite with which the priest ate the apples, his everyday fare must have been even more modest. For Peter, apples had always been a fruit symbolising the joy of living. He looked at them, thinking of a verse from Słowacki:

> *"With blood the Lord compared me to an apple tree,*
> *which does not grow tall reaching for the sky,*
> *but weighs down with fruit and juices sweet."*

He felt ashamed of the tears which rolled down his face and onto the floor; ashamed, for they went against his present mood of haughty pride: Yes, he was going to his death young, but he felt that in the light of cosmic justice he was not inferior to those old sages whose books he had just seen, for his life, as much as theirs, was the ray "that's never lost in darkness".

Suddenly, he was struck by the thought that the priest was a hypocrite who, having himself ascended the summits of intellect, fed others with belief in the obscure and dead canons of dogma . . .

He expressed the idea in a roundabout way:

"So, you believe, father, that it is only a storm that can open the heaviest of gates. But perhaps that gate should be approached with calm . . ."

"Be it a storm or an ant's labour, I think it's a shame that the present Polish church does not have its own thinkers who might break through the old walls . . ."

"And?"

" . . . and discover the new life."

"Hm . . . And how could you kill, believing in nothing?"

"Was I to be that evil which kills in faith? Yes, I believe in nothing but the pain of living and the joy of sunshine."

"So, the mind cannot fathom the depths of our lives . . ."

"I don't seek those supposed depths. All you can find there are old, worn out beliefs. It is below the dignity of Prometheus."

"Prometheus! Or the thinker who stole secrets from the other world!"

The priest fell silent and Peter started examining the painting.

"Do you believe in ghosts?"

"Ghosts?" Peter looked at the priest as if he were out of his mind, but decided to speak openly.

"This Spanish lady in the painting doesn't seem to be an apparition from another planet."

"Hm, my philosophy is based on my own experience, and the Spanish lady was nothing if not a ghost . . ."

The priest sank deeper into his armchair. The rolling clouds, the wailing wind, the darkness and that wonderful fire seemed to Peter to be an expression of what he felt inside: the demonic freedom of space above the mountains of life.

A long silence ensued.

A huge cat, striped like a tiger, sneaked in. It must have had a very bad temper for seeing Peter it started to spit. In the end it decided to ignore him and having jumped onto the back of the armchair it lay like a pillow, under the old man's head.

The priest blew out the ashes from the amber hookah and to Peter's horror filled it again with tobacco. Nevertheless, the youth took a burning splinter from the fire and, holding this spark of eternal fire in his chain-bound hands, passed it to the priest.

The one whom Colonel Sierakowski called Father Faust
began to tell a story.

The Infernal Rose

I knew Cardinal Metastasio quite well. I was liked by his
ladies, even though I was only a captain in the Papal Guard.
For you ought to know, young man, that not for nothing did
the Italians call him, as they did their king Victor Emanuel,
"the father of the nation". Yes, the cardinal had a taste for a
fine female body with the strong hips of a Maenad; a
beautiful and wise head was merely an addition.

(No, Peter had not expected such a connection between
the priest's ghost story and the body of a Maenad. But he
listened, leaning on the side-pillar of the huge fireplace,
standing in the cool half-shade. The fire, reflected in the
stained-glass windows, threw kaleidoscopic flashes all over
the library, playing with the precious stones encrusted in
the covers of the old volumes, on the stretched skin of the
Javanese boa and flickering on the glazed bowls from
Faenza.)

Being a rake and a carefree rascal from Volyn I belonged
to a race which, as is widely known, does not distinguish
itself for its patriotism and scholarship but is known for its
loud mouth and boasts manly strength. I was an exception in
one respect only, having diplomas in science, mathematics
and philosophy. Thus, I, Count Apolinary − the name is
unimportant, nobody here knows it anyway − used to dine
with the cardinal and the ladies in his gardens at the Attis
sarcophagus, which, adorned with violets, served us as a table
many a night . . . Hm . . .

(Here, the priest let out a huge cloud of smoke from his
pipe.)

One night I was walking down a narrow street in Traste-
vere, behind the Castel San Angelo. The street was empty,
my sabre rang cheerfully on the cobblestones. Not a single
passer-by in sight, darkness and silence reigned everywhere,

though the rows of old palaces were often taken over by a rowdy carnival . . .

The balmy evening air carried a scent from the pines whose silhouettes looked like pagodas in the dusk. At the same time a wet, and often deadly, breeze was blowing from the wonderful meadows of *maremmas* stretching along the sea outside Rome. In this fragrant freshness the thought of death began to knock gently on the back window of my mind.

There was not a soul in sight, the street-lamps were out and the only light came from a few windows, seeping through the Persian – or as they call them – Venetian blinds.

Suddenly, a rose fell at my feet. It gave off such a strong scent that it left a perfumed trail in its wake, hanging still in the air. I picked it up and though I could not see it in the dark I could have sworn it was scarlet red. I placed it on my heart and looked around trying to find the window it might have fallen from. The palace was drowned in darkness.

Then, I saw the light in the ground floor window; behind the bars, a lantern in her hand, stood a lady of exquisite beauty.

Following the custom practised by young Roman aristocrats ever since the times of Spanish occupation, I spread my richly embroidered cloak on the cobble-stones in the square of light. I bent my knee before the beauty and, sweeping the ground with my hat, I launched into an inspired speech full of admiration and amorous entreaties.

To my surprise the lady responded in Spanish:

"I am alone now, will you honour me with your company?"

I did not have to be invited twice.

The light disappeared. I reached for the old-fashioned, bronze knocker, depicting the Phoenix flying over a nest of snakes and when I turned it an invisible spring swung the door open. I entered, feeling my way in the darkness.

A strange, marvellous voice called my name from above:

"Señor Apollino . . ."

I had never heard a voice of such sweetness before. It

seemed like the sound of a fountain flowing into a crystal amphora. Such an unearthly voice one can hear only in springtime when the mountain glaciers blend their metallic music with the whisper of nymphs.

Slowly, I climbed the stairs, overcome by emotion.

There was more light on the second floor, where I saw an open door to a brightly lit room. The lady, wearing a dress such as one may see in the paintings of Velasques, led me into a splendid chamber where the ceiling was inlaid with huge blocks of carved black oak or ebony and the walls were covered by old tapestries from Arras.

She greeted me with a discreet wave of a rose so red it was almost black, and graciously showed me to a seat opposite her. I sat in one of the Gothic chairs, which looked as if it were both a throne and a confessional. The table glittered with crystal glasses and old faience bowls of rare beauty; the plates were of thick silver. I spoke fluent Spanish, luckily, but knowing the Spanish etiquette I did not dare to ask any probing questions. And so, while dining on strange, out-landish dishes, richly spiced in the old-fashioned way, we talked of love and mysticism. I do not remember much of our conversation, conducted in a way that enraptured the senses with the expectation of an unearthly ravishment. I only recall a couplet which the Doña spoke, among other, most peculiar sayings:

> *La muerte y el amor, pasando el camino,*
> *la noche los tomar en una posada.*

("Which means, if you do not understand Spanish . . ."
"Why, me?" responded Peter:

> "*Afloat in a gondola were Love and Death,*
> *when the night found them in the darkest depth.*"

"Hm . . . Your imagination, young man, works to the disad-vantage of philology. The poem means simply:

Love and Death walked along one road,
the night found them in an inn.

"Anyway, the next day . . ."

"You spent the whole night there?"

"I was not a priest then, but I shan't dwell on that. All I can tell you is this.)

There were many courses and I served the Doña myself, taking the dishes from a special niche with a revolving screen so that the servants on the other side could not see us. I did not hear the slightest noise which would betray the presence of anyone else.

After the desserts, which were a feast fit for the god Comus, we drank the wines of Jerez and Gatta, the latter being similar to champagne but better, for it does not bubble and go to one's head. Then, we moved to the salon decorated with enormous Venetian mirrors, old and frosted, and a fireplace with a blazing fire. There, in the tower-corner, we found a boudoir whose walls and ceiling were entirely covered by mirrors. It was furnished with tabourets and a small table in the Moorish style, inlaid with mother-of-pearl.

My mysterious hostess sat there in the glare of the fire. I looked around in astonishment, seeing her reflection wherever I looked – on the walls, the ceiling, even on the floor – as she sat surrounded by the aura of awe and desire, radiating a truly Luciferian[1] charm.

She picked up a mandolin and started singing a beautiful song. It is almost impossible to translate, so closely are the words bound up with the melody, but anyway – here is Satan talking to a nun:

> *The night of my soul spreads far and deep*
> *beyond the gates of Hell where gloom and darkness weep.*
> *And here we are, the guests of Hades*

[1] Lucifer – Satan, but also the planet Venus as morning star; hence the name "Venus of Hell" later.

where pure joy awaits us, not tears . . .
Break the yoke of the Cross, my love!
Nothing can stop you but the stars above.
– Throw away the habit, O Monster! And reveal your face!
Come and love me, the world is like a cemetery to me! . . .
Our wings will scorch the Earth as I fly with thee!
Radiate your grace
in this stellar light,
for I am your spirit
and you are my heart.

I left in the morning, hurrying to my duties outside the chambers of His Holiness, where at nine o'clock I was to escort him to mass for a great crowd of pilgrims.

Suddenly, at the end of the street, I realised I did not have my sabre at my side. It was impossible to carry out my duties without it, for the code of the Papal Guard is very strict and entirely based on honour. I could, after all, buy a sabre somewhere on the way, but what shame! I, the captain who would punish the slightest offence with a month in the prison of Castel San Angelo!

I rushed back and knocked on the door.

Silence.

I knocked harder and harder, finally pounding on the door with all my might, convinced that my beauty was alone in the palace and had not yet retired.

Silence.

The thundering echo of my struggles with the heavy bronze gate would have woken a bear from his winter sleep, let alone a lover from her slumbers. In the end, a good quarter of an hour later, a trembling old man came out from the adjoining house. He had a bunch of keys hanging from his belt.

"Pardon me, Your Honour, what do you want at this house?"

"I left my sabre there."

"When?"

"A quarter of an hour ago."

"It cannot be . . ."

"*Carajo, tonto, porco do Bocco, bougre de canaille, vieux saltimbanque!*" I roared at him, swearing in all the languages I knew. "When I, the captain of the Papal Guard say so it means it is so! You . . ."

"Yet it cannot be," said the old man phlegmatically, "the palace has been empty for the last three hundred years. It used to belong to a Spanish duchess and now belongs to one of her descendants. But he has never been here. He lives somewhere in Chile, where he will spend the rest of his life in prison, after committing a horrific murder. I've never seen anyone enter the palace since I was a young man, nor have I ever been inside it; I had to take an oath that I would never enter it."

I was stunned. I looked closely at the old man's face; he appeared quite honest. Was he mad?

So I asked him, kindly but firmly, to find the key and open the gate for me. After thinking for a while he shook his head:

"Well, my end is nigh . . . I can convince Your Honour, and see for myself if all is in order. Sometimes, at night, I hear strange noises, music played by an orchestra, and sometimes it is as if hundreds of people were dancing . . . Some terrible games take place there. Popes come and go, and the devil in the shape of a woman comes here."

"Let's go, *vamos, andiamo!*" I told the old man impatiently, irritated by his drivelling.

With difficulty, the old man turned the key in the rusted lock; apparently, the knocker with the Phoenix above the nest of snakes failed to do the trick this time . . .

"The same hall," I said to myself entering. "The sabre should be upstairs. We must be quiet, she will be asleep now."

"There is not a living soul in here," said the old man with conviction. "You see, Captain, there is an inch of dust on the stairs. But . . . *corpo della Madonna!* There are footprints here, just like yours, Your Honour . . . Evil powers are mixed up in this, or Your Honour has a spare key."

I left the grumbling gate-keeper behind and ran up the

stairs to warn the lady of my unexpected return. I reached the second floor and, finding no response to my knocking, I opened the doors.

The room was completely empty, and I could swear it was the same. I recognised the tapestries – a battle against the Moors and the royal coats of arms of Aragon and Castile – and the same Gothic chairs and table. All that was missing was the dinner-service. But that could be easily explained: the servants had cleared it away.

In the thick layer of dust covering the floor, which, indeed, had not been swept for centuries, I saw my footprints. They encircled the table in a tight ring and one line, straight as if left by a sleepwalker, led to the other end of the salon. I followed it to the tower-corner with its mirrored walls, passing the cold and windswept fireplace.

The boudoir was empty; even the small table in the Moorish style was missing. There, in the corner, stood my sabre.

I would have been less surprised if a purple thunder-bolt had struck me from the ceiling. I was in a dark labyrinth without a thread to follow.

"If I do not find the beautiful Doña's bedroom soon I'll have to doubt my sanity," I thought, though of course I did not realise then the true meaning of my experience.

"Who's led me here?" I burst out, running through the empty room with sabre in hand, ready to kill. I ran around trying the other doors but they were all locked with huge locks, the rust and spiders' webs seeming to confirm they had not been opened for a long time.

And how, in just fifteen minutes, could it all vanish? . . .

"Where is the lady who lives here? . . ."

I reached for the rose hidden on my breast. It was white, stained with blood . . .

"That is possible," I said to myself, "I could have cut myself struggling with the gate."

But the wonderful, infernally intoxicating scent of the rose brought to life the memories and . . . the certainty that here I had really held in my arms the live, beautiful Stranger.

I left the palace.

The street, Rome and I, Count Apolinary, the captain of the Papal Guard – mad? or converted to faith? The memory of those ravishing delights still burned in my veins, too hot to doubt that I had spent a night with the Venus of Hell.

I did not return to the Vatican. I placed my sabre as a votive offering on the altar of the first church I came across. Soon after I became a novice in the strictest of monastic orders and took my vows. To be honest, I regretted it sometimes. For if a man cannot fit into the world how can he fit into a priest's habit?

Later, I checked some old books and found that there once lived in that palace a Spanish duchess, a mistress of Cesar Borgia, who helped the Neapolitan king to imprison her lover by luring him into a trap.

STRANGE STREET

by Franciszek Mirandola

Climbing the narrow, winding, badly lit stairs he finally reached the third floor of an old house, tenanted exclusively by the poor, and opened the door with a big key.

He was tired after work at the Telegraph Office. Every time he returned home his head was still full of a rattling noise ticking out impossible messages. Only after two glasses of tea with rum could he start thinking clearly, but that was hardly a relief. All he could see before him were years of hopelessly boring, tiring, stupid work.

He lit a small, crooked lamp whose paper lampshade covered the remnants of the original glass one, broken years ago.

The room, or rather corridor with a kitchenette, carved out of a flat inhabited by women of doubtful occupation, was neglected, dirty and looked very unsavoury. But with the years he had grown to like it, the way one grows to like something after a time of enforced familiarity. Prisoners grow to like their cells just as well as the rich their plush studies, perhaps even more, for their confined space fills more quickly with thoughts and dreams – the only goods a poor man can own. One dreams and it seems that there is so much . . . so much ahead . . .

He lit his kerosene stove and went to the kitchen to get some water. He was just about to turn the tap on when he stopped. The tap was dripping. Automatically, he began listening carefully to the quick, irregular rhythm of the falling drops.

It spelt out:

"Strange Street, number 36 . . . Strange Street . . ."

A cold shiver ran through him. He recalled quickly all the

addresses of today's telegrams. No, there was no such address. Strange Street . . .

Was there such a street in the town?

He listened again:

"Strange Street, number 36 . . . Strange Street, number 36 . . ." the drops were ticking out.

He shivered again and, with a great effort of will, he turned the tap on. The water gushed into the sink splashing around, forcing him to step back. He returned to the room with a saucepanful and put it on the stove. Then he went over to the wicker shelf where with a few books he kept all sorts of odds and ends, found a bottle of rum, poured himself a glass and drank it in one gulp. He felt warmer and soon even bright and jolly.

He sat on the bed watching the blue kerosene flame licking the saucepan, which was blackened, scratched and worthless like everything around him. His eyes wandered back to the bookshelf but after a while he turned his head away.

"Strange Street," he thought, "where could it be?"

He felt as if he was rising to an altogether different level of awareness; for a moment he saw himself on a higher plane of consciousness, surrounded by strange, unknown apparitions.

But after a while he shook off this vision.

"What rubbish!" he said to himself aloud. "These are the results of my idiotic occupation."

And he began to worry what would become of him in one, two, ten years time . . .

"I'll go mad . . . Surely, I'll go mad!" he said again loudly. Then he got up and made for the kitchen . . . He did not even know why he was going there. He stopped by the door and listened attentively.

The water was dripping into the sink.

"Damn it," he swore and turned back. But before he had reached the bed he stopped, thought for a while and was back in the kitchen.

He stood by the door.

"Strange Street, number 36 . . . Strange Street, number 36 . . ."

Beyond any doubt, it was the water tapping out these words.

Quickly, he went up to the tap and turned it as tight as he could.

The water stopped dripping . . .

He sighed, but still waited, unsure what might happen next. The silence was almost complete; he could hear only the faint voices of people talking in the yard and a baby's wailing on the floor below.

Relieved, he returned to the room. He lifted the lid from the saucepan. A puff of steam rose in the air. He put some tea into the teapot and waited.

A bell rang.

"Tonia!" he said to himself. "Good."

He was glad he would not have to spend the rest of the evening alone in the flat.

"Hello," she greeted him cheerfully, put her arms around his neck and kissed him on the mouth.

Then she threw her hat and coat on the bed.

"What's new?" she asked. "Why are you looking so glum? Come on, tell me. Or maybe you've given yourself a day off, eh? You naughty boy!"

"No, no . . ." he defended himself. "I'm just overworked. I'm very tired and even a day off is beyond my wildest dreams. Go on, make some tea."

"Where are you going?" she asked, seeing him leave the room.

"Nowhere, I want to have a look . . ."

He came into the kitchen . . . and stopped surprised, even frightened, to find the tap dripping. He did not even make an effort to listen. He knew what it was saying.

"Strange Street, number 36 . . . Strange Street . . ."

He went back into the room and stood by the table, which by now Tonia had managed to tidy up a little.

"I've brought you something nice," she was babbling

away. "Guess what it is. Come on, guess . . ."

He did not reply and she looked at him.

"Good God! You're white as a sheet!" she cried out. "What is the matter with you? Tell me. Maybe you should lie down . . . Yes, yes . . . Go to bed now. Drink your tea in bed. Look what I've brought . . . It's a nice mix, isn't it?"

She was looking into his eyes, smiling endearingly.

"You've been looking rather pale these last few days. Do you feel ill?"

He shook his head.

"Come with me," he said gravely.

She was surprised but obediently followed him into the kitchen.

"Listen. Tell me what you hear," he said in a mysterious tone of voice.

Now she was becoming really worried.

"What's the matter with you, Frank! Good God . . . what is the matter?"

"Pst!" he put his finger on his lips. "Listen carefully."

She was listening with her eyes wide open, staring into his face.

"I can't hear anything," she said after a while. "Someone is talking in the yard, a baby is crying and the water is dripping . . ."

"Exactly . . ." he whispered, "water But what's the dripping water saying? Listen!"

"Good God . . . how am I to know? True . . . it is a bit like a telegraph message . . . It's ticking out . . . but I don't know what . . . I don't know Morse Code. Tap . . . tap tap . . . tap tap . . . that's all. Darling, it's childish! Let it drip. You know yourself it's childish. You are tired, that's what it is. Come, you must lie down . . ."

She pulled him towards the bed.

"Get undressed," she ordered him firmly.

"But what are you . . ." he was trying to resist. "It's only eight o'clock, it's just got dark."

"Get undressed, you're ill . . ."

"No, no, we'll have some tea and then I shall see. Anyway,

I'm not ill, it's only a headache. Don't worry about it . . . Sometimes, after work, my brain goes into overdrive. It's a terrible job, Tonia, I can tell you . . . a terrible job."

She busied herself at the table, pleased that he had started talking sense again.

"Blast it!" she cried out suddenly. "We've run out of sugar . . . Wait, I'll nip out to the corner shop . . ."

"Let me . . . I'll go," he said hurriedly.

He took his hat, threw a coat over his shoulders and left.

Passing through the kitchen he closed his eyes so as not to see the damned tap. But he could not stop his ears and so he heard that maddening, stupid dripping, which he could not help taking for a kind of telegram.

"Strange Street, number 36 . . . Strange Street . . . number 36 . . ." It followed him as he hurried down the stairs.

Outside he looked around for a policeman. He saw one standing across the road, at the other end of the street. In front of the shop he hesitated, put his hands in his pockets and slowed down. Then, as if pushed by some compulsion, he passed the shop's door and quickly walked on. In order to approach the constable he had to cross the road. Without thinking, and contrary to his meticulous habits, he stepped right into a muddy puddle. For a second he registered an unpleasant sensation, surprised that he was doing something so foolish, but he waded on.

"Excuse me, officer," he said lifting his hat, "where is Strange Street? Do you know such a street?"

The policeman looked down at him, observing him in silence, then turned on his heel and slowly walked away, apparently offended.

Frank sighed with relief. If it would not have made him look silly he would have given this guardian of law and order a big kiss. So, it was all nonsense after all, he thought.

He turned back towards the shop, where the lights were still on.

Inside, the shop was crowded. He stood at the counter next to an elderly gentleman, who evidently was not completely sober, one could smell it. He searched through his

pockets with difficulty, looking for money, and then counted it out very slowly.

For some reason Frank asked him in a whisper:

"Excuse me, sir . . . Do you know where Strange Street is?"

The gentleman kept counting out the money; he had not heard the question. At long last he received his package, but still waited. They found themselves on the street together.

"What is your name, young man?" asked the gentleman.

"Frank Grey," he answered surprised.

"And I am John Nevermind. That is my name since I started visiting Strange Street."

"Where is this street?"

"You would like to know, wouldn't you?"

"I would."

"And have you got much to lose? How much?"

"Money . . . money . . . I haven't got much money . . ." he stammered out.

"Not money! Have you got much to lose in life?"

"In life? . . . Nothing, almost nothing . . ."

"Good! Let's go."

Frank felt somewhat odd. He did not trust the man. He would rather go there alone.

"Someone is waiting for me . . ."

"A woman?"

He did not answer.

"Spit on it, I say. Spit! Let's go. But I'll tell you straight away, there is no return from there. You've got to know that in advance. You will return in flesh but never in spirit. Never!"

Frank shuddered. This man was not drunk. He pulled his arm away from the other's friendly grasp.

"No, I shan't go. But please, tell me where it is."

"Everywhere and nowhere."

"I don't understand."

"I know. Now, tell me, how did you find out about this street?"

"I can't tell you!"

"All right, all right," laughed the old man. "You haven't learnt it, I suppose, from any decent citizen."

"No, it sort of occurred to me."

"Excellent! Wonderful!" John Nevermind was pleased. "Some dream about it at night, to others it occurs while they are daydreaming. Excellent. I'm telling you, let's go."

Frank resisted.

"Please, tell me where it is, what is there. I'll go alone."

"It's nowhere! You understand? Just like there is no happiness, love, goodness . . . or clairvoyance. Yet it's everywhere, for it may come along at any time just like all those things. This very moment, in a second, you could find yourself on Strange Street which leads through life. So called decent citizens walk along Straight Street, Dignified, Senator Street. We, we go down Strange Street, Abysmal, Out-of-this-World Street."

"But you wanted to take me somewhere . . ."

"Where? To my flat, where I live. I wanted to make you my pupil."

"And yet . . ." he said disappointed, "yet I know it is somewhere . . . in Strange Street, number 36."

"That is my address."

"Strange. Very strange," whispered Frank Grey. "How could I know that?"

"Don't ask. As yet, this question is too difficult for you. One day you will be able to answer it yourself. I'm telling you, come with me. You will be my pupil."

"And what then?"

"I feel you have the calling. I will show you a path which leads beyond the working fields of life, into free, divine waywardness . . ."

"And what will I find there?"

"Freedom and wisdom. Raptures which no human breast can withstand, love which today would turn you into ashes. I shall teach your heart and one day it will become a vessel full of heavenly nectar."

He was listening surprised, frightened.

"I'll come tomorrow . . ."

"You'll never come if you don't come now. Come with me."

Frank wrenched his arm away again and stepping back he said firmly:

"I shall come tomorrow!"

"There is no tomorrow, only today . . . You have found a treasure and you want to pick it up tomorrow only because today you still have to pick up some rags? Think . . . just think!"

Frank took off his hat, he felt cold sweat on his brow. He was shivering nervously.

"Please, sir, give me your address. I give you my word I'll come tomorrow evening and will be happy to listen to you. Today I really can't."

"You can't . . ." the old man laughed quietly. "Ah, I knew you could not. There were so many of you and none could, each still had something else to do . . . just at that moment . . . on Lord Street, or Obvious, or Beautiful Street . . . Well . . . go, go . . ."

"Please give me your address," asked Frank.

"My address? But you know it . . ."

"I don't! Tell me exactly how to get there . . ."

The gentleman turned around and walked away without a word.

Frank Grey watched him go with deep regret. Then he shuddered, for the old man, having walked a few steps, suddenly disappeared, as if he had dissolved into the darkness.

Frank was struck by fear. He rubbed his eyes and looked around. He realised he was standing inside the shop, leaning against the wall. The owner was looking at him with pity.

"Feeling poorly, are we?"

He did not answer. He paid, took his packet and quickly ran home.

Leaping up the stairs he got to his flat, pulled the door open and stopped dead in his tracks. He listened, straining his ears without taking his eyes off the water tap. Not a drop fell into the sink.

He was overcome by a great, uncontainable sorrow.

He burst into the room and, turning to Tonia, shouted till the window-panes rattled in their frames:

"Get out!"

He was standing white as a sheet, pointing to the door, his teeth chattering.

"Have you gone mad?" she asked frightened.

"Out!" he shouted again and stamped his foot.

She started picking up her clothes, pale, sad and deeply hurt, her chest heaving with a stifled sob.

Feeling that his legs were giving way, he fell onto the bed and burst into tears.

"Frank! Frank!" cried Tonia.

She put her arms around him and wept with him.

THE VAMPIRE

by Władysław Reymont

(extract)

Zenon spent almost three days on the streets. On the morning after the inexplicable arrival of the letter he got up early, read the mysterious message again and, having dressed hastily, left the hotel. After that he wandered through the streets of London, sleeping and eating wherever and whenever he found the need.

He roamed the town for a long time, fleeing and yet searching, avoiding and yet unable to pull himself away from the crowds, examining closely every face, looking into every pair of eyes with fear, trembling with the impatient hope of catching a meaningful look, or hearing a word, or seeing a sign that what had been foretold would become real there and then.

He was oblivious to the cold, the rain, the fog and the time of day, wandering from place to place, often waiting for hours on street-corners or lurking around shop-windows, observing the passers-by and trying to make out their faces in the dark, running after anyone who seemed to give him a meaningful look. Sometimes he would enter a restaurant or a crowded pub to have a rest but as soon as he had scanned all the faces there he would leave his drink unfinished and be on his feet again. He felt he had to go on searching, go on waiting . . .

"Search – follow – do not ask – be fearless – S-O-F reveals secrets." The powerful, inexorable command of the words in the letter still resounded in his head.

He had not the slightest will to resist, he was like the fist of an unforgiving hand thrust towards an unknown target, following its course blindly, indifferent to anything but that dark, mysterious compulsion. And yet he had complete

presence of mind and was conscious of what was going on around him, except that he felt all his connections with his past life had been broken. He thought about it the way one thinks about strange stories heard a long time ago which are already drowning in the depths of oblivion.

"What is going to happen?" he thought in the rare moments of inner awakening which made him want to tear from the unknown future its secret. But the mist in which he was groping would not lift, the vicious circle of his vain pursuit would not break, he had to go on searching, he had to wait.

He would spend hours in the City, tossed on the waves of the crowd, surveying it, calm and remote, with his tense and hungry eyes. He visited museums, ventured deep into empty, wet and misty parks, walked along the embankment, travelled on all the omnibuses constantly changing routes, looked into banks and theatres, circled London on the underground. He went everywhere in his untiring, unremitting, feverish pursuit of an elusive shadow, always vigilant and full of hope, calm and confident he would find what he was looking for.

Even the policemen began to notice his pale face and wild eyes, at once empty and penetrating, constantly searching the crowd, and his unpredictable behaviour, as time and again he would plunge straight into the thickest flow of carriages and omnibuses, right under the horses' hoofs, emerging miraculously unhurt and oblivious of any danger. He was slowly losing his sense of reality in this mad pursuit after the unknown, perhaps even the non-existent. His attention, strained to its limits, ceased to register people in their individual forms, and now they appeared to him as one monstrous reptile with a thousand heads and legs writhing in a ceaseless, hollow, terrifying hum.

The whole of London seemed to him a fantastic jungle, vast and lifeless yet full of strange, dreadful and mysterious apparitions which he could not apprehend, but which he felt floating around in a perpetual state of becoming. And so he wandered in silence, with a vague, inexplicable sense of awe,

thinking he was beginning to catch a glimpse of what was hidden before his mortal eyes – *anima mundi* – the soul of the world . . .

He walked through the town as if through a stone-built fairy tale full of glittering trees he had never seen before. Now and again he would see an ailing, suffering house, bending under the weight of centuries, scarred with wounds and groaning with exhaustion; he would feel the painful shiver of trees drowned in the fog, dying and longing for the sun, for fresh spring breezes; he heard their never-ending moan and saw their tears rolling slowly down their sick branches.

He stopped before the Tower of London. It stood in sombre reverie, a tragically lonely remnant of days long past, rising loftily in its loneliness and proud contempt for the new life, the new days milling in squalor at the feet of its immortal majesty. But he ran away in panic from the insipid, rich but stupid palaces of the West End, which had seemed to jeer at him with their greasy, impudent voices of good reason, and equally he avoided the huge stores and shops where the lands of the world bemoaned their looted riches.

He would often become lost while listening to the lazy colloquy of the misty parks, or to the servile, mean whisperings of the erect, sentinel hedges. He listened to the birds flying past unseen shrieking out their woeful tales, he spoke to the homeless dogs living on the rotting rubbish dumps, who later followed him in packs. Everywhere and in everything he felt a soul full of pain, witnessed the tragic necessity of existence and the interminable violence of the brutal force of fate. Even the stone of the statues in Hyde Park seemed to be accusing those who had dragged them from the womb of eternal silence into the light of day. The ever-flowing waters of the Thames murmured their lament while the worn out, rusty machines, forged and bound by human thought and abandoned on the banks, tugged powerless at their moorings, groaning their quiet complaints at the never-ending toil of existence.

In the end he felt he was in a barely remembered dream, trembling and falling like a star into depths of infinity.

Then, without knowing how or why, Zenon found himself in Westminster Abbey, sitting almost dead with exhaustion under one of the statues, totally oblivious to what had happened to him or to the world around him. The sacred silence of the graves sobered him up a little. The statues, leaning towards him, stared at him with their wide open eyes, and the deep silence began to swell with their mute message. He shuddered and began making his way slowly through that stony crowd towards the exit.

He was in the transept, near the exit, when he stopped suddenly and hid again among the white statues. He saw a shadowy, but familiar, slender figure come through the main entrance, then turn to the left into a high, narrow aisle encircling the choir with a row of royal chapels. He followed her into the twilight of the aisle, where only high up, in the blackened network of the gothic ribbing, smouldered remnants of daylight, while below complete darkness reigned.

Daisy stood in front of one of the chapels and, leaning against the iron lattice, looked at a sarcophagus.

"I knew I would meet you," he whispered stopping by her side.

She gave him a stern look as if ordering silence.

He did not feel tired any more; the insane feeling had slipped from his soul like a dirty rag. He was a normal, ordinary man again.

"They feel better here, in the kingdom of eternal silence," he whispered again.

"Who knows? If their souls are still bound to their bodily image they will have to wander trapped in matter, and be here filling these aisles with their moans and longings for as long as this bronze and marble last, until Time turns everything into rubble and frees them to return to their destinies."

"That would be too terrible," Zenon shrugged off the vision.

"Who knows what one's life or death depends on, what binds a man and what redeems him?"

"S-O-F," he said slowly, almost against his will, the way one voices things deeply lodged in one's brain which suddenly come to one's lips of their own accord.

He felt her sway as she leaned on his shoulder for a moment, but she did not explain.

They moved on, stopping at all the chapels, which were drowning in the ever thickening darkness as only a dying glow emanated from the stained-glass windows.

"I haven't seen you for a long time," she said with an unusual softness, almost a reproach.

"A long time?" He was surprised, remembering suddenly the scene of flagellation and all the suspicions he had been trying so desperately to forget.

"You disappeared three days ago. Tracy began to worry about you."

"Three days! . . . No . . . I left today, maybe yesterday . . . no . . . really, it's never happened to me before, I can't remember . . ."

"You can't remember those three days?" A question rang discreetly in her voice.

"No, of course not. I know, today after breakfast you played on the harmonium in the reading-room." He was talking fast, struggling with his memory.

"You are mistaken. I haven't touched the keyboard for three days."

"So, what's happened to me? For three days . . ." he whispered fearfully.

He saw in his mind torn and misty images of something he could not properly focus upon in order to bring it out into the light.

"And yet . . . yet, I have been waiting for you."

She did not answer. The wardens, making their rounds with their torches before closing the abbey, began to ring the bell. They came out onto the square outside.

"Sometimes we forget our own existence or look at it as if it were not ours, as if it were happening outside of us. And

123

sometimes the soul is carried away in some mysterious whirl and loses the body without even being aware of it," she continued, deep in thought.

"So I too must have got lost in time then, I must have . . ."

Just then they reached the corner of Victoria Street and she gave him her hand.

"You are not going home?" he asked, shaking off the dreamy mood.

"I have to see my friends from Calcutta before dinner." She said it cheerfully and in the light pouring out of the shop-windows and street-lamps he saw on her face a strangely sweet and friendly expression, the like of which he had never seen before. She looked straight into his eyes softly, almost tenderly and when she looked again from the departing cab he was overjoyed. He stared after her for a long time and then stopped a cab and immediately went back to the hotel, hurrying the driver all the way.

He did not put the lights on in his rooms; he did not have the strength left to make any considered effort. He collapsed into an armchair and, staring into the night suffused with a golden light seeping from the street-lamps, he fell into reverie, following with his eyes the shadows made on the window-panes by the swaying trees.

"She must have been there," he thought, remembering her during the flagellation scene he had witnessed. He saw her again, her body covered in weals, writhing like a nest of blood-red snakes.

"She was there, she was," he kept repeating, feasting his eyes on her beauty and the shame of her nakedness, delighting in the painful certainty of his words, as if taking his revenge on her and at the same time feeling closer to her in sharing her secret.

"A medium . . . for flagellation," he whispered with bitter contempt, when suddenly the front door slammed and all the lights came on.

He looked around in surprise. The door was shut and there was no one in the room; only a railway map lay open on his desk with certain routes marked out in thick, red lines.

He stared at it in amazement, unable to understand who could have done this and when, for someone must have, only a moment ago, and might still be here . . . The heavy door-curtains swayed in the last dying swing as if someone had just passed by. The floorboards squeaked in the other room. A chair was moved. Someone was there, passing from room to room, making the furniture tremble; he could hear the distinct rustling of someone's steps.

"Annie!" he called out, thinking it might be the maid.

There was no answer; the rustling stopped. In its place he heard a quiet, faraway singing which sounded as if it were coming from the end room. He rushed towards it but that room was empty too. Yet, the singing grew stronger and resounded clearly throughout the flat. He recognised Daisy's voice and the strange, mysterious song.

He stood stupefied with fear, searching the room with his eyes. No, there was no one there, but the sound was still flooding in though he could not say from where. One moment he heard it around him, the next it floated high above. Then, it came in like a wave and stopped again, only to re-emerge fuller and stronger but somewhere farther away, possibly in the first room. He followed it as if in a trance, but the singing had already grown faint and was coming from some distance, as if from behind the windows, echoing in the crowns of the trees swathed in darkness . . . Or maybe he heard it within himself.

He was conscious and perfectly aware of what was happening around him, so without any further hesitation he decided to find out where the singing was coming from; he suspected that Daisy was at home in her rooms next door.

He knocked on the door energetically. Bagh, Daisy's black panther, answered him first with a short and angry snarl, and only after a while did the maid assure him through the closed door that Miss Daisy had gone out to town. He did not believe her and went downstairs to look for her in the communal reading-room.

"She is calling me. Yes, it's clear, she is calling me," he

realised suddenly, remembering what he had been following in vain these last few days.

"Follow, do not ask, follow, do not ask," he kept repeating through his white lips and then, without any further deliberation, without the slightest hesitation or resistance he got up, calm, with cold determination, to follow the irrevocable command which was overpowering him again.

He started walking, he did not know where, as he followed the song which was calling to him from the shadows, sometimes weak as a baby's whimper, leading him to the unknown.

"I am coming. I am coming," he whispered walking faster and faster.

When he reached Piccadilly the singing voice was drowned in the noise of the crowded street. He stood helpless, looking around, when suddenly he saw her clearly, in the light of a brightly lit shop-window, walking on the other side of the street. He ran after her but could not find his way through the crowd.

"Come what may," he thought, quite unsurprised by the meeting, even certain it was the reason he was there, that it was ordained to be.

He followed her a few steps behind, keeping his distance even when the crowds had disappeared and their steps echoed along the empty streets; he followed her like a shadow, like necessity itself.

They passed through streets, empty squares and sleeping parks filled with quiet whisperings and then climbed the wide steps of a railway station. He bought a ticket to the same station she had mentioned to the cashier. He was not trying to hide from her and they entered the waiting room almost at the same time, but she looked at him as if she did not see him; her wandering eyes passed by his face as if it were an unfamiliar object, the way one looks at a stone by the roadside. He did not feel hurt; he understood that it must be like this. At times he even thought that they were one and the same person, so strangely harmonious was his feeling of identity with her soul. They wandered around side by side

like two overlapping shadows, or two shafts of light which cannot be told apart.

He automatically followed her to the same train compartment, but before he reached it she shut the door, so he got into the next one. He stood at the window all the way, looking with empty eyes at the ghostly landscape looming out of the cloudy night, at the moon floating slowly through the rolling clouds, falling now and again into a blue, frayed precipice. If he saw anything it was her shadow, the black silhouette of her head lying in a square of light and moving with the train – she too must have been standing by the window.

They got out at a small, sleepy station, passed through the empty, silent rooms and a dark, equally empty driveway, and disappeared in the blackness of a lane flanked by rows of huge trees.

The wind roared and the trees swayed heavily. A sleepy flutter among the rustling leaves and a mournful groan filled the air. The roadside hedges stood shaking, the hard laurel leaves resounded with a sorrowful sobbing, fear flapped its wings like an owl and hid in the darkness, lying in wait.

They entered a park and an impenetrable dark, bushy thicket. Above their heads shone bright strands of clear sky, stretching like long, winding roads full of rolling clouds. In an occasional flood of moonlight the shadows of the trees crashed onto the road with a dead weight of blackness, like a row of corpses.

Zenon walked on without fear, keeping his eyes on the faint, often disappearing figure of Daisy, listening to the mournful music of the swaying trees. He was not thinking of anything in particular. The shadows, full of enigmatic flashes of light, flooded his soul with dancing, elusive visions of what was to come, and those future moments, born in some unfathomable depths, were pushing him into a dark, inexplicable fear of mystery.

They came out into an open space. A great black mansion appeared in front of them and in the moonlight Zenon could see clearly the sharp contours of ruined towers, the walls

gaping with broken windows, the old ivy which clung to the crumbling garden wall. Before he could find his bearings a shaft of blinding light burst from somewhere, probably the basement, and he heard doors bang.

Daisy disappeared and he was left alone, looking around helplessly. He was surrounded by the wall of trees bending with groans under the repeated gusts of wind like a crowd lashed by whips. The London lights glowed in the sky like a distant fire, huge but dying.

Nowhere was there a sign of human presence, or lights, or voices, only the sullen silence of decaying walls full of whistling wind. Everywhere bushes lay in wait, stretching out their grasping branches, stones and piles of rubble barred the way, and here and there glistened unseeing eyes of stale water.

He slowly walked around the house but all the doors were boarded up. In the end he returned to the wide stairs with ruined columns and balustrades, where he stopped in front of the main doors, uncertain what to do next. The wind grew stronger and stronger, howling in the ruins and even occasionally bringing down an odd piece of the wall. The trees were crashing into each other, rustling and swishing in the turbid darkness as the moon sank completely in the angry sea of rolling clouds. Then he heard the terrifying sound of faint voices coming from somewhere under the ground – where he could not say – as if from a grave, seeping through the walls or simply floating through space, raised from the very bottom of the night.

"Be fearless – do not ask – S-O-F reveals secrets." He repeated to himself the secret formula and, bravely taking in his hand a hammer he found hanging on a chain, he struck the door.

Silence . . . Only the bronze moaned, sending a long, hollow echo . . .

He struck again and said, stressing each letter:

"S-O-F."

The doors opened quietly, and the moment he came in they slammed behind him with a deafening crash.

He found himself in a high, dark hall. In the centre stood a huge copper censer full of red-hot coal emitting a heavy, intoxicating scent. Behind it loomed a colossal statue covered with purple drapery. Apart from these the hall was empty. From the smooth, naked walls of shiny stone leapt images of golden letters, mysterious symbols of fire, water and air, monsters and animals twisted in convulsions, masks screaming with horror, all barely visible through the strands of smoke and the shimmering purple of darkness.

He was looking around unable to find anybody, terrified by the dead silence which pressed on his soul like a gravestone, when suddenly the slab on which he was standing moved and began to float gently in a barely perceptible descent. He did not even stir but closed his eyes paralysed by fear and frozen by icy shivers. But he soon regained his senses when his hands felt a wall. Enveloped in total, impenetrable darkness he did not know what had happened to him or where he was, except that now he was in a low, narrow corridor. He bent down and bravely moved onward, holding on to the walls.

A chorus of low, muffled voices reached him again from afar like waves crashing against distant rocks. They moaned in the empty space with a faint quiver, coming closer and closer. He ran towards the sound, at once terrified and curious.

The corridor ended abruptly at a cold and slippery wall and the voices dissolved into silence. He was groping feverishly for a door when suddenly the floor gave way beneath him and he felt as if he were falling at incredible speed.

When he came to he found himself sitting on a stone bench. Carefully, he examined the walls around him. They were cold and smooth as if made of porphyry. The room was narrow but high, for even standing on the bench he could not reach the ceiling. One wall seemed to be colder than the others, as if made of glass, full of strange dents and hard, twisted lines, but with no sign of any doors or windows.

He collapsed in utter exhaustion, crushed by the weight of the terrible, stony silence. It seemed to him he had become a

part of that petrified silence and, as in a dream, he saw the wall in front of him begin to emerge slowly from the night, growing more and more transparent and green like water; through it he could see the faint contours of the sea-bed, fantastic grottoes, the bizarre flora and fauna of a monstrous nature, the scattered reflections of ghostly apparitions.

He was sure it was a dream and did not dare to move in case the vision vanished. He stared with heavy eyes into the depths, from the middle of which emerged a rock swathed in flames, like a fiery ejaculation, a torch blazing in the wind, its wreathing flames a nest of red serpents. In the greenish twilight of the sea-bed lay enormous boulders, trees with branches like claws swayed from side to side, everything quivered with a mysterious motion.

Yes, this cave could only be a dream. Bristling with stalac-tites hanging like monstrous icicles, its green twilight began to shimmer with a golden drizzle like swarms of luminous butterflies, from which stepped out a silent procession of heavy figures. They moved through the emerald depths as if under water, floating around the vision of blazing flames. Then came the sound of a thousand harps plucked in unison and the figures scattered, freezing on the stones like rusty toads. Soon after, another long procession emerged, clad in white, barefoot, with bare female breasts and the heads of snakes, birds and animals – the entire infernal court of the sinister Seth. They marched slowly, rhythmically, carrying on their shoulders a long, black bier. Having passed the burning rock they stopped, put the bier in front of it and spread out on each side in two rows like a pair of white wings.

Suddenly, there was a terrifying clap of thunder and a golden rod of lightning shot through the cave. Everybody fell on their faces; the rock exploded with flames that leapt high into the air like a volcano before quietly subsiding, billowing golden clouds of incense. Slowly, amidst the dead silence of becoming, rose the figure of Baphomet. He emerged from the weak, pale, trembling flames like an angry cloud from the smouldering depths until he appeared in the full splendour of his terrifying presence.

The golden half-moons of his horns shone on his narrow, hairless skull. Naked, slender and youthful, he was sitting with his knees wide open and between them, like a venomous snake, writhed a blood-red streak of lightning. The crooked claws at the end of his long arms touched the shrouded bier lying at his golden hoofs. The carbuncles of his eyes flashed with light as they swept over the heads of those lying before him in the dust of humility. His was a terrifying beauty – cold as a steel blade and poisoned with a deathly charm. There was a fierce sweetness in his tightly drawn lips and his angrily knitted eyebrows were like bows strung with vengeance and wrath. In the sinewy face and the high, proud brow there lay the hidden suffering of eternal rebellion, the unending night of unavenged wrongs and endless wanderings. His stooped and taut body seemed ready to leap at any moment, as if he appeared only to plunge back into the abyss and roam the icy deserts of silence, and run forever, without end, always . . .

Zenon beheld the vision with growing horror; he felt he was not asleep and yet he could not believe it. He was struggling for his sanity, he wanted to run away but the cold, unyielding nightmare was everywhere around him. He wanted to scream in a surge of maddening horror, but his voice died in his throat like a strangled nestling. He hurled himself on the transparent, vitreous wall, beating and kicking it, but it did not even make a sound; he only hurt his hands and knees, and fell onto the floor utterly exhausted.

After some time he raised his head; the wall was still glowing with light, and he heard a drawn out, monotonous chant of strange words, falling like heavy flowers and weaving themselves into a solemn wreath of feverish whispers:

"Lord of night and silence!"

"Be with us!" answered the echoes.

"Lord of the frightened and the oppressed!" the chant intensified with passion.

Zenon got up and put his face against the wall; the cave was almost entirely filled with darkness but for the central

figure of Baphomet, which shone brightly like a petrified streak of lightning. Drawn from the shadowy depths into this sphere of light floated the solemn, plaintive psalmody:

". . . who redeems the cursed."

"The only one."

"He who comforts the ravished."

"Immortal vengeance."

"He who is equal in power."

"Painful shadow."

"Light eternal pushed into the abyss."

"Fettered power!"

"Merciful power!"

"Holy power!"

Zenon suddenly recognised this strange litany. It had the same melody he had heard at the seance, the same words; until now he had been unable to recall where and when he had heard them.

But, as the chant continued, something stirred in the crowded and turbulent darkness. He could not make out the hazy contours. Misty, whitish shadows formed into a procession, floated around the figure, languished like trembling lights, and one of the shadows leaned over the bier. He clearly heard steps on the sharp gravel, whisperings, the hiss of flames, an invisible commotion.

Suddenly, the air was filled with a long, mournful roar.

"It's Bagh, Bagh!" he whispered, seeing the panther's silhouette leaping onto the bier. The shadowy pall fell off and a tall, naked figure rose slowly. He shuddered; he would have given his life to be able to see the face . . . All he could see was a slender, naked body, swathed in a cloak of long, rust-coloured hair, standing between Baphomet's knees.

A strong, sonorous voice rang out with a question:

"What do you want?"

"To die for Him," answered boldly another voice.

"Do you want to be wedded to Death?"

"I am wedded to vengeance and mystery."

"Do you curse A?"

"I do."

"Do you curse O?"

"I do."

"Do you curse M?"

"I do," were the clear, fearless answers.

He no longer paid any attention to the litany of terrible oaths and the pledges which turned his blood into ice, as he listened to the voice making them. He realised he had heard it before and, oblivious to the terrifying rite, he tried to remember the occasion, until in the end it dawned on him that it was Daisy, that it was she who was being sacrificed to Baphomet in this mysterious ceremony. But he was not surprised, for by now he was incapable of such a reaction.

The darkness paled and the cave gradually began to fill with light.

Daisy was sitting between Baphomet's knees in a position which mirrored his, her hands touching the panther stretched at her feet. Above her head, enveloped in the golden haze of incense, loomed the green-red, sad face of Satan, and his long arms seemed to be enfolding her in a tender embrace. That was all he could see clearly, for the rest whirled before his dazzled eyes like a dancing pageant of dimly remembered nightmares and apparitions. He did not know from where the visions came and could not tell if they were happening inside his mind.

There was the half-human, half-animal cortege of the dreaded god Seth leading a white lamb; the creature was killed with a heavy, stone knife by a man with a dog's head and then, accompanied by gruesome chants and curses, thrown to the panther.

There were the seven magic herbs sprinkled with the blood of an innocent babe, burnt and scattered to the seven corners of the world.

There was a procession of gigantic reptiles and toads dragging on ropes of hay a wooden cross, which amidst infernal giggling, spitting and swearing was torn to pieces, trampled and thrown under the golden hoofs.

There was a horde of indescribable monsters, a pack of

howling ghosts, vampires and ghouls, which appeared as if spawned by an insane brain, carrying on coffin lids a white symbolic Host which was then crushed before Baphomet's feet with terrifying screams and filthy abuse.

There was the bestiary of medieval cathedrals; the masks of all the fear and temptation hidden in the souls of saints were drawn out into the light, silent and gruesome, bearing holy books, symbols, insignia, effigies and ritual vestments which were piled onto an enormous stake; seven red flashes of lightning shot out of Baphomet's eyes, and seven thunderbolts hit the pyre, which burst into flames, whereupon all the ghosts and monsters around it threw themselves into a wild whirling dance.

A black swaying pillar of smoke engulfed Daisy's figure and filled the cave with an impenetrable darkness.

Zenon felt as if he were standing on the verge of an unknown, mysterious world and his mind's eye reached for the first time beyond the world of trivial, lazy thought and mundane facts, discovering infinite spaces, fantastic landscapes, flying over immense plateaux and bottomless ravines. He stepped back dazzled, full of the holy tranquillity of those visions and premonitions, his soul chilled by a breeze of immortal power.

"Don't be afraid! I am with you!" said Daisy's voice somewhere near him.

He felt so humble he prostrated himself at the feet of the invisible Daisy and whispered in a voice full of humility and devotion:

"I know nothing, I understand nothing, but I feel you are with me."

"Think – and you will always find me."

His soul closed to everything around him and slipped into a trance.

When he arose from the floor the cave was empty and flooded by a pale-blue light. Baphomet stood in purple flames like a burning bush, while Daisy's white body, lying at his feet, was slowly devoured by the crawling shadow of the panther which took her into its embrace. An inhuman fear

for her doubled Zenon's failing strength, he screamed with all the might of his horror and hurled himself upon the glass wall in a vain attempt to run to her rescue.

Suddenly everything vanished, the bronze door slammed with a great crash and he found himself again outside the ruin, confused and helpless as before, as if he had never entered the place.

"Where could she have disappeared to?" he thought scanning the ruins in surprise, remembering nothing of what had just happened to him. He circled the house again and having found, as before, all the entrances boarded up he stopped discouraged, uncertain of what to do.

The glow of London's lights was fading out in an overcast and pale sky awash with light as yet lifeless and grey. The stars were growing dim like dying eyes and the massive, rugged clouds were rolling low with mute petulance. The trees, rocked by the wind, were waking up from a heavy sleep, stretching their black, aching branches. The day was rising wet and numb with cold, reflected in the bluish puddles glistening everywhere around. The hard contours of the ruined house were growing larger in the daylight and the blind, empty fields were rising sluggishly from the slumber of the night. The dawn was rising amidst the receding chaos of darkness.

Zenon too began to awake from his nocturnal oblivion, chastened by the cold wind. So, without further deliberation he left the ruins and made his way back toward the station.

He walked down the alley between the rows of huge trees where night was still fluttering its dark wings, listening to the wind howling its wild wintry morning hymn and to the shrill song of a strayed peacock. A flock of crows rose in sudden flight from the trees, sending a shower of broken twigs and branches. He sat down to wait out the gathering windstorm.

And there he stayed, imprisoned by the wind and enthralled by the power of the elements, fused with them, joining in the mournful wail of the hurricane, singing the wild, desultory but powerful song without words, the hymn of blind and mighty Nature.

He forgot about returning and began wandering among the trees in the grey twilight, his mind adrift.

In the rotting grass he found a faded flower and pressed it to his burning lips. A sudden, irrepressible longing swelled his heart with such love, such insatiable desire to fuse with Nature, to be one with the night and the sky, to feel like the trees and wind. He rose and, imbued with the power of unfettered tenderness, ran around embracing trees, kneeling before bushes, stroking branches and kissing grass, pouring his heartfelt tears of happiness over those dear and holy beings, long lost and suddenly found anew.

THE SHADOW OF QUEEN BARBARA

by Lucjan Siemiński

Sadness reigned in the royal chambers of Cracow Castle. The long, snow-swept corridors whistled with wind, window panes rattled in their lead frames, piles of dry logs crackled in the fires.

In the lower chambers were gathered soldiers, guards and pages. They sat in groups, dressed after Spanish, Hungarian or German fashion. Some played dice, throwing around handfuls of coppers, others crowded around the fire and huge pitchers of hot beer, engaged in the more serious pastime of conversation.

The upper floors were wrapped in complete silence. Since the death of Queen Barbara never loud laughter, never an outward display of joy had disturbed their eerie stillness.

In a high-ceilinged room covered with black damask stood a lonely bed with curtains drawn around it. As much as the grey light of the winter day and the flickering glow of dying flames in the marble fire allowed, one could see through a chink in the curtains the face of a sick man: it was pale, with sunken cheeks and half-closed eyes; the black beard that once was carefully parted into two strands now flowed dishevelled onto his chest.

By the bed, on a low chair with a high leather back painted in gold Chinese flowers, sat a tall thin man. He sat still and thoughtful, occasionally stroking his long beard or the long curly hair which fell onto his face. Every move of his hand sent flashes from an expensive signet which bore an engraving of the river Sabbathion on a round cornelian. Apart from this precious stone the man wore no other

jewellery. At his side hung a plain curved sabre, its end protruding from under a long fur-lined coat thrown over a short blue *żupan*[1].

He was a Jewish doctor, Simon of Ginzburg. Now and again he would bend over the bed to check the pulse of the sick King Sigismund Augustus. He would watch the king's face for a long while and then, shaking his head, return to reading a big parchment scroll – a tractatus written in Arabic letters, probably by Maymonides. His face showed dissatisfaction and anxiety.

The sick king tossed and turned in his bed, from time to time stretching his hands only to let them fall limply by his sides. One could see it was a sick soul that was the source of his suffering, for apart from mournful sighs the king gave no other signs of pain. His eyes were closed all the time, but the bulging veins on his brow, his trembling lips visited occasionally by a fleeting bitter smile, led one to believe that his mind's eye beheld the vivid image of a long lost loved one.

His hands, folded as if in prayer and resting on his chest, unclasped and slipped to his sides. Suddenly, one of them felt something and Augustus opened his big black eyes, still smouldering with the old fire of a passion that neither the long illness nor tears could extinguish. A feverish blush coloured his face yellowed with prolonged sickness. He sat up in bed all by himself and drew back the curtains; the light from the window fell on a miniature portrait he was holding in his hand. It was a portrait of Queen Barbara.

The memory of his companion, who had brightened the best days of his life with a brief happiness, rent his already bleeding heart and hot tears flowed down his face. The violent emotion drained his strength. His head fell back on the pillow and a deathly paleness returned to his visage.

The doctor, watching closely all the symptoms of the king's illness, almost lost his head seeing such a display of

[1] A traditional knee-length frock worn by Polish noblemen in 15-18c.

passion. Medical science of the day did not extend very far; the physicians knew little about weaknesses of the heart, those migraines, spleens and spasms, fashionable or otherwise. The nature of our forefathers was hard and well tempered, like their armour.

Nevertheless, the doctor could not leave the king in such a state. He took out a little flask and pulled the cork; the aromatic scent of its contents brought Augustus back to his senses.

"Thank you, Simon, thank you," said the king, gratefully holding out his hand. "I see how hard you work to bring me strength and comfort in my sickness. But it's all in vain. Neither you, nor the Paduan sages who taught you can help me. Here, here," he pointed to his heart, "lies the source of all my trouble, and for this human knowledge knows no remedy. Since she . . ." here he stopped and sighed, "since she so suddenly and unexpectedly orphaned my bed . . . How did it happen? Why? The possibility of ever parting with her hadn't even crossed my mind. I did not believe that damned astrologer who had foreseen her death a year in advance and I banished him from the country as a crook. Alas, it all came true, so horribly true! The longing is destroying me, it's eating me away. Look at my hands, my legs: only skin and bones left. Look at my sunken eyes . . . Oh, my good Simon . . . I'm well beyond human help. At night when I dream, during the day when I close my eyes, always I see her, standing before me, just as she did that night when I saw her for the last time. I stretch my hands towards her, want to hold her in my arms, yet always she escapes me . . ." Here Augustus stopped, sunken in thought, and then, as if struck by a sudden notion, he spoke again: "Doctor, have you heard of the power of magic art? It seems the only hope left to me. The old man you see there sleeping by the fire, he used to entertain me in my younger days with stories of strange events to which he was a witness himself. I like listening to him even now. The other day he told me a story about some German prince who called out his beloved from the grave. Those were the days . . . But that there are people learned in the art of

magic, who can call out the dead from their graves, this I am sure of, I am strongly convinced of that."

"Sire," spoke Simon of Ginzburg seriously, with a touch of personal pride, "my science does not teach me this. We use simple natural methods when it comes to repairing health. 'Tis true there are followers of black magic, but people say the evil spirit is mixed up in it. They are children of Moloch. I used to know one Nostradamus who studied medicine with me. It's an arduous study, the profit small; he threw his Hippocrates out of the window, broke the old skeleton and took up service with an astrologer. Now he is first among the crooks."

"Nostradamus!" cried out the king with enthusiasm, having missed the doctor's last words. "He works miracles at the French court now! I've read his *Centuria* where he unveiled the whole future with his prophetic powers. Lucky Henry II! He has a great man for a friend, while I, the poor Polish king, the lord of wide lands – not a single magus or an astrologer at my court!"

"But love of your subjects will give you greater happiness, your lordship," spoke the old man by the fire. Until then it seemed he had been dozing quietly after a night spent by the king's side, but in truth he had missed not a word from the conversation. He was over sixty but his movements still had a youthful spryness. He had small bright shifty eyes, lips twisted in a permanent sneer, his big bold head was covered with a pointed hat of golden lamé. He wore a checked blue and yellow costume and a belt with little bells; in his hand he held a wooden clapper with tufts of foxes' tails attached to it. All this made up the dress of a court jester, which was indeed the noble office held by the man who so boldly interrupted the conversation. He was Mr Goose, or Goosey, as he was called after the gaggling rancorous bird. He was a contemporary of Stańczyk, with whom he had vied for the crown of first wit and with whom he had got up to all kinds of mischief, giving the whole town plenty to talk about for days afterwards. They had laughed at his jests then, but now his wit had lost its sharpness and the only reward for his jokes was his own chuckle.

"I know, my lord, where all this talking is leading to," continued the jester. "But such people are not easy to find these days. There was one, but he too disappeared without a trace. But say a word and I'm sure your courtiers will oblige, for that is how they earn their offices and add to their honours. Who knows, maybe the Queen Mother will send a clever Italian too . . ."

The last words the jester spoke under his breath with a customary sneer, shaking the bells on his jester's hat.

"You are right," said the king, "I need a man who would . . . you understand . . . who would undertake to call out from the grave the shadow of my dear wife Barbara. Five hundred pieces of gold, vouched with my royal word, and even more, for he would earn the personal gratitude of a monarch. Let them announce it to the world. Such is my will."

"Let's leave the dead in peace, I say. Your late wife sleeps the sleep of angels; do not wake her, sire. She was not happy in this world, why bring her back? It won't happen without the devil's help, anyway, and once you let him catch a hair from your head he will hold you as his own for eternity."

Despite the jester's warning, the king persisted in his wish. For his character was composed of strange elements: with all the weakness typical of the House of Yagellons, he could be stubborn as a mule. Brought up amidst the Italian luxuries and corruption of his mother's court, with the blood of the Sforzas in his veins, he liked to indulge his wildest fancies. Sigismund Augustus held out no great promise for Poland: for how could a man raised among ladies-in-waiting learn to give sound counsel or stand firm in battle? It was a miracle that the words of Captain Raczyński had not come true when the over-solicitous queen Bona recalled the eight year old prince from the Vallachian crusade: "A boy who never heard a gun-shot will never grow to have a fighting spirit."

In those days faith in magic was widespread. Royal courts had their astrologers and magicians and Augustus tried to follow the fashion of the times. He spent enormous sums on witches who slowly killed the gullible king with their herbs and potions, and who knows, perhaps that was the reason

why he left Poland without an heir from the blessed house of Yagellons.

Later that day the king was visited by dignitaries of the Crown who came to enquire after his health, among them the witty Chancellor Ocieski and Father Podlodowski, the favourite of the late queen Barbara. How surprised were these lords to see the king talking with such animation and excitement. At first they put it down to the learning and experience of Simon Ginzburg, but the latter admitted with all the modesty of a wise man such as he was, that the king refused to take any medicine from him. Only later, when Augustus led the conversation towards magic, when others joined in with stories extolling the art and its practitioners, and when finally the king announced his wish to have his late wife called out of the grave and the prize set for such an endeavour if successful, only then they realised that the sudden improvement in the royal health was nothing but a desperate attempt to cling to hope, even if it were a mere fancy.

The thought of a possible miracle had wrought great changes in the king. He thought of nothing else, night and day, dreaming strange visions fed by his feverish mind. Such was the cure for the longing that had been eating him away and it seemed to work. For as the new overriding desire took hold in his mind, so the violent eruptions of passion of earlier days lost their intensity.

It is hard to judge what the courtiers thought of the king's announcement, but to his face each supported him in his resolve; some out of profit, others out of consideration for his health, but all out of conviction that the art of magic was capable of even greater things.

The following days saw a great stir in the castle, servants running to and fro from morn to dusk. People from all over the world streamed in, as if to a bazaar in Venice or Constantinople: here a band of ragged Gypsies with their jingles and tambourines, there a travelling German juggler, an alchemist spreading out his flasks and retorts on the ground, or a cabalist muttering mysterious formulae from a big book.

The world and his wife. They all came in the hope that even if they did not achieve much, at least they would fill their stomachs with good food and drink. And they were not disappointed: the visitors were greeted with generosity and no money was spared to give them what they needed for their tricks and exhibitions; many a charlatan or a crook, having made first a lot of noise and confusion, disappeared like a ball under a thimblerig.

Soon, however, it became clear that all the effort and money were in vain. None of those vagabonds even attempted to call out the shadow of the late queen. Some admitted simply that the task was beyond their powers, others blamed the lack of appropriate herbs, or of tools which could be found only in the temple of Ammon or in the Egyptian pyramids. But let us leave the castle and the king already doubting the possibility of a miracle; let's leave the obliging courtiers and penniless crooks, and direct our gaze elsewhere.

The churches of Cracow rang their vesper-bells, beginning the long Advent evening, with many celebrations carrying on late into the night. Through the narrow unlit streets rolled the carriages of rich lords, preceded by running footmen with torches. Crowds on foot and on horseback flowed like waves from one place to another; storey-high wagons packed with merchandise from Venice and Holland rumbled along the stone-paved streets, wading through the air filled with the cries of street-vendors and the calls of the city guards. All that noise and commotion, like blood in the veins, pumped life into the great capital, a Hanseatic city blossoming under the happy reign of the Yagellons.

The worldly hubbub was dying away in the back streets of the poorer part of the town where only a few passers-by scurried along the walls. Here and there a lit window gave some light onto the street, but apart from that only the whiteness of the snow fought against the darkness of night.

In one of those streets appeared a tall man. He was wrapped in a cloak worn by the doctors of Academia. He moved slowly, hands clasped at his back, his head low. He

seemed to avoid the gaze of other passers-by, preferring the shadow of the walls.

"So I am to be the rescuer of some unknown virgin maid," he muttered to himself, stopping every few steps. "The new horoscope shows clearly a new star shining with the brightness of great riches and happiness. How am I to explain this premonition that brings me here? Would a maid with such prospects be of use to me?"

Thus talking to himself, the man was about to turn into another street when he heard a noise and saw a crowd of people with lamps and torches. Without thinking long, he stepped back and hid in the dark behind a column. The crowd was advancing in his direction, led by a priest, probably a canon of the cathedral, his face glowing in the light of the torches. Following him were people armed with pikes and pole-axes, and from the colours they wore our man recognised them as soldiers from the private army of Zebrzydowski, the bishop of Cracow.

The sight made him shudder: "Damned premonitions," he cursed, "what the devil's made me come here? What if I fall into the hands of these butchers? I've fooled them twice but this time they may send me up in smoke, to father Lucifer."

It was obvious he must have had closer contact with the servants of the Inquisition before, for he held his breath and nervously wiped beads of cold sweat from his forehead. Only when the crowd stopped a few houses away from him did he let out a sigh of relief and begin to observe the scene with interest.

Someone banged on the door, but there was no answer. The banging grew louder, accompanied by voices shouting threats and curses, the priest's voice clearly the loudest among them.

"Open up and surrender!" they demanded from the street but silence was the only answer.

"Knock down the door!"

The bishop's soldiers began to pound the heavy oak door with their axes. The crowd was pushing from all directions as

the frightened neighbours ran out onto the street. The bars and hinges broke and the soldiers ran into the house just as an upstairs window was flung open and in it appeared an old man with a lamp in his hand. It was Krupka Przecławski, a well known Cracow merchant, accused of open faith in Luther's heresy. Seeing him the crowd fell silent.

"Who's given you the right to disturb the peace of a free citizen in his own house?! If I am guilty of anything I will go before the court and shall be cleared. You people . . ." He wanted to continue but cries – "On the stake with the heretic! Stone him! Burn the apostate!" – drowned his voice. The curses thrown at him like a shower of stones forced him to retreat from the window. The stranger in the black cloak, as frightened as he was curious, moved closer, the better to see how the whole affair would end.

Ten minutes had passed when the crowd, seeing the old man with a young girl at his side being led out of the house by the servant of the Inquisition, burst forth with new cries of wild joy. People, carried away with fanatic hatred, threw themselves at the pair, tearing off their clothes, spitting and cursing. The soldiers tried in vain to stave off the attack with their long pikes. The old man took the raining blows calmly, without a moan; the swooning girl was pushed around from one pair of hands to another. The mob, like a fluid mass, flowed down the narrow street lit up by burning books and papers thrown out of Krupka's house.

"Stop!" A commanding voice rose above the tumult and halted the procession. "Stop, you wreckers, you thoughtless hot-heads! Eh, lads! Clear out this rabble, and these holy knights of the faith!"

"It's Zborowski's men!" shouted someone from the crowd, and at once a fierce battle broke out between the men of Castelan Marcin Zborowski and the bishop's servants defending the prey in their hands. For a long while the fighting parties rolled to and fro like a rough sea, spilling from one street into another and filling the air with the deafening crash of sabres and the booming echo of gunshots; a sad example of how the rich lords, under cover of defending freedom of

opinion or the laws of the Republic, exacted justice for their own interest.

And then, it was as if someone had swept the streets: a hollow silence settled where only half an hour before the madness of fanaticism had unleashed a small civil war and smeared itself with brotherly blood. In the dark corner of an empty side street our stranger attended to a girl lying senseless on the ground. Holding her head, he was rubbing her face with snow. He took out a little flask and let a few drops of some potion into her mouth. The girl sighed and opened her eyes. The potion worked: the girl got up and sat on a broken-off piece of wall.

"What a nightmare! We must get out of here! Is it you, Mr Przecławski, sir? They want to kill you. We must run away!"

"Calm down, my child," said the stranger. "I am not Mr Przecławski but a good friend who wants to help you. We have no time to lose. Gather your strength, if you have any left, and let us leave this dangerous place." Having said that, the stranger took off his cloak: "Put this on, my child. It's very cold, and besides, you mustn't be recognised."

The frightened girl decided to put her trust in the man whom fate had sent to her rescue. She wrapped herself in his cloak from head to toe and followed him as quickly as she possibly could in her fright and weariness. The most difficult thing was to leave the town where the strange looking pair drew the attention of curious eyes. But once they had passed the gates they slowed down and headed for the darkness lying outside the walls.

The girl was still in a state of shock. It seemed to her that the bloodthirsty mob was still pursuing her; the slightest rustle echoed in her ears with their wild murderous cries. She could not gather the thoughts which ran wildly through her mind, and only fear kept pushing and prodding her on in the footsteps of her guide.

From time to time the stranger would turn to the girl, giving her short directions or bidding her to hurry up. Otherwise he walked deep in thought, pondering the miraculous

coincidence that had brought the events of this and the other world together: was the prophecy he had divined from the letters written by the finger of the Almighty about to be fulfilled . . . ? Now he was in the possession of that virgin maid for whom Fate prescribed such a great future. One day he – her rescuer – would be the recipient of her gratitude.

Thus he explained to himself the dark premonition and the miraculous coincidence that had led him to the girl. Dreams and visions flooded his thoughts, and he would not have woken up from that dreamy state for a long while if it had not been for a group of people approaching from the river, laughing and talking loudly. He wanted to get out of their way but it was too late; a group of drunken fishermen was already coming towards them. He quickened his pace to avoid being accosted but some of the men greeted him with noisy friendliness:

"Hey, brother, come with us for a drop of mead. Let's celebrate as befits this holy day. We're a good company and all are merry!"

The stranger was of no mind to celebrate anything with the fishermen. He pushed them away, cursed them and gave them what must have been a very peculiar look, for despite their heads steaming with drink, those who came up and took him under his arms stepped back terrified and let him through.

"Holy spirit!" mumbled one of them crossing himself. "Methought I'd go straight to hell, so hard he shoved me. And that look! I swear all the mead's gone out of me head."

"Look at him, brothers, scooting on a broom with his witch-wife Baba Yaga. They say he's taken service with the devil. He was gone for a few years but he always crops up where you haven't sowed him. 'Tis a bad omen, brothers, when evil crosses your path."

"Nothing a good drink wouldn't cure!" shouted someone. "Let's go to The Cockerel and drink the devil dry!"

"The devil himself sent these drunks to try me," muttered the stranger to himself. "Hurry up, my child. It's not far now. You will be safe here, among these rocks."

Hard to say how the girl took these words, for she followed him in silence, like a ghost. The gloomy barrenness of Krzemionki Rocks made no impression on her now. The folk tales spoke of air-borne castles where the devil held his all-night capers and where many a traveller lost his mind or broke his neck, pushed off a rock.

And thus they walked on, their figures visible for a long while, winding their way, now up, now down the hill, till they disappeared among the twisting ravines.

Daylight, seeping through a hole in the cave's roof, brought out from the shadows a spacious room. Its smooth chiselled walls were covered with reliefs of the signs of the Zodiac, sphinxes and mummies, placed in specially carved niches. On the stone tables stood retorts and glassy spheres filled with precious liquids used for the production of gold; heaps of blackened scrolls rose to the ceiling. In a corner, resting on an oak reading desk and chained to the wall, lay the *Liber Magnus*, the essence of the art of magic, the scourge of infernal powers. Completing the picture were several huge telescopes, a pile of astrological tools and a polished metal mirror of intricate workmanship draped in a half-transparent veil.

This Pandemonium made a strange impression on the girl's mind. Still frightened, she huddled in a corner, although now, instead of the torn rags, she wore a very becoming fur-lined tunic made of gold-threaded cloth, and her face, not so long ago pale with fear and purple with cold, was now gently flushed with colour. The young maid certainly appreciated the change in her fate yet she could not help but return to the disturbing memories that still floated through her mind like wisps of mist. She was afraid to make a step or say a word to her benefactor who sat before her in a big chair, watching her with interest.

He was a man of mature age, his long thick beard streaked with strands of silver hair. His lively, deep-seated eyes, smouldering with the fire of passion, glimmered with keen intelligence; there were few who could withstand his gaze. Time, or the habit of prolonged meditation, had furrowed his high

brow with deep parallel lines which on occasions would meet in a triangle. A thick moustache covered his mouth, as if meant to hide the quick wicked smile that betrayed his true feelings. He was cloaked in a long black robe bordered with hieroglyphs, on his breast hung a huge amulet and on his head he wore a doctor's biretta. In his sinewy hands he held a scroll of parchment covered with strange writing from which now and again he would raise his eyes to examine with pleasure the face of the young maid.

"Come closer, Barbara. I knew a lady of that name once. Her star shone bright, but it died all too soon. Your face bears a strong resemblance to hers, to those divine features that conquered the heart of a great king. This waist, these eyes, this bosom, so young and unripe yet, one day shall equal that famous beauty. Even so, the Heavens have pro-cured a great destiny for you. I saw it in the stars: they augur well. Here is your horoscope," he was saying, pointing at the scroll. "A favourite of one of the mighty kings of the earth, untold riches will be lavished upon you, your life will pass in luxury and you shall know happiness in all its splendour. You, whom I have rescued from the clutches of death – you shall owe it all to me."

The prophetic fire burnt in the astrologer's eyes, his face flushed with colour. He took the girl by the hand, led her to the mirror and took off the veil. "Look," he said, "have I told you the truth?"

Curiosity was stronger than fear and shyness: the girl raised her eyes and looked into the polished surface of the mirror; the astrologer was watching her from the side. At first she observed the unfolding chain of events with calm concentration, then she smiled and gave out a cry of delight; in the end she was transported into a state of rapture. In the mirror she saw another being, just like herself, her life blended with the features of the spectre, her soul entered its eyes. Still as a statue, one would think she would have watched the spectacle for hours if it had not been for the veil which the astrologer suddenly lowered onto the mirror; at once the vision of the future scattered away.

The maid covered her eyes with both hands, as if wanting to save the remains of the shattered images. The astrologer, carried away by his prophetic powers, compared her to women who with beauty and intrigues ruled the courts of weak monarchs; and not without reason. A plan was hatching in his mind: her beauty could be a useful tool in bettering his prospects, for the character of the wise man was tainted by greed; he would gladly exchange the gold that he produced in his crucibles for the king's silver. A fugitive from the courts of Inquisition, banished from the royal court for dark machinations, he now sighed for the lost respect and the good life others like him enjoyed.

Suddenly, someone knocked on the door, and knocked again three times. The astrologer pricked up his ears. "We have a visitor, it seems. You must not be seen, my child. Leave the room, be quick." He pushed open a hidden door in the wall and the girl disappeared. Then he hurried to greet the unexpected guest.

"Greetings, Mr Twardowski," called out Goosey from the door.

"Welcome, welcome, old friend," the magician greeted him, and embraced his guest.

"I nearly lost my way, wandering from rock to rock, but it's been a long time since I last visited you in this cave of yours. Ever since the queen's death we've been on the road, first wandering round Lithuania, then visiting one *seym*[2] after another, and now my good master has been taken gravely ill. I've been at his bedside for a month now. I found it hard to leave him, good servant as I am, and so I couldn't visit you."

"But tell me, Mr Goosey, what's the news at court? Any changes? Does the king still bear his old grudge against me? Does he still think I was in collusion with the Queen Mother? Does he know I'm still here, against his orders, safe behind the rumours that the devil dragged me to hell?"

"The king knows everything."

[2] A Polish diet, in 15–18c. Poland held at all levels from provincial dietines to the national General Seym.

"He does? And who told him?"

"I did."

Twardowski boiled with rage: "You've betrayed me, you old wind-bag!"

"Calm down, old friend, calm down, and wait till I'm finished. The king knows everything and knows it from me. Since entering the unhappy state of widowhood, he has set his mind on the idea – crazy or not I cannot judge – to see the shadow of his late wife. He invited magicians, crooks and tricksters from all over the world but not one of them even tried, although the reward of five hundred pieces of gold should have been temptation enough . . ."

"Five hundred pieces, you say?" exclaimed Twardowski. "And no one even tried?"

"Not one. Augustus lost all hope and slipped back into illness and despair again. I felt pity for my master . . . Then I remembered you, my good sir, and gave the king to understand that there was but one man who could help him, if only one knew where to find him . . . 'Who? Twardowski?' asked the king. 'Himself,' I said. 'Right you are, but where to find him? I would forgive him everything.' 'Give me your word, Sire.' 'Here it is,' said the king giving me his hand, 'but remember, Goosey, do not jest with me.' And so I told the king your story and hadn't even finished telling it when he told me to go to Krzemionki and fetch you."

Twardowski was pacing the room, his pace now slow now quick, following his thoughts. Suddenly, he stopped before the jester, as if struck by a happy thought, which instantly flashed in his eyes.

"I shall go with you, Mr Goosey," he said shaking the latter's hand, "and bring consolation to the palace of kings. Five hundred gold pieces – a great reward, but it's not the profit that tempts me. The fame of a wise man, and the health of the Crown – that is all I desire."

In vain did the courtiers rack their brains to guess the reason behind the preparations being carried out in the castle; no one knew about Twardowski and his secret meetings with the king. Masons and carpenters worked day and

night in the lower chamber, which during the reign of king Sigismund, the father, had served as an armoury. Everything was carried out in the greatest secrecy. The king took a handful of courtiers into his confidence and those were sworn to silence. He and Twardowski held meetings late into the night, of which the only witness was old Goosey. The lords of the Crown loudly complained that the king put his trust in people who should not be trusted, that he hazarded his health, so dear to the nation, that he emptied the coffers with reckless spending to the detriment of his own, as well as his subjects' welfare. Such complaints could be heard then and long afterwards, but Augustus' fondness for things supernatural, for magic and sorcery of all kinds, stayed with him to the last hour of his life.

It was past eleven at night. The castle had already been asleep for some time, as was the custom of our forefathers. In the royal chamber, however, a silver lamp was still lit, burning the purest oil. King Augustus sat in a big chair, wrapped in a black velvet coat lined with sable fur, his feet resting on a footstool; next to him stood Goosey whispering something into the royal ear. The king paid little attention to him; his face, the signs of illness already fading away, showed impatience and apprehension.

"Well, Janusz," he called to the footman who had just entered the room, "do I have to wait long?"

"He will be here in a few minutes, Your Highness," answered the servant and took his place by the door.

Those few minutes seemed an eternity to the king.

"Tell me a story, I am bored," he said to Goosey and then rebuked the jester for telling him old jokes, and for neglecting his duties. He ordered the two footmen standing by the door to help him up and take him for a stroll around the room. But soon he berated them for clumsiness and returned to his chair. His impatience reached boiling point; he was just about to send curses on the astrologer's head when the door opened and in came Twardowski. Augustus looked at him and lowered his head guiltily without saying a word. There was an air of gravity and triumph

about the magician. He walked up to the king and whispered:

"The hour of ghosts is upon us, your majesty. Are you ready for it?"

"I am ready for everything, even if I'm to see Hell and all its devils," exclaimed the king eagerly.

"But, remember our agreement, Sire. Otherwise you will bring damnation on your head and ours. Ghosts may be vindictive."

"Oh, I shall fulfil any conditions! I know the pains I'm going to suffer. I shall keep my passion in check. I can be still as a stone – but pray, do not torment me any longer. Lead on, this uncertainty is killing all my courage."

The magician gave the king another hard look to give weight to his demand.

Two strapping footmen hurried to the king and helped him to his feet. Goosey went first, followed by two other servants with lamps. The procession wound its way down the secret passage, through vaulted corridors and galleries, to the lower chamber where everything was prepared and where Twardowski was already awaiting the king's arrival.

"Oh, my heart, how it's pounding," the king muttered to himself as he sat in a chair. "He has me scared now, damn him. Hold my hands, I may forget myself when the time comes, lose my strength and presence of mind, and who knows, maybe even my soul."

Twardowski drew a circle on the ground with a long staff, muttered some magic formulae and ordered the last lamp that was giving faint light in the huge room to be taken away. It was dark as in a grave. The king was silent, trembling with anticipation. By his side stood the two footmen holding his hands and the old jester; the rest were sent away. At first they heard a distant murmur, like the surging of spring rivers, then a howling wind, so strong it seemed to be pushing the old Wawel castle off its granite bedrock. The magician's voice rose and fell, some inhuman force tugged at the chains and clasps of the great book as he turned its pages covered with fiery characters. Then the gale abated. The castle clock began

to chime the midnight hour. Augustus felt weak. He squeezed the hand of one of the lackeys and cried out: "Help me!"

The astrologer pronounced his terrifying formulae again in a great voice. The huge doors burst from their hinges and a great gust of wind brought into the middle of the room a woman's figure, clad in white and luminous, as if bathed in Bengal light. It was the late queen. She looked just as she had that last evening: lilies at her side, hands crossed on her breasts, a smile from beyond this world and eyes closed.

For a brief moment Augustus lost his senses, but he came around before his courtiers hurried with smelling salts. He saw the ghost; his face turned white as a sheet, veins bulged on his brow, his eyes burnt with unearthly fire. He jumped to his feet, stretched out his hands and threw himself forward, falling, ready to press the ghost to his heart, to pour his own soul into it: "Barbara! My dear wife!"

The servants who, frightened by the vision, had forgotten their duties, managed to catch him just in time, one by the coat, the other by the hand. The spectre disappeared; only the voice of angry Twardowski echoed between the walls.

"Light! Bring in the light! The king's passed out. Call in the doctor. Quick! Help!"

Soon a crowd of woken courtiers poured into the room with lamps and torches, the whole castle was up on their feet. Strange rumours were being passed from mouth to mouth; Augustus was carried senseless in his chair back to his bedroom where Simon of Ginzburg waited by his bedside.

Every night, till the end of his life – or as the folk tales have it, until the devil, on the strength of the *verbum nobile* given to the seven year contract, laid his hands on him in the inn called Rome and dragged him to Hell – Twardowski visited the king in his royal chambers where both discussed weighty and mysterious matters. He foretold the king's death at the age of seventy two, and so the young monarch thought it safe to enjoy life while he could, putting off his penance for the sins of youth till later. But after years of indulging in

all the worldly pleasures his vital powers were soon diminished and he joined his forefathers twenty years earlier than predicted, that is in 1572, at the age of fifty two.

The virgin maid rescued by Twardowski from the mob's frenzy, spent the following years hidden in the cave on Krzemionki, and to her master's surprise made great progress in the art of magic. In one respect, his prediction came true: used by the king in alleviating his various weaknesses, which she cured with herbs and magic, showered with gold and precious stones, she ruled the court, as well as the king's heart for a long time, and like an evil spirit stayed with him at the hour of his death. She was well known from our secret history, the king's favourite, Barbara Giżanka.

THE HEAD FULL OF SCREAMING HAIR

by Jan Barszczewski

I ran into Doctor M., our district physician, in Witebsk where we both happened to be on business. After a chat about this and that the doctor said:

"And where are you going to dine?"

"Wherever the good Lord will serve me," I said. "With money one can easily find dinner in a town."

"Let's go to the Karlissons', his food is always first rate."

"But won't it be too dear for a nobleman?"

"No dearer than anywhere else, and even if it is it'll be tastier. No need to stint oneself."

I agreed. And so we entered a huge room where we found a small group of guests. They were eating, drinking, smoking pipes, laughing at each other, imitating and mocking all the vices and eccentricities of the people they knew, jeering at everybody, sparing neither women nor the old.

Seated at a table I observed those jesters with surprise as, roaring with laughter, they showed off their wits, all the while examining themselves from top to toe in the mirror. "It's good sometimes to visit a tavern," said the doctor. "People are quicker to take off their masks here and one can get a good look at who they really are."

He had scarcely finished saying these words when a man entered the room. He was tall, with bristling, thick hair, restless eyes and a round but pale face, as if it contained only bile and water. All turned their eyes on him while he sat on the sofa and, holding his head, moaned: "Oh, they give me no peace." He asked for a glass of rum, drank half of it and, as if sunken in thought, sat in silence for a few minutes; then he

got up and looked at himself in the mirror, put a hand on his head and said: "Oh, now at last they are still and have gone quiet for a while." While everybody looked at him in astonishment my companion said:

"You're sick, it seems to me, you must have a headache. I don't think the rum is going to help, more likely it'll do you harm."

"No one asked your advice."

"I'm a doctor, it's my duty."

"You may be a doctor but you haven't guessed the nature of my suffering. You'd better tell me what's the easiest way to die, as I've no hope of getting better and I'm sure to die soon."

"My science aims to prolong human life and doesn't advise on death, for death will meet us anyway."

"Death will meet us, true, who doesn't know that?"

"Yes, that truth is known to all, but not everybody likes to think about it."

"Sure, when life is kind. But anyone who suffers as I do, will have no regret in leaving the world."

"So, pray, what is the nature of your suffering?"

"Hair! Hair has poisoned my life!"

As he said that, the circle of merry guests at the other side burst out laughing and one could hear their voices saying:

"Eh, and wasn't it a lovely tress?"

"Shouldn't have cut it off, should you? There's a good reason here, they say, that in doing that you cut the bond of mutual feeling."

"But it did bother him though, the hair, so he cut it off and it came back to life in the moonlight."

"Had no respect, and it was lovely singing hair."

"Look, look – even in the sunshine it moves as if it's alive."

Hearing these jests the suffering man looked at them in anger, jumped up from his chair and started pacing the room silently.

Then the company of men left, and on leaving one of them said:

"Good health, dear Henry, drink some more rum and all will be well."

"That's what I've come to," said Henry turning to the doctor. "I've become a laughing stock for callous people who take delight in making fun of someone else's misery. Everywhere, wherever I meet them, they try to increase my torment by mocking the awful events in my past."

"Your nerves are too sensitive if you take offence from such people," the doctor said. "Sitting here I was able to observe what they were like, and with no shame they heaped stinging and unkind words on everybody they knew in town."

"I was a different man once, indifferent to laughter and mockery alike, nothing offended my sensibilities. It's the hair, it has ruined my whole life!"

Presently he fell silent as if listening to something, and suddenly pointing to his hair, "Here," he said, "one has just sung and the others are moving, soon they'll be crying out all together. You cannot see what is happening on my head!" And having said that he turned back to his glass and quickly finished off the rum.

"Listen to my words," said the doctor. "Ask for some water and sugar and mix them together, at least that will do less harm. My advice is to relinquish your present treatment altogether."

The man took his glass and stood in front of the mirror touching his hair. Then he turned to the doctor and, measuring him up with an anxious eye, he said:

"I'll give it up if you find a better one for me. However I shall not disregard the first part of your advice." And having said that he asked to be served water . . . and drank a glass of punch.

"Tell me the story of your life. If I know how your suffering began it may be that I can find a way to help you."

"Can you find a way to bring back the past?"

"The past teaches us how to use the present."

"My illness is new, neither simple people with their instinct nor the medics with their science have yet discovered

the herb that can cure it. But I see in you a sincere desire to help me in my misery and so I shall tell you the more important incidents that have befallen me in my life:

I was my parents' only child. In childhood I did not know what it meant to be refused anything. Servants attended to my every whim and a home tutor taught me the basics of French in a most gentle way, so as to avoid unpleasant thoughts and stimulate happy ones, a state of mind which our worldly society holds in higher esteem than a thorough learning in the sciences.

When I was fifteen my father sent me to Riga for a year so that I could improve my acquaintance with the French and German tongues from the best teachers, and acquire a proper taste in all the things which find approval in the eyes of the luminaries reigning in the salons.

He gave me more money than my needs warranted and I encountered none but the flower of youth as I led a merry life. Nobody told me then that time passes without returning, that man's health is weak and succumbs to sorrowful changes, and that the joy of happy years is but a dream.

Following my return home I spent my time hunting from dawn to dusk. My father spared no expense in the upkeep of rifles, greyhounds and dogs, and I was allowed to make use of them for as long as I wanted; I had beautiful horses and would buy fashionable carriages.

After a few years my fellow citizens elected me to office in the district. In town I found many friends, my house resounded with fun and parties during which my guests often greeted the dawn, drinking wine and playing cards.

Thus four years went by; then my parents passed away. I returned home resolved to take care of the estate and found it weighed down by debt. My father's creditors were arriving from everywhere demanding their money with threats and the courts were asking for unpaid taxes. I realised the danger and for the first time turned my attention to the future.

"You have to marry," said my neighbour, "Miss Amelia,

daughter of the commissioner who administers the estates of G., a beautiful girl, well brought up and, from what I hear, with a dowry in excess of ten thousand silver roubles. Her father put away a handy little fortune as a commissioner and an administrator, and it is a matter of little concern that he is not connected with the local gentry who elect themselves as they please to the district offices. In your circumstances money is needed, not family connections, which, in my opinion, are of no consequence anyway." I saw that my neighbour's advice was truth itself, agreed to the choice and asked him for help in urging my suit. Ten thousand silver roubles, or even less, would be enough to relieve the estate of the burden of debt and moreover, the many virtues of the commissioner's daughter were well known in the district. And so, to bring these arguments to the right conclusion we both went to pay her parents a visit.

Seeing Amelia for the first time I noted the full extent of her beauty – her lovely figure might serve as the model for a most beautiful painting, her face radiated mildness of temper, her blue eyes reflected quiet melancholy and a pleasant dreaminess. Conversing with her about the future and the changeable fortunes of this world I learnt that through the influence of upbringing and inborn humility she believed in intuition and the unfathomable mysteries of nature. My neighbour candidly informed her mother and father of the needs of my estate, and both Amelia and her parents agreed to the match. After the wedding I was the happiest of men; I brought my wife into my house and paid off all my debts.

"Ah, why didn't I believe in intuition? Doctor, will you agree that in an angel's quiet voice a sensitive human soul can hear a warning far better than the wisdom acquired through experience and science?"

"One can see it often enough," said the doctor, "but not everybody possesses such an instinct."

"Why did I refuse to believe Amelia's loving heart?"

"On what account? And with what consequence?"

★

For three years we were both happy, and even though on occasions our thoughts and ideas crossed in conversation we always managed to make peace, as Amelia, in answer to my stubbornness, would quickly choose another subject to avoid a quarrel.

One fine spring evening we went out for a stroll to the nearby woods which were full of singing birds. Amelia, walking along the path, would often grow silent.

"I observe," I said, "that something must be whispering in your ear, for you don't answer me and you drift away with your melancholy thoughts."

"Indeed, some kind of longing comes upon me, I don't know why."

"Is it the songs of the cuckoos and nightingales that affect you so?"

"It may be," she answered in a quiet voice.

As we were talking I saw a hunched old man dressed in black coming down a little path which crossed the wood from the left. He had a pale face, clear bright eyes under his bushy eyebrows, and on his back hung a basket covered with a black russet cloak. I was curious to know who this strange man was and from where he was travelling. When we met I asked him:

"Who are you and where are you coming from, little father?"

He took off his old, crumpled hat and bowing low he said:

"I live in the wide world, looking for kind benefactors, warring against the prejudice and human folly of dreams." This answer stirred in me a need to pursue the conversation further.

"And for what reasons," I said, "have you waged this war against prejudice and human dreams?"

"For the reason that people failed to understand me and their own advantage. I have travelled around the world, learnt all about human needs and studied the most secret mysteries of nature. I wanted to bring solace and relief to the inhabitants of this poor and barren land, but instead of a reward they threw curses at me, denying me a peaceful refuge."

"What did you do," I asked, "for the inhabitants of this land?"

"I wanted to do good but was twice repaid with persecution. I cannot forget it though more than twenty years have passed since. I discovered a method of producing gold and wanted to improve and share it with the local citizens. Lord X, a rich man, had an estate near Polock and a house in town where he lived, and where he also gave me a small room to pursue my work. But, a terrible accident happened there. I once left the door to my room open and on the table, wrapped in a piece of paper, was a special white powder used in many applications of this science. Lord X's wife came into the room and took some of the powder thinking it to be a medicine for headaches. She asked for a glass of water, poured in the powder, drank it and soon died. Persecuted by the courts I, an innocent man, had to flee and find myself a refuge elsewhere. I turned to Lord Y, offering to disclose to him my wonderful secret. We arranged for a test at midnight at the cemetery but this gentleman and his servant whose assistance was needed, lacked the strength to withstand the test of the great work and fainted. Fearing to be persecuted anew I left them there, lying in the cemetery, and escaped. I never returned to those parts and made a resolution never to disclose my secret to the world again."

"And what do you have concealed in the basket?"

"I carry rabbits with me," he answered. "If a kind master will let me have a simple house somewhere for my lodgings I'll start breeding them; they breed fast and in no time I shall have good sustenance in my poor state."

"Lift the cloak and show me your rabbits." Scarcely had he done so when Amelia backed off and cried out with fear:

"Ah! Ah! what horrible bats! Cover them, cover them quickly, I can't bear to look at these monsters."

I looked at her in astonishment for, truly, all I could see were young black rabbits. The old man gave her a quick, sharp glance and said:

"Look closer, my lady, these are young black rabbits. They

haven't grown up properly yet." And holding one of them by the ears he took it out of the basket.

"Ah! Ah! what a horrible bat! Have mercy on me, please don't show it, put it back in the basket. I don't want to, I can't look at such a monstrosity."

Thinking that in this exaggerated fear there was only Amelia's fancy and stubbornness, I invited the old man to spend the night at the Grange and promised him that next day I should give him his own lodgings. He bowed and made his way towards the manor. We walked home in silence. Amelia looked unusually worried; she was pale and had tears in her eyes. I was looking at her in surprise, searching my mind for possible reasons why she should be denying such an obvious truth – for with my own eyes I had seen only young rabbits. In the end I broke the silence and said:

"Well, Amelia? Do you still insist that the old man had bats in his basket? It's a strange caprice to mock an old man and accuse him of lying."

"I didn't mean to mock him," she said, "but I trust my own eyes."

"I am sorry that you offended the poor man. You could see yourself from his conversation he is a naturally intelligent man, and a scholar. It's a shame he should be so unhappy."

"His gaze and that terrible face . . . Why did we have to stop him? We should have let him go . . ."

"Your strange mood today surprises me. I mean to keep him here for much longer. I intend to give the poor soul a refuge and let him stay on the estate for as long as he wants."

Amelia said not a word. The quarrel was over and we returned home in silence.

Not far from the manor house, near the river, stood a lone house surrounded by fir-trees. In my father's day it was occupied by a serf and his family, but later I moved them to a nearby village, incorporating into the estate the land they had worked. The following day I rose early and took the old man to this house where he might have a quiet refuge in his last years. He thanked me and once inside let his rabbits out of the basket. He lived alone. Sometimes he wandered about the

fields and shady woods, not sleeping at night, often appearing in different places in his black cloak like a terrible spectre. Seeing him in the moonlight the villagers were afraid to approach and would run away from him as if from a ghost. Strange stories began to circulate about him in the neighbourhood. People were telling each other that at midnight they saw a flock of bats above his roof, and that owls and ravens were at his beck and call.

I laughed hearing these tales told by simple people. I often visited the old man's lonely retreat and liked to talk with him, sometimes for hours. In the autumn I would listen to the rustling of the old firs, looking at his face on which the smile had died for ever. Outside the window, on a sandy hill swarmed a mass of black rabbits, hopping in and out of their holes. Seeing all these things I felt myself change and my soul sink into melancholy brooding.

Amelia refused to see him and did not like to hear anybody mention him. I, on the contrary, spoke to him with pleasure, and after a few months I was under his spell so completely that I would believe anything he said.

One day at the end of September, just before sunset, I walked into the old man's house. The autumnal wind howled outside the walls while he sat, resting his head on his hand, watching his rabbits running all about the house. When he saw me he got up and said:

"It's curious, all this time I've been living on your lordship's estate I've got to know all the surrounding woods and have seen in them all kinds of trees, but scarcely any oaks. Only a couple of versts away did I find two trees of this kind, which were about a hundred years old, with a few young ones around them which must have grown from acorns sown by the wind."

"I haven't paid any attention to it," I said. "There are plenty of other trees which do just as well for the needs of the estate."

"Birch and elm are good to use, that's true, but is there a more magnificent sight than an oak grove? Those trees will grow for centuries – my advice to your lordship is to dig

them up now, in the autumn, and plant them all on the hill I saw in the garden by the pond, where no tree has grown yet."

"It will be many years before they grow and I am sure not to live to see them tall and magnificent on that hill, for human life is too short."

He gave me a stern look which sent shivers down my back and as if taunting me, he repeated my words:

"Human life is short indeed. But why worry about it? Your lordship is still young, you have a strong constitution and will live to be a hundred. You will yet enjoy the shade of those oak trees with your friends. Throw away all those sad thoughts, Sir, you are the master and all should serve your interest."

I took his advice. The next day I ordered the gardener to go and ask the old man to show him the young oak trees and then take them to the park and plant them on the hill. The gardener hearing my order became frightened; his face went white and he said in a changed voice:

"Sir, why this strange idea? Oak trees do not blossom, they bear no fruit and no one gets any use out of them. Linden trees are best to decorate a park with. Surely it would be better to plant those on the hill."

"I don't need your advice," I said. "Do as you are told and do it quick."

"I have heard from old people that whoever sows or plants oak trees won't live to see out the year."

"And if I hear you repeat such nonsense ever again I promise you that you will earn five hundred lashes. Go, do as you are told."

The gardener, afraid to talk to me further, left in a state of anxiety and started looking for a chance to ask my wife if she could persuade me to give up my design. In the evening, when I left home for a short while, he came into Amelia's room and with tears in his eyes threw himself at her feet and told her the whole story.

When I returned in good humour she met me with these words:

"Why, Henry, this strange idea to plant oak trees in the garden? I can see neither need nor beauty in it. The poor gardener came to me very worried saying that it is the greatest misfortune to replant this tree, for it takes the strength away from those who look after it and so cuts their lives short. I know that superstitions grow from ignorance, but what right do we have to treat people cruelly just because they lack education? One has to find a gentler way to make them abandon their foolish superstitions. After all they are our brothers, and it's a grave sin to treat them unjustly."

"It seems to me," I said looking at her with anger, "you yourself are like this gardener. It's you who are trying to protect foolishness, but your protection is to no avail."

"Probably that cruel old man gave you the advice. Tell him to take the gardener's place and do it all himself. He does nothing but wander around the fields and woods all day."

"The men are mine, this is how I want it and so it will be."

When I said this tears poured from Amelia's eyes and she quickly went out to the other room.

The gardener, seeing that all his hopes were ruined, brought the young oak trees from the forest and planted them on the hill as I had instructed. Soon after he became melancholy. In vain others told him that oak trees had no influence on human life. He began to wither, his strength was fading and the following spring, just as the trees were sprouting their new leaves, he ended his sad life. After the gardener's death, when I told the old man about the superstitions of that simple soul and the weakness of his character, he looked at me, knit his brow as a sign of his contempt and said:

"So much the better, you have nothing to regret. You have many stupid people and have lost only one of them."

Soon, the old man's trickery put even greater strain on the harmony between me and Amelia. I intended to build a new wooden house and when I realised I was short of bricks for the foundation I went out in search of a good brickfield.

Wandering about the fields I met the old man who said, pointing at the cemetery and the old chapel standing near the manor:

"What an ill-fitting place for a cemetery! All you can see from your window are wooden crosses and a chapel, what an unpleasant view! You are visited by many young friends and these crosses, always getting in the way, might make anybody gloomy and melancholy. I would advise your lordship to allot another place for the village cemetery, somewhere out of sight, behind the forest. The bricks from the chapel can be used for the foundations of the house and the place turned into an oatfield to cover any signs of human bones rotting in the ground."

I praised the old man's cultured taste, his scientific knowledge of human character and the secrets of nature. I sent for my men to raze the wooden crosses, gather the gravestones into a pile and, having pulled down the chapel, to carry the bricks to a site on the estate.

My serfs who gathered from all the surrounding villages pleaded with me vainly not to disturb those holy memories and the place where the remains of their parents and relatives lay. Equally vain were the vicar's attempts to prove to me that I was taking – *nomen omen* – a "grave sin" on my conscience; in vain did my neighbours accuse me to my face of betraying the customs of my ancestors. In the end Amelia, seeing that all the pleading and persuasion were falling on deaf ears, spoke to me greatly worried:

"Henry, this chapel and cemetery were in the same place during your father's and grandfather's lifetime. These crosses and graves never inspired terrible thoughts in them. They would often kneel there at sunrise or sunset to pray earnestly for their kinsfolk. It is a custom everywhere in these parts to build cemeteries in the open and near roads, so that people passing by may say a prayer for the dead. I'm sure it is that cruel man who gave you such a wicked thought, but remember that one day God will judge our deeds."

"It's none of your business," I answered angrily. "I know what I'm doing. The old man whom you call cruel, is

laughing at this nonsense. You care too much about those who are long gone from this world."

And so I persevered in my stubbornness. In two days there was not a trace left of the cemetery, its bricks had been used for the foundations, and after a few months we all moved in to a new house. It was then that I began to notice in Amelia even greater changes. Her eyes and her face were constantly veiled with sorrow; she kept saying that she could see strange apparitions in the new house, that she dreamed terrible dreams and sometimes at midnight she could hear groans. Every morning and every evening she prayed, kneeling for hours, and her face changed so much that after the passage of a few weeks someone who had known her earlier might barely recognise her.

When I spoke to the old man about my wife's suffering he looked at me, nodded and said:

"How little your lordship knows about the female character. It's nothing more than stubbornness and anger that she cannot rule her husband and do as she pleases. I could tell you a secret which I have discovered, but I fear to reveal it, or people will say that I'm destroying your marital harmony."

"But, pray, tell me, for who should be more concerned than a husband?"

"I am greatly obliged to your lordship for your goodness in granting a refuge to an old man, who on this earthly journey through life has gained all kinds of experience, and who has learned to look calmly and see all the secrets of thought and action. I shall tell you the secret then, the secret which I have kept in my mind for several months and have not spoken of to anybody – your wife's hair is alive."

"I have never heard of such a strange thing. What does it mean?"

"I shall tell you, Sir, and how I came to observe it. I remember once, you had guests in the house. The day was bright and quiet, and taking advantage of the weather you all went out for a stroll. Your lordship was deep in conversation with two elderly gentlemen, while your wife walked ahead, surrounded by the younger ones. As they talked to her they

were constantly looking at her hair. When they came closer to the wood where I was hidden behind a tree I was very curious to see why they were eyeing her hair so. My keen eye sees far and I soon noticed that in the sunlight your wife's hair was moving both in her plait and all over her head. Ah, one thing you have to watch out for, Sir, for there are strange and wonderful charms in this world; the young will stare without understanding the force with which restlessness and passions flare up in their hearts."

"Is this possible?" I said surprised.

"Of course, Sir. I will tell you how to convince yourself in this matter. Not only is her hair alive, but there is also one hair in her plait which, when the sun is set and dusk covers the earth, cries all night until dawn. That is why she can sleep only for a short time and often wakes up and moans, and why she bursts out crying in the evening. My advice is this: when she is in the other room where she always says her prayers, stand close to her and keep your ears open. Or better still, listen closely in the stillness of the night, when the hair sings loudest."

I was very nervous and curious. I resolved to stay awake all night to find out the truth. In the evening, when Amelia lit a candle and went to the other room to say her prayers, I followed her. I tiptoed to the open door and, straining my ears, I heard a thin high buzzing, like a mosquito circling around her head. Then I withdrew the same way without waiting for her to finish her prayers.

I was still up after midnight, playing patience in a separate room, pretending I was trying to discover the fate of my various wishes and intentions. When it was silent and everybody was asleep I put out the candle and came into the bedroom like a ghost. Amelia lay in bed, moaning in her sleep. Moonlight was falling on the foot of the bed through the half open window, while from the bedhead came the buzz of a fly caught in a spider's web. I felt shivers running all over my body and I thought: "So that's how it is!" and for the rest of the night I could not sleep a wink.

Next morning I went to the old man and told him

everything. "So now you believe me," he said, "I was right. But this is not the end of it. We need to find a way to make this live hair less attractive to the young folk. Order your wife to cut off her plait and bring it to me at night before the first cock-crow, and I will show you truly curious things, such as your eyes have never seen."

Amelia did not know, or even suspect our collusion and cruel intentions. When she saw me she asked in a quiet voice:

"What happened, Henry, that you didn't sleep last night? You were playing cards late, all alone at the table and in the morning you were gone."

"I could not sleep the whole night and in the morning I went out for a walk, but your crying hair gave me no peace even then."

"I don't understand this riddle, it's the first I have heard of crying hair."

"Yet our guests liked your moving hair."

"Speak plainly, Henry, I'm no good at guessing."

"I'll tell you clearly then: I want you to cut your hair, it's more proper for a married woman to have her head covered."

"A strange caprice."

"Strange, perhaps, but a just one," I said. "I do not wish to see you boasting of your wonderful plait which draws everybody's eyes to it with its magic power. If you want me to have any peace of mind be so kind and have your hair cut."

"I see now," said Amelia, "it is your peace of mind that matters." She called a maid, ordered her to cut her hair and, sobbing, left the room.

Just before midnight I took Amelia's plait and went to the old man's lonely house. From the light in the window I saw he was not asleep yet. I came into the house. He was sitting at the table leaning on his hands, apparently sunken in deep thought. The rabbits stirred and emerged from the corners of the room, their eyes aglow with a ruby-like fire. The old man got up and said:

"Has your lordship done as I advised him?"

"I have done all that you told me and I have brought you my wife's hair." Having said that I pulled Amelia's plait from my pocket and put it on the table in front of him.

"Now you will see something strange," he said and took a huge wooden bowl, filled it with water and put a strand of the hair into it. He stood still for some time looking keenly into the bowl. The light on the table was burning low, as if dying out, while the moon came out from behind the black clouds and shone its pale light through the window. Soon the wind rose and the sigh of the surrounding firs broke the stony silence. I looked at the old man. It seemed that his lips, white like a dead man's, were moving, as if whispering something; fear came upon me and shivers ran down my spine. In the end he told me: "Come closer and see what is happening."

I looked into the bowl and beheld strange things. Living hair, writhing and darting in all directions, surged in the water like leeches. I watched in amazement for a long while. In the end he carried the wet hair, and the rest of the plait, out of the house and threw it into the river. And in the moonlight it seemed to me that all the hair, still writhing, swam on the surface of the water.

After this terrifying exercise he said: "You can rest assured, Sir, that this hair's mysterious power will no longer attract your guests' eyes."

My cruel behaviour made Amelia cry secretly for days; her health failed and she grew weaker by the day. She was unable to sleep and whenever she closed her eyes she would see figures rising from graves.

One day, just before sunset, a horrible incident happened. Amelia was sitting alone in the garden, but when the evening dusk began to spread and dew covered the grass and the air became cold and wet she decided to return to her rooms. The moment she stepped over the threshold she cried out in terror and fell senseless. Everybody ran to her and picked her up; there was not a drop of blood left in her face. She was laid in her bed and only after great effort did she regain her breath.

When she came to she said that in that moment the old

man had shown himself to her in a horrible form, his eyes burning with a fire the colour of blood as he held a big knife in his hand, threatening her with death.

Seeing the extent to which her health was ruined and her nerves weakened I finally felt pity in my heart and immediately sent for a doctor.

Every day now messengers ran to the town with prescriptions, and all available medical remedies were used to consolidate her strength. A few days passed and the medicines had no effect; they brought no change for the better but made her weaker and her suffering grew even more severe.

Her parents, having learned about her dangerous illness, came to visit, but her wish, and the doctor's advice, was that she should continue her treatment in her parents' home, where perhaps her mind would be eased more quickly and the medicine be more effective.

I agreed and Amelia, with her mother and father, left my house, promising to return as soon as her health improved.

After three days I received a letter with a black seal which said: "Yesterday at five o'clock in the afternoon Amelia ended her sad life."

When I read it, suddenly the hair on my head started moving and screaming horribly, and I was overcome by a terrible fear. I realised then what ill fortune this old man had led me to. I grabbed a loaded pistol and ran to his house with the intention of killing him . . . The moment I opened the door a huge flock of bats flew out of the empty room, and amid a terrifying squeal spread out above the roof and the trees; the old man and his rabbits had disappeared without trace.

I abandoned my house. I was too scared to live in it, too scared to come out and see the hills, the woods and meadows, for wherever I looked my eyes saw the black, satanic figure of the cruel old man.

"Here, doctor, is the story of my life."

After a short silence he put his hand on his head and

looking into the mirror said: "Even now I can feel my hair moving and screaming. Do you know then how to cure my misfortune?"

Trying to offer some consolation the doctor invited him for a visit and gave him his address. Shortly afterwards we left the inn, while he stayed there. Two days later I departed from Witebsk and have never seen him since.

I AM BURNIN'

by Henryk Rzewuski

After the defeat of the Bar Confederacy,[1] which swallowed
even the meagre patrimony I had inherited from my ances-
tors, my position was critical. As the losers we could not
expect any favour from the victors and I would no doubt
have ended up eating bread and salt in some noble house
were it not for Kayetan Sołtyk, the good bishop of Cracow,
who remembered we had some blood in common, my
mother being *de domo* Sołtyk. This great man, blessed be he
for ever, helped me in my need, brought me into his fold and
in his grace gave me a little village which feeds me and
clothes me to this very day.

Now, before he became the bishop of Cracow, Kayetan
Sołtyk was bishop of Kiev and as such had considerable Epis-
copal estates in the Ukraine. When taking his Cracow throne
he had brought with him one Pogorzelski, a man of noble
birth who despite having "Wrong" in his escutcheon was an
honest and very able administrator. It was to him that the
bishop entrusted the Salomonov domain, one of the largest
in the Episcopal estates. And even though brought up in the
Ukraine, where by God's grace the land bears fruit whether
one works it or not, this Pogorzelski soon acquired such skill
in our way of running things that he stood as an example to
other Crakovian landholders and the bishop valued him
above all his land-stewards.

We all liked Mr Pogorzelski, for he was a virtuous and

[1] Bar Confederacy – an armed league of Polish nobility and aristoc-
racy established in 1768 in the city of Bar in Podole against the last
king of Poland Stanisław August Poniatowski, his reforms and the
Russian domination.

learned man, and on top of that a cheerful, kind and obliging soul. According to some of the bishop's courtiers he was a bit of a queer fish, though I have never shared in this opinion. But true enough, he used to tell strange tales, like this story he told us, calling Heaven as his witness, about his travels through Polesie.

One day he stopped at an inn to rest his horses. He was sitting in the cart when a Poleshan approached him with an old arquebuse and said: "Good sir, will you buy this gun from me? Very handy when it comes to shooting game, she is."

"And how much are you asking?"

"Thirty silver pieces and not a shilling less."

"Are you mad? Every bit of it is from a different parish, the lock's held in place by a piece of string, the barrel's eaten by rust and the butt — good grief — how can you put such a lump of rot to your face?"

"'Tis true, sir, but it has one virtue."

"What's that?"

"Well, it's this, that when you take aim, having loaded it first, whatever game you fancy, just think of it and it'll come to you. But you have to fire right away, sir, or there will be trouble."

"Well, gentlemen," Pogorzelski carried on, "I was mighty tempted to try it, so I took aim, thought of a bear and sure enough, some dozen paces away I saw a Gypsy leading a bear on a chain. I fired. The Gypsy vanished with the chain, leaving just the big bear lying dead. I paid the Poleshan what he was asking, and had he asked three times as much for this gun I would have paid it even if I'd had to sell the shirt off my back.

"So, there was I, driving along, gun in hand, and trying it all the time I soon had my cart loaded with all kinds of game. Then a thought struck me — 'Isn't this all the trick of some evil spirit?' I began to pray. When I finished I was even more convinced it was a gift from the devil. I threw all the game off my cart, and the gun too, but then I glanced over my shoulder and saw the gun following me. So I stopped, took the gun and tied it to a tree with my own hands. A while

later, the gun came running alongside the cart. That made me really scared. But as I was near Uszomierz I put the gun in the cart and told the driver to take me straight to the Carmelites. There, I handed the gun to the prior telling him the whole story and he ordered it to be burnt in the courtyard, in my presence. And what do you say, gentlemen? Such a stench of sulphur came from the fire it was impossible to stay in the courtyard. But what's more, when the fire died out there was no trace of the gun left – lock, stock and barrel – all burnt like straw."

Another time he told us that one day, when he went hunting with his dogs, he ventured deep into the woods whereupon a beggar-woman seized his horse by the reins and asked for alms.

"I put my hand in my pocket," said Pogorzelski, "to see if I hadn't a spare copper, for it's a sin to let the poor go unprovided, but all I found was a half-zloty. That was the time when they had just introduced zlotys, half-zlotys and silver groshes. I felt pity for the woman but was just as sorry to part with the coin – in our Ukraine everything's aplenty but money is dear. I said to myself aloud: 'I wouldn't stint a silver grosh but a half-zloty – that hurts. If you change it with a silver grosh I'll give you what I have in my pocket.' And she says to me: 'Give it to me, sir, and here is a silver grosh.' We exchanged the coins and I put hers in my pocket. And what do you think – I could not get rid of it. Whenever I gave it to anyone I found it back in my pocket. I did not pass a beggar without giving it away and yet it always came back to me. Until one day I got carried away at a card table and lost all my money, including my silver grosh. Shame. But then I thought 'It'll come back.' Well, it didn't. It sank like a pebble in the well, and I swore never to take up a pack of cards again, which vow, as you know gentlemen, I honour to this very day."

These are tales which defy belief, and it was everybody's view that he, being a Russian and thus naturally inclined to superstition, would blab on about things he thought he had experienced but in truth had not. As for myself, I knew him

to be so upright that I believed his every word, for if we were to withhold our belief in such people the sum of human knowledge would be very small indeed. He who puts too much faith in others is often cheated, especially if he keeps bad company, but he who puts all his trust in his own judgement and holds the word of decent people for nothing, thinking their reason inferior to his own – he will never be a wise man.

Now, you should know that the Samsonov domain used to belong to the dukes of Zator, who, though Poles, were the vassals of the German Emperor. There is a story that Wilibald, the last of the dukes, had an only daughter whom he betrothed at the age of ten to the Emperor's nephew. His intention was to save the independence of his dukedom, which with the end of the male line was to be reincorporated into the Polish Crown. This powerful and independent ruler built a fortified castle in Samsonov where he liked to stay sometimes. He was an arrogant and cruel man with neither fear of God nor love for his people. Now it so happened, that when she was sixteen his daughter fell in love with a young Polish knight and let him carry her off on the very day that the Emperor's nephew arrived in Zator to take her hand in marriage. You can easily imagine the shame and anger of the duke at the offence done to so powerful a prince, as well as the ruin of all his plans. He left Zator and settled for good, as he proclaimed, in Samsonov Castle. There, he dedicated himself to a life of piety, praying every day in his chapel, receiving monks and pilgrims, but he did not forgive his daughter and forbade everybody to speak to him about her.

All this time his daughter lived and suffered under the weight of her father's curse. In the end she and her husband went to see the bishop of Cracow, with whose indulgence they had married, to ask if he could obtain for her the duke's forgiveness. The bishop went to Samsonov and when the duke received him kindly he ventured to speak of his pastoral mission, begging him to purge his heart of the anger he bore his daughter. The duke agreed and even told the bishop that

if his daughter and son-in-law were to come to his castle, together with the priest who had married them, he would endeavour to show them what his true feelings were. So the bishop brought them to Samsonov, wanting to witness for himself such a moving reconciliation between the father and his daughter. All this happened in his presence, and the duke showed himself to be so kind that the bishop blessed him many times, repeating that it was the happiest day of his pastoral office.

But scarcely had the bishop left the castle when he was attacked by a detachment of armed men, who quickly defeated his escort. He himself was dragged from the carriage and wounded, and would have been hacked to death had the good Lord not sent unexpected deliverance in the person of the brave Earl of Skałka, who happened to be passing with a handful of other knights and his own escort on his way to a tournament in Tyniec. The Earl saved the bishop from the hands of the bandits, rounded them all up and, together with the half-dead cleric, brought them to Cracow. There, the attackers were recognised as belonging to the duke's army and confessed that they had been sent by him to kill the bishop and his escort.

The bishop excommunicated the duke, and the king ordered him to come to Cracow. The duke answered proudly that being a sovereign ruler he did not recognise any other jurisdiction but that of the Emperor himself, that he therefore would not submit himself to any Episcopal or royal trial and that he was ready to answer force with force, confident that the Emperor would not allow his vassal to be humiliated.

The duke would no doubt have met a bad end, as there was no trace of his daughter, son-in-law or the priest who had come with them, though one could surmise that he had had them all murdered. Just one thing saved him and that was that he died soon after, cursed forever, without the last sacrament for which he did not even ask. They say he died blaspheming, his body black as coal.

After his death, the duchy of Zator with some of its land

was incorporated into the Crown. The rest was shared out among the relatives of the duke's son-in-law and the priest's family who claimed compensation for the murder. The Samsonov domain was included in the Episcopal estate and in time the whole affair was forgotten.

When, during Pogorzelski's administration, the bishop was touring his estates he also visited Samsonov, where he stayed a few days, and where I, with other courtiers, attended him. The bishop expressed a wish to see the interior of the castle, which had remained undisturbed by human presence for centuries. The peasants used to say that it was haunted at night, that sometimes one could hear groans and strange noises coming from the castle's chambers. Pogorzelski and his workmen opened all the castle doors and on the next day we all went with the bishop to see it.

The castle, built solidly in the old-fashioned way, had survived the centuries intact, but inside it was infested by bats, with spider-webs everywhere and so much dust that it looked an utter ruin. There were remnants of old paintings, stuccoes carved in stone, spiders hanging from the ceiling and furniture which made such an impression on us that we walked around greatly saddened. As for the bishop, he did not seem to be much bothered and what is more, when he had seen the whole castle, he said to Pogorzelski: "My dear fellow, it's a beautiful castle, with such a magnificent view. We must make it habitable again. Prepare yourself a lodging in the castle so that you can keep an eye on the work and start on it right away. Next year, God willing, I shall be your guest, as I have a mind to spend a few weeks here with my little flock."

Soon after our departure, Pogorzelski found space for himself and his office in some comfortable rooms in the east wing of the castle. He had them cleared, put in new stoves and windows, and before long, complying with his master's wish, he moved in. The restoration commenced immediately and the castle was cleaned thoroughly from the cellars to the roof. Even a huge cask of Hungarian wine was found, hanging in the vaults on an iron girdle. It was so old one

could cut it with a knife, and barely a dozen bottles were filled with its liquid.

Mr Pogorzelski visited Cracow often and, knowing him to be a jolly character, we noted with surprise that he was becoming strangely moody, till in the end he succumbed to something akin to black melancholy. Finally it came to the point that he went to see the bishop, requesting to be released from his duties and asking permission to return to the Ukraine.

Our bishop, who had the heart of an angel and was very attached to his servants, was surprised and saddened: "Why, my Poggy," he says, "have I wronged you that you want to leave me so?"

"No, Your Excellency, nowhere will I find a better life. The bread's good here and it grieves me to leave so good a master, but I cannot stand such molestation any longer."

"From whom, my dear?"

"From whom? Evil spirits, that's from whom."

"Good God, Poggy! Have you lost all your faculties? You must be sick."

"I know your Excellency will think me out of my right mind, but I swear on Christ's wounds that what I have said is the truth and since I have moved into this accursed castle I've had no peace from the devil."

"And what does he do to you?"

"What does he do? He keeps telling me what I am doing, that's what. I get up, say my prayers and the moment I have finished I hear these words: 'Mr Pogorzelski, here you are praying and I AM BURNIN'!' I cross myself and the voice says: 'Mr Pogorzelski, here you are crossing yourself and I AM BURNIN'!' I command the horses to be got ready and it goes again: 'Mr Pogorzelski, here you are leaving and I AM BURNIN'!' No matter what I do the devil's voice is telling me 'Mr Pogorzelski, I AM BURNIN'!'"

"Why don't you move out and go back to your previous lodgings?" asked the bishop.

"Ha, I would, but once you've got into trouble it's not so easy to get out. The voice follows me around the castle, out

in the fields, and it has even come with me to Cracow. Only this morning, when I had my things packed to come to Cracow and from there to the Ukraine, I hear the same voice: 'Mr Pogorzelski, here you are going back to the Ukraine to be rid of me, but it's no use. You are packing and I AM BURNIN'!'"

"And tell me, my Pogorzelski, has anyone apart from yourself heard the voice?"

"That is just the crux of it: if it was only me I would think myself sick and that would be the end of it. But a few nights ago I got such a headache that I woke my servant Khvedko, a Russian like myself, and told him to bring me some saffron tea. He went off, prepared it quite quickly and was soon back with a pot of boiling tea and a cup on a tray. Just as I was reaching my hand for my tea the voice said: 'Mr Pogorzelski, here you are drinking your tea and I AM BURNIN'!' My Khvedko dropped the tray on me, burning me in turn with the hot tea, and ran off screaming."

My dear gentlemen, I was present with others at the conversation, just as you see me here.

"This is extraordinary," said the bishop, "but it is no good you leaving me for as you say yourself the voice follows you everywhere and so it will follow you to the Ukraine."

"I hope that the Holy Lady of Berdichov will deliver me from it."

"My dear Poggy, the Holy Lady reigns as much here as in Berdichov. Why, Jesus granted to our person the power to cast out evil spirits too, so go back to Samsonov. We shall follow on after you tomorrow and say a mass *pontificaliter* in the castle, you just prepare everything with my chaplain."

Next day, we all went with the bishop to Samsonov. The bishop stayed at the manor, as the castle was not ready yet, the masons, carpenters and stove-setters being still hard at work inside. Early next morning the bishop asked to be taken to the castle, where we were all awaiting him. A proper altar was set up in a clean room and quite a crowd was already there. I myself and Pogorzelski welcomed the bishop at the door and just as we were leading him to the room

where the holy mysteries were to be officiated we heard the voice: "Mr Pogorzelski, verily, you are setting a bishop on me and I AM BURNIN'!" This disconcerted the bishop a little, but he only stopped for a moment and then moved on.

We looked on as he prayed for a long time before beginning the mass, obviously trying to muster all his powers, and we saw his face brighten with a kind of holiness. Then he officiated *pontificaliter* a sung mass. The clerics who came with him, his court and the people of Samsonov answered, while Mr Pogorzelski lay prostrate in the shape of a cross on the floor listening to the mass. After the mass the bishop, still standing at the altar, leaned on his crosier and, taking the cross in his hand, spoke in a powerful voice: "Praise be to the Lord!" to which we all answered "And we praise Him." Suddenly a single voice could be heard: "Mr Pogorzelski, here you are praising the Lord and I AM BURNIN'!"

Just imagine, gentlemen, how scared we were, even though it was not night but a bright morning.

The bishop began his exorcism. There are still peasants in Samsonov who remember it well and you can ask them whether what I say is true. When the exorcism was over the bishop said: "Hear, Spirit created by God! In the name of this God born Man by the Holy Virgin, who put me as his shepherd to tend this flock, I order you to tell us who you are and what I can do to help you."

And the terrible voice answered: "There is no help for me. I was the duke of Zator who caused the death of my daughter, my son-in-law and the priest who married them, and for as long as there is any living creature in the castle I shall haunt whoever resides here till the bodies of my victims are buried in consecrated ground."

"Where are these bodies?" asked the bishop.

"In this castle. Bring your architect and he will find them."

Bojanowski, the bishop's architect, was immediately sent for from Cracow. When he measured the castle he found a double wall, had it pulled down and indeed, a narrow room was revealed with three skeletons in it, two male and one

female. Apparently, the duke had them bricked up alive and they died of starvation.

The bishop gave them a splendid burial, founded a memorial chapel of great beauty, which stands in Samsonov to this very day, and left the chaplain there to say three masses a week for the peace of the three souls. After the funeral Mr Pogorzelski was never again molested by the voice.

THE GREY ROOM

by Stefan Grabiński

My new room didn't satisfy me either. At first, it seemed that what had made me leave my previous lodgings could not possibly happen again, that here I should be safe from that strange malaise which had forced me to abandon the other place. But a few days spent in this newly rented room convinced me that my latest refuge was even worse, as certain familiar, unsettling characteristics began to manifest themselves in sharper and more defined form. After a week's stay in the new place I came to the unpleasant conclusion that I had fallen into a trap a hundred times more complex than the previous one, that the uncomfortable atmosphere which drove me out of my last dwelling had appeared again, and with considerably greater force.

As I became aware of this undesirable state of affairs I started to look for the reasons in myself. Perhaps the room had nothing to do with it? Perhaps it was I who had dragged the unpleasant mood along with me and unaware of it I was trying to project it into my new surroundings, regarding it as something outside of me I was dishonestly attempting to mask my own weakness?

But this supposition seemed to be undermined by the sense of inner peace which at that time was pervading my whole being and by my exceptionally good state of health. And so, I soon stumbled upon a new hypothesis, which quickly turned into a certainty confirmed by my everyday experience.

Led by a well-guided premonition I asked for some information concerning the tenant who had lodged in the room immediately before me. One can imagine my surprise when I was given the name of Łańcuta. It was the same man

who had also rented my previous lodgings. Some strange coincidence had made me his successor twice in a row. Apart from that there was no other connection between us, I didn't even know who he was or what he looked like.

In fact, I was unable to learn anything more about him than his name – Kazimierz Łańcuta – and that he had lived here for several months. Questioned as to how long ago he moved out and where to, the concierge mumbled something vague, apparently unwilling to go into greater detail. Nevertheless, judging from the expression on his face, I surmised that he could have told me more about my predecessor but preferred to remain silent – either he was naturally taciturn or was following the landlord's orders; perhaps he did not want to give information on principle.

Only later did I understand his careful tactics; indeed, from the landlord's point of view it was the only possible approach: one shouldn't put off prospective tenants. The mystery was explained only after my own experiences threw more light on the character of the ex-lodger and his deliberately concealed fate.

At any rate, the similar atmosphere of both rooms, so strangely parallel with the identity of the previous lodger, gave me a lot to think about.

As the time passed I was growing more and more convinced that the soul – if I may put it this way – of the two rooms was permeated with Łańcuta's being. And that something like this is possible I do not doubt. In fact I think that the expression – "To leave behind somewhere a part of one's soul" – should be taken as more than just a metaphor. Our everyday existence when shared with a given place, a long stay in some environment, even if devoid of human presence, or limited to the sphere of inanimate objects, has, after a time, to result in mutual influence and interaction. Slowly, a kind of elusive symbiosis evolves, the signs of which can be preserved long after the termination of direct contact. We leave behind us a psychic energy which clings to the things and places it has grown used to. Those remnants, a subtle residue of past relationships, linger on for years, who knows,

perhaps for hundreds of years, invisible to those who are insensitive to them but nevertheless present, showing themselves on occasions through a more definite gesture.

Hence the strange fear and at the same time respect we have for old castles, ruined houses, the venerable monuments of the past. Nothing is lost and nothing goes to waste; among the barren walls and deserted cloisters languish persistent echoes of years gone by . . .

But in this case there was one important detail which caught my attention and which I had to take into account from the start. According to the concierge, Łańcuta had lived in the house just for a few months before moving somewhere else. Thus, the time in which he could influence the room's interior and impregnate it with his presence was relatively shorter than the time he had spent in the previous room. And yet, his imprint was stronger here than there, where he had more than two years to make his mark on the surroundings. It must have been, then, that the power which his psyche radiated in later days was much stronger and so produced more definite results in a much shorter time. The only question was – to what should we put down this disproportional increase of psychic potential?

Considering the kind of mood permeating my present lodgings the explanation for this phenomenon lay not in an amplification of the life energies of its previous inhabitant. To the contrary, on the basis of various observations I came to the conclusion that the more likely cause was some inner decomposition, a sort of spiritual disorder – and a powerful one at that – which infected the surrounding atmosphere. Most probably, at that time Łańcuta was a sick man. This seemed to be confirmed by a basic, all-pervasive tone, present in the room. It was a quiet, hopelessly sad melancholy. It oozed from the ashen wall coverings, from the metallic sheen of velvet upholstery and gleamed from the silver frames of the paintings. One could sense it in the air diffused into thousands of imperceptible particles, one could feel, almost touch the soft, delicate fabric it spun throughout the interior. A sad, grey room . . .

Even the flowers in the pots by the window, and those bigger ones in the vases near the bookcase, seemed to conform to the pervading style: leaning strangely to one side the stems and flowers were bent sadly in a limp meditation.

Even the voice – though the room was big and sparsely furnished – seemed to be hiding shyly in its corners and niches, like an intruder startled by his own boldness. The sound of my steps fell on the floor without an echo; I passed like a shadow.

I was overcome by a longing to sit down in a corner, in a plush armchair, and having lit a cigarette to spend hours ruminating, letting my eyes run aimlessly after the little spiral clouds of smoke as they slowly formed themselves into rings and clung to the ceiling in floating ribbons . . . I was drawn to the rosewood piano to play gentle melodies in soft and sorrowful tones like autumnal sobs . . .

After the first week of my stay a strange dreamy pattern started to embroider itself upon this grey malaise, visiting me in my sleep every night.

The content of the dreams would be more or less the same. It seemed they had a fixed theme which would be subtly modified with slight variations, like adaptations of the same story.

The background for their monotonous action was my room. At a certain point in the night it would appear like a film on the screen, its furniture sleeping in the corners and its melancholy reflected by the bored mirrors, staying there through the long hours of my sleep. Near the window, resting on his elbow, sat a man with a long pale face, gazing sadly onto the street. Sometimes he stayed there for hours. Then he would get up and cross the room a few times in slow, automatic strides, his eyes fixed on the floor, as if rapt in thought. Sometimes he would stop, rub his brow and raise his large clear eyes full of quiet melancholy. When tired of walking he would sit down again, but this time at the desk by the left wall, and with his face hidden in his hands he would stay motionless for a long while. Occasionally he wrote something in a small, restless hand. When he had finished he

would throw away the pen, straighten his slender frame and start walking again. Wanting to gain more space he would walk in a circle; in which he was encouraged by the general layout of the room's furniture. I noticed however that the circle caved in unevenly near the wardrobe standing in the right corner by the door. Here the curve of his path would swerve away from it, as if he was trying to avoid that corner.

This constituted the entire content of my dreams. After a few hours of monotonous perambulations interspersed with longer and shorter rests by the window, at the table, or in one of the armchairs, the sad man, and with him the vision of the room, would melt away and sink into the depths of sleep; I would usually wake up before dawn. This pattern would be repeated without change night after night.

The persistence of returning images and their characteristic style soon led me to an unshakeable conviction that the actor in this nightly pantomime was no one else but Łańcuta himself. Those dreams full of melancholy monotony were, so to speak, a visual realisation of the room's soul felt so depressingly during daytime, a practical materialisation of things too subtle for the light of day.

I suspect that the same was still going on uninterrupted through the day but its direct perception was made impossible by the misleading senses and the intellect, all too clever in its arrogance.

For the stars exist in daytime too, though, outshone by the mighty rays of the sun, they become visible only after its setting. One is reminded of letters written with so-called "invisible ink" which disappears when dry, leaving the paper seemingly blank. In order to read such a letter one has to hold it near a fire to warm it; then the invisible letters will re-emerge, drawn out by the heat.

At first I found it interesting to watch the dreams and observe the connections which undoubtedly existed between them and the daily atmosphere of the room. But then I began to realise that slowly but surely I was giving in to the harmful influence of my surroundings, that my dreams and

the interior in which I spent my days had a very negative effect on me, poisoning my mind with invisible venom.

I decided to defend myself, to wage war against my invisible predecessor, to confront him and oust his memory which had permeated everything around me.

The first thing to do was to replace the furnishings of the room. For it was these, as I rightly suspected, that constituted the points of attraction for the poisonous remnants of Łańcuta's psyche. I hoped that removing them from the room would strip it of its allure and sever important bonds sustaining this dangerous relationship.

This I carried out systematically, almost like an experiment, using a method whereby I made slight, hardly perceptible changes.

To start with, I ordered the removal of a big, plush armchair which stood by the window and had it replaced with an ordinary chair. Even this slight modification of the furnishings had a clear impact on the dream's progress, which became somewhat simplified. It lost one of its features – the image of Łańcuta sitting by the window; not once throughout the night did the melancholy figure occupy the new chair.

Next day I removed the desk and put in its place a small card table, not omitting to change the writing accessories at the same time. Although the next night Łańcuta did sit at the new table he was not leaning on it now, he did not touch the pen and generally tried to avoid any contact with the new object.

When I finally changed the remaining old chair for an elegant, recently acquired stool, he did not even come close to it. This part of the room became for him a strange, and therefore hostile, terrain which was obviously to be avoided.

And thus, gradually, I got rid of one piece after another, introducing completely new furniture, the style of which contrasted violently with the old, the colours of the upholstery bright and full of deliberate loudness. After two weeks there remained only the wardrobe and a mirror hanging next to it. These two objects I decided to leave unchanged for an

– as it seemed to me – obvious reason: Łańcuta apparently felt no affinity with this part of the room and avoided it ostentatiously. Why then waste the effort?

The changes had a salutary effect on my everyday environment. The room cheered up somehow, the stifling atmosphere of melancholy weakened, giving way to a sunnier mood. At the same time my dreams also moved into a new phase. Along with the continuing metamorphosis of the room Łańcuta seemed to be literally losing ground from under his feet. First I cut him off from the window, then barred his access to that part of the room where the desk had stood, limiting him to a couple of armchairs. Finally, when I removed even those, he was left only with a narrow space between the new pieces of furniture. Evidently, the change in atmosphere began to affect him too. I noticed that the contours of his until now distinctly drawn figure were becoming more and more hazy, and with every night his image grew fainter, more evanescent; I saw him as if through a fog. In the end he stopped walking among the chairs and moved like a shadow across the walls. Sometimes his whole frame would be torn apart, with only fragments of his body or the outline of his face still visible. I had no doubts whatsoever – the defeated Łańcuta was in retreat. Delighted with the now certain victory and rubbing my hands with pleasure I set out to deliver the final blow: I had the steely grey wallpaper torn off and replaced by red.

The result did not disappoint me: the shadow of my persistent *bête noire* stopped flitting about my walls.

Yet, I could still feel his presence in the air. It was elusive, greatly rarefied, but nevertheless there. I had to make the atmosphere utterly repugnant to him.

To this end, for two nights running, I threw a wild, Bacchic party. I myself provoked the debauchery of the drunken guests, fuelling a fire which raged with healthy, young and rampant lust. We went mad. After these hellish, all night revelries, which brought a lot of complaints from my neighbours, at the end of the third night I threw myself on the bed fully dressed and, utterly exhausted, immediately fell asleep.

At first the exhaustion was stronger than dreams and I slept without visions. But after several hours of rest I saw, as usual, my room emerging out of the dreamy mists of my sleep. I looked at it calmly, smiling triumphantly: there was nobody in my room, absolutely nobody.

Just to be sure I let my victorious eyes scan all the corners and starting with the window I went over most of the room. I checked the armchairs, examined the ceiling, carefully passed over the walls – not a trace of the suspicious presence, nowhere even the slightest sign. Suddenly, turning my eyes into the dark recess by the door – the only part of the room he always so carefully avoided – I saw him. He stood there: a clearly visible figure, a little stooped as usual, with his back turned to me.

He had just stretched his hand towards the wardrobe, turned the key and opened it. Standing motionless he stared at its emptiness, at the rows of wooden pegs like bared teeth. Slowly, with calm deliberation, he pulled out of his pocket a kind of tape or a leather strap and tied it to one of the pegs and knotted the loose end into a noose. Before I knew what was happening he was already hanging. The body, wrung by a mortal convulsion, swung sideways and into the light of the mirror's reflection. In its perspective I saw the hanging man's face: it was twisted into a sneering grin and was looking straight at me . . .

I tore out of bed screaming and, shaking feverishly, I jumped through the window onto the street. Without looking back I ran into the night, along the empty streets, until I reached a tavern. Here I was immediately surrounded by a bunch of roughs whose merry-making sobered me up; I needed them desperately. They took me to another, even more sordid drinking hole, and then to a third, and to a fourth; I went with them everywhere until dawn. Then I staggered into some hotel where I slept like a stone.

Next day I moved into a cheerful, sunny little place on the outskirts of town. I never returned to my old room.

THE BLACK HAMLET

by Stefan Grabiński

Was it only a dream, a terrible dream, or reality, a hundred times more terrifying reality? If it was only a dream — then let its cursed memory vanish for ever, let it no longer poison the life of my soul with its venom! . . .

Sleep and waking! Dream and reality! In what utter confusion they merge, with what fury they collide on the crossroads of thought! . . . Someone malicious beyond human measure has removed all the border signs and obliterated the boundaries, gone without a trace are all the sign-posts, and delusion — the mad queen of stray paths and highways — reigns supreme . . .

What is a dream? What's being awake? What is reality? . . . Tell me! Have mercy on my torment and tell me! Speak, resolve the terrible doubt! . . .

In vain I plead, in vain . . . No one will give me an answer. No one in the whole wide world . . .

Is there another reality beyond this one? Can one, sometimes, in some exceptional circumstances, cross over to the other side? Can one bring back a "souvenir" — ha, ha, ha! — a "keepsake"? Can one return from the land of dreams with a memento — yes, ha, ha, ha, that's right — a memento, a token of remembrance?

Tell me, I beseech you by all that is sacred, tell me — is something like that possible? . . .

You deny it, don't you? . . . It's impossible, it's madness, isn't it? . . . It's obviously madness, the chimera of a sick mind?

And yet, yet, I have proof, fatal proof. There are reminders, you see, cursed reminders which bear witness. If, after some time, there appear other hideous reminders, a hundredfold more frightful, for which I wait, plunged in this inhu-

man torment, then I am doomed. Hopelessly, hopelessly . . .

Oh, if I could only find in this reality that surrounds me some equivalent of my "memento"! Just one point of contact with the carefree, innocent sunshine of awakening! . . .

But I search in vain. With this key one can unlock no door on earth. For a week I've been telling my friends and strangers what's happened to me, but everywhere I have met with incredulity, indifference or laughter. Some consider me mad and get out of my way. But maybe soon, perhaps in a matter of days, even hours, you will start avoiding me for a different, a completely different reason . . . And then, yes, I shall say you are right and avoid the thresholds of your peaceful homes . . .

And all this happened in a matter of ten minutes! Within ten minutes I lived through one of the maddest adventures, strange and ghastly like a madman's nightmare.

Lived through, or dreamed? . . . I do not know, I do not know.

In the time which earthly clocks need to swing their pendulums six hundred times I visited a strange place, beheld a land not of this world, and with the passage of the tenth minute I found myself back in my own room. For a short while, which must have spilt into another, less constricted dimension, I fell out of the folds of the mundane and having travelled in some unknown direction I returned to the back door of reality . . .

The strangest thing is that I do not know what was happening to me during this time – was I there as a man of flesh and blood, or was it only in my mind that I journeyed there for those few short moments? Was it an abnormal, pathological state, or was it an experience in the true sense of the word, only in a different reality?

I cannot in any way throw a bridge between that world in which I found myself, following I know not what road, and the world I have grown used to since childhood. I cannot find a path to that other, nightmarish side which weighs upon my memory with its overwhelming gloom. Somebody

must treacherously have removed the connecting passage, mined the bridges. And then an abyss opened up beneath me, dark, unfathomable, bottomless . . .

It happened a week ago, on the 31st of May, between five and ten past five p.m. That fatal date hangs, to this day, above my desk, a sinister reminder.

That day I came back home about three o'clock, rather upset about some unpleasant event whose details are irrelevant. I hardly touched my dinner and, having lit a cigarette, threw myself on the sofa. Soon, I fell into a nervous, restless sleep; what I dreamed I cannot remember. I woke up about half past four with a nasty taste in my mouth and with great difficulty dragged myself off the sofa. I had another cigarette and sat at the desk leafing through my encyclopaedia.

I felt rather odd. I threw away the half smoked cigarette and asked my servant to bring me tea. After a few minutes a steaming cup stood before me. I put sugar in and squeezed a few drops of lemon juice. By then it was a quarter to five.

I sipped some tea and stretched out comfortably on the armchair by the desk, resting my head on my hand. In this position I spent about ten minutes. When I awoke from this reverie and glanced at my watch it was nearly five. That was the last moment "on this side" which I clearly remember. What happened next I do not know. At this point my memory has a gap, a mnemonic gap I cannot fill . . .

The next thing I know is that I found myself on a lonely road. The world was swathed in a grey dawn, the withes of the weeping willows growing on both sides of the road swayed in a light breeze . . .

I walked fast, raising clouds of dust, a thick layer of which soon covered my shoes and clothes.

Suddenly, the road turned to the left, becoming a narrow winding path which ran along the bottom of a deep ravine. I followed the path and after a few minutes emerged from the ravine into a meadow with a stream running across it. I

looked around. Before me stretched a plain, wide open and flat as a table. The eye, tired from the monotony, lost itself on the horizon.

I turned towards the stream. There was a small, wooden footbridge with railings which I crossed, and I chose at random a path which led to the right.

Then the terrain changed rapidly; the grass disappeared, replaced by the glistening, metallic blackness of coal. Everything was covered with thick coal-dust, lumps of slag, dross and tarry soot. This bed of refuse exuded a hot breath, filling the air with sweltering heat. Soon my brow was covered with sweat . . .

A group of buildings loomed on the horizon. I walked automatically towards them, even though the path had now disappeared, petering out among the dumps of slag and coal-dust. Before long I reached a cluster of houses.

It was a kind of suburban village or hamlet of not more than twenty houses. The air almost rang with an eerie silence. There was only one street running down a long, narrow slope and not a soul in sight. The buildings stretched out in a helix-like line; six houses of the lower part of the hamlet spread out in a spiral around a lake glistening like a steel plate, while the upper part unwound north in a double row.

The houses were a gruesome sight. On their angular carcasses, covered with a dirty, grey lime, sat roofs of black, tar-soaked asphalt. The rectangular sheets with sealed edges overlapped each other like the carapaceous plates of a reptile, patched up here and there with paltry pieces of rugs soaked in birch-tar, old hides and sheets of corrugated iron. The colour of those gloomy houses with tightly shut doors and boarded up windows blended with the blackness of the ground into a peculiarly mournful landscape.

On entering the village an unbearable stench, like a mixture of sulphur and asphalt, immediately invaded one's nostrils. Its source was probably the lake, which spilt its dirty, unwholesome waters on the southern end. Not a single tree, not one blade of grass cheered the gloomy hamlet. The barren ground, choked with black, dry dust, could bear no

fruit. Only by the lake grew a cluster of bushes with rusty fruits like paradise apples, their branches bent over the water and reflected in it like a bloody smile. I stretched out my hand and picked one of those apples. It crumbled in my fingers into dust, empty like a puff-ball, rotten and putrid . . .

The water in the lake was peculiar, too. Thick, saturated with sulphur, salts and tar, it lay dead in its deep bed surrounded by slabs of rock. It must have been a bed of asphalt, as here and there one could see floating pieces of curdled tar.

The steep banks of the lake bristled with sharp rocks glistening in the light with thick layers of glassy salt. On those rocks, grey and barren, sat big, black condor-like birds. The lifeless lake seemed to influence their slow, languid movements. They sat as if chained to their stony plinths, stretching from time to time their hideous, long, naked necks towards the water . . .

The lake and the village were bathed in a grey radiance wearying to the eye. Despite the lack of the sun, hidden somewhere behind the clouds, it was hot and stuffy as if in an enclosed space. From the soil covered with the black fleece of coal-dust came invisible waves of heat as if from red-hot sheets of metal.

I set off walking around the accursed lake. Not a breath of wind rippled its smooth surface. It drowsed motionless in its bed like a huge, black eye in a skull draped in a stony pall. Only here and there drifted lumps of loosened asphalt or long, rainbowed ribbons of oily water.

I picked up a stone and threw it into the deep. It sank only half way and began rising lazily back to the surface. The water in the lake was a saturated solution.

I came closer to one of the birds and, carried away by an aversion I could not contain, I tried to shoo it from its rocky perch with my walking stick. The bird turned its glum, evil eye on me and with its beak tore the walking stick out of my hand. Then it moved heavily onto a lower shelf and started sharpening its crooked, steely claws on the rock.

I left the bird alone and moved on. For some time now the lake had been exuding fetid fumes of tar and sulphur. Soon,

their thick, yellow-grey mist covered half the lake and spread out in smoky coils among the houses. I put a handkerchief to my face and walked away quickly towards the street. I was just about to venture between the buildings when a dry, wooden noise reached me from around the corner. In the absolute silence of the village this sudden and unusual sound jarred in my ears with a malicious grinding. I quickened my step. After a moment I heard a second outburst of the same noise, this time much closer. Now I was quite certain – it was the sound of wooden rattles.

And I was right. Having passed the second house on the right I saw a group of people in long brown habits with hoods over their heads disappearing around the corner. It was they who were shaking the wooden rattles in their hands.

I wanted to run after them but I thought better of it. It crossed my mind that perhaps the inhabitants of this strange hamlet did not wish for the company of strangers and intruders, and therefore, when they noticed my presence, they deliberately locked themselves up in their houses. Besides, the unbearable stuffiness and sweltering heat of the place made it so odious that I wanted to get out of there as soon as I possibly could.

And so I moved on, walking past the black buildings. Then, in the door of the last house on the left, I saw a young woman, about thirty years of age. Tall and slender like a fir, she wore a long, snow-white robe gathered in at the waist with a few rounds of plaited rope. A fantastic, black turban sat on her lovely, classical head. The face, beautiful beyond words, was striking in its terrible paleness. From under the arches of her eyebrows, resting on the bridge of her Roman nose, looked out a pair of most unusual eyes – pale-green, with gold-tinted rings around the pupils, shining at the slightest movement with an opalescent radiance like two beryl crystals. Her eyes corresponded strangely with the steely, ashen colour of the hair escaping in curls from under her black turban. On the red coral lips played a nonchalant, flirting smile.

She fastened her seductive eyes on me and withstood my gaze without embarrassment. Mesmerised, I took off my hat. The admiration which she undoubtedly saw in my face favourably disposed her towards me, for she was the first to speak:

"Welcome, dear guest, to the house of my grandfathers."

Her melodious voice was sweet and caressing like a flute and she spoke in an odd, old-fashioned style.

"Lovely lady," I responded, "where am I? What is this strange village? Who lives here and why are your houses locked?"

She smiled mysteriously.

"Put a rein on your tongue which races ahead like a wild horse. Restrain your curiosity. Do not reach too hastily for the flower of charm and mystery or it shall wilt in your hand before its time, bereft of its beauty."

"Let it be as you wish," I answered resignedly. "But tell me at least the name of your village."

"You are in Black Hamlet."

What an apt name, I thought, and added aloud: "And you are its wonderful pearl."

She stretched towards me her small, alabaster hand with a ruby ring on the middle finger.

"Come under my roof, dear traveller, and rest, for the road must have made you weary. I am alone."

I accepted the sweet invitation and holding hands we entered her home.

The room she led me into must have taken up almost the entire wing of the house. It was very spacious and its windows faced in three different directions. I was immediately struck by the contrast between the simple, wooden walls made of rough timber like a mountain hut and the luxury of the furnishing. The walls were covered by heavy, Persian rugs adorned by a fine collection of Saracen cold steel with fantastic scimitars, damask swords and bucklers. Two ottomans covered with kilims met at a sharp angle in the middle of the room, while in the corners stood silver tripods with bronze censers burning with ambergris. From the beam hung three oil lamps filling the room with a soft, dim light.

I had an impression of being transported miraculously into one of those exotic interiors where the hot, oriental imagination spun the yarn of One Thousand and One Nights. One could easily forget that this house was one of those black, hideous buildings I had been looking at with such abhorrence, and about the stinking lake on whose rocky banks sat those repulsive vultures. The shutters, bolted fast, and the windows covered with green tapestries, cut off this Levantine oasis from its gloomy surroundings . . .

We sat down by a small bamboo table laid for two, facing each other. My lovely hostess lifted a teapot with her fingers, poured the tea into two cups and handed one to me.

"Before I am able fully to enjoy your hospitality, beautiful lady," I said, "I would like to know your name. It must be as melodious as your voice."

"Those who live by the lake call me Mafrosia. My family and neighbours call me Mafra, for short."

"A strange name," I said looking into her eyes.

At this moment another roll of rattles reached us from outside. I shuddered and looked at her enquiringly:

"What is the meaning of this noise, Mafra? It is the third time I've heard it in Black Hamlet."

She seemed to be perturbed and irritated.

"Fools!" she muttered through her teeth, as if to herself. "Fools, they have started those stupid rites again."

But since we heard no more of the noise I forgot about it completely and gave myself entirely to the pleasures of Mafra's company.

She was charming like an odalisque and her caresses were equally rich. Her manner of speech, flowery like a Persian carpet, full of metaphors and poetic hyperboles, intoxicated with a fragrance of rare, unique and oddly chosen words. Her young, firm body, barely protected against my eyes by the light, transparent gauze of her peplos, exuded a scent of exotic oils and confused the senses with a promise of unknown raptures . . .

I completely lost my sense of time and cannot remember

how long that wonderful moment lasted – an hour, two, or more?

At last she allowed me to unwrap her black turban and I buried my hands in her hair. Our hungry lips fastened in a painfully sweet, tragic kiss and remained so for a long, long while . . .

Suddenly I felt a pain on my right cheek and the taste of blood in my mouth – in a loving frenzy Mafra had bitten me . . . I took her in my arms.

She did not resist, returning each of my caresses with one of her own. But when, drunk with excess of delight, I moved away for a moment, devouring her inscrutable face with my eyes, she gave a terrible laugh, which turned the blood in my veins to ice . . .

"Mafra! What happened to you?" I cried out. "What does all this mean?"

"Ha, ha, ha! . . . Ha, ha, ha! . . . It means that in the heat of love you have possessed the King of Lepers' daughter. Look! You recognise this mark?"

She bared her chest and I saw a terrible wound which had already eaten deeply into her beautiful breast.

"See? I am marked too! But now you are ours," she added with a vindictive smile. "You, too, belong to us. Mafra's kiss has sealed your fate for ever! Ha, ha, ha! Ha, ha, ha!"

Terrible fear grasped me by the throat and at the same time a blinding rage made me reach out for a dagger hanging on the wall. I sank it in the breast of my treacherous lover. The blood gushed in a scarlet fountain and the silence of Black Hamlet was torn by the lone scream of the leper princess . . .

With the dagger still in my hand and my face contorted in a grimace of horror I burst from the accursed house. People in brown burnouses barred my way, surrounding me with a circle of cadaverous, rotting faces. I hurled myself at one of them and, having broken out of the loathsome ring, I ran. I tore along the black, narrow street towards the lake, followed by the dry patter of bare feet and muffled, throaty cries in a

strange language. My legs, driven by fear, were growing weak and I stumbled, feeling the blood pounding madly in my temples with a thousand hammers. With the last of my draining strength I dashed in a different direction in an attempt to get out of the village when suddenly I saw those terrible vultures approaching from the lake – they were drawing in on me in a huge half-moon, cutting off my last route of escape. They were already so close that I could see the metallic gleam of their claws and could feel on my face their heavy, poisonous breath. The world whirled around me and I fell as if struck by lightning, senseless, into the dust of the road . . .

When I came round I found myself sitting in a chair at my own desk in my flat. In my right hand I was holding a dagger steeped in fresh blood. Disgusted, I threw it into the waste-paper basket and passed my hand over my forehead. The horrible adventure ran through my head like a film, as I remembered vividly each minute detail.

Leaning my face on my hands I felt a burning pain. I looked into the mirror: my right cheek was bleeding and displayed distinct bite-marks.

A souvenir from Mafra, I thought, and a cold shiver ran through my body. I glanced at my shoes; they were covered by a thick layer of grey dust. I took one of them off and examined the sole – it bore traces of coal and slag.

The question was, how had I arrived back at my home? Was I transported here after I fainted? Then the servants should know about it. Hm . . . What is the date?

I looked at the calendar and to my surprise I saw the date was the 31st of May. Had my servant forgotten to tear off a page?

Judging by the position of the sun it was late afternoon; my watch was showing ten past five.

Hm . . . It must be the afternoon of the 1st of June.

I rang for my servant, covering my wounded cheek with my hand.

"What's today's date?" I asked him.

"Thirty first of May, sir," he answered somewhat surprised.

"You must be joking, Casimir," I said irritated. "I am not in a mood for jokes. Well?"

"I swear to God, it's the thirty first of May, quarter to six," he repeated, giving an exact answer. "You returned later than usual, sir, very tired, and you must have dozed off while drinking your tea."

"Are you mad, Casimir, or do you think I am?" I shouted, getting up from the desk.

"Honest to God, it's the truth. Half an hour ago you ordered tea. I served it and left. Here, sir, there is the proof – you haven't finished your tea, the glass is still standing where I put it. It's half empty –" he added pointing triumphantly to the desk.

To my amazement I had to agree that he was right.

"Hm . . ." I slumped resigned on the chair. "So you really saw me here, at the desk, only half an hour ago?"

"But of course, most certainly."

"Hm . . . And you didn't look into the room between five and ten past five?"

"Not once. Why? You don't like me to come into your room without being called."

"Thank you. You may leave."

When the servant disappeared behind the door I opened my first aid box, took out a flask of disinfectant and carefully cleaned the wound on my face. Calmed by this operation I retrieved the dagger from the basket and examined it. The blood on the blade had already coagulated and dried into a dark cherry smudge. The handle, inlaid with sandalwood, bore an inscription in Arabic, probably a verse from the Koran.

I was struck by the thought that I had seen this dagger before and then my wondering gaze fell on the encyclopaedia, lying open on the desk since yesterday. My eyes stopped on the word "dagger".

"Hm . . ." I thought, "what a strange coincidence."

Then I remembered that on the previous day, looking

through the illustrations in my encyclopaedia, I had come across one with a gloss on the word "dagger". I immediately went back to it to compare it with my bloody souvenir and to my amazement I found what seemed to be its original. The daggers were identical in all their detail; even the inscription on the handle was the same. This useful book gave the exact translation.

"O, Allah, Akbar Allah," read the inscription, "Protect my flesh from the cruel disease."

"A peculiar motto," I thought, closing the book.

Yet, having in my possession such undeniable proof that what I had been through in Black Hamlet was real, the calm indifference of my surroundings seemed to me nothing short of mockery. I decided therefore to find a solution to this mystery as soon as possible. Mafra's infernal laughter was still ringing in my ears and her cruel, vengeful words sent cold shivers of fear through me – pure, unadulterated fear that those words might come true. A horrible curiosity made me want to leave my house and talk to other people, to hear from them a confirmation of the gruesome truth. Curiosity? Or maybe a faint hope that had they denied it I could have taken it all for a dream?

Perhaps I should even turn myself in to the police to find out what had happened to me, just to gain some information . . . I looked at my watch. Alas, it was too late to take the appropriate steps, it had to be put off till the next day. I had before me a very long, dark, sleepless night . . .

Today I have visited the police and told them I was the murderer of a leper girl from Black Hamlet. The sergeant who took my statement looked me in the eye and asked for further details. When I finished my story he approached me and taking me by the arm said softly:

"Dear doctor, please forgive me for being so forthright, but, speaking as a police officer, I think this is a matter for a psychiatrist. I cannot help you." The man obviously took me for a lunatic.

"But sergeant," I insisted, "I have evidence! This dagger, the wound on my face!"

"This evidence does not change my opinion of the matter. You must be suffering from a nervous disorder, doctor."

He shook my hand. I left, relieved and grateful to the man.

Then I went to the municipal offices to get some more information. I asked for the maps of all the villages, estates and settlements within a five mile radius of the town. I found that there were only two places in the town's vicinity which might be of any interest to me, one in the south, called Wańków Hamlet, the other in the east, Żołyń Hamlet.

I noted down the details and casually asked one of the clerks if he had heard about a refuge for lepers set up recently near the town. The clerk, an old acquaintance of mine, looked at me as if he did not believe his own ears and burst out with a hearty laugh.

"He, he, he, I see the good doctor has come to pull my leg. What a joke, oh, please! A leper colony near Dworzanów! In our country, an oasis for the afflicted with a biblical disease! I'll be damned, that's a good joke! He, he, he! I wouldn't even dream of it."

His answer was more than clear. Nevertheless, wanting to make sure, I visited both hamlets. The result was obviously negative, neither of them resembled the black village, and their inhabitants had not dreamed of leprosy either . . .

So what was it? What was it? How am I to explain the bite on my cheek? How am I to explain the bloody dagger? . . .

Today is the 21st of June. Three weeks have passed since that dreadful afternoon. For twenty one days I have lived with my nerves on edge, in constant fear. I will not be able to stand it much longer. I will have to shoot myself . . . Or go mad . . .

I have searched the entire district within a few miles of the centre of the town – Black Hamlet is nowhere to be found . . .

There are moments when I wonder at my own foolishness in looking for this place. How can I think of finding it at all if I know that the supposed events took no longer than ten

minutes and my flat is a good half hour journey on a tram to the nearest suburb? How can I look for the Black Hamlet in such circumstances? How can I? How can I?

And yet I am looking, I still am, and I tremble at the thought that one day I may find it . . .

25th June 1903

Yesterday I visited an old school-friend, a well-known psychiatrist, and told him the whole story. He was very interested and thought it was an exceptional case. He examined the dagger and the scar on my cheek very carefully. Then he examined me. Something did not seem right, for he shook his head several times. At the end he gave me his opinion:

"You will have to undergo intensive treatment. You've had a nervous breakdown of a very acute form. In such a state one is very open to suggestions; you must avoid these at all costs. Best thing would be to go for a long trip, perhaps France, or London . . . Ah, one more thing, most important: under no circumstances should you think about this whole crazy adventure. No analyses, no examinations, no inquiries. You are to have a good time, laugh a lot and love a lot, but do not think about it. You understand? Just do not think about it. The consequences may be fatal," he added seriously, with emphasis.

30th June 1903

I have not heeded my colleague's advice and have not gone anywhere. I can't, I can't. Something keeps me in this town and does not allow me to leave it. Instead, I went to see a dermatologist, Doctor Wiersza. He listened to my story patiently, examined the scar on my face, by now completely healed, and took a sample of my blood. He found nothing. That calmed me a little. A blood test, at any rate, was something positive.

The story of the dagger also interested him. He asked me to bring it to him to test the blood on the blade. I assisted him with the analysis. The result surprised us both. Wiersza

concluded that the blood on the dagger showed signs of pathological changes. So, Mafra's organism was poisoned with some unknown bacteria . . .

10th July

Ha, ha, ha! Ha, ha, ha! Now I shall have to buy a wooden rattle myself! . . .

This morning, irritated by a strong itch on my left breast, I opened my shirt and saw spreading through my flesh a wide, snow-white blemish . . . Half an hour later I showed it to Doctor Wiersza.

He looked at me like at a vampire and moved a few steps away. Scared, the poor quack! I am not even surprised.

After a while he said in a muffled voice, avoiding my eyes:

"In some inexplicable way your fears have come true. You have the first stage of *Lepra orientalis* . . ."

I stumbled out of the consulting room, into the street.

"Out of my way, you despicable rabble! Keep away from me! Away! I'm a leper! I'm a leper!"

THE GENTLEMAN WITH A GOATEE

by Karol Makuszyński

My friend, a decent fellow and a poet, told me this story, which seems like the tale of a certified lunatic. This friend gave me his "honest to God word of honour" three times that he partook in the whole affair. Had it been once, maybe I could somehow believe him, but three times – it's a bit much. Incidentally, I should also mention that my friend is a prodigious drinker. From that angle the whole thing begins to make sense.

Here is what he told me for what it's worth:

Not so long ago I was shocked, rather nicely I might add, by the news that an old miser, whose little fortune I was to inherit, had eaten a roasted pig and an incredible amount of prunes, all washed down with ice-cold water. When one is seventy, one shouldn't do this kind of thing unless one has a proper heir. Nature's revenge was swift and the good old man died. I was told with great affection how he kept his faculties clear and sharp to the last and how – out of thrifti- ness – he blew out the candle a long while before his death. Before returning his soul to God he also consumed a small roast chicken, so as not to waste it.

Because it all happened in a small, shabby, provincial town I had to go there to check if my benefactor was really dead, for it might well have turned out that – out of thriftiness – he had slipped into a coma for couple of years to save on candles and food. The inheritance was, of course, the least of my concerns, though I was greatly consoled by the fact that these days it is only in small towns that a big inheritance can be found. There, the good deceased had every chance to lead

a modest and God-fearing life, medicine is cheaper and doctors not so greedy. I honestly pity those who expect an inheritance, say in Warsaw, where the costs of death are incalculable and the inheritance shrinks like the wild ass's skin in Monsieur Balzac's novel.

As for myself, I was content enough with my scrupulous deceased relative not to complain too much about having to stay in such a grey muddy town. I looked suitably disconsolate and the deceased, if he could have seen me, would have experienced a moment of true joy. This good man always fared well in whatever he did and even after his death he was lucky to have an heir like myself.

When it became clear that the dear departed, even if he were to wake up from a coma, would not be able to shift the heavy load of stony earth (for provincial workmanship is not the slap-dash job one sees so often in the capital and the grave-diggers are diligent and conscientious), and that the soul of the old miser had been sent off to paradise with full pomp and ceremony, i.e. in a black suit cut at the back, then it was time to think how to soothe my grief and sorrow.

I still had to walk the streets of this pleasant town for another two days. My kind relative, by then enjoying all the wonderful delights of paradise free of charge, could not reproach me that with my own money (as his was still trapped in countless formalities), I wanted to console my disconsolate and sleep-starved soul. Only wicked and hypocritical people pretend on receiving an inheritance that they are dying of grief. A rational man should give pleasure to the departed by giving proof that their wealth will not be misused but consumed amidst joy and blessed merry-making, that, in a word, he will do what they could not for the fear of suffering terrible pangs of conscience for all eternity.

It was quite difficult to paint this grey town red. True, one could order pineapple ice cream and a Havana cigar after dinner, but such an order would make no sense. It would only create a crowd of onlookers, and in vain too, for in the whole town there was not a single pineapple or Havana cigar. Yes, one could reserve all the rooms in the best hotel in town,

which would cause a sensation. But this idea would be equally pointless, for in the hotel there were only two rooms, including one with a billiard table, which on occasion served as a bed.

But it was not altogether a bad town. It is not fair to judge by appearances, for after all I did find some first class entertainment. There was a cabaret in town, a circus show or something of the sort. A green poster with crooked, red painted letters passing for a print, said that every evening the "Café Japanese" hosted a "*performance fantastique*" of the world's most distinguished stars, namely artists from the capital.

Ha! Life bursts with joy like a geyser, even here!

Near the town there were famous oil wells which attracted rich people with a weakness for gambling, and who as such were therefore either happy or unhappy. Luckily, and unluckily, Nature invented one remedy for both afflictions: champagne. Naturally, after such a convoluted argument the conclusion is simple: even in such a shabby town a cabaret where one can get champagne has a fair chance of success. Man never drinks oil but he can always turn it into wine. It is the divine part of his human nature that he can change everything – tar, salt, fertilisers, wheat and potatoes – into wine. Like a magician.

However, it was not without a certain apprehension that I entered this establishment which was all the rage with the locals. The establishment was a seedy hole and its history was amply illustrated by its wallpapers. Countless generations of flies had died and been buried on a "chandelier" of fly-paper and a magnificent mirror – scratched, cracked in the middle and misty throughout – which adorned one of the walls. Looking into this mirror one backed off instantly in terror. It was a magic mirror. The prettiest face became ugly, one's eyes ran away from each other as if struck by sudden fear, the nose assumed a monstrous shape and the mouth was twisted as if with terrible pain; one was looking at a ghastly, green and terrifying apparition. It was the true mirror of life in which all earthly tinsel and wretchedness were given their

proper form. In the turbid depths of the mirror one could see a terrible ghost laughing satanically – ha! ha! ha!

One side of the stuffy room was taken up by the buffet. On a long sideboard, covered with a greasy oilcloth which no amount of water would wash clean, stood some glasses, cold meats and cheeses, things which were supposed to gladden the stomach. But there were also things which were a joy for the eyes, and through the eyes, a joy for the spirit. In small metal vases of indeterminate colour stood flowers – artificial flowers – resembling a dusty, withered, shop-soiled virtue. Even someone bent on taking his own life would shudder to see such a feast.

On the other side there was a stage which looked like a disused catafalque. On it stood an upright piano whose soul had died a long time ago, but which would, when pulled by the hair of its strings, give out from beyond the grave a terrible, hoarse wheezing. This piano, battered around the ribs, tortured passionately by a horrible Torquemada, shook like a black coffin containing a deceased writhing in convulsions of bad conscience; it cried, hiccuped and moaned in a hollow, underground bass, it gurgled and sputtered in a spasmodic raucous cough of galloping consumption, howled like a mad dog, hooted with the wooden voice of an owl, then wailed in the squeaky, shivering voice of a foundling left on a doorstep in the middle of a freezing night. All these voices rose and died in a rhythm that, when one closed one's eyes, induced a vision of a skeleton dancing a crazy jig, prancing about and rattling its bones, humming to itself, now high, now low, and sometimes getting no sound at all from its death-scorched wind-pipe, as every other key was dead. An instrument like this must have the soul of an old spinster, who with her indefatigably appalling piano-playing has poisoned her neighbours' life, and now they pull her hair, crunch her bosom with every squeeze of the pedal, while she is moaning her heart out, poor thing.

This piano with its soul whining like a hungry dog must have moved many listeners. Kind people, once they've poured the goodness of wine into their hearts, always take

pity on an instrument like this. One pours into it some wine, another a glass of cognac, others throw in a sardine, an odd slice of lemon, a cigar. And the beast devours it all and starts crying again, and sobbing, and wheezing, and tearing its guts out with a terrible howl.

Behind the bar sat a fat lady, at the piano a thin maestro. The lady's bosom was of such ample abundance it seemed it could feed not just a fair sized baby but a hundred hungry Tartars. It was only short of a miracle that someone as skinny as that zombie banging the bones of his fingers against the bones of the keyboard could remain so thin for long in her company. One could put on weight just looking at this goodly woman. She was sitting behind the bar counting sugar cubes and slices of lemon. Whenever someone looked at her she smiled the smile of a toad dreaming of its lover. Since it was a Sunday the place was full of people, but not so many that the beauty from behind the bar could not have cuddled them all up to her bosom.

At the door I was greeted by the director of the cabaret.

When I looked at that face I shuddered. The man was wearing evening dress which any corpse with a minimum of self-respect would have refused to have put on, kicking like a mule. The soiled shirt-front, visibly attached to the invisible shirt, had stuck into it two pieces of glass passing for diamonds, the trousers were folding into a concertina. But the face was really unusual. He was advanced, not to say hoary, in years, with black, sharp and wise eyes, and a goatee beard. His face, pale and strangely intelligent, bore signs of the suffering which had ploughed through it leaving behind deep furrows. His brow was high, wise, the brow of a thinking man, constantly worried by something for ever rolling and crashing at the bottom of his soul. It was a gaunt, pale face whose paleness was verging on blue, yet a face which in all its ugliness was quite attractive. One got the impression that he was a grand nobleman defeated by some misfortune, who still dons his worn out, grease-stained evening dress and, prowling the forest of life, fights for survival.

There was one thing in this face which was truly beautiful – his smile. It was a sad, quiet smile, sort of dreamy, kind and obliging, but at the same time painful and ironic; a smile of frosty contempt which was constantly present, lurking at the corners of his lips.

When I entered he sized me up with one piercing glance of his wise eyes and quickly walked up to me. I noticed then that he had a pronounced limp. With a bow he led me to my table near the bar, from behind which I was greeted by the barmaid's fat and rancid smile.

The gentleman with the goatee had apparently singled me out from the small company of guests who were as keen on merry-making as if the event were a paralytics' ball or the annual conference of Suicides Anonymous.

The atmosphere was heavy, sultry and muggy.

The cabaret director explained to me that I had missed the first two numbers of the programme, but no matter, they weren't worth seeing. In a moment though, the real attractions would begin and so it was only proper to ask if I would care for a bite to eat. No, I would not. Still, whoever comes to a cabaret must be looking for excitement and usually doesn't care for anything else. And he who doesn't care for anything, usually wants to get drunk. Well, that was the least of my temptations. It is easier, however, to kill a couple of hours with a bottle than without it. You can talk to a bottle and it won't answer back. How right were those wise men who considered a bottle man's most worthy companion. And so I asked the good director who was awaiting my orders with a wise and gentle smile:

"What wine do you have?"

"The worst in the world," answered this strange man kindly.

The answer was impressive. I smiled.

"There are no good wines left anywhere in the world," he carried on, "Human baseness could not even respect wine. What can we serve you, sir? A glass of soda with yeast and sugar. What would you like me to call this horsepiss? At least the name is old and original."

I looked at this odd and honest man with admiration. At the same time he, too, looked into my eyes. I was struck by the feeling that I had seen his strange and interesting face before.

"Two days ago, dear sir," the director said quietly.

"What happened two days ago?"

"You saw me at your uncle's house."

I was confused. What a fellow. Does he read thoughts or something?

"You read thoughts?"

"By no means, no, but the face of a man who is trying to remember something is very easy to read. At that particular moment you could only be preoccupied with my unworthy person. It's simple."

"Yes . . . simple. Please sit down, *Monsieur Directeur*."

"Thank you very much. You're very kind. In a minute I'm doing my number on that damn stage but there is still time . . ."

We were served some "Champagne Nouveau" and the waiter's terrible visage, the sight of which would fill any judge's heart with joy, inquired whether to pour a glass for the director. I readily assented.

"You have to drink what you have brewed yourself, sir," I said rather worried, seeing I had found a companion in disaster, for the champagne looked indeed like a disaster. It was pale yellow, like a man driven to despair by insomnia, bitter like a terminally ill patient, and acidic like someone suffering from a liver complaint. And it reeked of cork. In a word, high marks.

"One doesn't drink wine but the joy it brings, and one drinks the soul of a man who shares it," said the director.

"Beautifully said . . . So, I saw you at my uncle's funeral? Yes, I remember now . . . Were you his friend?"

"I never had the honour of making the gentleman's acquaintance."

"Ah, but your face was so full of sadness . . ."

"Yes, one human being less on this earth . . . though it's small cause for sorrow. In fact, the only reason I was so sad was that it was someone else being buried, and not me."

"Well, well, and who was the lady in heavy mourning at your side, the one who was crying so lugubriously?"

"You mean the 'heavy lady in mourning'. It was my wife. There, she who is sitting now behind the bar."

"Incredible! And what, pray, was your wife's connection with my uncle?"

"None."

"I don't understand. So why was the woman crying?"

"You see, my dear sir, I am also a funeral director . . ."

"Ah . . . Oh . . ."

"Yes. I had the honour of taking in person the measurements of the departed to make sure he would be comfortable in his coffin. No need to add that it was done with all due respect so as not to crumple the corpse as they usually do. You have no idea of the brutal lack of respect with which those vultures in the funeral business handle mortal remains."

"And your wife?"

"The role of my wife in this sad ceremony was more artistic in nature. My wife was an actress and used to play sorrowful and weepy parts. A mother who lost seven children in a day could not cry like she can, without the slightest cause or provocation. An exceptional woman . . . Would you allow me to send her a glass of this awful wine? Her talent deserves it."

"But please do, a whole bottle!"

"Thank you. Indeed, a bottle will bring her more joy than a thimbleful like this. Let it be her reward for the heartfelt tears she shed on your uncle's path to eternity."

"But why all these tears?"

"I was about to explain. The distinguished and honourable deceased, as you must be aware, was not particularly given to generosity. I think that I won't offend the memory of your dear relative if I say that even a dog would have left his house if he had to compete for bones with the master."

I nodded sadly.

"Yes, my dear sir," continued the director, "since no one

expected that you would come to pay this good man your last respects . . ."

"But why? I have come for my inheritance!"

"That is also a form of respect for the dead, and he must have felt a real pleasure seeing his wealth about to be taken over by a kind man, as kind as yourself . . ."

"Oh, don't mention it . . ."

"So, since the dear departed wished to have a sumptuous funeral – perhaps because he shied away from a sumptuous life – and to this end left a tidy sum with the solicitor, I engaged my wife to pour out all her tears. I think she rose to her sad and heartrending role magnificently. Were you pleased?"

"Please, thank your wife. She was crying as movingly as if it were she and not I who had inherited the money . . ."

"Thank you, sir, spoken like a true artist . . . Well, with your permission, I shall return in half an hour as it is my turn on the stage. You will see some extraordinary magic."

"Can't wait to see it."

"See you later, then."

He left me, dragging his left foot, shod in a strangely cobbled shoe, and came onto the stage. He gave a short speech for the benefit of the audience who were already nicely oiled, and who greeted him like an old friend. He bowed in my direction.

What a great fellow! A funeral director, cabaret director, magician, the soul of a grieving clown, idiotically honest, bombastic, modest and scathingly ironic. I watched with interest what he could do as a conjuror. To start with, he performed a few of the tricks usually seen in a shabby circus, the ones with cards, rings and watches lent by the reluctant public. He took out of his mouth crumpled newspapers on fire, belching smoke like a steam engine, imitated beautifully the voices of animals and birds, and in the end performed an extraordinary and dangerous trick: for a split second he disappeared, and reappeared again.

I was not drunk, and I rubbed my eyes to make sure I was not asleep or under some kind of hypnotic suggestion. The director noticed this from the stage and smiled at me.

The public clapped their hands with shy enthusiasm.

As for myself, I admit I was amazed by the masterful precision of this trickery and applauded my chance friend with honest admiration. On his return to my table I congratulated him heartily:

"Your disappearing trick, without screens or veils, was excellent. How does one do it?"

"Simply, one disappears."

"But how?"

"It's difficult to explain. But in fact it's no trick at all to disappear. So many things disappear in this world – fortunes, people, wives, lovers, and no one is surprised. My trick is surprising precisely because I reappear again. But I can get away with it, it's a cabaret. Many people would be met with a very unpleasant, even violent, reception if, having once disappeared, they reappeared again. If for instance your dear uncle, who disappeared into eternity . . . But I'm only joking, I hope you are not offended. Not many people return from there . . ."

"Not many? Methinks, no one returns from there!"

"That cannot be stated with complete certainty. But, to turn our conversation to other topics – there is one person I would gladly teach this trick to, omitting the reappearing part . . . Don't look towards the bar . . . Careful! If only she, ah . . . My wife . . ."

"Oh . . ."

"My wife is an angel, sir. But in life even angels, you understand . . ."

"Let's drink," I interrupted hastily, "you're becoming gloomy."

"Ah, yes, thank you. Since you are so kind, I'll have a glass. Soon the place will be empty. Are you in a great hurry?"

"I'm leaving tomorrow morning at eight, and I am not sleepy yet. I'll be glad to stay for a chat."

"I'll be gladder still. But, please don't be offended by my directness: could I send my wife something to drink, with your compliments?"

"But of course! Waiter, wine."

"Perhaps something else? Something stronger . . . ? A bottle of rum for instance?"

"Rum? For a lady? A bottle?"

"Oh, she can handle it. She is a gentle creature, but strong. Strong drink, moreover, has a soothing effect on her. She has a special predilection for rum because it makes her dreamy. I as well. And if you don't mind, I'd venture to recommend we change from this wine to something less awful."

"Cognac?"

"You drink cognac, and I, with your permission, vodka. Ordinary, neat vodka."

I ordered. My uncle turned in his grave and groaned, I heard it clearly.

"Vodka," my companion carried on, "has many noble characteristics: it soothes pain, enlivens the temperament, stirs the heavy, lazy northern blood. Apart from that, it looks like crystal clear spring water, and perhaps that is why it is liked so much by the good-natured Sarmatians.[1] Here, we have more winter than summer, more ice than sunshine; and vodka is nothing but melted ice. Every nation drinks in this way: the Italians and the French drink the gold of melted sunshine, we the ice. That's why a Pole glides through life as if on skates, and that is why he often staggers, for he finds it slippery. The Pole's sorrow is so hot that he finds it necessary to cool it with vodka, the sorrow of other nations is cold so they have to fuel it with wine. We have this undeniable advantage over other nations of the world in that we can drink anything. In this respect we are a nation of pure genius. If a Spaniard drank a bottle of our 'pure one' he would die in agony; a Pole would only be roused to drink Spanish wine. A mighty nation and always ready for a drink. But one has to know how to drink. To see a jolly drunken Pole is inspiring. What power, my dear fellow, what stamina, what open-heartedness! An Englishman drinks like a fugitive, in hiding, bad. In this respect I hold him in contempt. A Frenchman

[1]Sarmatia – anciently a region reaching from the Vistula and Danube to the Volga and Caucasus, the legendary cradle of Poland.

drinks beautifully, a German – it's not a pretty sight. How could beer defeat the wonderful and heroic power of wine? It's ridiculous. I'm beginning to worry seriously about the French growing into the habit of drinking beer. These are bad and dangerous things. I'm thinking of writing a manifesto imploring the French to stick to wine and ban beer drinking. Your health."

"Thank you. This cognac is infernal."

"Infernal? Don't think that everything from hell is bad, with the exception of women, though I think that even hell didn't want what women have done in its name."

"Do you mean there are no heavenly women?"

"Of course there are. How many times has the devil assumed the guise of an angel? It's one of the oldest and easiest of hellish tricks. Apropos of hell, my wife is sending her regards as she is about to retire. With your permission, I'll ask her for a little more time and offer her your goodbyes."

"Where do you live?"

"Here. If I may put it this way, in the ante-chamber of the temple of art . . . There, behind that curtain there are the doors which lead to our apartments. They are very modest as they are converted lumber-rooms. That is why everything has the musty smell of a museum, though the only museum piece is my august spouse."

"Please, convey my regards."

"Thank you. You show great kindness in honouring the monster."

"But, my dear fellow! How can you . . . ?"

"I can, I can," he said melancholically, "the Egyptians had their holy crocodile and I have my wife . . . I'll be back in a minute."

The kind man limped away towards his "apartments". In that room full of fuel-oil fumes, cigar smoke and the smell of an old wiping cloth, which even the strongest blast of fresh air wouldn't shift, there was no one left. The cut-throat dressed as a waiter was counting the night's takings at his table. I asked him to bring me more alcohol, paid the bill and

told him to go to the devil, adding that the director would close the shop himself.

I was left alone. It seemed to me however that the greenish, already thinner ghost of my uncle swam out from behind the stove and, having counted the bottles with his bony finger, sighed deeply like the Ghost in a provincial production of Hamlet. But it only seemed like that. I was alone and the ghost must have been born in the bottle of cognac.

I looked in the direction from where I expected to see my companion return. All that came from there were rising screams and the quiet voice of my table companion.

"Rum goings-on," I thought.

Suddenly I heard myself scream – I saw the director sitting next to me at the table.

"Here I am," he said in a sad voice.

I did not see him coming through the door. In fact I did not see anything . . .

"How – where did you come from?" I whispered terrified.

"Yes, I returned quite fast, which surprised you. But had you been present at the conversation with my wife you would be surprised why it took me so long. Apropos, you are a man of honour and perfect manners, I must ask you openly if you are offended by the fact that you are sitting with a man who only seconds ago had his face slapped?"

"You?"

"I wish it were someone else but there were no other candidates."

"Your wife? So violent? Why did you give her the rum then?"

"It would have been worse without it, the rum deprived her mighty feet of certainty in their movements, and the movements of their speed and power, so that in the end it was the soul rather than the flesh that suffered."

"You poor man . . ."

"Ah, sir, your sympathy is like a wonderful balsam poured over my head. I haven't felt so good, so joyful for a hundred million years. I thank you from the bottom of my heart. I

spend my days among such rabble that an hour spent with a man of such irreproachable manners and lofty soul is, for me, a great happiness."

"Drink then."

"Thank you. Even this stuff tastes unusually good. Let's make it a bit stronger."

He raised his glass of vodka and just as he was bringing it to his lips something terrible happened: his eyes turned green, his face pale, and from the glass burst out a bluish red, toxic flame. The director emptied it with relish.

I leapt off my chair. My head must have looked like a brush as the terrifying fear made my hair stand on end. I wanted to run away.

"What . . . what was that? . . ." I stammered.

"Some like it cold, some like it hot," said the director in a voice which seemed to be coming from his stomach. "Something wrong?"

"Who are you, for God's sake? Who are you?!" I cried out in a strangled voice.

Suddenly the lights went low and it became very quiet, as in a theatre. The director got up from his chair, bowed and said:

"The Devil, at your service."

Something grabbed me by the throat till I felt I was choking; my eyes were popping out of their sockets and my heart started pounding in my chest like a man trying to run away from a fire, my legs gave way and I couldn't even tell whether my hair was still standing on end or not, for inside my head I felt my brain turning into a block of ice.

The terrible man suddenly became sad. His eyes switched off like green lights and more normal colours returned to his face. The room became light again and he started speaking in a melancholy voice:

"And there we are. Even you became frightened, even you. I am sorry, I can't begin to tell you how sorry I am. Please, sit down and calm your nerves . . ."

He came up to me and forced me onto the chair. My soul

fled like a little deer while my numbed body could not make the slightest move. I followed him with my stupefied, frightened, half-crazed eyes, my ears full of whirring noise. Seeing that it had come to no harm my heart was slowly returning to its normal beat. I had an impression he was talking to me from far away, as if through a speaking-tube:

"These are the results of scaring children with the devil. Tell me yourself – what's so frightening about me? I am just like the others, only a bit uglier . . ."

"Eyes! . . ." something said within me, but it was not me who spoke.

"Eyes? . . . They just flashed a bit. Haven't you ever seen flashing eyes, or green eyes?"

"The foot . . ." said something within me again.

"The foot? Well, it's a bit out of shape. What can I do, my dear fellow, it's a hoof. But I prefer my devil's hoof to some people's feet. At least it is more of a horse's foot than that of an ass. And what, pray, is so extraordinary about my foot?"

"You drank fire . . ." I said with the voice of a dying man.

"If you could stand it you would drink it this way yourself. With respect, even the devil cannot stand that stuff people make out of potatoes without adding a touch of refinement. I rather prefer it in a fiery form . . . There, there . . . Nothing to be frightened of, really, is there?"

"No . . ."

"And you aren't that frightened anymore?"

"A bit less . . ."

"So now, looking at it clearly and without fear you can see what dirty tricks have been used by the opposition to disgrace the devil – black, horned, terrifying, breathing fire, always on the look out to catch a soul . . . My dear sir, never in my whole life have I done anybody any harm. Besides, what am I, a poor good-natured devil, compared to a man? And the amount of pain the devil gets from him is simply beyond measure . . . Well, are we feeling better now?"

"A bit better, but please, don't do any of your tricks!"

"Ha, ha!" laughed the devil, "my repertoire is very limited.

I'll only show you my tricks if you ask; you have seen some already, anyway. Let's drink."

"Let's drink. It's very nice talking to you, but you've scared the hell out of me, if I may put it that way."

"I can guarantee you, dear sir, that you would have been just as scared seeing an angel. Except that you won't see one. The devil is a creature much closer to man, much more curious and sociable. An angel is a count, an aristocrat, a subtle and delicate creature, and therefore reluctant to enter into the earthly atmosphere, which, to tell the truth, doesn't even smell all that nice. And the devil, a ruddy peasant, a brother-man-to-all, a good mate and old pal, won't turn up his nose, he'll stick it in and be happy anywhere, no whimsy or pretension. An angel though, finds it difficult to appear among people, he has to assume a more poetic, comely and tender form, he has to be a youth with lovely hair, swathed in white, with a long staff in his hand. Just imagine such a wonderful creature in the grey, human crowd. As for the devil, he is so like man, or should I say, man is so like the devil, that the keenest eye can't tell them apart. Would you guess what I am if I hadn't told you?"

"Maybe not . . . But your sudden reappearance . . ."

"They show better tricks at the cinema."

"So, please, tell me . . . Would you mind? . . ."

"I am proud that you ask a devil for permission. Usually they chase away the wretched devil like a dog. Please, ask your questions."

"Where did you come from? Why here and why in this form? You, a powerful being . . ."

"Powerful? Oh, my good young man! What false information you have! What do you call power? That I can turn my eyes green? That I drink vodka with fire? Any decent drunkard can do that trick for you. Of course, I do know more tricks of that sort, and more effective too, but that's all. This is just a means, a more or less skilful, more or less clever means."

"To what?"

"To keep up the good name of the firm. Hell is in a bankrupt state. Man has grown wiser, more skilful and clever than the devil himself."

"Impossible!"

"Alas, only too possible. Those few secrets that a devil had at his disposal to gain a reasonable degree of respect and position in the world have been almost entirely usurped by man. We are not protected by the Patent Office, my dear sir. And imagine the effort needed to give all these tricks the aura of wonder, horror and mystery – all this business with witches' sabbaths, brooms, goats, pucks, the midnight hour, anointing with magic potions and flying out of chimneys. And the result? The result was that when in a godforsaken hole of a village an old cow stopped giving milk, a witch had to be found and burnt, it was 'Get the devil!' then. Don't you think it ridiculous? Witches! Any actress would do for all the burnt witches."

"Unfortunately . . ."

"Or take that business of flying. The devil used to fly on a stretched-out cloak, clumsily, without comfort and in a ridiculous, grotesque way. Now, think what an envious eye he must be casting at the aeroplane, he can't fly around the world in just a few moments, you know . . . And the radio? Man is terrible, sir. He will be the devil's downfall, nay, he is that already!"

"What are you saying?"

"I say it with bitterness but I am telling the truth. Man improved on the devil's methods, made them more effective. The devil has to sweat weaving an intricate web of intrigue, use scores of people and strain his wits to come up with a slander. And then he jumps with joy that he is such a genius and has managed to create a situation where a man got another stitched up in a libel. Ha! Pick up any newspaper now and tell me who can do better: the devil or a man, a man with his few inches of newsprint?"

"Indeed, you amaze me."

"I could amaze you even more but we would need more time – and more wine to make it pleasant enough – for me

to show you how obsolete is the devil, that much needed and useful creature."

"Needed? Useful?"

"Yes, sir. Just like certain antibodies in the human organism the devil was necessary to the world. He was the cause of commotion, liveliness and excitement, he could bring life to boiling point, excite the mind and, to his own misfortune, he trained man to fight stupidity, sluggishness and futility. The devil taught Cain to envy, true! Noah to drink, true! But at the same time the devil taught the Greeks to sculpt and Ovid to write poetry about the art of love-making. The Borgias were devils skilled in poisoning, but Shakespeare, too, was a devil who knew more about man than the best trained devil in the profession. Voltaire was a terrible, malicious and witty devil, Napoleon vain and magnificent. These are all flesh of our flesh. Hell was a heavy, shapeless, pregnant cloud and these people were its flashes of lightning. We were good at gathering material and they, using us and our stupidity, made their incredible careers out of it. Man robbed us of all our ideas and inventions, and he robbed the heavens too, stealing the lightning."

"Why did you allow this?"

"You forget we are under a wardship and have no right of open representation. In the forest of life we are merely poachers while the true hunter, hunting openly and with lethal weapons, is Man."

"Poor devils."

"Thank you for your good words . . . What I'm telling you is only a rough outline of the devil's tragedy. If we were to look at it more closely, to examine the idea of the devil in all its contexts we would have to write volumes, talk about it for years. And what do I know? Nothing. I am only a devil of the seventieth degree, a very insignificant and poor devil. You ought to know that all the esoteric theories took their hierarchy of initiation from our system. I am merely an infernal menial, a hell-proletarian, though I must add, an intelligent proletarian . . ."

"I've already had the pleasure of making a note of that . . ."

224

"Oh, I am touched . . . There are however outstanding, wise devils of genius . . . They would be able to show you how man, the cleverest being in the universe, is indebted to us."

"Permit me to ask you this: do you hate people?"

"That would be saying too much. I am afraid of people and one can't be said to be fond of somebody one fears."

"Why have you assumed human form? Why are you sitting here living a human life?"

"Necessity, my dear sir. And this is my heart-rending tragedy. I was expelled from hell . . ."

"Expelled? From hell? You must be joking. Hell does not give anything back."

"That's another false legend about hell. In fact I was stripped of the rights of resident, hence my sorrow and nostalgia. It's all those damn cutbacks."

"Ha, ha, ha!"

"Your laughter wounds my heart. I'm not joking, hell was swept by a wave of job reductions."

"But why?"

"There's a recession in hell. I'll try to explain. You see, when the world was, one way or the other, still cultivating virtue, or as you say, lived in fear of God, we were rather empty. We had to win people, work for it, make expeditions. Devils were sent out into the world like salesmen and they would jump out of their seventh skin to bring someone back to hell. You understand? . . ."

"It's not that difficult to grasp."

"Even I, a devil of the lowest rank, even I had something to do, in fact quite a lot. Once I spent seven years tempting a cashier to 'do' the till. It took half a year to persuade a girl to 'forget herself'. And today? Today, my dear sir, the road to hell is flooded by a crowd of volunteers, horrible, new people, uninteresting, with bad manners, smelly, badly dressed, grey people. What hell needs a devil? Half of them tell lies, a third of them steal, a quarter of them do the dirtiest things and all of them play on the stock exchange. For God's sake! Ten years ago you wouldn't find a businessman there even if you tried. Now, go and see . . ."

"If you don't mind, I'll take your word for it . . ."

"Oh, I didn't mean it, you still have time. But I'll tell you a stranger thing: not so long ago a Polish cobbler was a rare thing in hell."

"Can't be!"

"And yet it's true. They were a tough, brave, honest and God-fearing breed; it was easier to find a cardinal in hell than a cobbler. And today? Today you can have an army of cobblers in hell. Terrible what's become of these people. The cobblers were soon followed by tailors, tailors by the other trades. So what's the devil to do? Nothing. Only keep order at the gates so the rascals don't push one another. Never was hell so full of riff-raff as it is now. Thus, half of the workforce went to the devil, that is, they were made redundant and thrown out onto the street. On the street meaning we were transferred to earth, where there is wailing and gnashing of teeth. And so I'm here, and weep."

"Do you really feel so bad?"

"Bad? Sir, I am the most unhappy being on earth."

"Well, well, well . . ."

"Don't you believe me? Look what I am and where I am! In a rotten, muddy hole performing tricks in a cabaret."

"I can see that, but I don't understand. With your tricks and your intelligence you could live like a prince in Paris."

"No, sir, I can't. My stupid trickery is good enough for this riff-raff, even my more difficult tricks are just for them. I would draw too much attention to myself in Paris, which would be dangerous. Besides, Paris is overcrowded with devils, everybody went into the big cities. A few found a place in the diplomatic corps, many opened bars and gambling houses. I'm too modest and unused to big city life. So I've clenched my teeth and vegetate here. And anyway, I used to work in these parts, I know the country and the people. I don't want to take risks; even here I've had enough troubles. At any rate, my heart's broken by homesickness."

"So, has life been so bad from the beginning?"

"No. I tried different professions. Of course there was a problem for, as you can see, this damn foot always gets in the

way. With such a foot I cannot be a postman, a messenger, an actor, singer, cyclist, soldier, I cannot be a dance teacher. So I had to try my hand at all sorts of things and managed to earn a bit of money."

"Excellent!"

"Alas, I entered a partnership with someone who cheated me. Then I gambled on the stock exchange and went bust. I was ruined and you see now what I do. I want to cry when I walk onto this stage."

"With due respect, I don't want to offend you . . ."

"Please, go ahead . . ."

"Well, with all your intelligence, with your phenomenal skills and your devilish disappearing act, you could . . ."

"What? . . . Go on . . ."

"You could make a lot of money any way you wanted to."

"What way, for instance?"

"Well . . . The simplest . . . Any old bank . . . you understand . . . Any jeweller . . ."

"What?"

"Please, don't be offended, but it's so simple . . ."

"No, sir. It is not that simple. I am not offended, for you are a human being and you cannot imagine that I can not, that I should not take advantage of my devilish skills. But, you see, the devil is not a robber, even though he is robbed. Whatever deal the devil struck up man always cheated him, never the other way round. The devil believed in man's word, man believed it should not be kept. He had an easy way out and always took it. But the devil upholds the rules of honour, and honour forbids stealing."

"Please, forgive me . . ."

"Oh, never mind, you couldn't have thought differently. Devils have never had a good name. Many human traits pain me, many I find ridiculous and irritating but what truly rouses my bile is man's total disregard for the devil. Man doesn't know himself why, and to what purpose, he throws around all these stupid sayings about the devil – 'the devil take you!', 'go to the devil', 'devil's bones' and 'devil's books' a mountain of terrifying beauty will always be 'the devil's

rock' and a dangerous pass 'the devil's pass' or 'neck'. Let it be, some of them are simply stupid, the others, true, come from admiration for the devil. But please explain to me, where do sayings like 'satanic laughter' or the 'devil's smile' come from?"

"Indeed, I don't know . . ."

"I do. Man draws his knowledge about the devil from the opera. Some idiot actor playing the devil squeezes a couple of croaks out of his belly which are then called 'satanic' or 'infernal laughter'."

"And how does the devil laugh?"

"The devil never laughs. Nowhere in the universe is there a being more profoundly sad, more woeful than the devil. Why? This is not the time or the place for such questions. Let us leave it. But returning to my story I have yet another practical problem: I have no documents. As you've probably guessed I have not been christened and so I haven't a birth certificate. I arrived in this world as a finished product, in the form you are seeing now, without any ID."

I smiled but did not say anything. The devil noticed my smile and responded to it:

"A false one? Nothing simpler. But as I told you I have an aversion to cheating. One can live without documents and, obviously, it is easier in a small town where little attention is paid to these things than in a big city, where you're asked to produce your documents at every step . . ."

"But how on earth could you get married without a birth certificate? Not to mention the fact that one usually marries in church?"

"My dear sir, it's easier to get a wife than an ID. The solemn ceremony of my marriage is not only left undocumented but no one has seen it. My wife was an opportunity sent by heaven, if I may put it that way. And since I couldn't expect heaven to send also its blessings and happiness I've ended up groaning under this heaviest of misfortunes."

"But isn't living in sin also dishonest?"

"Not in the least. It's a good, honest business only without the customary approval. Sometimes it is marriage that is out-

right dishonest, as people make a vow they know they are not going to keep. Besides, in the matter of love, when it really binds two people together, the question of dishonesty doesn't arise. People, and I must insist that I am a man, do not cheat when they get together; they do it after."

"Do you love your wife?"

"I have a rather sentimental disposition . . ."

"Does she know who you are?"

"No. I don't think she even suspects that I am a devil, for if she did she would have more respect for me, or even fear me."

"She feels none of these . . . ?"

"If persistent knocking on the head with a fairly heavy object is a sign of respect I am the most respected of husbands."

"Why do you suffer all this?"

"I am a man, sir. The devil in me rebels but the man in me accepts that I must suffer. Besides, the romantic side of life according to human conception, this thing called love, which this woman constantly bestows upon me, a love somewhat cloudy, perhaps even a touch too stormy and so full of pain, this love is my only diversion. Humbled as a man I forget that I am a free devil. My suffering is that much smaller and my wife's yelping helps to numb my homesick heart."

"Extraordinary! So you miss hell so much?"

"Oh, yes. I feel so awfully miserable I wouldn't dare to tell you just how much. I can't live in the atmosphere of moral fustiness, in this morass, among thieves and small time crooks, among petty swindles and perfidies. I want to die!"

"What's stopping you? Is it so difficult to die?"

The poor devil looked at me sadly.

"Of course! It's easy, it's easy for you, it's easy for everybody. For me, it's not easy."

"Are you afraid?"

"What the hell are you talking about? I want to die the way you want to live; for no other way but through the gates of death can I return where my soul longs to be, among my own kind."

"But they don't want you there."

"You're beginning to understand my situation. Yes, they don't want me there and they won't allow me to die. One day they will, the devil is not as unrelentingly merciless as man. One day my brothers will take pity on me and let me escape from this prison."

"Have you tried to die?"

"But of course. I kept thinking, deluding myself with the hope that I'd be called back or that they'd let me in if I just turned up. I shot myself, the bullet went through me and broke the window. I tried to drown myself, keeping my head under the water for hours until I got bored stiff. My relationship with this woman wasn't such a thoughtless step. I was counting on moving hell with my torture and humiliation; I was hoping that what could not be achieved through the deadliest of means could be achieved by a woman . . ."

"That reasoning is not altogether groundless . . ."

"And yet . . . I ate cyanide like sweets, I threw myself under trains but all I could achieve was their derailment. Hence my sorrow and melancholy. In desperation I wanted to intoxicate myself, fall into a state which would be at least half a death, I wanted to go mad and I've read all you people have written about it . . ."

"And nothing?"

"As you can see . . . nothing."

"What about hanging . . . ?"

"Oh, twenty times, it's not even worth mentioning. I was hanging for hours only to be taken down . . ."

"But, my dear fellow . . . !"

"Yes, sir?"

"Do you think I'm an idiot, or merely drunk?"

"You are drunk to what I call a 'reasonable' degree, and your intelligence amazes me. I wouldn't dare to insult a man I'm drinking with. Drinking binds people together more than anything."

"So it's all true?"

"I told you, all that is human in me is the body."

I rubbed my eyes and a terrible thought entered my mind.

"Do forgive me," I said, "it's not that I don't believe you . . . it's just that it is so unbelievable . . ."

"It would be interesting to see, wouldn't it?"

"Exactly!"

"Well, what would you like me to do? Have you got a gun?"

"Unfortunately . . ."

"Some poison?"

"Apart from the one we are drinking, no."

"Wait! there's a solid hook in the wall here and it shouldn't be a problem to find a rope. I'll hang myself for your pleasure . . . I see there's a bottle of cognac left. With your permission, I wouldn't like to leave behind anything as good as this."

A feverish excitement came over me. The man was serious. He drank for a long while and then said:

"Please, pray for me that I go to hell . . ."

"If it pleases you . . . What are you doing?! Are you mad?!"

"I'm hanging myself!"

"I can't let you!"

"Dear sir, I am quite drunk but I know what I'm doing. You just sit down, smoke your cigarette and watch. If you feel lonely take me down, if you want to leave, leave. My wife will take me down tomorrow morning and I'll come and see you before your departure. Good night, I'll be seeing you."

I was standing completely paralysed, watching this madman tying the rope to the hook, getting up on the chair, putting his head through the noose, tightening it and finally kicking the chair away. I had no strength to cry out. I had a feeling that the rope was tightening round my own neck. What have I done? Oh, what have I done?

The poor devil stretched tensely and his head inclined to the left, a perfect picture. A smile of gentle contempt was stuck on his face, his eyes were closed. No sound came from him. He was hanging quietly, he must have been dead.

An icy fear swept over me and I started shivering. I felt my hair stand on end. I wanted to cry for help but couldn't.

What was the use of crying anyway? This terrifying jester was by now laughing in hell, the charlatan-magician had paid for his stupid joke with his life.

I sobered up and it dawned on me that I was to blame for the man's death and that I would have to answer for it. We were seen drinking together, I was the last person seen with him alive. The situation was beginning to look grim.

I was overcome by cowardice which crept out from some dark crevice of my heart. I ran away. Furtively, gingerly, careful not to be seen by anybody. Fear followed me and I ran just ahead of it. I burst into the hotel and started packing hurriedly. Grey dawn was already looking in through the windows. My train was leaving in a few hours. Sheer despair!

Weak, overcome by fear, I was going mad under the torture. Two hours left, one hour. It's broad daylight, they must have found that tragic fool, that drunkard who tricked another drunkard. The police will be here any minute.

Someone knocked on my door.

My heart stopped in its tracks like a frightened hare in a burrow. My hands gripped the chair.

"The police!" my soul groaned inside me.

Someone knocked again and, since I did not respond, entered the room.

On all the devils of all hells! I reeled, my eyes nearly fell out of my head. Cold sweat broke out on my forehead.

He! It was he, in person, standing in the doorway smiling his gentle contemptuous smile.

"I'm sorry," he said sadly, "but I wanted to keep my word."

"Is it you?"

"What's so strange? I told you I would come. I was a bit sad that you left my company and, so lightly, half a bottle of cognac. But it's the human way, I'm still trying to understand it. If you hanged yourself I would not leave you alone . . . But please, don't be offended . . ."

"The fear . . ."

"Yes, I understand, I understand, let's not talk about it . . . It's

232

nothing compared to the fact that I've failed again. I was hanging for hours, in vain. My dear sir, I am so unhappy . . ."

My heart was touched. Indeed, this must be the unhappiest man on earth. Suddenly, out of my gloomy reverie came a brilliant thought.

"My dear fellow! Have you got some time to spare?"

"A hundred, two hundred million years . . ."

"In half an hour I'm leaving for the capital, come with me!"

"My misfortune is the same wherever I go. What for?"

"How am I to know? It's always easier to find death in a big city."

"I'm coming!" cried the director.

"And your wife?"

"It's easier to find a husband in the provinces."

And in that way this good old devil became my friend. I had an inexplicable weakness for him and I liked the lame wise wretch. In fact all my friends grew to like him too for his kindness, his wit and bitter but gentle sense of humour.

A few times he tried to kill himself in "big city style": he would throw himself from the top floor of the tallest building in town but managed only to scare a dog, which ran away bewildered by the view of a man who fell from the sky, then sprang to his feet, cursed, and walked away.

I had my plans, but I was careful, cunning and purposeful. It would be too boring to tell the whole story of how I reached my goal. Suffice it to say that this charming devil, once in Rome, did as the Romans do, and after a year became a playwright. Of course, his talent was diabolical. He wrote an excellent play and then began to write for a living. I cut off his allowance. At this point the story begins to be really interesting: the critics denied he had talent, accused him of being too pretentious, full of clichéd wisdom, his ironies too virulent, and they stated he was too slavish a follower of G.B. Shaw. That's what was said about the wise, old devil because he was, the fool, a Pole and wrote in Polish. His novel was sent to the devil, his great poem *Inferno* condemned as "falsely demonic" rubbish.

This stirred up in him his hellish pride; the devil was suffering. The insults heaped on him were painful and poisonous, he was torn limb from limb and thrown into despair. Quite well fed when with me, now he was losing weight by the day; he turned grey and looked old. Someone wrote about him in a magazine that a man who leaves his wife on the street is scum, not a poet.

The devil who swallowed cyanide like aspirin could not swallow what was written about him. He suffered terrible torment. His noble soul was reduced to spasms of utter desperation. Soon nobody wanted to publish his stupid books. He came to ask me for money. I refused. When I visited him (he lived in an attic despite his fame), he was lying in bed, a broken, tortured man. The triumph of his initial success had been too great for the subsequent disappointment not to be terrible.

One night he sent for me.

I found a skeleton ravaged by hunger and despair surrounded by piles of manuscripts.

He gave me one of his gentle smiles:

"Thank you," he said quietly. "Now I understand how wisely you led me to it. Tonight I will die . . . Of hunger . . . To think that I, an old devil, haven't thought of it before, that to die all I had to do was to start writing books . . . How wise you are, how wise . . . I only hope they'll take me back in hell . . . for I cannot bear it any longer . . ."

He took my hand, and died with a wise and kindly smile on his face.

He must have died properly for there was a sudden, strange noise in the air, like the wind howling. It was the devils, his brothers, crying when they saw what had happened to him and what terrible torture he suffered, the devil who wrote books in Poland.

And so they welcomed him back to Hell with great love and compassion.

DINNER AT COUNTESS KOTŁUBAY'S

by Witold Gombrowicz

It's difficult to state with absolute certainty what my intimate acquaintance with Countess Kotłubay was founded upon. Naturally, speaking of intimacy, I have in mind only that fragile mode of closeness possible between a full-blooded and to-the-bone aristocratic member of society, and an individual from a sphere which is respectable and worthy enough, but only middle class. I flatter myself that on a good day I possess in my demeanour a certain loftiness, a deeper gaze and a sense of idealism, which allowed me to win the discriminating sympathy of the countess. For since childhood I have felt a close affinity with Pascal's "thinking reed" and have had an inclination towards the sublime; I often spend long hours contemplating lofty and beautiful ideas.

This selfless inquiry – this nobility of thought, this romantic, aristocratic, idealistic, slightly anachronistic attitude of mind – earned me, as I suspect, access to the countess's *petits-fours* and to her incomparable Friday dinners. For the countess belonged to that rare breed of women – at once evangelic and renaissance – who preside over charity balls and at the same time pay homage to the Muses. Her countless acts of compassion aroused admiration. The fame of her philanthropic "teas" and artistic "five o'clocks" at which she performed like some Medici princess was widely spread while the smaller salon, where the countess used to receive just a handful of truly close and trustworthy guests, was tempting in its exclusivity.

But most famous were the countess's vegetarian dinners.

Those dinners gave her, as she used to say, a breathing space in the continuous stream of philanthropy. They were something of a holiday, a new point of departure. "I too want to have something for myself," said the countess with a sad smile inviting me for the first time to one of those dinners two months ago. "Please come on Friday. A little singing and music, a small circle of my closest friends and you. And it's on Friday in order to avoid even a shadow of thought about, well . . . meat," she recoiled slightly, "about this eternal meat of yours and this blood . . . Too much carnivorousness, too many meaty smells. You see no happiness beyond a bloody beefsteak! You run away from fasts. You would gobble up disgusting scraps of meat all day long without a break! I am throwing down my gauntlet," she added with a subtle wink of her eye, meaningful and symbolic as usual. "I want to convince you that a fast is not a diet, but a feast for the spirit."

What an honour! To be numbered among the ten people, fifteen at most, who obtain access to the meatless dinners of the countess!

The world of high society has always held a magnetic attraction for me, let alone the world of those dinners. It seems that the countess's secret aim was to dig, as it were, new trenches of Holy Alliance[1] against the barbarity of our days (after all the blood of the Krasińskis ran in her veins),[2] that she wanted to pay tribute to the deep conviction that blue-blooded aristocracy exists not only to adorn fêtes and parties but that also in other, spiritual and artistic areas, it is

[1] Holy Alliance – a league formed after the fall of Napoleon by the sovereigns of Austria, Russia and Prussia, professedly to regulate all national and international relations in accordance with the principles of Christian charity.

[2] An allusion to a masterpiece of Polish romantic literature "The Un-Divine Comedy" and its author Count Zygmunt Krasinski who, shaken by waves of popular unrest sweeping the post-Napoleonic Europe, depicted an apocalyptic vision of the collapse and destruction of European culture.

capable of self-sufficiency by virtue of the superiority of its race; that therefore a truly aspiring salon is an aristocratic salon. It was an archaic, if somewhat unoriginal thought, but at any rate – in its venerable archaism – unbelievably brave and deep, such as could rightly be expected from the descendant of hetmans.[3] And indeed, at the table in the historic dining-room, away from corpses and murders, away from the billions of slaughtered cows and oxen, the representatives of the oldest families under the leadership of the countess would resurrect Plato's symposia. It seemed that the spirit of poetry and philosophy rose from among the crystal and flowers and that the charmed words fell spontaneously into rhyme.

There was for instance one prince who at the countess's request took the role of intellectual and philosopher, and he acted it in such a princely manner, delivering such beautiful and noble ideas, that on hearing them Plato himself would have humbly consented to wait upon the prince, napkin in hand. There was a baroness who undertook to enliven the meetings with her singing, and although she had never been taught to sing I doubt whether Ada Sari would have sung so well in such a situation. Something inexpressibly marvellous, wonderfully vegetarian, luxuriously vegetarian, I would say, was contained in the gastronomic frugality of those parties; and seeing those gigantic fortunes modestly bent over small portions of kohlrabi made an unforgettable impression, particularly in view of the horrific carnivorousness of our times. Even our teeth, the teeth of rodents, were losing their Cain-like stigma. As for the cuisine – undoubtedly the countess's cuisine had no equal. The extraordinarily rich juicy taste of her tomatoes stuffed with rice, the firmness and aroma of her omelettes with asparagus were truly divine.

After a few months, on the Friday I'm going to speak about, I was honoured with another invitation, and with understandable nervousness I drove in a modest drozhka

[3] Hetman – one of the four highest commanders of the Polish army up until 18c.; a position usually held by members of aristocratic families.

under the ancient fronton of the palace located near Warsaw. But instead of the greater number of people I had expected I found only two guests, and even these were not in the least distinguished: an old toothless marquise who made a virtue of necessity by indulging in vegetables every day of the week, and some baron, namely Baron de Apfelbaum of a somewhat dubious family, who by means of his millions and his mother – *née* princess Pstryczyńska – had redeemed himself from the number of his ancestors and his otherwise irredeemable nose. From the start I sensed a subtle dissonance, as if something was out of tune. Moreover, the pumpkin soup – *spécialité de la maison* – soup from a pumpkin cooked sweet and tender, which was served as the first course, turned out to be unexpectedly thin, watery and tasteless. However I betrayed not the slightest sign of surprise or disappointment (this kind of behaviour would be acceptable anywhere else but not at Countess Kotłubay's); instead, with my face bright and exalted I managed a compliment:

> *"Can one praise this soup any further?*
> *Cooked without a corpse or a murder."*

As I mentioned before, at the countess's Friday dinners poetic verses would form themselves on one's lips as a result of the exceptional harmony and loftiness of these meetings; it would be simply unbecoming not to weave rhymes into stretches of prose. Suddenly – to my horror! – Baron de Apfelbaum, who, as a poet of exceeding refinement and a fastidious gourmand, was an ardent admirer of the hostess's inspired gastronomy, leans towards me and whispers in my ear with ill-concealed distaste and an anger which I never would have suspected of him:

> *"The soup could be good – agree without rancour*
> *if only the cook weren't such a . . ."*

Surprised by this naughty aside I coughed. What did he mean by that? Luckily the baron restrained himself. What

238

on earth had happened since my last visit? The dinner seemed merely to be the phantom of a dinner, the food was mean, the faces were long . . . After the soup the second course was served – a platter of thin and peaky carrot in brown flour and butter. I admired the spiritual strength of the countess. Pale, in a black *toilette* with family diamonds, she consumed the dubious dish with undaunted courage, thus forcing us to follow her, and with her usual skill she led the conversation towards celestial heights. She started off with charm, though not without melancholy, waving her napkin:

> *"Let there flow some deeper thoughts, more fruity!*
> *Tell me now, friends – what is Beauty?"*

I responded immediately, giving myself suitable airs and glittering along with the front of my evening suit:

> *"No doubt it's Love in all its ways!*
> *On us it shines and bestows its rays!*
> *On us – the birds who don't sow but reap,*
> *The dee-jayed birds on this earthly trip."*

The countess thanked me with a smile for the immaculate beauty of this thought. The baron, like a thoroughbred seized by the spirit of noble rivalry, drumming his fingers, throwing sparks from the precious stones – and rhymes whose art he alone possessed – took off:

> *"Beauty – rose,*
> *Beauty – storm,*
> *(and so on . . .)*
> *But more beautiful than those*
> *is Charity. For look, behold!*
> *Outside it's raining all the time.*
> *Wind, rain and cold –*
> *like a punishment for a crime.*
> *Oh! those unhappy and poor of mine!*

> *Indeed, this little tear of sympathy,*
> *This little shower of charity,*
> *This is the secret of beauty and nobility."*

"Beautifully expressed, dear sir," lisped out the toothless marquise ecstatically. "Wonderful! Charity! Saint Francis of Assisi! I too have my poor, little children suffering from the English disease, to whom I have sacrificed my toothless old age. We ought to think constantly about the poor, unhappy ones."

"About prisoners and cripples who can't afford artificial limbs," added the baron.

"About old, skinny, emaciated ex-school mistresses," said the countess compassionately.

"About hairdressers prostrated by swollen veins and starving miners suffering from ischemia," I added, deeply moved.

"Yes," said the countess, as her eyes lit up and she looked into the distance. "Yes, Love, Charity, two flowers – *roses de thé*, tea roses of life . . . But one shouldn't forget about one's noble duty to oneself." And having thought a little, she said, paraphrasing the famous dictum of Prince Poniatowski: "God entrusted me with Maria Kotłubay and to Him alone shall I return her!"[4]

> *"I need to stir inside me all the might*
> *to keep ideals in my sight,*
> *the everlasting light."*

"Bravo! Excellent! What a thought! Deep! wise! proud! God entrusted me with Maria Kotłubay and to Him alone

[4] The legend has it that Prince Josef Poniatowski – nephew of the last king of Poland Stanislaus Augustus Poniatowski – threw himself into the river Elbe after the defeat of Napoleon in the "Battle of the Nations". This defeat dashed all the hopes the Poles had for the resurrection of an independent Poland under Napoleon's protectorate, with Prince Josef as its head.

shall I return her!" – cried out everybody, while I, bearing in mind that Prince Josef had been mentioned, allowed myself to strike gently the note of patriotism: "And remember always – Eagle White."[5]

The servants brought in an enormous cauliflower swimming in fresh butter, glistening with gold, although on the basis of previous experience one could only assume that its colouring was as misleading as a consumptive's flush. That's what the conversation at the countess's was like. It was a feast even in such unfavourable gastronomic circumstances. I flatter myself that my statement that Love was the most beautiful virtue was by no means a shallow one; I'd even say it might be a jewel in the crown of any philosophical poem. And then another of the guests throws in an aphorism that Charity is even more beautiful than Love. Wonderful! And true! For indeed, when one thinks about it deeply Charity spreads its cloak wider and covers more than lofty Love. But that's not the end of it. This wise Amphitryon of ours, anxious that we should not be carried away by Love and Charity, mentions *en passant* the noble duties one owes to oneself; and then I, subtly taking advantage of the ending on "-ight", added just one thing – "Eagle White". And the form, the manners, the mastery of self-expression, the noble and elegant frugality of the feast, all competing with the content. "Oh no!" I thought delightedly, "someone who has never been to the countess's Friday dinner – he does not, properly speaking, know the aristocracy."

"Excellent cauliflower," all of a sudden muttered the baron, gastronome and poet, and in his voice one could detect pleased surprise.

"Indeed," confirmed the countess looking at the plate with suspicion.

As for myself I noticed nothing extraordinary in the taste of the cauliflower. It seemed to me as pale as the previous dishes.

[5] White Eagle – Polish national emblem.

"Could it be Philip?" asked the countess, her eyes firing sparks.

"We'd better check," said the marquise mistrustfully.

"Call Philip!" ordered the countess.

"There is no reason to hide it from you, my dear fellow," said Baron de Apfelbaum and explained to me in a low voice, with badly concealed irritation, what was the matter. Thus, no more and no less, on the previous Friday the countess had caught the cook seasoning her idea of a vegetarian feast with bouillon. What a rascal! I couldn't believe it. Indeed, only a cook could have done such a thing! What's worse the obstinate cook, as I heard, showed no repentance but had the cheek to contrive in his defence a peculiar argument – that he wanted their lordships to have their cake and eat it. What did he mean by that? (Allegedly, his previous employment was with a bishop.) Only when the countess threatened him with immediate dismissal did he swear to discontinue the practice. "Fool!" the baron summed up his story. "The fool, let himself be caught! And that's why, as you see, most people haven't come, and hm, if it hadn't been for the cauliflower I'm afraid they would be quite right."

"No," said the toothless marquise chewing the vegetable with her gums, "it's not a meaty taste . . . Smack, smack . . . It's not a meaty taste, rather . . . *comment dirais-je* – exceptionally nourishing; must have masses of vitamins."

"Something pepper-like," remarked the baron, discreetly helping himself to another portion. "Something delicately peppery . . . smack, smack . . . but meatless," he added hastily. "Clearly vegetarian, peppery-cauliflowery. You can rely on my palate, my dear Countess. In the matter of taste I'm another Pythia." But the countess would not calm down until the cook appeared before her – a long, skinny, ginger-haired character with an oblique look – and swore on the grave of his dead wife that the cauliflower was pure beyond reproach.

"Cooks – they are all like that," I said sympathetically and helped myself too to the dish which was enjoying such popularity (although I still couldn't find in it any outstanding quality). "Oh, yes, one needs to keep an eye on cooks." (I'm

not sure whether such remarks were sufficiently tactful but I was overcome by the excitement – light as champagne bubbles.) "Cook – in that funny hat of his and an apron!"

"Philip looks so good-natured," said the countess with a tone of sadness and a mute reproach, as she reached out for the butter-dish.

"Good-natured, good-natured . . ." I was insisting on my opinions perhaps too stubbornly. "However, a cook . . . a cook – please consider this fact, ladies and gentlemen – is a common fellow, *homo vulgaris*, whose task it is to prepare elegant, exquisite dishes – there's a dangerous paradox. Churlishness preparing elegance! What's that supposed to mean?"

"Extraordinary aroma," said the countess inhaling the bouquet of the cauliflower with her nostrils wide open (I couldn't smell it), and without putting down the fork which constantly flickered in her hand.

"Extraordinary," repeated the banker, and in order not to spatter his shirt frills with the butter he tucked the napkin under his collar. "Just a little more, if I may, dear Countess. I'm reviving indeed after that, hm, soup . . . Smack, smack . . . True, cooks cannot be trusted. I had a cook who cooked Italian macaroni like no one else. I would simply stuff myself! And one day, can you imagine, I come into the kitchen and see in the saucepan my macaroni swarming, literally swarming! And it was earth-worms – smack, smack – earth-worms which the rascal was serving as macaroni. Since then I never – smack, smack – look into saucepans."

"There we are," I said. "Precisely." And I went on saying something about cooks, that they are assassins, small time murderers who don't care what or how as long as there is something to pepper, dress up or prepare. Not entirely proper remarks, and indeed wholly obnoxious, but I got carried away. "You, Dear Countess, who shudder at the idea of touching a cook's head – in soup – you eat his hair!" I could have gone on in that vein even longer, for in no time at all I was overwhelmed by a tide of treacherous eloquence – when suddenly I stopped. No one was listening to me. An extraordinary vista opened before me – that of the countess, an

aristocratic patroness and dogaressa, devouring in silence and with such greed that her ears were quivering. It was a sight which both frightened and astonished me. The baron was seconding her bravely, bent over the plate, slurping and smacking with all his heart. The old marquise too was trying to catch up with them, chewing and swallowing enormous chunks, apparently in fear that they would snatch up the best bits from under her nose.

This sudden and incredible picture of gluttony – I can't express it in any other way – such gluttony, in such a house, this dreadful transgression, this crashing discord, so shocked the foundation of my being that, unable to constrain myself, I sneezed. And because I had left my handkerchief in the pocket of my coat I was forced to excuse myself from the guests and leave the table. In the hall, having collapsed on a chair, I tried to calm my bewildered senses.

Only someone who like me had known the countess, the baron and the marquise for such a long time, the elegance of their movements, the delicacy, the frugality and subtlety of all their habits (especially their habits of eating), and the impeccable nobility of their features – only he could appreciate the impression they had made upon me. At that moment I glanced accidentally at a copy of the *Red Courier* sticking out from my coat pocket and my attention was drawn to a sensational headline:

MYSTERIOUS DISAPPEARANCE OF CAULIFLOWER!
Cauliflower Under Threat of Freezing to Death!

And below the following note:

– The farm-hand Walenty Cauliflower from the village of Rudka which belongs to the widely esteemed Countess Kotłubay has reported at the police station that his son Bolek, eight years old, round nose, blond hair, has run away from home. According to the police report the boy ran away because his father flogged him with a belt when drunk and his mother starved him (unfortu-

*nately a common occurrence in these days of crisis). There is a fear
that the boy could freeze to death wandering about the fields in
the bitter autumn weather.*

"Tss," I hissed to myself. "Tss . . ." I looked through the
window at the fields veiled by a thin screen of rain. I re-
turned to the dining-room where the enormous silver
platter gaped emptily with the remains of the cauliflower.
The countess's stomach looked as if she were seven months
pregnant, the baron was virtually drowning his head in the
plate and the old marquise was chewing, tirelessly moving her
jaws – indeed I'm forced to admit it – like a cow. "Divine!
Marvellous!" they kept repeating, "Splendid, supreme!" Ut-
terly confused I tried the cauliflower once more, giving it all my
attention. But I tried in vain to find something that would
even partially justify the astounding behaviour of the guests.

"What on earth can you see in it?" I mumbled shyly, a bit
ashamed.

"Ha ha ha, he's asking!" cried out the baron stuffing
himself, in excellent humour.

"Don't you really see, young man?" asked the marquise
without stopping her consumption even for a second.

"You are not a gastronome, sir," remarked the baron as if
with a shade of polite commiseration. "And me . . . *Et moi, je ne
suis pas gastronome – je suis gastrosophe!*" And either my ears
deceived me or, as he was pronouncing this French phrase,
something swelled within him so that the last word "*gastro-
sophe*" was expelled from the puffed cheeks with an ostenta-
tious superiority which I had never seen him show before.

"Well cooked, certainly . . . very tasty, yes, very . . . but . . ."
I stumbled.

"But? . . . What 'but'? So you really cannot grasp the taste?
The delicate freshness, the . . . smack . . . indefinable firmness,
the particular pepperiness, the fragrance, the alcohol? Why,
of course, dear sir is only pretending, he must be teasing us."
It was the first time since we met that I had been addressed
from such a height as "dear sir".

"Don't tell him!" the countess interrupted coquettishly,

rolling with laughter, "Don't tell him! He won't understand anyway!"

"Good taste, young man, one sucks with one's mother's milk," lisped the marquise good-naturedly, giving me, as it seemed, to understand that my mother – peace to her memory – must have fed me with a different kind of milk.

And then all of them, forgoing the rest of the dinner, carried their full stomachs over to the golden Louis XVI boudoir where, sprawling on all the softest armchairs, they began to laugh heartily, no doubt at me, as if I had indeed given them reason for such merriment. I have been rubbing shoulders with the aristocracy at teas and charitable concerts for a long time but on my word never have I seen such behaviour, never such a transformation, such an inexplicable metamorphosis. Not knowing whether to stand or sit down, whether to be serious or rather *faire bonne mine a mauvais jeu* and grin, I made a vague and shy attempt to return to Arcadia, that is to Beauty, that is to the pumpkin soup:

"Returning to what is beauty . . ."

"Enough! Enough," cried out Baron de Apfelbaum stopping his ears. "What a bore! Now playtime! *S'encanailler!* I'll sing something better for you! An operetta piece!"

> *"What a funny little twit!*
> *Understands he not a bit.*
> *Let me sharpen then his wit:*
> *Nothing is beautiful in virtue of Beauty chaste.*
> *What's beautiful is of Good Taste.*
> *Taste! Taste! It's got to bear this sign!*
> *That's how Beauty I define!"*

"Bravo!" exclaimed the countess and the marquise repeated after her, revealing her gums in a senile giggle, "Bravo! *Cocasse! Charmant!*"

"But it seems to me that . . . it's not like that . . ." I stuttered, my stupefied look ill becoming my evening dress.

"We, the aristocracy," the marquise leaned towards me good-naturedly, "we cultivate a great liberty of manners

246

within our closest circles; but then, as you might have heard, sometimes we even use coarse expressions, sometimes we are frivolous and more often than not – in our own way – vulgar. But one doesn't need to be frightened. One needs to get used to us."

"We are not so terrible," added the baron patronisingly. "Although our vulgarity is more difficult to comprehend than our elegance."

"No, we are not terrible!" shrieked the countess, "We don't eat people alive!"

"We don't eat anybody except . . ."

"Apart from . . ."

"*Fi donc*, ha ha ha!" they burst out laughing, throwing embroidered cushions in the air, and the countess sang:

> *"Yes, yes,*
> *Everything – good taste!*
> *Everything – good taste!*
> *To make lobsters for consumption fit*
> *One must torture them a bit.*
> *Even turkey won't be fat*
> *At the drop of a hat,*
> *Tease it slowly, without haste . . .*
> *Do you know how my lips taste?*
> *Who has different taste alas*
> *Cannot equal be to us."*

"But why," I whispered, "Countess . . . Peas, carrots, celery, kohlrabi . . ."

"Cauliflower," added the baron choking suspiciously.

"That's it," I said in complete confusion, "That's it! . . . Cauliflower! . . . Cauliflower . . . Fasting . . . Vegetarian vegetables . . ."

"And what about the cauliflower? Tasty, what? Good? I expect you've understood the taste of this cauliflower." What a tone. How patronising. What a scarcely detectable but dangerous lordly impatience in his tone. I began to stutter, didn't know what to answer, how to deny, or

confirm. And then (oh! I would never have believed that this noble, humane individual, this brother-poet, could let me feel to such an extent how their lordships change their manners), then, having spread himself comfortably in the arm-chair, caressing the thin leg he had inherited from Princess Pstryczyńska, he said to the ladies in a tone which virtually annihilated me: "Truly, dear Countess, it's not worth inviting to dinner individuals whose taste has not yet passed the stage of a complete primitive."

And no longer paying any attention to me they began, glasses in hand, to tell jokes among themselves, in such a way that all of a sudden I became superfluous, *quantité negligeable*: about Alice and her "chimeras", about Gaba and Buba, about Princess Mary, about some "pheasants" and about this one being "intolerable" and the other "impossible". They gossiped and told anecdotes in a coded, higher language, using expressions such as "maddening", "fantastic", "incredible", "absolutely", and as often as not swearing – "damn it" or "bloody hell", till it seemed almost possible that this kind of conversation was the peak of human abilities. And I, with my concept of Beauty, humanity and all the other topics of a thinking reed, not knowing why and how, annihilated and put aside like a useless tool, I couldn't find a word to say. They also swapped baffling, aristocratic jokes which caused extraordinary mirth, but to which I, unable to understand them, could hardly raise a smile. Oh God! What had happened? What a sudden and cruel change! Why was their behaviour so different now? Were these the same people with whom, not so long ago, I had been sharing so harmoniously the milk of human kindness and the pumpkin soup? Why this sudden and inexplicable estrangement and coldness? Why so much irony, so much incomprehensible, painful derision, even in their appearance? And such distance, such unapproachable remoteness! I couldn't explain to myself this metamorphosis, and the marquise's words about the "closed circle" led me to think of all those horrible rumours which were spread among the middle classes, which I usually refused to believe, about the two faces of aristocracy

and their double life. In the end, incapable of enduring my own silence, which with every second was pushing me into a terrible abyss, I addressed the countess without rhyme or reason, like a late echo from the past:

"Please forgive my interruption Countess . . . you promised to sign for me your trioletes *Chit-chats of my Soul.*"

"Pardon me?" she asked not hearing the question, playful and exhilarated. "You were saying?"

"Do forgive me – you promised to sign for me your poems *Chit-chats of my Soul.*"

"Ah yes, true, true," said the countess absent-mindedly but with her usual kindness (usual? or different? or new to such an extent that my cheeks flushed crimson without any conscious co-operation on my part); and having taken from a little table a small book bound in white she scribbled casually a few kind words on the title page and signed it: "Countess Kotuboy". "But Countess!" I cried out painfully, hurt seeing this historic name so twisted, "Kotłubay!"

"What absent-mindedness!" exclaimed the countess amidst the general merriment, "What absent-mindedness!" But I found nothing to laugh at in all this. Tss . . . I almost hissed again. The countess laughed loudly and proudly and at the same time her aristocratic foot performed various flourishes on the carpet in an immensely ticklish and enticing way, as if delighting itself with the thinness of its own ankle – now to the left, now to the right, and in circles. The baron, tilted back in his armchair, seemed to be just getting ready for an excellent *bon-mot* –but his little ear, so typical of the Pstryczyńskis, was even smaller than usual, while the fingers pushed a grape between his lips. The marquise was sitting with her usual elegance, yet it was as if her long thin neck, the neck of a grand dame, grew even longer, and its withered skin seemed to be winking at me. And I should add a small but not irrelevant detail that out there the rain, blown by the wind, was lashing against the window panes like a thin whip.

Perhaps I took my sudden and undeserved fall from grace

too much to heart and, perhaps, this gave way to that persecution complex which preys on low-born individuals admitted to high society, while certain accidental associations, certain, say, analogies may have made me over-sensitive. I don't want to deny it, perhaps . . . But suddenly I sensed an extraordinary change in them. And I'm not denying that their grandness, subtlety, elegance and politeness were still as grand, subtle, elegant and polite as they could possibly be – no doubt, but at the same time, and without reason, they were so suffocating that I was inclined to think that all those splendid and humanitarian virtues had gone berserk, as if bitten by a gadfly! What's more, it struck me suddenly (and it was undeniably the effect of that little foot, the ear and the neck), that without looking, and ignoring me in a lordly manner, they still saw my confusion and found it a constant source of delight. I was also touched with a premonition that "Kotuboy" wasn't necessarily only a *lapsus linguae*, that in a word, if I'm to state it clearly – Kotuboy, means – "kot-u-boy". "Caught you boy!" Yes, yes, the glittering noses of their patent-leather shoes confirmed my terrifying suspicion. It seemed that behind my back they were still splitting their sides with laughter because I hadn't caught on to the taste of the cauliflower, that for me this cauliflower was an ordinary vegetable, that I had proven thus my complete naivety and my lamentably bourgeois breed by failing to appreciate the cauliflower as I ought. They were secretly splitting their sides with laughter which was about to burst forth had I but given the slightest inkling of the emotions raging within me. Yes, oh yes, they were ignoring me, pretending I was not there, but at the same time, using slyly those particular parts of their aristocratic bodies – that little foot, the ear, the neck – they were provoking and daring me to break off the seal on their secret.

No need to repeat again how this quiet tempting, this sly, unhealthy flirting shocked everything that was of the thinking reed in me. I remembered vaguely the "secret" of aristocracy, this mystery of taste, this secret which no one will come to possess who is not one of the chosen, even if, as

Schopenhauer says, one were to memorise three hundred rules of *savoir-vivre*. And if I were dazzled for a while with the hope that having discovered this secret I would be initiated into their circle, that I would be saying "fantastic" and "absolutely" just like them, even then, other things aside, the anxiety and the fear of – why not say it openly – of being slapped on the face completely paralysed my burning curiosity. One is never sure of the aristocracy. With the aristocracy one needs to be more careful than with a tamed leopard. Once, someone from the bourgeoisie was asked by a Princess X about his mother's maiden name. Encouraged by the liberal manners reigning in that salon and by the tolerance with which his two previous jokes had been acknowledged, thinking he could take liberties, he answered, "Excuse the expression – Piędzik." And because of this "Excuse . . ." (which turned out to be vulgar), he was immediately thrown out.[6]

"Philip . . ." I was thinking carefully, "But Philip swore . . . ! A cook is nevertheless a cook. A cook is a cook, a cauliflower is a cauliflower and the countess a countess, and I wouldn't wish anyone to forget about the last! Yes, the countess is a countess, the baron is a baron, the gusts of wind and the rain outside – wind and rain. And the little hands groping in the darkness, the back bruised by a fatherly thong, now lashed by waves of rain, are just little hands and a bruised back, nothing more . . . And the countess is without any doubt a countess. The countess is a countess and, would to God, that she may not dish out a flick on the nose!"

Seeing that I remained in a complete, virtually paralysed state of passivity, they began to circle stealthily around me, closer and closer, growing more and more provocative and showing more openly their readiness to indulge in mockery and pranks. "Look at his frightened face!" cried the countess suddenly and they all began to jeer and mock me, that, surely, I must be "scandalised" and "horrified" since no doubt in

[6] Piędzik – an ordinary surname, but one which through its coarseness showed its bearer to be of peasant stock.

my sphere no one "talks rhubarb" or plays pranks, that in my sphere manners are incomparably better, and not as barbaric as amongst them, the aristocracy. Pretending to be frightened by my seriousness they began to rebuke and admonish each other jokingly as if to show that above all they cared about my opinion.

"Don't talk nonsense, sir! You are awful!" cried out the countess (although in fact the baron wasn't awful; apart, that is, from his little ear which he was touching, not without pleasure, with the tips of his thin bony fingers).

"Behave yourselves, you lot!" shouted the baron. (The countess and the marquise were behaving quite properly.) "Stop drivelling! Don't sprawl on the sofa! Stop fidgeting and don't put your feet on the table!" (God forbid! The countess was in no way going to do anything of the sort.) "You are hurting the feelings of this unfortunate. Your little nose, Countess, is too aristocratic, really. Have pity!" (Who, I ask, was supposed to be pitied on the account of that little nose?) The marquise shed silent tears of joy. However, the fact that I put my head in the sand like an ostrich excited them more and more: they looked as if they had thrown caution to the winds, insisting that I should understand; and unable to restrain themselves they were making more and more transparent allusions. Allusions? To what? Oh, natur- ally, still to the same thing, and more clearly, circling closer and closer, with more and more daring . . .

"May I smoke?" asked the baron with affectation, taking out a gold cigarette-case. ("May I smoke?" As if he was una- ware that out there the dampness and rain, and the dreadful cold wind could freeze one stiff within minutes. "May I smoke?")

"Can you hear the rain lashing down?" lisped the marquise naively. (Lashing?! Sure it's lashing! It must have lashed everything good and proper.) "Ah, listen to that pitter-patter of single drops. Listen to the tap-tap-tap, listen, oh listen to the raindrops!"

"Oh, what foul weather, what awful wind," said the countess. "Ah, ha ha ha, what a terrific squall, hell to look

at! The very sight makes me laugh and gives me goose-pimples!"

"Ha ha ha!" followed the baron. "Look how everything is dripping so magnificently! Look at the arabesques the water is drawing on the window panes. Look at the squelchy mud, its greasy stickiness, how smudgy it is. Just like Cumberland sauce! And this little bit of rain, how it flays and flays, beautifully flays! And this little bit of wind, how it bites and bites! How it crushes, how it tenderises, how it roasts! On my word, it makes my mouth water!"

"Truly, it's very tasty, very, very tasty."

"Extremely elegant!"

"Just like *cotelette de volaille!*"

"Just like *fricassée a la Heine!*"

"Or like crabs in ragoût!"

After these *bon-mots* thrown around with the liberty which only the full-blooded aristocracy can afford, there followed movements and gestures whose . . . whose meaning I wished, curled up in my chair, oh, how I wished I couldn't understand! I won't even mention here that the ear, the nose, the neck and the little foot were exceeding themselves and were reaching the stage of complete frenzy. What's more, the banker, having inhaled his cigarette smoke deeply, was puffing little blue circles into the air. Had it been one or two, by God! But he puffed and puffed one after another, his lips shaped into a little *moue*, while the countess and the marquise clapped their hands! And every circle soared up into the air, vanishing in a melodious haze. The long, white, serpent-like hand of the countess rested all the time on the variegated satin of the armchair while her nervy ankle twisted under the table, evil like a snake, black and baneful. It made me feel very uneasy! And that's not all, I swear I don't exaggerate, the baron went so far in his effrontery that having lifted his upper lip he took out his tooth-pick from his pocket and started to pick his teeth – yes, his teeth – rich, corrupt, abounding with gold, teeth!

Struck dumb, completely at a loss as to what to do and where to escape to, I turned imploringly to the marquise –

who of all of them had been the most sympathetic, and who at the dining table had extolled so movingly Charity and children suffering from the English disease – I turned to her and began to talk about Charity, almost begging for it myself! "You, Madame," I said, "who with such sacrifice assist the unfortunate children. Madame?" For Christ's sake! Do you know what she said? Surprised, she looked at me with her faded eyes, wiped away the tears caused by the excess of hilarity and then, as if remembering, she said: "Oh you mean my little ones suffering from the English disease? . . . Oh yes, indeed, when one sees how clumsily they move on those twisted pegs of theirs, how they stumble about and fall over, it makes one feel still vigorous! Old but vigorous! In the old days I used to ride in a black riding-hood and shiny boots, on English thoroughbreds, but now – *hélas, les beaux temps sont passés* – now that I'm not able to because of my age I ride cheerfully on my little twisted English cripples." Her hand suddenly stretched down and I jumped away, for I swear she was going to show me her old but straight, healthy and vigorous leg!

"Christ the Lord!" I cried half alive, "But Love, Charity, Beauty, prisoners, cripples, emaciated ex-schoolmistresses."

"We remember them, we do," said the countess laughing, and cold sweat ran down my neck. "Those poor, dear schoolmistresses."

"We remember," the old marquise reassured me.

"We remember," repeated Baron de Apfelbaum. "We remember"(I was petrified) "those good old prisoners."

They weren't looking at me but somewhere at the ceiling, turning up their heads as if that were the only way they could constrain the violent spasms of their cheek muscles. Ha! I had no doubt left, I understood in the end where I was and my jaw started trembling uncontrollably. And the rain was still lashing against the window panes like a thin whip.

"But God, God does exist . . ." I stuttered in the end, my strength leaving me, desperately looking for some refuge. "God exists," I added in a lower voice, for the name of God sounded so out of place that in the ensuing silence I could

see on their faces all the inauspicious signs confirming my *faux pas*. I was only waiting for the moment when they would show me the door.

"Gold?" responded Baron de Apfelbaum after a while, crushing me with his incomparable tact, "Gold? Of course it exists. I deal in gold."

Who could reply to this? Who wouldn't, as they say, forget the tongue in his mouth? I shut up. The marquise sat at the piano while the baron began dancing with the countess, and from their every move there flowed so much good taste and elegance that – oh – I wanted to escape. But how to leave without saying goodbye? And how to say goodbye while they were still dancing? I was watching them from the corner and – on my word! – never, never had I dreamt of such wanton abandon. No, I can't go against my nature and describe what happened. No, no one can demand that from me. Suffice it to say that when the countess put forward her little foot the baron withdrew his, many, many times, and all this while their faces showed inexhaustible dignity, bearing such an expression as if this dance were – phew! – an ordinary tango; with the marquise churning out trills and arpeggios on the piano! But I knew by then what it was, they had forced it down my throat – it was the dance of cannibals! The dance of cannibals! All done with daintiness, good taste and elegance. I was only looking around for a heathen god, a primeval monster with a square skull, turned out lips, round cheeks and squashed nose, presiding over the bacchanalia from somewhere above. And turning my eyes towards the window I saw something just like that: a round, childish face, with a squashed nose, with raised eyebrows, sticking out ears, skinny and feverish, staring with the cosmic idiocy of a savage divinity, with such unearthly enchantment that for an hour or two I sat as if hypnotised, unable to tear my eyes away from the buttons of my waistcoat.

And when at dawn, I finally sneaked out, down the slippery steps into the grey drizzle, I noticed in the flower bed under the window, a body among the dried irises. It was of course a corpse, the corpse of an eight-year-old boy,

blond hair, round nose, wasted to such a degree that one could say it was completely devoured. Only here and there, under the dirty skin remained a little flesh. Ha, so poor Bolek Cauliflower had managed to wander as far as here, tempted by the light of the windows, visible from the distant, muddy fields. And as I was running out of the gate the cook, Philip, appeared out of nowhere – white, in a round cap, with ginger hair and squinting eyes, skinny but grand with the grandeur of a master of culinary art who first slaughters a chicken in order to serve it later on the table in a ragout. Cringing, bowing and wagging his tail he said in a servile tone of voice:

"I hope your lordship enjoyed his lenten fare . . ."

FATHER'S EXPERIMENTS

by Bruno Schulz

(extract)

The end of winter that year stood under the sign of particularly opportune astronomical arrangements. The colourful predictions of the calendar blossomed red in the snowy outskirts of mornings, and the glow of red Sundays and holidays spread over into the next week, giving the coming days a cold gleam of false and short-lived fire. Deluded hearts beat a little faster for a while, dazzled by the heralding redness which proclaimed nothing and was but a mere red herring, a colourful calendar humbug vermilioned on the week's cover. Beginning at Epiphany we sat night after night over the white pageantry of the table shining with silver and candlesticks, playing an unending game of patience. With each hour the night behind the window grew brighter and brighter, all sugar-frosted and glistening, full of sprouting almonds and ever-spreading ices. The moon, that inexhaustible transformist, wholly engrossed in her late lunar practices, celebrated her subsequent phases, becoming more and more luminous, laying herself out in all the *preference*[1] figures, doubling all the suits. Even during daytime she could often be seen standing by, ready in advance, brassy and lacklustre – the melancholy Queen of Clubs – awaiting her turn. Meanwhile, whole skyfuls of lambs passed through her lonely profile in a quiet, white and vast migration, covering her thinly with iridescent scales the colour of mother-of-pearl, which, near evening, set over the entire colourful firmament.

Later, one merely turned the leaves of empty days. The wind passed over the roofs with a heavy rumble, blowing

[1] *Preference* – a French card game resembling auction bridge, popular in Poland at the turn of 19c.

257

down the cold chimneys right to their hearths, building im-
aginary scaffolds and walls above the town, only to pull down
those air-built structures amidst the crash of beams and raft-
ers. Sometimes a fire would break out on the far outskirts of
town. The chimney-sweeps would scud around the roofs and
galleries under the torn, copper-rust sky. Moving from one
patch to another, high up as weather-cocks, they would be
dreaming in this vaulting perspective that the wind might
open up the lids of the roofs to reveal for a moment the girls'
attics, and slam them shut again over the grand, effervescent
book of the town − that intoxicating tale which could be
read for many days and nights.

Later, exhausted, the winds died out. In our shop-window
the shop assistants hung out the spring-time selection of cloth,
and soon, from the soft colours of the wool, the weather
became milder, tinged itself with lavender and blossomed in
pale reseda. The snow shrank, puckered into babyish fleece. It
was soaked up dry into the air, drunk by the cobalt breezes,
absorbed back into the vast, concave sky without sun or
clouds. Here and there in people's houses oleanders had al-
ready come into bloom, the windows were flung open and
in the dumb reverie of the blue day the mindless twittering
of sparrows filled the rooms. Over the clean squares there
were violent fleeting clashes of coal-tits and chaffinches, who
swooped with a terrifying chirp and dispersed in all direc-
tions, swept away by a gust of wind, blotted out, annihilated
by the empty azure. For a moment all that was left were
colourful specks floating in the eye, a fistful of confetti
thrown blindly into the bright space, which then melted
away into the neutral sky-blue.

The premature spring season was on. Young articled clerks
wore high, stiff collars and their moustaches twirled up into
spirals; they were the epitome of chic and elegance. During
the days washed over by the gales as if by a flood, when the
winds rumbled high above the town, the clerks would greet
from afar ladies of their acquaintance, raising their colourful
bowler-hats. Leaning their backs against the wind, their coats
flapping about, stiff and discreet, they would then turn their

gaze away so as not to expose their lady-friends to gossip. The ladies would momentarily lose the ground under their feet, crying out in fright, their frocks flaring up, but regaining their composure they would respond with a smile.

Sometimes, on an afternoon when the wind calmed down, Adela would be out on the porch cleaning huge, copper pots which purred with a metallic rasp under her hand. The sky would stand still over the shingle-roofs, holding its breath, branching out into blue avenues. A breeze would bring the lost refrain of a distant hurdy-gurdy. The shop assistants, sent out on an errand, would stop next to her by the kitchen door, leaning against the porch, drunk with the day's long wind, their heads full of the deafening chirp of the sparrows. One could not hear the quiet words formed under their breath, accompanied by innocent faces and a false nonchalance, words which in fact were aimed at shocking Adela. Touched to the quick, she would react violently, cursing them in a rage, hackles up, and her face, grey and cloudy from spring daydreaming, would redden with anger and pleasure. They would lower their eyes with abject devotion and the wicked satisfaction that they had succeeded in making her lose her temper. Mornings and afternoons passed by. They floated in the everyday hubbub of the town seen from our porch, above the labyrinth of roofs and houses lambent with the turbid radiance of those grey weeks. The tinkers ran around shouting out their services, sometimes Shloma's powerful sneeze enriched the town's remote, scattered din like a witty aside. In a secluded square the madwoman Tłuya, driven to despair by taunting children, began to dance her wild sarabande, raising high her skirts to the delight of the crowd. All those outbursts were flattened, smoothed out into a grey monotonous clatter by a gentle breeze which spread it evenly throughout the smoky, milky afternoon air above the sea of shingle-roofs. Adela, leaning on the porch balustrade, bent over the far heaving hum of the town, fished out of it all the louder accents and, smiling, put those strayed syllables together, trying to make some sense of the huge, grey monotony of the day as it rose and fell.

It was the epoch of mechanics and electricity. A whole bundle of inventions had fallen out from under the wings of human genius. In the homes of the middle classes appeared a new range of cigar sets equipped with electric lighters – one turn of a switch and a swarm of electric sparks lit up a wick soaked in petrol. It all stirred hopes which would not be denied. A music box in the shape of a Chinese pagoda, when wound up, would immediately start playing a miniature rondo, turning around like a carousel, the bells would ring out in trills, the wings of little doors would open out revealing the spinning barrel-organ heart churning out a snuff-box triolet. All the houses had electric bells installed and domestic life stood under the sign of galvanism; a coil of insulated wire was the symbol of the times. In the salons young dandies who demonstrated Galvani's effect received the admiring gazes of the ladies. The electric conductor opened the way to women's hearts. When the experiment succeeded the heroes of the day sent kisses amidst the applause of the salons. We did not have to wait long before the town filled with velocipedes of all shapes and sizes. The philosophical outlook on life was *de rigueur*. Whoever accepted the idea of progress had also to accept the consequences and mount a velocipede. Naturally, the first were the articled clerks, that avant-garde of new ideas. With their twirled up moustaches and colourful bowler-hats, the hope and flower of our youth, pushing aside the rowdy onlookers they rode into the crowd on their enormous bicycles and tricycles, rattling the wire spokes. Resting their hands on the broad handlebars, manoeuvring the giant hoops of the wheels from their dicky-seats they cut a winding, wavy line into the merry multitude. Some were overcome by a missionary zeal and rising on their rattling pedals, as in stirrups, spoke to the people from on high, prophesying a new, happy era for Mankind – redemption through the bicycle ... And rode on through the applause bowing in all directions.

And yet, there was something pitifully compromising in those splendid, triumphal parades, a grinding, jarring note,

harsh and painful, which even at the height of their triumph made them sway unsteadily on the brink of parody. The riders must have felt it themselves as they hung on their intricate apparatus like spiders, straddle-legged on the pedals like giant hopping frogs, waddling on the widely rolling rims. They were only one small step away from ridicule and they were taking that step with despair, bending over the handle-bars and doubling their speed – a gyrating web of jerky acrobats taking a wild tumble. No wonder. Man, on the strength of an illicit joke, was entering a province of unbeliev-able facilities gained too cheaply, below cost, practically gratis, and this disproportion between profit and investment, this obvious swindling of Nature and the excessive payment for a trick – even a brilliant one – had to be balanced with self-parody. So they rode through the impetuous bursts of laughter, pitiful victors, martyrs of their genius. Such was the comic power of those marvels of technology.

When my brother brought an electromagnet from school for the first time, when we all experienced with trembling souls and fingers the secretly vibrant life locked in an electric circuit, my father smiled in superiority. A far-reaching idea was taking shape in his head, he concentrated, closing a chain of long-entertained suspicions. Why was father smiling to himself? Why were his eyes turning up, watering, in mocking devotion? Who can tell? Did he suspect a hoax, a base intrigue, a transparent machination behind the startling mani-festations of secret power? From that moment dates father's conversion to laboratory experiments.

Father's laboratory was simple: a few coils of wire, a couple of jars of acid, zinc, lead and carbon – that constituted the entire workshop of this extraordinary esoterist. "Matter," he would pronounce with muffled snorts, lowering his eyes coyly, "matter, my dear sirs . . ." He would never finish his sentence, leaving us to guess that he was on the trail of some fat trick, that we were all wholly and truly duped. With his eyes lowered father would scoff at this eternal fetish. – *Panta rei!* – he would cry out, describing with his hands the eternal circulation of substance. For a long time he had wanted to

mobilise its latent powers, to render its rigid mass in a flux, to pave the way for its universal penetration, transfusion, for omnicirculation – its only true state of being. "*Principium individuationis* – tinker's cuss," he would say, and with that he would express his unbridled contempt for this greatest of First Principles. He would let it slip out in passing, running along the wire and with his eyes shut, touching delicately various points of the circuit, trying to feel minute differences in potential. Bent over the wire he made small incisions in it, listening intently, and in the blink of an eye he was ten paces away repeating the procedure. He seemed to have ten hands and twenty senses. His scattered attention was working in a hundred places at the same time. No point of space was free of his suspicion. Jabbing at the wire in one place he would suddenly spring like a cat aiming at another spot, missing it in embarrassment. "Excuse me," he would say, turning to a surprised observer of his manipulations, "excuse me, I am particularly interested in this point of space currently occupied by your body. Would you mind moving for a moment?" And in a flash he would be taking his rapid measurements again, quick and nimble like a canary, hopping dextrously in the pulsating throb of his finely tuned nerves.

The metals, dipped in acidic solutions, salty and patinous in this painful bath, began their transmission in the dark. Awoken from their numb deadness they hummed a monotonous, metallic song, emitting an intermolecular radiance into the perpetual twilight of those late, mournful days. The poles swelled with an invisible charge which seeped into the swirling darkness. A barely felt tickle, blind tingling currents ran through the space polarised into concentric power lines, falling into rotating spirals of magnetic fields. Now and again, the instruments would signal to each other from a deep sleep, breaking their lethargic slumber, sending delayed, belated communications in hapless monosyllables – dash, dot, dash ... Father stood in the middle of those migrating currents with a painful smile, shaken by this stammering articulation, this wretched life locked up for ever and without a way out, which sent

feeble messages in crippled half-syllables from the fettered depths.

As a result of his researches father reached astounding conclusions. For instance, he demonstrated that an electric bell, operating on the principle of Neeff's hammer, was a mere hoax. It was not Man who was breaking into Nature's laboratory, but Nature Herself who was drawing him into Her own machinations, and through his experiments pursuing Her own goals, which led no one knew where. At dinner-time my father would touch his thumbnail with the handle of the spoon sticking out of the soup, and suddenly the lamp would start ringing with Neeff's hammer. The whole apparatus was simply superfluous, it had nothing to do with the matter in hand. Neeff's hammer was a point of convergence for the impulses of matter feeling its way through the human wit. Nature willed and worked; Man was merely an oscillating needle, a shuttle shooting up and down the loom according to Her will. He himself was just one of the components, a part of Neeff's hammer.

Someone dropped into the conversation the word "mesmerism" and father readily picked it up. He had found the last link needed to lock the chain of his theory. According to it Man was only a transit station, a momentary knot of mesmeric currents tangling hither and thither in the womb of eternal matter. All the inventions in which He triumphed were traps set up by Nature, the snares of the unknown. Father's experiments began to take on the character of magic, they smacked of a conjurer's juggling tricks. I shall omit the numerous experiments with pigeons which, in the course of manipulation with his magic wand, were conjured forth into two, three, or ten, and then gradually, and with effort, manipulated back into the wand. He would raise his hat and out they would fly, all of them, returning to reality and fluttering down on the table in an undulating, cooing and bustling flock. Sometimes he would interrupt himself unexpectedly in the middle of an experiment. For a moment he stood undecided, with his eyes closed, and then ran out in a trot into the hallway and stuck his head into the chimney

flue. The soot-padded darkness wrapped it in blissful silence, snug like a womb of nothingness, soothing it with a flow of warm currents. Shutting his eyes father stood for a while in this warm, dark void. We all felt that this incident was not part of the demonstration, that it was all taking place, as it were, behind the scenes. We would turn a blind eye to this marginal fact, which indeed belonged to another order of things.

My father had in his repertoire really perturbing tricks, which overwhelmed with true melancholy. The chairs in our dining-room had tall, beautifully carved backs. They depicted garlands of leaves and flowers carved in a realistic manner, but with one flick of father's hand they would suddenly assume the indefinable, yet witty, pointedness of a grotesque physiognomy. The visage began to blink and wink meaningfully and it was all too embarrassing for words, almost unbearable, until, with an invincible inevitability, the winks began to take a quite definite direction and some of those present would cry out: "Auntie Wendy! Good God, auntie Wendy!" The ladies would start screaming for it was auntie Wendy true to life, nay, her very self was here in person on a visit, sitting and carrying on her interminable discourse without letting anybody get a word in edgeways. Father's miracles were collapsing under their own weight, for the presence of the real auntie Wendy in all her usual ordinariness and earthiness precluded any thought of miracles.

Before we move on to the other events of that unforgettable winter, we ought to mention a certain incident which in our family chronicles has always been shamefully hushed up. Whatever happened to uncle Edward? He arrived on a visit, suspecting nothing, bursting with health and energy, his wife and little daughter left behind in the provinces, pining for his return. He came in the best of spirits to have a little fun and rest away from the family. And what happened? Father's experiments had an electrifying effect on him. As soon as the first demonstrations were over he got up, took his coat off and put himself entirely at father's disposal. Unconditionally! He pronounced this word with an insistent stare and a firm handshake. Father understood. He made sure however

that uncle was free of the commonplace prejudice concerning the *Principium individuationis*. It turned out that – no, none, none whatsoever. Uncle was a liberal, free of any prejudice, his only passion was to serve Science. At first father left him a certain degree of freedom. He was still making preparations for the main experiment. Uncle Edward took advantage of his liberty to wander around the town. He bought himself a velocipede of impressive size and on its gigantic wheel toured the square looking from the height of his seat into first floor windows. When passing our house he would raise his hat, greeting the ladies standing at the window. He had a small pointed beard and a twirled up moustache. Soon, however, he came to the conclusion that the velocipede was incapable of revealing the deeper mechanical mysteries, that this ingenious apparatus was unable to deliver metaphysical thrills on a permanent basis. And then started the experiments, to which uncle's lack of prejudice concerning the *Principium individuationis* proved so invaluable. Uncle Edward had no reservations against being, for the benefit of science, physically reduced to the naked principle of Neeff's hammer. He agreed without complaint to the gradual reduction of all his properties with the aim of revealing his bare essence, identical, as he had long suspected, with the aforementioned principle.

Having locked himself up in his study father began dismantling uncle Edward's tangled essence with an exhausting psychoanalysis that spread over many days and nights. The table in the study began to fill with the disassembled complexes of his psyche. At the beginning uncle still joined us at mealtimes, albeit greatly reduced, trying to take part in our conversations. He even had another go on the velocipede. Later, he relinquished even this exercise seeing himself more and more incomplete. He developed a certain bashfulness, characteristic of that stage of reduction. He avoided people. At the same time father was getting nearer and nearer to accomplishing the goal of his endeavours. He reduced uncle to an essential minimum, removing step by step all that was inessential. He placed him in a casement of the stairwell,

arranging his elements according to the principle of Leclanche's cell. The wall was mouldy there and dry rot was spreading its pearly ornament. Father availed himself of uncle's capital of enthusiasm without scruple, stretching his thread along the entire length of the hallway and into the west wing of the house. Moving on a ladder along the wall of the dark corridor he hammered into it little pins marking the route of uncle's current incarnation. Those smoky, yellowish afternoons were almost completely dark. Father used a lighted candle with which he illuminated carefully every inch of the mouldy wall. According to some versions uncle Edward, until then so heroically composed, in the last moment showed nevertheless signs of vexation. They even say that it came to a violent, though belated outburst, which almost wrecked the nearly finished work. But the installation was already in place and uncle Edward, just as in life he had been an exemplary husband, father and businessman, so now too, in his final role, he succumbed in the end to higher reason.

Uncle functioned very well. There was no instance when he refused to work. Freed of the tangled complications in which he had been lost so many times before, he found at last the purity of a uniform and straightforward principle to which now he could be constantly, if irrevocably, amenable. In exchange for his unmanageable diversity he gained a simple, "no-problem" immortality. Was he happy? We would ask in vain. This question applies only to beings who contain a wealth of alternatives and opportunities thanks to which actual reality can withstand and reflect real possibilities. But uncle Edward had no alternatives, for him the dichotomy "happy – unhappy" did not exist, since he was absolutely self-contained. One could not refrain from expressing a certain admiration, seeing him function with such unfailing precision. Even his wife, aunt Teresa, when she arrived after her husband, could not resist pressing the button every now and again in order to hear this sonorous if piercing sound, in which she could recognise the timbre of his voice when he was irritated. As for his daughter Eddy,

one could say that she was delighted with her father's career, though later she took out on me a kind of revenge, making me pay for my father's acts. But that belongs to another story.

MOTHER JOANNA OF THE ANGELS

by Jarosław Iwaszkiewicz

(extract)

Father Suryn lived in the old granary, a large, wooden two-storey building situated behind the convent, next to the farm buildings. The ground floor housed all kinds of lumber-rooms and served as a store for timber. Wide, rickety stairs led to a long gallery which ran along the second floor where there were doors to the rooms. There were six rooms, all the same, narrow but comfortable. Each had a window looking out onto the convent garden and each had a big bed, table, chair and a crucifix hanging on the wall. All the priests lived here: Lactancius, Ignatius and Imber, Fathers Salomon and Miga, the nuns' confessor. Father Suryn was put up in the last free room.

Father Suryn was used to long services, but after the church fair, the exorcisms and the vespers celebrated at the end of the day, he felt very tired. He went to bed early without touching the sumptuous supper brought to him by Sister Margaret, without even reciting the prescribed breviaries. The sight of the possessed nuns, the long, public casting out of devils had filled him with horror. Even though he was an experienced exorcist, it was the first time he had seen such a mass possession by demons.

He needed to drive his thoughts away from the scenes he had witnessed and began to think about things far removed from the Ludyń convent. He wanted to return to his child-hood – he always thought about it whenever he felt weary and overwhelmed by the affairs of the world. He liked the feeling of wandering back to this blue-green mist of yore, which surrounded him like the floating down of blossom in

spring long ago, and which surrounded him now, whenever he wanted to call it back . . .

He was falling into a kind of numb meditation. Stretched on his bed, he sank slowly into the warm waters of nothingness. And then, out of the deeps, like water weeds, like frogs soaking up the spring sunshine and changing into swallows, emerged the memories of childhood: a small farm and his stern father, a farmhand – the religious Mykita, who was later killed with an axe by a mad peasant – and above all the gentle smile of his mother. These memories did not come to life within him, but floated above him, intertwining and creating a canopy of quiet, sleepy music. They surrounded him with a murmur, like that heard on a warm, summer day near a bee-hive.

He remembered Mykita listening to the drone of the bees and trying to guess whether they were going to swarm soon. This joyous, summery drone hung above Father Suryn's head, filling him with an unexpected peace and happiness. He was almost asleep, half asleep and half awake, letting his thoughts run free. The horrible ones, the worst, were melting away leaving him in a golden bliss. There also came a thought about Mother Joanna, but it had no sting in it. Quite the opposite – it was a light and clement thought. He forgot the terrifying expression on her face during the exorcism and saw her walking in the limpid light of the overcast September afternoon, shy and as if enraptured, in front of the small flock of nuns. How pure she had seemed to him then, how clear were her blue eyes.

Suddenly he shuddered, full of disgust, remembering all that came after. At the same time a hollow pain seized his heart as he thought about the suffering of this fragile body and the soul so full of light. How could he hope to defeat Satan who was so powerful? And what was it Father Brym said? Perhaps indeed there – there is no Satan? A cold shiver ran through him at the very thought that Mother Joanna might be the victim of a non-existent Satan, merely possessed by a lack of goodness. Were these only her own faults and sins which she called Zabulon, Gresil, Issaakaron

and Sparky? Could it be that this soul, this strayed and confused soul he was entrusted with, had already been damned before he made any contact with it?

"Joseph," he told himself, "remember to pray for lost souls."

He said that and suddenly sat up in his bed. He thought that his own soul must have gone astray too, for he had not said the prescribed prayers but instead had thrown himself into bed like an animal. He jumped to his feet and grabbed the scourge hanging on the wall. He flagellated himself furiously until the feeling of physical pain drowned the sorrow he felt in his heart. He lashed himself for a long time and then took out fresh linen and began putting it on, discarding the old. This operation always gave him a lot of trouble and took a long time. He wrapped the fresh cloth carefully around his feet and took off, with great difficulty and disgust, the shirt covering his body. Even though it was dark in the room he saw his body, he felt it. He could not decide to bare it, yet, having done so, he could not bring himself to cover it with clean, white linen. He thought it a waste of good linen which was about to be sullied. He wiped his back, bleeding after the lashing, with a towel and those bloody marks on the linen – thick linen from Smolensk – filled his soul both with torment and consolation. He pulled on a shirt, then a warm, woollen doublet and, finally, a pair of leggings. Dressed in this way he went to bed again.

But he could not sleep. The smell of fresh linen, the pain both of the new and the old reopened wounds, kept him awake. He began to think and plan how he should conduct further exorcisms and, again, imagined the fragile, crippled figure of Mother Joanna.

That piteous memory jerked him out of bed and threw him down on his knees. "The soul condemned shall be redeemed!" he kept repeating in his thoughts and then cried out: "God! God! God!"

As he prayed he could not resist offering himself to the Divine Majesty. He wanted to be burdened with the same unhappiness that had befallen Mother Joanna, he wanted to

experience all the feelings she was experiencing, he wanted to be possessed as she was, to share the whole burden that weighed upon her, and he pleaded with God to let her find the true path of Love and Virtue leading to salvation, to transfer all her sins and misfortunes onto his shoulders. At that moment he felt with an overwhelming passion that his only desire was to deliver that soul from Satan's embrace. He was ready to suffer the cruellest tortures – and for these he begged – if only she could attain eternal joy and solace in her life on earth.

"And what if Satan will leave her and take possession of me?" he asked himself. "I am not afraid to be taken for a madman. The world jeers and laughs at madmen so let it jeer at me. I shall be like Jesus at Herod's court. Let them beat me, let them abuse me, I shall pin to my hat this wonderful bouquet which the world so despises – the bouquet of madness. I shall, as our holy Father St. Ignatius teaches us, arouse in the people of the world scorn and anger, suffer unjust persecution, and I alone shall know the pain of such sacrifice and its rewards . . ."

Beads of sweat covered Father Suryn's brow during this awesome prayer and he felt in his heart such fervour, a faith so colossal, that should he at that moment be shown the satanic might he could have crushed it like a worm. He thought about it and looked out of the window. The cold, remote stars glittered in the clear sky. But he did not see that black nebula he always thought he saw amidst the brightness of the constellations. Indeed, the existence of Satan, which he felt so strongly, particularly during the prayer, did not come to stand before him this time and even in the deepest fold of his soul – which he used to compare to a chestnut – he did not see the black spider. He fell asleep.

Next day, after mass, Father Suryn was to continue with his exorcisms. The ceremony was to take place in the convent church and the other sisters were to be excluded. Sister Margaret of the Cross, the only one not possessed, was to spend the time praying near her mother superior. There were not many people. The Prince Jakub, although still in

town, was tired after the spectacle of the previous day and this time did not attend. Nevertheless, the shining heads of Messrs Chrząszczewski, Piątkowski and Wołodkiewicz, half-shaven after Polish fashion, could still be seen in the crowd.

Father Suryn lay prostrate throughout the entire celebration of the mass, praying to the Holy Spirit for inspiration. When he arose two sisters led Mother Joanna in. Seeing her, Father Suryn was overcome with pity. Her face was pale and tired, the eyes full of great sorrow, but she held her head high, walking with a proud step, and thus she stopped in front of Father Suryn. The four exorcists of the previous day sat on the benches in the presbytery and watched with curiosity, faint smiles playing on their lips, to see how Father Suryn would go about his task, which they, despite their professional approach and exemplary piety, had been unable to bring to a satisfactory conclusion.

Father Suryn looked long into Mother Joanna's eyes but she did not avert them even for a moment. The wrestling duel of their eyes continued for some time until Mother Joanna could not bear Suryn's gentle gaze any longer. She turned her eyes away and collapsed on her knees. The sisters who had brought her left, and now Mother Joanna had to face her exorcist alone. Powerless and tired, she knelt meekly in front of him.

As if inspired, Father Suryn turned to the altar, opened the tabernacle and having taken out the Host put it in the silver case he kept in his pocket. Holding this Sanctissimum in his hand he made a step towards the penitent.

She jumped to her feet and ran away a few steps screaming "No! No!" Suddenly the evil spirit threw her to the ground and began hurling her to and fro in terrible convulsions. Father Lactancius, familiar with these scenes, motioned to the sacristans who brought in an oak bench. Father Suryn stood with the silver case in his hand, undecided what to do. The sacristans quickly tied Mother Joanna to the bench, but she did not stop writhing and struggling, even when bound with leather straps. She howled and gnashed her teeth.

Father Suryn, holding the holy sacraments, intoned the Magnificat. Mr Aniołek, the organist, picked up the Gregorian melody with huge chords and the organ bellowed emphatically. The four priests rose from the stalls singing with joy and ardour the song of adoration. Mother Joanna's writhing weakened.

Amidst the sounds of enthusiastic singing, Father Suryn moved towards the woman strapped on the bench and knelt by her side. Mother Joanna gave him a sullen look. In her eyes he saw expectation, fear and triumph, and great exultation. Terrible sorrow poured into the Father's heart. Without thinking, he placed the Host in its silver case on the heart of the possessed woman.

Mother Joanna shrieked piercingly, then tensed and stiffened with her eyes closed.

Her breast, on which the silver case was resting now, heaved violently and then, gradually, the heaving calmed. Mr Aniołek sang verse after verse in his heavenly voice until the organ grew silent and died out in the high flutes and *vox humana*. Silence spread through the church, as the faithful crowded close to the latticed gates holding them back from the presbytery to get a better view of what was about to happen.

But nothing happened. Mother Joanna was breathing hard. All that could be heard was her breathing, and Father Suryn's. The priest moved on his knees to the nun's head and said in a quiet, even voice:

"My daughter, let us pray together. I shall say my prayers and you try to join me in spirit. May peace come to you."

Then he shut his eyes and, leaning towards Mother Joanna's ear, he began:

"Eripe me de inimicis meis, Deus meus, et ab insurgentibus in me libera me.

Eripe me de operantibus iniquitatem et de viris sanguinum, salva me.

Quia ecce cepurunt animam meam: irruescunt in me fortes.

Nec iniquitas mea, nec peccatum meum, domine, sine iniquitate cucurri et direxi.

Exsurge in occursum meum, tu Domine, Deus virtutum, Deus Israel![1]

The priest's whisper floated, rising and falling, through the silence that hung in the church, like the murmur of a forest stream; the effect was like stepping out from the tumult of a Levantine city into the silence of a monastery cloister and hearing the quiet murmur of a fountain, which lends that silence the quality of peace. As Father Suryn went on, reciting psalm after psalm, the expression on the nun's face changed. Tiredness was giving way to inspiration, resistance was melting in the glowing warmth of submission. Slowly, she drew her hands together and laid them on her breasts, so that the precious holy case was resting between her slender fingers; but she was not touching it.

Father Suryn prayed with his eyes shut, reciting the Latin verses with total abandonment. And as his passion grew, the vivid image of the Evil One was growing in his mind. He saw Satan's efforts to overpower the human soul in order to take it in a kind of mystic matrimony, and with one aim – to defy the divine command, to rise in rebellion, as stupid as it was futile, against the Lord of all creation. And as he prayed he felt he was rising above the Earth and began to see clearly the full impotence of all the evil spawned by Satan and the utter futility of all his hopeless endeavours. And he saw how immutable are the divine laws guiding the stars and planets in Heaven and men on Earth, and how Satan in his frothing rage tries and fails to overturn the eternal order. He saw Satan's rage and powerlessness, which when compared with the might and vastness of Our Lord revealed the insignificance of Satan, and mankind. He drew great consolation

[1] Psalm no 59 in King James version of the Bible (or 58 in the Vulgate):

Deliver me from my enemies, O my God, defend me from them that rise up in me . . .

from this. His heart took strength from seeing the devil black and small in Mother Joanna's soul, and from seeing the precious diamond of her salvation still shining in Christ's hand. And this feeling rose in him like the fragrant fumes of scented oils spilt on a church floor, till on his lips appeared a sweet smile of heavenly joy. Soon, this smile found its reflection on the lips of the tired nun. Accustomed to the terrible shouting of Father Lactancius which had long ceased to make any impression on her, she was at first surprised by the tenderness of the Latin phrases, but then, perhaps exasperated by their incomprehensible sound, she finally succumbed to the magic power of the words whose clarity of order had brought that heavenly smile to Father Suryn's face. She was warmed by his tenderness and smiled back.

After a while Father Suryn became silent. The last echo of his voice floated away and the priest opened his eyes, as if waking from sleep and returning to reality after a long journey to mysterious lands. He noticed immediately the angelic smile and the hands, laid like flowers, on the nun's breasts. He moved away for a moment and then, bending over her again, he said:

"My daughter, try to fill your soul with heavenly love and return it to God's heart, for it is this love with which He loves us. Here, on your heart, you are holding a heart burning with sublime love. Can you resist this fire? Can you not answer love with love?"

Mother Joanna moved suddenly. Father Suryn took away the silver case. The nun opened her eyes and looked at him trustingly.

"Love drives evil away," he whispered. "Fill yourself with it completely, so that there is no room in you where evil may hide itself. be good like a child, be joyful like a child, for God loves us very much."

With a smooth, graceful movement, so different from yesterday's, Mother Joanna freed herself from the leather straps binding her, and knelt on the bench, joining her hands as in prayer. Tears were rolling down her cheeks. Father Suryn knelt below her and said:

"Let us pray. Our Father who art in Heaven . . ."

Mother Joanna repeated the words of the prayer with emotion.

Father Suryn carried the Host back to the altar, returned to Mother Joanna, took her by the arm and, leading her to the altar, intoned in a full, joyous voice:

"*Gloria Patri et Filio . . .*"

The whole church sobbed. Only on the lips of the other exorcists, especially Father Imber's, played a vague smile, as if they were thinking "It's not such an easy game with Leviathan."

And indeed they were right. For the next morning Sister Margaret reported to Father Suryn that both the mother superior and the other sisters of the convent had been tormented by the demons that night with particular violence.

All Father Suryn's attempts to tame the dark forces proved ineffective. His method of calming the mother superior gave excellent results but only for a short time. Demons, as if enraged by Father Suryn's prevalence, would return with even greater force, shaking the sisters and Mother Joanna with increased violence, filling their mouths with wicked, blasphemous words and telling through their lips tales untrue and improbable, but utterly shameful and shocking. There were times Father Suryn was ready to drop with exhaustion. His prayers for Mother Joanna went on for hours, sometimes even for a whole day. But at night the terrible screams, the nuns running down the corridors and the cries of Father Garnec, who had been burnt at the stake for witchcraft, returned to haunt the convent; even Sparky, cast out by Father Salomon during the previous exorcism, returned to Mother Joanna's body. He had the peculiar ability to induce in Mother Joanna moments of spontaneous, unrestrained merriment. She would laugh and giggle for no reason, playing with words and babbling with nonsense. On such occasions Father Suryn lamented that in one hour she would lose all that she had gained through a week of pious contemplation.

In the end Father Suryn decided to discontinue public exorcisms and recommence them in private. In the convent's attic he found an empty room with two entrances and ordered that it be divided in two with a see-through partition, like a fence, creating in this way something like a small *parlatorium*. Mother Joanna was usually on one side of the fence, Father Suryn on the other; the complete silence reigning in the attic helped them to be closer to each other. Father Suryn was trying to find a way to Mother Joanna's soul and in this solitude it was easier to find peace and, more important, honesty. At first Father Suryn felt the reluctance and resistance with which she was guarding her heart against him, not letting him know what secrets she carried inside her. But through prayer, reciting psalms and breviaries together, her resistance was melting and falling away. After a few days of prayers and conversations Mother Joanna, quite unexpectedly, began to talk about herself. The confession flowed easily and was full of detail. However, Mother Joanna was confessing all her thoughts and deeds too easily and Father Suryn began to suspect that her reminiscences were not entirely accurate. After a few hours of these easy conversations, which replaced the difficult struggle with her obstinacy, undoubtedly inspired by Satan, he realised that Mother Joanna wanted to interest him in her experiences, and was therefore telling her stories with colour and exaggeration. Anyway, Mother Joanna had lived in the convent practically since childhood and did not know the world. During the meetings conducted in the convent's parlatorium she heard this and that, and was now repeating words belonging to the outside world without a proper understanding of their meaning. She would say for instance that her sins were a "hearty attachment" to certain creatures, or that she had "passions". But after a closer interrogation it turned out that the "attachments" meant being fond of talking to some people and the "passions" she was giving in to were simple weaknesses, like eating a lot of jam with honey or being used to sleeping under an eiderdown. Mother Joanna did not seem to be able to tell the difference

between a grave and a venial sin. After some time however, Father Suryn noticed that in this respect, too, she was deliberately misleading him. One day she would emphasise the words "sinful attachment" and "passions" to interest and shock him and then, the next day, after his careful questioning, she would explain to him the completely innocent meaning of those dangerous expressions. And so, Father Suryn found to his considerable pain that those sweet talks in the secluded *parlatorium* had devilish connotations. All the things she confessed to him she had done prompted by the devil, who wanted to convince him of her apparent innocence. She wanted to show herself a saint for whom the slightest indulgence in eating the delicacies sent her by a noblewoman from the town seemed a loathsome sin. He noticed also that her real passion was the desire to make everybody interested in her, to exalt herself above others by whatever means. And so she firmly insisted that of all the sisters in the Ludyń convent she was the one whom the devil possessed most completely.

Reason told him that those talks and ascetic practices – they would flagellate themselves together – carried out in the peaceful attic were just as fruitless as the official exorcisms in the church in front of a great crowd of people. But he could not find the strength to discontinue them. They were permeating him with saintliness, with a pious satisfaction derived from communing with the highest regions of the soul, and even for him they held a great importance, for they were smothering that black spider which also kept spinning its web in his soul. Despite the fear he felt thinking about Mother Joanna's possession, these conversations were for him a source of great joy.

But finally, that very joy made him stop to think and after some time he terminated this kind of exorcism, too. He did not see how these talks, which were to lead Mother Joanna onto the path of perfect prayer, diminished in any way the power of the evil spirits. The possession continued. Father Suryn took a few days of rest. He was in despair.

The other tenants in the granary where he lived could not

understand him at all. The previous exorcists were in fact rather pleased with his failure, though after his first exercise they spoke of him with words of admiration. He avoided talking to his fellow-priests, even though he heard them through the wall as they used to gather for an evening talk, especially in Father Imber's room, who was reputed to keep in his cupboard many a good flask of wine. He was afraid of the cynical conversations of these priests. He knew what they were talking about in the evenings and he felt that he would find those gatherings very painful.

In such moments of doubt he would turn to Father Brym, the parish vicar, who was not involved in casting out the devil and had a very sober opinion about what was going on in the convent. He was a pious man, and full of common sense.

A few days after the termination of his holy practices Father Suryn went to see the vicar. He found him, as usual, sitting by the fire in the big room, playing with little Krysia. Her older brother Alex was bringing in firewood and was asked to bring also two mugs of hot beer with cream and cheese for the vicar and his guest.

Father Suryn was always surprised that the vicar allowed the children to play so freely in his rooms and did not discipline them more. Had Father Brym been a little younger Suryn might have suspected something improper in it. But he did not want to ask lest the vicar thought he was doubting his good judgement.

This time the vicar began to tell him about the children himself. He took Krysia off his lap and said:

"Go, my child. Alex, take Krysia to the kitchen."

When the children disappeared behind the door he turned to Father Suryn:

"Poor children. They are my only joy. What will become of them?"

"Are they orphans?" asked Suryn.

"The mother is still alive. She is a cook at Ożarowski's."

"And the father?"

"You don't know? He was burned."

"Ah," guessed Suryn, "so they are Garnec's children . . ."

"Yes . . . What kind of fate awaits them? Children of a priest . . . and a sorcerer . . ."

"You believe in his ill intentions, vicar?"

"Unfortunately, yes. I may not believe in his sorcery, but in his ill intentions always."

Father Suryn shuddered.

"Sorcerer! He was burned! Satan was in him!"

Father Brym smiled.

"As in each and every one of us, perhaps?"

"Us?" Father Suryn felt uneasy.

"Bigger, or smaller . . . Methinks I myself have inside a little devil that tempts me to this sweet beer and cheese."

Father Suryn bridled at this:

"You make a joke out of such terrible things, vicar."

"God forbid! Do I?" protested the vicar, quite merrily, taking a good swig out of his mug. "But if evil exists it may be both big and small. The great devil — Behemoth — who acts through great sinners and murderers, and a small one, perhaps his name is Beer? who tempts our flesh with little pleasures."

Father Suryn shook his head.

"Oh no, father, no! Satan, once he gets inside, possesses a man completely. He becomes his second nature. Second? What am I saying, first! He becomes the very man! The soul of his soul. Oh, how horrid it is!"

He covered his face with his hands.

The vicar looked at him carefully from the corner of his eye. Then he twisted his mouth into a horseshoe, as if saying, "He is lost." At last he broke the silence:

"Father Provincial sent me a letter through one of the pilgrims. He wrote he should be here in a few weeks time."

Father Suryn lowered his hands and looked anxiously at Brym.

"And here I am, no wiser than before . . ."

"What can we do? It's God's will."

"But that God allows it . . ."

"Tsss . . ." the vicar put a finger on his lips, "tsss, don't blaspheme. You are close to it."

Father Suryn covered his face again and moaned with despair:

"What am I to do? What am I to do?"

The vicar smiled.

"First of all drink this beer. Give yourself some strength. You've grown thin with all these tribulations, my good chaplain. Now, on your way back, go for a long walk, take the Smolensk road, to the woods. See what the world looks like. True, it's autumn now, but, every season has its own charm. The woods are full of mushrooms . . . Yesterday, Alex and I brought back a whole basket. And today, as it's a fast-day, we had an excellent mushroom ragout . . ."

"Mushrooms," said Father Suryn, as if he did not believe such things still existed in this world.

"Don't worry," carried on Father Brym, "don't worry. We have a tsadick here, a Jewish wonder-worker, and he always says, 'Worry? You don't have to open your door to it. It'll come through the window anyway . . .'"

Father Suryn took his hands away from his face and again started shaking his head.

"Ah, it's terrible. To see all this torment. How these women must suffer. And why? And on top of that those public exorcisms. People come to them as if it were a circus . . ."

Father Brym sighed.

"That's true," he said. "I have thought about it myself many times. Those wenches . . . forgive me, those maidens are fired up like tight-rope dancers. People watch them like the King's theatre – ha-ha-ha! – and all that questioning comes to nothing . . . I hear you've started dealing with Mother Joanna in private?" he asked after a while suspiciously.

"I think," answered Father Suryn with simplicity, "that in private one can pour into this vessel more love, more hope, and it's easier to drive away that shameful conceit which is sitting in her. And who is this tsadick?" he added.

"He lives here," answered the vicar. "Jews come to see him from as far away as Vilnius and Vitebsk. He isn't even

that old, his name is Reb Ishe from Zabłudów. A wise man, they say. He knows the Talmud by heart, as they all do."

"Reb Ishe from Zabłudów . . ." repeated Suryn ponderingly.

"Go, go, father," said the vicar looking at the chaplain's eyes, which were wandering around finding nothing to rest on, "go for a walk. It's a lovely day today, no rain. Go and look around the town."

Father Suryn rose from his seat, embraced the vicar.

"You haven't drunk your beer, pity," said Father Brym with deep reproach.

"No, I don't drink . . ." smiled Father Suryn sadly, and left.

In the hall he was surprised by little Krysia, who stood with a big watering can shouting "Boo! Boo!"

"What are you doing?" he asked the girl.

"I'm scaring off the wolves," she answered. "Alex's gone hunting," and she went on swinging the can and banging it with her little fist, "Boo! Boo!"

Father Suryn shrugged his shoulders. He could not understand this game. "Although," he thought, "there was no less truth in the 'scaring the wolves' than in casting out the devil . . ." The thought frightened him. Yet the sight of Krysia's puffed up cheeks moved him, just like the cheeks of the little cherubs flying around the Holy Virgin in the picture in the monastery church. "Children are like the angels," he thought again. "For what are the angels but God's children? Maybe in her childish 'Boo!' there is an even greater tribute to the Creator? . . ."

Then he remembered Mother Joanna showing how the Thrones and the Seraphim bowed before the Lord God of Hosts, and suddenly he felt a shiver of fear running all over his body.

From the parish church he turned down towards the river, beyond which the road led to the woods. He walked down the hill and, crossing the bridge, he noticed Kaziuk, the boy from the inn, standing among the half-green trees and yellow bushes. Kaziuk took off his sheepskin hat and greeted him.

"Praise be to the Lord."

"And what are you doing here, Kaziuk?" asked Father Suryn.

"Waiting for the master, the mistress told me to. He's coming back from Smolensk."

"With supplies?"

"Something like that. And here, at the bridge, it's not always safe."

"Oh?"

"Ah, it's just silly talk. I've never seen anything here."

"And what news at the inn? Is the mistress well?"

"Sure she's well. What could be wrong with her?"

"And did you earn a lot during the fair?"

"The master maybe did, but me?"

"Lord Chrząszczewski, or Mr Wołodkiewicz, haven't they given you anything?"

"Eh, would Mr Wołodkiewicz give me anything? He is a wicked man."

Father Suryn laughed.

"Kaziuk, don't judge people."

"Oh, but Father, when I say something I mean it for sure."

Suddenly Kaziuk moved closer to Suryn and looking straight into his eyes he said firmly:

"He is a wicked man, one shouldn't listen to him."

"But I don't!"

Father Suryn was explaining himself as in front of a superior. It surprised him.

"One mustn't ask him questions," repeated the boy.

"Ah, Kaziuk, you are a strange man," said Father Suryn somewhat irritated. "What are you warning me against?" The priest was not pleased with this meeting.

At that moment a hollow rumbling came from the other end of the wooden bridge and a cart rolled into view.

"Master's coming," said Kaziuk.

The cart rolled up quickly and stopped. Kaziuk ran off towards the master but stopped suddenly. On the cart, next to Master Janko, sat Wincenty Wołodkiewicz.

"Talk of the devil . . ." said Kaziuk slowly and began to help the master to unload the cart so that the toll-keepers at the

gate could not see them. In the meantime Mr Wołodkiewicz got off the cart and came to greet Father Suryn.

"What a long time! What a long time!" he shouted, trying to plant a kiss on the priest's arm. "How strange! Whenever I come to Ludyń I run straight into the good father. I've been to Smolensk again!" he was shouting as if Suryn stood seven miles away. "Kind Lord Chrząszczewski took me in his carriage and I travelled like a lord. Now I've come back on the cart like a commoner. And so in truth it should be. But would you believe, good Father?" here Wołodkiewicz raised his big finger, "I nearly became a courtier of the Prince! Well, what can't be done today can be done tomorrow . . ."

Janko and Kaziuk drove off on the cart towards the town. Mr Wołodkiewicz and the priest followed on foot. Father Suryn gave up the idea of walking in the woods and picking mushrooms, and did not know why. Wołodkiewicz's relentless talking fascinated him. Maybe he could even go with him to the inn?

"You must be surprised, my good Father," shouted Wołodkiewicz, "to see me again in this town?"

The priest had to admit that the thought had not even crossed his mind. Wołodkiewicz was as much a part of Ludyń as its mud and autumnal mists.

"Something draws me here," Wołodkiewicz carried on. "I've neglected my business on the estate, and here I am, stuck. My brother is doing the ploughing for me. This place must have a magnet which pulls me here."

He giggled, poking the priest in the ribs till the latter looked at him with annoyance. Wołodkiewicz restrained himself.

"Business, my good Father, business!" he said growing serious all of a sudden, "and an important business, too, for it concerns his majesty's chambers."

Father Suryn did not know why and how the question he asked Wołodkiewicz had come into his head:

"My good sir, you are familiar with the town, they say a tsadick lives here, Reb Ishe from Zabłudów. Do you know where?"

Wołodkiewicz looked at the priest from under his eyelids and repeated:

"Reb Ishe of Zabłudów? I do. Everybody does. I can take you there myself, Father."

"And why should I want to go there?" asked Father Suryn.

"Well, who knows what may happen? Maybe the father will need a tsadick's advice, who knows? They know about the devil, too, do you think they don't? He is a wonder-worker . . . They say he can cast the devil out."

The priest stopped and looked at Wołodkiewicz questioningly.

"Mr Wołodkiewicz, sir, you are pulling my leg."

"Why, me? Sure he can! As my name is Wołodkiewicz! I am telling you, Father, Ishe can cast their devils out."

"With what power can he do that?" Father Suryn cried out in despair.

"Do I know? How am I to know? He casts the devil out with the help of Beelzebub! So they say. Possessed Jewesses come to him from all over the place."

Thus they reached the toll-gates where the toll-keepers were apparently in good humour, for they did not check the goods but took the money and let the cart through. Now they had to walk uphill towards the parish church. On top of the hill, where the street turned, right towards the church and straight towards the other toll-gates and the convent, there, on the left hand side stood a large house, built of brick, in a style rarely seen in those parts, with a high attic and arcades. Local people called it the "King's House" since King Stephen had stopped here on his way to lay siege to Smolensk. Now the house was neglected, the stucco falling off everywhere, opening redbrick wounds on the blind walls. The attic had lost most of its adorning stone spheres and in the niches, where statues used to stand, one could see only the remaining fragments of their feet.

Seeing the house, Wołodkiewicz became more animated.

"Father," he said, "you see this house? Reb Ishe lives

there, just here. If you like I can take you to him straight away. Reb Ishe had communications with Lord Chrząszcze-wski . . ."

Father Suryn was surprised.

"With Lord Chrząszczewski?" he repeated.

"Sure. Do you think, Father, these lords come here just for the lovely eyes of Ludyń maids?"

"Communications concerning what?"

"Who am I to know? Now that Jewish envoy has been to see the Pope . . . maybe it's that, maybe some other business. Well, Father, are you coming?"

They were just passing by the "King's House". Wołod-kiewicz stopped and so did Father Suryn. Passively and helplessly, Father Suryn stared at the slight figure of the nobleman, clad in a worn out *delia*[2] and a shabby sheepskin, who was standing before him shifting slightly from one foot to another as if getting ready to jump.

Father Suryn felt he was devoid of any will of his own, that something stronger than himself was pushing him into the orbit of the unforseeable. He was afraid, but felt he had already given in.

"Let us go then," he said.

And suddenly they turned and passed through the wide open oak gates.

They found themselves in a spacious, dark vestibule. Feeling their way in the darkness they found the wide stairs and started climbing up.

Father Suryn put his feet on the stairs as if he was climbing the gallows, but did not want to go back. As he was going up this Jacob's ladder – as if in a dream – all kinds of thoughts and visions went through his mind, as if he were about to say farewell to his life on earth. His entire uncomplicated life passed in front of his eyes, and particularly vivid was that memorable moment in Vilnius cathedral when he was thirteen. He was attending an early morning mass. It was

[2]A fur-lined coat worn by Polish noblemen.

some time after his mother had entered a Carmelite convent. He was praying rather half-heartedly, thinking of his mother who had left him, and nursing a faint feeling of reproach for her piety. And suddenly, he saw, not with his mind's eye, but with the eyes of his body, the Holy Mother descending towards him accompanied by two angels. As if in a dream, he could not make out any details; he did not see what she was like, how she was dressed, what she was standing on, or how she was descending, but he saw her smiling a heavenly smile and an inexpressible joy filled his heart. The Lady stretched her hand towards him and said, or maybe it was only in his heart that he heard her voice: "I am your mother now, serve me and work for me. Mind only that you do not lose your soul." And the sweetness which filled him became so strong, so painfully overwhelming, it permeated his whole being and threw him onto the stony floor. He was repeating: "I shall serve you, I am yours till the end of the world, Holy Mother, protect my soul from Satan and all His weapons, so I can save it from eternal damnation!" And he was filled with great fear of being damned forever. He also saw, for the first time, the black spider as it lay in wait for his soul. He called to the Virgin Mary: "Protect me! Protect me, my Holy Mother!"

That vision came back to him with such vividness that here, on the Jewish steps, he almost relived it again. The memory of the sweetness brimming in him then, of that unbound happiness, became itself that very sweetness and happiness, and his heart began to beat fast, as if it were about to burst. He kept repeating "I shall serve you! I shall serve you, only protect me from Satan!"

His meditation was suddenly interrupted by Wołodkie-wicz. The small nobleman tripped on an uneven step and cursed:

"Damned stairs! They must be stairs to Hell! I almost fell, like in that inn . . ."

Father Suryn managed to shake off his dreaminess. They stood before the door. A faint light was seeping through a gap somewhere, falling on the small copper hammer which lay on an oak plate. Wołodkiewicz grasped the hammer and

knocked hard. The door soon opened and a long, Jewish youth in a tall fur cap appeared. He stood before the visitors and put a finger to his lips, watching them with a gentle smile in his huge, velvet eyes. He was so young that on his chin and around the ears he had only a few single hairs. His complexion was yellow and devoid of any ruddiness, as it often is with people who rarely venture outside.

"We've come to see the tsadick," said Wołodkiewicz quite loudly.

"You cannot see him . . ."

Wołodkiewicz stepped inside revealing Father Suryn. The young Jew became confused and afraid.

"Please, please," he said, "I shall . . . in a moment . . ."

He almost pulled the visitors inside and closed the door behind them.

"One moment, one moment," he muttered and with a few silent steps disappeared into the darkness of the antechamber. The guests stood waiting in the doorway. The antechamber was completely empty. A moment later the big door in front of them opened and the youth returned.

"Reb says to come in," he said.

Wołodkiewicz remained behind and Father Suryn realised he must enter the tsadick's room alone. He crossed the threshold, bowed and after a few steps stopped.

A big room with a low ceiling and covered windows was lit by many flickering candles. But despite them the light was still weak, as if soaked up by the dusk. The walls and the floor were completely covered by a great number of carpets, lying on top of each other, overlapping on the walls, creating a thick, impenetrable layer which absorbed the slightest noise. Words spoken inside this room sounded flat and died like sparks in the wind.

Behind a long oak table, on which lay a single book surrounded by candles, sat a man, not yet old. He too had a yellow complexion and a long beard which fell on his chest in two flowing waves. Father Suryn reflected that he looked like the late king Sigismund Augustus.

The visitor bowed again and stood in silence. The young

288

Jew remained by the door, full of respect, yet ready to assist in the discussion. Reb Ishe raised his eyes from the book and looked at the priest. His eyes betrayed no surprise, but were very penetrating. At last he rose and without leaving his place behind the table he said:

"*Salve.*"

Father Suryn felt that in this greeting there was an invitation to speak Latin, but at such a moment he had no courage to trust his thoughts to a foreign, and more, a classical language. He was afraid that what he wanted to say would sound strange in classical grammar and that he would betray his thoughts following the well known but stale formulae. He therefore said in Polish:

"Forgive me for disturbing . . . but . . ."

Here he stopped and glanced at the rabbi questioningly but the latter stood unmoved and expressionless. He did not even try to help him finish the sentence.

"You must be surprised," said Father Suryn and moved a step towards the narrow table.

"No," said the tsadick in a resonant voice, "no. I have long expected that one of you would come to see me."

Father Suryn hesitated.

"You know then?" he asked.

"I do," answered the rabbi quietly.

"What is it?" asked the priest again.

"I do not know. I would have to see."

"Oh!" sighed the priest.

"Are they real demons? . . ."

"Ah! Indeed," responded Father Suryn eagerly, "are they real demons? And what are demons anyway?"

Reb Ishe suddenly lost his air of indifference, his face assumed a strange expression and his eyes lit up with sparks of irony. He laughed.

"So, the good father comes to the poor rabbi to ask him what are demons? The father doesn't know? Didn't they teach the father sacred theology? The father does not know. The father hesitates? Perhaps these are not demons, and only lack of angels?" He laughed again. "The angel left Mother

289

Joanna and she is now left alone with her own soul. Perhaps it is only her human nature?"

Father Suryn lost patience. He walked quickly towards the table and stood in front of the rabbi, stretching his hand towards him. The youth by the door shifted from one foot to the other. Reb Ishe pulled back his head gently, so that his eyes were hidden in shadow and the candlelight fell only on his black satin caftan and the intricate arabesques of his thin beard.

"Do not judge, do not taunt, Jew!" shouted the priest, "I know that your knowledge is greater than mine. But you just sit here in this room without windows, with your books, with your candles . . . and nothing . . . you care nothing that people suffer, that women . . ."

Father Suryn stopped, for the tsadick's eyes, concealed in the shadow, flamed with such contempt and irony that the indignant priest was lost for words. He lowered his hand, seeing he would achieve nothing with this kind of argument.

"Women suffer," repeated Reb Ishe. "Let them. Such is woman's fate. No one can escape his fate."

Here he looked at Father Suryn meaningfully. For a moment both remained silent.

"Tell me," whispered the priest pleadingly, "what do you know about demons?"

The Jew laughed.

"Sit down, Father," he said and sat down himself.

His eyes returned into the orbit of the candlelight. Father Suryn sat on a stool. They were now separated by the narrow oak table and the open book. Father Suryn was surprised to notice that the book contained a Latin text. The priest leaned over the table towards the tsadick and fastened his eyes on his lips, shut tight among the thin strands of his beard, as if twisted by a bitter taste.

"We keep our knowledge to ourselves," said Reb Ishe after a while in a low voice.

"And you do not want to fight the evil spirit?" asked the priest.

"First tell me, Father, what is the evil spirit," said Reb Ishe

with an ironic smile, "and where does he live? And what is he like? And whence comes he? And who created him?" he asked louder all of a sudden. "Did the Lord create him? Adonai?"

Father Suryn leaned back.

"God!" he cried. "Who else could create him?"

"And who created the world?" asked the rabbi with temptation in his voice.

"Stop it," whispered the priest again.

"And what if Satan created the world?"

"Are you a Manichean?"

"And if the Lord created the world why is there so much evil in it? And death, and wars, and diseases? And why does He . . . us, Jews, persecute?" he moaned suddenly as if in a synagogue. "Why do they kill our sons, rape our daughters? Why do we have to send an envoy to the Pope? The Jews send an envoy to the Pope to deny all the horrors people tell about them. Why all this, good father?"

Father Suryn did not feel comfortable in this room. It was hot and stuffy. Beads of sweat were rolling down his brow. Small, silver bowls standing among the candles gave out a heavy scent, which felt oppressive to him. The thoughts expressed by the tsadick were not new to Father Suryn. More than once, more than a hundred times he had pondered them, but now, so clearly and forcibly formulated, they were driving him to despair. For he could not answer them, neither for himself nor for the Jew.

"Original sin . . ." he whispered quietly.

"Original sin! The fall of the first parents! And how many times have people fallen and risen again?" cried out Reb Ishe. "How many times has patient Abel met his death from Cain's hand? What sins have not gathered over the damned head of Man? But all the evil done by Man does not explain the evil which torments him. The fall of the first man! The fall of the first angel! Why did the angels descend on Earth and beget giants with women? . . . Well, tell me, Father!"

Father Suryn hung his head.

"Angels," he said in an undertone, "are incomprehensible beings."

"This mother of yours calls herself Joanna of the Angels," said Reb Ishe with scorn, "but what does she know about angels? About those powerful spirits who are everywhere, who look after people, follow them into battle, go with them to the fair? The angels who take care of the music, the light and the stars? What are angels, Father? What is Metatron, the highest of the angels?"

"I don't know," said Father Suryn who was beginning to feel dizzy from the quick questions thrown at him in a quiet, husky voice.

"Our father, Jacob," continued the rabbi, "saw the angels ascending and descending the ladder. Whither were they going? To Heaven. And whither were they coming? To Earth. And why were they coming to Earth? To live on Earth. The angels also live on Earth, the angels can also possess a human soul."

"God sends them," said Father Suryn.

"And who sends the devil? Without the Lord's will Satan cannot possess a human soul . . ."

"When can Satan possess a human soul?"

"When? When a man falls in love with him!"

"What love can there be for Satan?"

"Love lies at the bottom of everything that happens in the world. Satan possesses the soul through love. And when he wants to possess it completely He leaves his stamp on it . . . We had here in Ludyń one young puritz, he loved so much, so much he loved one Jewish girl . . ."

The young man standing by the door sighed deeply; Father Suryn turned and gave him a curious glance. But Reb Ishe continued.

" . . . that later, when he died, he entered her body! And they brought her to me, and she stood there, where you are standing now, and I called on this spirit to come out . . ."

"And what? And what?" asked the priest excited.

"And the spirit did not want to come out."

"See?" whispered Suryn with a kind of satisfaction.

"But he told me he so loved this girl that he'd never leave her. And that they would come out together, his soul and her soul. That is what he told me." Reb stopped suddenly and for the first time there appeared something more humane in his eyes, a sort of pain, or pity. At that moment he hesitated, or perhaps held his breath.

"And what happened?" asked Father Suryn.

"Ay vay . . ." sighed the youth by the door.

"And she died," said Reb Ishe and suddenly, unexpectedly, covered his face with his hand. "Ay vay . . ." he repeated after his pupil, "and he took her soul, and she died. Strong is love, like death," he added after a while.

The rabbi's voice became calm, as if smothered by the dead air in the room in which all sound had died.

"Oh, I shall learn nothing from you," groaned the priest resting his chin on his hand.

The tsadick bridled at the words and spread out his arms.

"You want to know everything at once," he started again passionately, and then, lowering his voice, added quickly: "That which my father learned from his father, and his father from his father, and his great-grandfathers, that which is written on the parchments of Zohar and in the Temureh, all this you want to know, and you want me to tell you all this in three words? Pass it on like some business deal, with receipts and I.O.Us? Hush, hush! Hush, I say! About all the demons, those created by the Pre-Eternal One, Adonai, and those born of the sons of angels and earthly women? And about those which rise and multiply in the souls of the damned? And those which rise from cemeteries to possess their beloved? And those which are born in human souls, born and growing slowly, ever so slowly, like snails, like snakes, till they fill up the soul completely? And you want to know about those which rise in you, poisoning your mind, which blacken your kingly pride and watch only how to strip you of your wisdom and put their seal on you? And about those which dwelt in the four elements and now are in your heart, heart, heart, heart!" He rose from his seat in a torrent of violent cries and stood pointing his

finger at Suryn's chest; the priest was afraid to move on his stool.

Reb Ishe calmed as quickly as he had been roused. He was sitting again before the priest, still and cold, with a yellow, wax-like mask on his face. After a while he started calmly again:

"And you want to know about those demons which are rising in you higher and higher, holding you stronger and stronger . . ."

Father Suryn interrupted him:

"My demons are my problem, my soul is my soul."

The rabbi fastened his penetrating eyes on him and hissed:

"I am you, you are me!"

Father Suryn leapt off the stool and leaned over the table resting on his hands.

"God!" he cried out, "what are you saying!"

Reb Ishe smiled mysteriously as if all that he knew and thought about were forever beyond Father Suryn's comprehension. He tightened his thin lips with contempt. He waited for a while but the priest did not change his position, leaning on the table, full of hopeless despair and expectation. He could not utter another word. Only after a long pause did the rabbi speak again:

"And you do not know what it's like when the demon which lived in a woman's body enters you and begins to tempt you with all these things you have till now regarded as the lowest form of depravity . . . and which now will fill up your heart with an indescribable sweetness."

Father Suryn slumped to his knees and hid his face in his hands. He was ravaged by emotions which he could not name. They swept over him like a hurricane. In vain did he recall all the exorcisms of St. Ignatius, in vain did he try to regain possession of himself, to understand himself in order to understand the rabbi, and as in the cabala, to free himself from his power by naming all his tricks; his head swam in a red mist and his heart was gripped by such terrible fear that he shook like a leaf in November.

"Holy Mother," he kept repeating in his mind, "help me!"

"You want to know something about demons?" the rabbi's dispassionate voice flowed above Suryn's head, "Let him enter your soul. Then you shall see what he is like and you shall learn all his nature and cunning. You shall see and you shall know his sweetness and his bitterness. And the first is the demon of pride Leviathan, and the second is the demon of uncleanliness Behemot, and the third is the demon of jealousy and all anger Asmodeus . . . You shall see, you shall see if they won't sink their claws in your heart."

Father Suryn leapt to his feet staring at the rabbi with horror and quickly backed to the door.

"Oh!" he cried out, "cursed be thine head!"

The rabbi smiled and stroked his beard.

"You, Father, you know nothing. You walk in darkness and your ignorance is like the black cloak of night."

"God is my witness!"

"And I will teach you nothing," carried on the tsadick, "for you can no longer learn anything, and my knowledge is no longer yours."

"You are I," whispered Father Suryn from the door.

"Oh!" laughed the rabbi, "but the teachings of my Lord are no longer yours."

He suddenly jumped to his feet, shut the book lying in front of him with a great clasp and slammed it on the table with one loud smack.

"Out!" he cried in a terrible voice. All of a sudden Father Suryn found himself behind the door, where he bumped straight into Wołodkiewicz, whose small eyes were shining with curiosity.

"Let's go, let's leave here," said the priest pulling Wołodkiewicz by the sleeve. Tripping and staggering along the walls he found his way to the stairs and down towards the door. Wołodkiewicz could hardly keep up with him.

"Father, Father!" he called after the priest.

But Father Suryn was in too much of a hurry, and only when they found themselves outside in the fresh air was he

able to let out a sigh of relief. The heavy scent was still swirling in his nostrils. He pulled a handkerchief out of his pocket and wiped his forehead.

"God, have mercy upon me," he kept repeating.

"Come, Father," said Wołodkiewicz, "come quick, you must drink a glass of vodka, you don't look yourself."

They set off quickly down the narrow street towards the toll-gates. Suddenly, in front of them appeared Kaziuk. He must have noticed Suryn's pale face, for without a word he took him by the arm and quickly led him away.

When they stopped in front of the inn, Father Suryn wanted to go to his room but Kaziuk held him back.

"No, Father," he said, "come, drink some mead, it'll do you good."

"Nothing will help me," moaned Father Suryn with heart-rending despair, "I am damned!"

Never in his life had he felt such terrifying claws of fear sinking into his heart. He hooked onto Kaziuk's arm like a drunkard and stared into his eyes. Kaziuk turned his head away.

"Nobody knows that," he said, "until the last moment."

And as Wołodkiewicz had already disappeared into the inn Kaziuk whispered into Suryn's ear:

"I know where Wołodkiewicz took you, Father. And didn't I tell you not to ask him about anything?"

Father Suryn did not answer. In silence they went into the inn.

Some time after midnight Father Suryn woke up suddenly, as if someone were shaking him, and immediately felt the Evil One sprawling inside him. He felt that the awakened Satan had grown more tangible and that he himself was swelling up with the substance of evil which flowed through him. And then he remembered the axe on which Wołodkiewicz had tripped when they first came into the inn. An overwhelming sense of the object's existence surged in him with such violence that he stretched himself as if trying to push away the cover of the night, and said:

"So, you are here."

"I am," answered Satan.

"Will you possess me completely?"

"Completely," said the Evil One.

Now Father Suryn felt again that he was drowning. The black water filled the space around him and rose inside, bubbling in his chest, in his lungs, flowing out of his throat in a torrent of darkness and blood. His breath was short and muffled, coming from his mouth with great difficulty, like a whistling wind. His hands tore at the shirt on his chest.

"Go away," he said gasping for air, "go away, don't torture me."

Satan let go a little.

"Go away, leave me completely," said Father Suryn, and gathering all his strength he pulled together his scattered thoughts and began to pray.

"Oh, Lord, hasten to my aid," he sighed deeply from his heart.

Satan let go even more. He moved away but emerged from the night and hung in the air in the form of a bat. Father Suryn wanted to cross himself but his hand was like lead.

"Go away," he repeated.

The devil giggled. His giggle was light, thin and it seemed to Father Suryn that it was he himself who was laughing so heartily, but this quiet sound filled the whole space completely. There was no room in the entire world for anything else, only this giggle. Ugh!

"I shall go," whispered the bat, "I shall go. But if I am to leave you I shall have to go back to Mother Joanna. And then I shan't leave her, ever."

Father Suryn shuddered. He remembered Mother Joanna's eyes looking at him as if she wanted to give him her soul, and he was overwhelmed by a terrible, inexpressible sorrow. He choked back the sobs and, breathing heavily, thought of this woman he had come to love. So the devil was to possess this gentle body again? He shuddered once more and his love suddenly rose and grew beyond night, beyond sorrow and Satan.

"I shall go," said Satan, "I shall go gladly. I much prefer the female body."

Father Suryn felt the knives of pain sinking into his heart, his legs, his belly.

"Do not go," he whispered.

"What do you mean, 'do not go'? On the contrary, I am leaving you now, you shall be free, light and, as you say, saved. And Mother Joanna will be mine till the end of time. For ever."

"Stay, take me."

"But you are not wholly in my power yet. You are praying. I can leave you very easily."

"Take me completely."

"Give yourself to me for ever."

"I do," whispered Father Suryn feeling his hair standing on end and his brow, his back, and his face chilled by cold sweat.

"I will take you," said Satan and hovered lower over the priest's bed, "I will, but I need your agreement."

"And you won't leave me?" Father Suryn questioned the darkness with hope and despair.

"Never," whispered Satan, like a lover.

"And you won't go back to Mother Joanna?"

"Never," answered Satan with even greater passion.

"And Mother Joanna shall be for ever free of devils?"

"For ever," came the answer from the night.

"And will she be saved?"

A black cloud, soft as down, descended on Father Suryn's body. He threw his head back as if succumbing to a wave of pleasure, and listened to the voices which came to him from all sides, ringing in his ears, in his head, behind his eyes. They repeated in a chorus:

"She will be a saint, a saint . . ."

The veil of darkness rose again above him and Satan said:

"But it depends on you."

"What am I to do?" asked Father Suryn with pain.

"Give yourself to me for ever," said Satan.

"What am I to do?" asked Father Suryn again and

298

his head began to spin. He was flooded suddenly by his memories of childhood, the scent of hay spread all around him and he felt that it was the last time in this world that he was given to enjoy it, and that into this scent of old days, so beloved and dear to him, there seeped already another smell – God, how nauseating, sweet and horrible.

"Do not call God," said Satan.

"What am I to do?" asked the priest for the last time.

"Give yourself to me for ever," repeated Satan and sat on the edge of the bed. At the same time Father Suryn felt the coldness of the floor under his feet.

"Do you remember the axe?" whispered slowly the Evil One.

"I do!" responded Father Suryn angrily, and suddenly it appeared before his eyes glistening, leaning against the chopping block in the hallway. "I do," he repeated and stood up.

He stretched his hands in the darkness and made a few unsteady steps. At first he felt his way like a blind man, but then he found a strong supportive arm. He moved on with confidence and found the door.

He entered the alcove.

"It's here, it's here, it's here," repeated Satan in a soothing whisper, slowly leading him on.

Thus Father Suryn crossed in silence the empty inn and found himself in the hallway. His hands felt for the axe; it was standing exactly where he had left it a few weeks ago. The main door creaked and the stable gate opened before him revealing a space deeper and blacker than the night, its dark silence broken from time to time by the horses' snorting. The axe and Suryn's arm were growing into one terrible, unerring tool. He felt his blood pouring from his veins into the shaft and throbbing in the blade with a tingling pulse. Satan pushed harder and harder, squeezing the priest's heart in an iron grip. Like the irritating buzz of a fly, around Father Suryn's head circled the whispered words:

"For ever, for ever, for ever . . ."

THE LEGS OF ISOLDA MORGAN

by Bruno Jasieński

> *"Ah, what a leg!*
> *A slightly swollen leg . . ."*
> Dostoyevski "Brothers Karamazov"

> *"It will happen on a morning*
> *or an afternoon . . ."*
> Bruno Jasieński "A Tram Ballad"

I

When fourteen nervous hands – gloved and bare – managed finally to pull out from under the number 18 tram the blood-splattered body of Isolda Morgan, her legs cut just below the crotch and hanging on a few strands of tendon, all their owners suddenly experienced the unpleasant feeling of having perpetrated an indiscretion. The girl was twenty three, had thick chestnut hair strewn in disarray, a face of unsullied beauty and lovely, slender legs ending in hips almost below her breasts – an unmistakable sign of the exquisite in female form.

What followed next happened all too quickly.

An ambulance came and went, taking the whole incident with it. An hour later both legs were amputated and the patient, moved to the clinic's isolation ward, already slept with a heavy, dreamless and strength-giving sleep.

2

Berg, being at that time in another town, was informed of what had happened only the following day in a short, vague

letter mentioning an accident and urging him to return immediately.

The tumult on the platform, the slamming of doors, the smell of fresh paint and the flashing kaleidoscope of trees in the window's diaphragm, all strung like rosary beads on the thread of a numb, hollow anxiety, slipped deep inside him in a vertical line, like a crack. By the time he was listening to the doctor's dry, technical report he was perfectly calm.

When the medical explanations were over he asked to see the patient.

He entered the isolation ward with the doctor.

The patient was awake.

Berg stood at the foot of the bed. He knew he would have to say something, but at that moment he could think of nothing appropriate.

(. . . Heavy, downy rows of chestnut trees, standing in a long, uncompromisingly straight perspective, a cool, moist taste on the lips pressed against other lips, the warmth of a little hand felt through suede gloves . . . Do you remember? . . .)

He even tried to smile but then his eyes fell to the drooping line of the eiderdown modulating into an incomprehensible void below the hips.

(. . . God, oh, God, I mustn't think . . .)

A sweet, sticky liquid rose in his throat.

And the chestnut trees again, and the taste of moist lips, and the long, slender leg emerging from a sunny froth of skirts.

(. . . shushhh, I mustn't cry . . .)

What a funny face the doctor has. His left moustache is drooping, like a beetle's whisker, and on the tip of his nose a tiny pimple.

And then his eyes met hers – the eyes of a frightened, beaten dog (. . . they drowned its puppies – at father's, in the yard . . .), as if begging for mercy, staring at him in tense expectation.

He felt that under those eyes he was growing embarrassed, blushing like a schoolboy, that he had been standing there a

good few minutes and that he would have to say something, and that he – he would say nothing.

Suddenly, he felt like running away.

(. . . people on the street, drozhkas, clatter, trams, trrr . . .)

Why does this doctor have such a funny face? Ah, here's the door handle . . . Pull it. Now.

He leapt down the steps, four at a time, until he found himself in the street among a motley, feverish crowd. He slumped down, red, burning, like a rug. Round, round infinity. The enormous dot of the sun above the inflated "i" of the city.

People ran, walked, jostled, the cars whirred, the trams rang, spitting and swallowing new passengers at the stops, and passing him with the monotonous grinding of polished rails.

3

It was already late evening when the clinic's orderly Timote Lerche – a broad-shouldered old stager with a pox-marked face and rusty stubble – was approached by a young, well-dressed man who led him aside and rolling a five-hundred-franc note in his fingers, enquired if he could do him a favour.

Timote Lerche assured the stranger that he was entirely at his disposal.

Then the young man, grasping him in a friendly gesture under the arm, explained that he was a relative of Isolda Morgan, the victim of a tram accident, who had been brought here two days ago, and that he would like – if it was at all possible (here the banknote rustled with encouragement) – to take both of his cousin's amputated legs.

Timote Lerche did not show the slightest surprise. He confirmed with a nod that he fully understood and was happy to oblige, provided of course that the required limbs had not been thrown away with other offal; and, showing the guest to a chair, he disappeared.

He returned after twenty minutes, carrying under his arm

a long box, carefully wrapped in grey paper. The parcel could easily be taken for a packet from a fashion store and the pink ribbon with which it was tied gave it even a touch of elegance.

Timote Lerche handed the packet to the guest in silence. The five hundred francs were drowned in his overalls. He then enquired of the stranger if the latter would like a boy to deliver the packet home. The stranger however declined the offer and having placed the parcel under his arm left, accompanied by deep bows from the orderly and two porters.

4

In Berg's office the news of his misfortune spread quickly, and created around his person an atmosphere of whispers and silent sympathy. The city's power station, where he was one of the twelve engineers, offered him a month's leave. Berg refused. He turned up at work as usual, very early. In the evenings he stayed at home. Colleagues who tried to visit him after work, found a note on his door – "Please do not disturb."

They knew that since his visit to the clinic he had not been back to see Isolda and explained it to themselves in various ways. Apart from that, his behaviour was quite as before, he talked and smiled. With time they simply came to the conclusion that his love for Isolda was not very great. This opinion was later generally accepted and soon they stopped worrying about him. Nevertheless, they were left with the elusive, mute reproach that he had come to terms with it so easily.

5

These were legs of provocative whiteness and singular length. Beginning with a tiny, narrow, finely arched foot with its appropriately slender ankle they erupted into an exquisitely formed calf, high and firm. From the small knee the white

thigh of velvety sheen was covered with a net of those barely visible blue veins which give the female body its marble-like gravity.

The little feet were still drowning in the shallow, patent-leather shoes and the legs were still covered by black silk stockings to just above the knee, exactly as they had been at the moment when they had last carried their owner. The amputation had to be executed just below the groin and was carried out so quickly that there was no need to bare the legs. Placed on the sofa and nonchalantly crossed, their top ends wrapped generously in the blanket, they looked like the live limbs of a sleeping woman.

Berg would sit with them for hours. He knew every muscle and called it by its name. Moving his hand along the *quadriceps cruris* his fingers caressed lightly the inside of the thigh, just where the groin is linked with the knee by a delicately drawn muscle *gracilis*, also known by the name of *defensor virginitatis*, the weakest of all muscles in the female leg. His whole tortured love for Isolda was concentrated now on her legs. He would lie on the sofa for hours, nestling his lips to the soft, fragrant skin of the pink thighs, just as he had done before, when they still belonged to her. Of Isolda herself he thought very rarely. Or more precisely, did not think at all. The visit to the clinic had left him with nothing but a feeling of estrangement and disgust. What could he care for that other truncated half of the woman, a formless trunk, tragic and disgusting? Cuddling up in sweet exhaustion to her wonderful legs, of which he was now the sole owner, he felt complete happiness.

That Isolda's legs were just as fresh and pink after two weeks as they had been a day after the operation was for him a matter of natural course. Anything else did not even enter his mind. It would seem to him as much of a nonsense as that Phidias's Nike was threatened with putrefaction just because she had no head. Anyway, they were still the legs of a living woman, separated from the rest by a simple accident, without ceasing to be her organic part, linked for ever with the live unity of her indivisible personality.

It is twelve midnight. Berg's night shift at the power station. He could in fact sit upstairs in his office but somewhere (there, deep inside), he fears loneliness, though he does not allow himself to be aware of the thought.

The bright light of the lamps and the rhythmic clank of the machines have a soothing, soporific effect.

Berg is walking down the aisle between two rows of racing machinery.

The swish of whirling sprockets, the crashing of levers.

The music of hot steel.

He stares at the whirling wheel and feels slightly dizzy.

After a while his attention is drawn to a giant piston which rises and falls with monotonous precision. It produces a strained, hollow wheeze. Berg thinks of sexual intercourse. He is watching the piston's tireless rising and falling with growing terror. The copulating machine. "Why don't they breed?" says Berg to himself and feels an ice-cold chill on his spine. "Wild, barren animals," he throws the remark over his shoulder and hurries away.

But he has not reached the end of the aisle. On the right and on the left the pistons rise and fall with frantic momentum. Berg feels a breeze of hard, uncompromising hatred coming from the machines. The eternal hatred of a worker towards his exploiter. He feels small and helpless, at the mercy of these iron creatures. He feels like screaming but manages to control himself. "They hate me," he thinks candidly, "but they are fixed and cannot hurt me."

To prove to himself that he is not afraid he stops in front of one of them and watches it for a while with disdain. The wheel's revolutions are here somewhat slower, languid. The beast is watching, lying in wait. Berg feels a sudden urge to touch a sprocket with his hand. He cannot take his eyes off the steel slider.

"I'll touch it quickly and move my hand away," he thinks with clear determination.

He wants to tear himself away and run but he cannot. And

the wheel is turning slower and slower, growing more and more sluggish . . . The giant arm of the sprocket grows longer and longer . . . He feels its cold breath. In a moment it will touch his face. Jesus Christ!

Suddenly, Berg feels a sharp pain in the shoulder. Someone's bony fingers pull him away with incredible force and he hears a hard, rasping voice like a horn of Jericho:

"Careful, sir! You could fall into the machine."

He sees above him the greasy face of a worker, his big blue eyes watching him from under knitted eyebrows.

"You go upstairs, sir, have a nap. We can take care here ourselves," the voice says with authority against which Berg feels weak and docile like a child.

The strong, bony hand leads him, almost carries him, through the engine room, and lets him out onto the yard.

"Thank you," says Berg quietly and sees above him the sky's enormous, black face covered in pimples of stars.

7

A week after this incident Berg left the power station earlier than usual and headed for the opposite end of town.

The smell of hibiscus on a golden, autumnal day. The boundless calm of the air alarms and horrifies. Everything is in a slumber, still, not a twig stirs, only the leaves, one after the other, detach themselves with deathly silence and fall on the sand in wide, long serpentines.

> *Dry leaves are falling,*
> *Falling slowly, rhythmically,*
> *Rustling softly they spread on the ground*
> *Frightened of the air's deadly hold.*
> *Above their whispering bed the round,*
> *Red, purple and gold,*
> *the sun is setting slowly,*
> *Melancholically, anaemically.*

Just before Berg left the station the older mechanic Ginter had fallen into one of the biggest machines. When he was pulled out he was a formless mass. For Berg, the thought is unpleasant and he tries to avoid it.

Since the memorable night a week ago when he became aware of that relentless, unyielding hatred the feeling of its presence has been growing day by day and he cannot shake it off. Whenever he has to walk through the engine room he does so very quickly, his eyes fixed on the floor. The smell of blunt, impotent hatred blowing from the room fills him with unspeakable, cold terror. He looks into the workers' faces trying to read from them a confirmation of the same feeling, but their faces are closed and stare at him with a hard, grim look. For some time now Berg has been haunted by the thought that the people working here for years have all gone insane. He catches himself observing their movements and on this basis tries to confirm his suspicion. On occasions when he is obliged to exchange a few words with a worker he feels confused and cuts his conversation short.

"Would that I had gone mad myself," thinks Berg and a plan immediately unfolds in his mind.

Yes, that will be best. He will leave here and find himself an office job. That will surely calm him down.

Suddenly he hears behind him a piercing whine. A passing car catches him with its wing and throws him to the pavement. He hears people cursing.

Completely unnerved, he has to lean against a tree to gather his thoughts. Fear hidden deep inside creeps out and looks straight into his eyes.

"I have to think it through, think it through," repeats Berg, but at the same time he feels that in fact everything has already been thought through for him. There is no way out. Just a moment ago he thought with ridiculous naivety that changing his job would be enough to shut himself off from the hatred of the machine. Now he can see that the machine lies in wait for him everywhere. He has to watch his every step.

Suddenly Berg feels trapped. All the machines he has ever

seen roll out from around the corners of his subconscious and surround him with an iron ring. Like a fragile thread of light leading out of this labyrinth a cry rises inside him, the name – Isolda!

He looks around. He is somewhere in an unfamiliar part of town. Only now he feels how tired he is. Time to go home.

A tram approaches. The sight makes Berg shudder. He wants to scream. He looks at the face of a passenger on his right. It is calm, good-natured and contented, like a mask. Suddenly, under the pressure of Berg's eyes the mask cracks into a horrible gaping smile and for a second Berg sees the red open mouth of madness just a few inches away from his own face.

8

The atmosphere at work becomes more tense by the day. Since Ginter's tragic death the unnoticeable whisperings of the workers have changed into a low rumble. They talk of striking.

More and more often Berg bumps into small groups of workers, who disperse on seeing him. A small, square proclamation of the strike has been hanging on the gates for two days and no one takes it off.

That night Berg cries for a long time with his face buried in Isolda's legs. The time has come. Fate prods him on, handing him the role of saviour.

9

The engine room is dark and gapes with emptiness. Berg, after he has shut the door behind him, stands leaning against the wall, remembering less and less why he has come here. Never since he came here for the first time as a young engineer has he seen this room unlit and silent. He is confounded. At first he wants to turn the lights on but then

he remembers that there is no power in the whole town because the power station is on strike. The thought restores his clarity of mind. He tries to think calmly. He takes a torch from his pocket and switches it on. A sharp shaft of light cuts through the darkness. The black void seems now even blacker. The contours of huge wheels loom in it like black wings of giants.

Berg feels that if he stays here a moment longer he will run away. He takes a few steps forward. Now his movements are completely mechanical. It seems to be further away than he thought. He thinks he has already passed it. He raises the torch. Only now he sees that he is standing right in front of the control panel. In the bright glare of light the clock-meters glow like a pair of eyes.

Berg takes from his pocket a file and a hammer.

The clock-eyes stare at him steadily and coldly. His hand gripping the hammer is calm and confident. Now what he needs is a cool head.

The clock-eyes become strange and magnetic. Berg remembers a fakir he saw in a circus, who charmed a snake with his eyes. Now he knows what that snake must have felt – it came to bite but could not move, trammelled by the strange stare. This lasts a while. Then, in a last effort of will Berg suddenly raises the hammer and, with a power he did not know he was capable of, strikes at the panel.

The crash of smashed marble shatters the silence.

Tranquillity – warm, light, deep like a lake . . .

Suddenly something incomprehensible happens – for a moment he is blinded by a flood of light. The motionless black wheels begin to turn. Berg feels a hard blow on the head and falls, hitting the floor with his face.

10

On the fourth page of the only newspaper still published and sold out within an hour, between the news bulletins, there is an announcement in small print:

" . . . caught red-handed attempting sabotage, just as he was trying to destroy the machinery of the city's power station, Engineer Witold Berg will be put before the workers' tribunal . . ."

II

The huge factory floor is drowned by a sea of human heads. In the middle stands a tribune erected from a few boxes. A thin, freckled student with quivering white eyelashes reads the indictment in a colourless voice. The black-haired, big-nosed, slick-licked book-keeper slowly and gravely turns the pages of a notebook. From time to time the freckled student raises his voice, which sounds strangely tearful, and then the crowd's murmur sweeps the room like a gust of wind.

The hearing drags on hopelessly. In fact, everybody already knows the sentence; all that remains to do is to carry out the prescribed formalities.

Finally the student sits down, wipes his nose in a handker-chief while the book-keeper, speaking in a thin metallic voice, gestures vaguely to the right:

"Bring in the accused."

A wave of hollow murmur rolls through the room. Then the door on the right opens, a little too loudly, and escorted by four workers armed with Mausers, Berg enters. The crowd parts, making way for them to the tribune. The murmurs grow, slowly changing into a hubbub of hostile voices.

A bell.

The hearing continues.

The arms of the clock move at snail's pace with stubborn helplessness.

Suddenly the hum intensifies and the sea of heads turns as if pushed towards the tribune. On the tribune stands Berg.

He is very pale, his eyes restless, a strand of hair has fallen onto his forehead. He is dressed neatly, in a jacket. He speaks in a quiet sonorous voice, often stopping in search of a word:

"The day of vengeance has come. The proletariat, conscious of its objectives is ready to fight. In order that the struggle be effective we have first to make clear who is the deadly enemy. It is enough to destroy this enemy and the evil will be abated. This enemy is doubtless the bourgeoisie but it is not the prime enemy. When the money is taken away from the bourgeoisie the proletarian masses will swell by several million heads. The problems of the proletariat will not be solved this way. The enemy is something else, something closer, something with which the worker is in daily contact, at work, something which imperceptibly saps his strength, his health and sometimes takes his life. This enemy is the machine. Not for nothing is the bourgeoisie so proud of the machine, its greatest achievement, which provides it with thousands of comforts. But if they think that they have found in it merely a new weapon to fight the elements and a new way of exploiting the proletariat they are wrong. The machine has multiplied as a pest, it has gnawed its way into every corner of life and from a tool it has transformed itself into a master. The bourgeoisie is now completely conquered by the machine and cannot live without it.

"But the worker has always hated the machine. From the beginning it has been his curse and destitution. Tens of thousands of the unemployed, thousands of deaths and maimed bodies, widows and orphans without bread – that is what the machine means to the worker. Now when the day of open and victorious struggle has come, the proletariat's task lies here: to free mankind from the machine. The machine needs to be destroyed, destroyed now if we do not want the machine to destroy us."

At this moment Berg is beautiful. His face is burning red and his hair crowns his brow like a wreath.

Modest applause and a long unresolved silence. Berg leaves the tribune.

The freckled student rises from the table. He is frightened. He blinks his little eyes. He speaks in a rushed, angered voice.

It seems to him that the engineer simply wanted to make

mock of the tribunal, but the applause he has just heard (here an undecided turn to the side), forces upon him the duty to answer. Destruction of machines which are the cultural heritage of the whole of mankind, and therefore also of the proletariat, would be nothing short of a return to barbarism. The machine serves equally the masters and the workers. What will the proletariat do without machines? Aren't trams, water pumps which everybody uses, aren't they machines too?

Berg cannot listen to the end. He walks through the crowd out onto the street. People step back to make way. It is raining, a thin, autumnal drizzle, soft as tears. Berg feels a growing lump in his throat. His whole speech and the appeal seem to him merely a ridiculous parody. Why bother? These people are the same as the others, only less "intelligent". It's too late anyway.

12

A few days later, when the general strike was proclaimed, Berg went out in the morning. The day was clear and sunny. The squares lay in silence. There were no trams.

Berg came out onto the widest street and walked up the hill. The streets pulsated, as if drunk. All the gates gaped with anxiety. The silence became heavy. Everything seemed to be lying in wait for something which was about to happen. Berg quickened his pace. The eerie silence began to grow heavy on him. He wanted to go home.

On a street corner someone grabbed his shoulder. Clear blue eyes and a peaked cap seen somewhere before. The mechanic from the power station.

"I heard you at the tribunal," he speaks in a clear, ringing voice. "I didn't understand everything but you said that the time is coming when the machines will rule over us and not us over them. And now look – our one move and everything stops. And silence like before the creation of the world. What do you say to that?"

He was all fragrance, he was beaming with joy and power like the sun – We! We!

Berg looked at his face and felt an overwhelming desire to tear that joy out of him and see those round eyes fill with animal fear.

They walked towards the triumphal arch. Berg spoke.

"By now it doesn't matter really. You have failed to understand the machine, you who stand so close to it. And yet it was so simple. The machine's soul is motion, *perpetuum mobile*. Whereas our element has always been that of limitation. We have inoculated ourselves with a deadly vaccine which is slowly taking over our whole organism.

"We are nearing the end with mathematical precision. Soon, everything around us will be taken over by machines. We shall live among them. We are making our every move dependent on a machine. We are surrendering our weapons. We give ourselves into the hands of a hostile element, alien to our nature. The iron ring of nervous exertion, thanks to which we still can maintain our hegemony, will break any moment now. The only choice left to us then will be war or madness. Nobody can see that now, nobody can understand. We are blinded by our own power. There is no way out. We have brought ourselves to bay. And anyway we have it now in our blood. You cannot live without the machine. Your ancestors could still survive. You won't. It's too late for any defence. All we can do is wait. The poison is in us. We have poisoned ourselves with our power, the bane of civilisation."

"Goodbye," he said suddenly straight into the mechanic's ear, shaking his hand vigorously. "I'm going the other way . . ."

13

One late evening, when the sergeant on duty at the number 10 police station was just getting ready for his night's rest, a man appeared behind his desk. White as a sheet, eyes burning, he introduced himself as Witold Berg, an engineer

working at the city's power station, and reported the theft of some legs. He demanded categorically that a police task force be assigned to him immediately, stressing that there was no time to lose.

At the time there were only two officers present at the station and the sergeant explained to him politely that he would have to wait a while as there was insufficient manpower at his disposal, and he would have to request more men by phone. The stranger then stated he could not wait a minute longer and that since this station could not help him he would go to another one.

The sergeant tried to detain the man by all kinds of argument. Then the second officer, who had now returned from making a phone-call, said that the men requested should be arriving within three minutes.

Meanwhile, a statement had to be taken down.

However, nothing more could be got from the man than that while he was out that evening someone had stolen a pair of legs from his flat.

"And here they are," said the friendly sergeant. "No need to worry, was there?"

Six square-built men came in and flanked the door.

"The men are at your disposal," said the officer. "Just lead the way, sir."

Berg shook the sergeant's hand, which was extended to him with eagerness, and led the way. But scarcely had he crossed the threshold when he felt twelve strong hands on his body which brought him to the floor. He was trying to free himself, he kicked, bit, rolled with them on the ground, he almost managed to escape them a couple of times, till he fell down, knocked out by a blow and was strapped. He had a sensation of floating downwards and for a moment the moist, autumnal air swept over his body. Finally he realised he was being pushed into a small, tight box. Then the lid of the box slammed shut. Berg lost consciousness.

But for the officers of the number 10 police station the night was not over yet. The steps on the stairs had only just died away when they were called to a case at 14, N. St.,

314

where a student Isolda Morgan, who had lost both her legs in a tram accident two months before, had poisoned herself with sulphuric acid.

14

He came to bathed in light. Through a little, high window poured white, blinding moonlight. The room was small and unfurnished. The stone-paved floor glistened in the shaft of white light.

He got to his feet, sprightly and agile. Only now did he realise that his arms were strapped. Without the slightest effort he freed himself from the unfamiliar robe and threw it under the bed.

The moon shone bright and clear.

"I'll go out on the street," thought Berg and came to the door. But the door had no handle and was shut. Then he slowly came up to the wall, pushed it out of his way and went out.

On the street he was immediately swallowed up by the frenzied crowd hurrying in a single direction. He walked, pushed about by other passers-by, along wide brightly lit streets he did not recognise. The moon shone with strong cold light like a huge incandescent lamp.

On the corner of some street or other he felt a little hand under his arm. He turned to look. By his side walked a slim, young girl. She had a child's face and dark, long eyelashes. They did not speak. At the next corner the girl turned. He followed her obediently without even asking himself where he was going. Thus they walked the whole length of the street. On the next street the girl led him into a big dark house faintly lit by an oil lamp. He climbed narrow wooden steps up to the second floor. She opened a door with a key.

In a small, neatly furnished room she sat him on the bed and started to undress. When she took her shirt off he saw that she had tiny, very white and firm breasts and that her hips were wide and of pleasing shape. He remembered he

had not had a woman for two months. He took her greedily the way people take bread in time of hunger. Her hips were soft and agile, as if set on springs; they rose and fell rhythmically so that one could lie motionless and the intercourse was driven by a force of its own. He took her time and time again. When he stretched exhausted on the pillows she started to dress. Then he realised he had no money. He told her. She was not angry. She put her clothes on quickly. She said she had to go out again. They left together. Outside the gate they parted.

The street was wide and full of people. Everybody hurried in one direction as if upset by something. To avoid the jostling crowd Berg stepped off the pavement and walked the rest of the way on the road. He was thinking about this strange woman he had just possessed, of her incredible hips. Suddenly he heard a prolonged, threatening grinding behind him. He looked over his shoulder. He saw an approaching tram. It was almost touching his back. Only then did he realise that he was walking between the two glistening polished rails of the tramway. He started to run, as fast as he could. He could not run off the track. He knew with lucid clarity that the moment he put his foot on the rail he would slip and fall under the tram. He ran straight ahead with a speed he could not believe he possessed, the menacing song of the pursuing tram ringing in his ears. He tried to shout – not a sound. Wait, there should be a stop here somewhere . . . But there were no stops. At long last he saw one looming in the distance. Berg gathered all his strength. Just to get there. He did.

But the tram did not stop, it sped on. They passed one stop, then another. Berg felt his hair standing on end and his legs began to fail him. Suddenly an old, worn out octastich, written a long time ago, rattled in his brain:

> *It will happen on a morning or an afternoon,*
> *unexpectedly, yet as a matter of course,*
> *you will hear the rumble and thunder soon*
> *of the trams that never stop at the stops*

316

They will speed on the rails, a hop, a skip and a jump
half asleep, red, stupid machines
tearing perspectives, bent on a ramp,
the fours, the sevens and the eighteens . . .

He looked behind – the tram was almost touching his back. The lit sign glared with the number 18.

Other trams passed them. On the rear platform of one of them he saw Isolda leaning on a railing, waving a handkerchief at him.

With a last effort he grabbed the bulging eye of the tram's reflector and hung on with both hands, suspended in the air.

Long, mad trams thundered past him one after the other, full of white-faced, terrified passengers.

THE WHITE WORMS

by Wiktor Woroszylski

That memorable summer – hot, though bursting occasionally with a sudden downpour – I was doing my service as a recruit in the 76th infantry regiment in Grodno.

The signs, whose secret meaning we were soon to understand, began to appear as early as the spring. The lilacs blossomed somewhat before their time and their big, swelling sprays gave out a strange scent. Not that it was so different from usual, but much stronger, stifling and dizzying. People walked around in those scented clouds as if drunk. Then, one evening during a violent storm, three flashes of lightning like flaming forks struck the town. The first hit the parish church, the second hit the Russian, and the third the synagogue. And that very same night the riotous lilacs wilted, also before their time. In the furrows of the fields squirmed pale worms which the birds didn't want to touch. Again, they were like normal worms but longer and thinner, and as wriggly as earthworms. The crows circled low over the freshly upturned earth, but every time one of them landed on a ridge it just as soon turned its head away and without touching the worm took off with a great flutter. In all honesty, I didn't give it much thought then. I was young, inexperienced and had eyes for other things. Only when the advancing horror claimed its first victim did I begin to think.

The victim was Prokopiuk, my predecessor as the major's batman. One balmy evening Prokopiuk took a swim in the Niemen. The place wasn't deep, just before the Chalky Hills where the bank props them up as if with great effort. Prokopiuk was a very good swimmer, and he wasn't the only one there. The sun set and there was no Prokopiuk. We started calling him, shouting his name, swimming out as far as the

middle of the river – Prokopiuk had disappeared. Then one of us spotted something shiny on the river bank. It was a little silver cross which must have got tangled up in his shirt when the poor wretch was taking his clothes off. We realised at once that Prokopiuk had nothing to protect him from the evil that had pulled him into the deeps. Maybe it got him with cramp, or it caught him in the weeds at the bottom; be that as it may, he could not get away. He was found a week later, a hundred kilometres not down, but upriver. His body was hard, as if it hadn't been in the water, but his eye-sockets were emptied clean and on his neck had appeared a thin white line, just like those worms.

That's how I became the major's batman. *It* had already started its games and stalked the major's every step. Only a few days in my new post had passed when I found myself right in the middle of it all.

One morning the major called me in a strange voice. I came in to see what was up and he, red in the face: "Look here," he said pointing to his left boot, which only minutes ago I'd polished to a shine. I looked and right on top of the major's foot there was a grey mark, like a dog's footprint, or some such beast's. I didn't even try to say one word of excuse, just grabbed the brush and got down to polishing again. In a short while the left boot was as shiny as the right. The major looked at it closely, nodded his head, satisfied. "And let it be the last time," he said in a calmer voice.

But the moment he'd said it I saw on the boot, though now more towards the toe, the same footprint appearing again. This time, even before he noticed it himself, the major understood what we were up against just by looking at my face. I grabbed the wax and started all over again. He wasn't saying a word now, we were both staring at the boot, waiting to see what was going to happen next. And we didn't have to wait long. I was struggling with that boot, on and off the major's foot, for over two hours, and as long as it was off the dog's foot was in no hurry to play its game, but as soon as it was on – the same thing all over again.

The major pulled out his wallet and counted out one

hundred and twenty zlotys, and sent me to Dominikańska Street for a new pair of boots. Carrying them home I peeped into the box every now and again to see if the dog's footprint had appeared, but everything was all right. The major also examined the boots closely from every side. Still uncertain, he put one on, and then the other, strolled across the room, checked them again, and sighed with relief. I did too. The major fastened his belt, put his hat on and walked towards the door. Just as he was putting his left foot on the threshold – and all this time I kept my eye on that foot – the dog's footprint appeared, clearer and bigger than before. My hair stood on end. The major staggered as if he were drunk, collapsed into the armchair and took the boots off in a great hurry.

"The only solution," he mumbled, "is to go to Lida, or take one's own life."

And so we went to the city of Lida to find a pair of boots untouched by the evil curse.

On the way back the major took a seat in the first class compartment, naturally, but didn't send me to third class, instead giving me the order to stand in the corridor and keep a close eye on him. Despite our successful shopping trip the major was still rather unsettled and full of foreboding. He felt a bit better though, when he saw his travelling companion, a young lady in a hunting uniform; he was never indifferent to ladies' charms. Nevertheless, even while entertaining her with his charming wit, he couldn't help looking at the boot, and she soon noticed this.

The lady was one of those bold young things, and far from putting on an innocent air, she received the major's compliments with loud laughter. I would have spit and moved on but he was charmed, imagining himself on a great adventure. Before long he was asking her name and address. To this last one she answered only with a little smile on her ruby lips, and after the first "Lu-. . ." she said slowly, "-cy . . ." and stopped mysteriously.

"Lucy?" the major guessed eagerly, but she turned her head. "Maybe Lucilla?" She didn't confirm that either.

"By the way," she changed the subject, "Why are you constantly looking at your boots? Are you looking for something? A bloodstain? The devil's sign?" and with an audacious move of her shapely foot, shod in a tightly fitted hunting boot, she touched his. She immediately withdrew it, but for a moment I thought I saw, just as the lady's foot touched the major's new boot, the dog's footprint flash out on the leg of the boot, only to disappear again. The major however noticed nothing, but suddenly he became very lively, which surprised me, for in these matters my major was a dull old dog.

Leaning over, moving closer, taking the young lady's hand clad in a glove of delicate leather, he started whispering those sweet nothings with which he was always trying to wheedle the fairer sex, but this time, I felt, he seemed to have been taken in by his own words. She was answering him, but unlike other young ladies, her words sounded rather strange. Yet he carried on with his wooing regardless, like a child walking deeper into dark woods.

As he rambled on, enraptured, about her eyes and their rare brightness she told him: "I tear them out." She said it calmly without taking her face away from his. "Hundreds of thousands of eyes shine through mine . . . But it's not enough . . . you understand? Not enough . . ." and she laughed loudly.

A cold chill ran all over me as if I had stepped into a treacherous mire, even though I didn't understand what she was really saying. Her eyes indeed were burning like torches, I never saw anything like it, and as I was looking at them over my shoulder I felt, after the chill, a burning heat spreading through my bones.

"I'll give you mine," mumbled out the major, "for . . ."

"Who knows," she laughed seductively, "perhaps . . ." and in one movement of her head, quick as a flash, she undid her hair which covered her like a black, shimmering veil. But it lasted only a moment, no longer than before when she had touched the major's boot. She moved her head again and the hair was pinned and bound up high as before. I didn't like

these tricks but the major was staring at her as if in a trance, licking his dry lips.

At that moment the train halted in the forest. The twisted branch of a pine-tree scraped on the window with its prickly hand, as if reminding, or calling someone out. The young lady got up from her seat, and giving the major a mysterious look with those burning eyes of hers, she slipped out of the compartment without a word. She passed, leaving in her wake a stifling scent of blooming lilac, and slithered rather than walked through the hot, shimmering air.

The major sat entranced and I thought he wouldn't wake up before Grodno, and thank God for that. But I was wrong, for when the train stopped again after fifteen minutes, my master suddenly stood up and signalled that this was where we were getting off. I jumped after him off the train which was already gathering speed and looked around trying to see where we were. It was not a proper stop: no signs, no buildings, not a soul in sight; only the forest, deep, impenetrable forest on both sides of the track. There was however something like a path, narrow and twisting, gleaming among the trees, but I felt a strange force pushing me from it and I dreaded making a single step towards it.

"Major, sir," I blurted out. "Sir, they are waiting for us in Grodno."

He looked at me with the look of a gravely sick man and, merely waving his hand in answer, turned towards the path. I followed him willy-nilly, dragging my feet.

The forest was swelling with darkness and a monotonous rustling but the path, against all expectations, was still clearly visible and we moved along without stopping. Soon I felt the uniform sticking to my body, either from the quick march or from the humid air of the summer day, or else from the horror I felt in this wood. At first glance it was no different from other woods in those parts and yet it held, it seemed, some evil secret which, speaking for myself, I wasn't at all curious to know.

I don't know how long we walked. It seemed an eternity to me, but it was probably not all that long for suddenly the

twisted, hairy pines gave way to a wide meadow filled with a sifted evening light, rather than the darkness of the night. In the middle of the meadow stood a building which at one moment appeared to be a gamekeeper's lodge and the next a kind of factory, and every time I rubbed my eyes one was changing into the other. One thing was the same – the thick, fleecy smoke belching out of the chimney, piercing the nose with an acrid smell. "Well, I never! They must be brewing moonshine," I thought. But I soon doubted my simple guess for in the beamed wall above the porch a square of light opened up and in it, like in a picture frame, appeared the young lady from the train.

"At last!" she cried out and gave the major her hand. She led him inside and before he crossed the threshold I caught sight of another figure – paltry, with squinty eyes and a small moustache – which reminded me of that pimp in the Ziemiański Hotel. But the door was shut and I was left alone outside on the porch, completely lost, without the foggiest idea what to do next.

I calmed down and started pacing to and fro on the soft moss, like a guard, though what it was I was guarding – the major's falling into one of his many temptations, or into a dangerous, God forbid, deadly trap? – this I couldn't tell, though I had a feeling of foreboding.

By now the night was growing dark and the hole in the tree-tops above the meadow was filling with glittering stardust. In the end I got fed up with stomping back and forth, and just as I was about to bang on the door I heard an old croaky voice whispering into my ear:

"Local man, are you?"

I looked around: next to me stood a mean whipster of a fellow in a turned out sheepskin and sackcloth pants, and on his head he had what at first looked like a huge woolly hat but which after a while I saw was not a hat but a mass of fleeced hair, what in the old days was called a *plica*.

"I am," I answered unwillingly. "And who are you? The gamekeeper?"

"I am Gmyr," he announced. "I'm sure you know the name . . ."

"Gmyr?" I shuddered. "It's the devil's name. I remember Gmyr the Devil who once played a nasty trick on my grandpa and led him into the marshes. Grandpa left home a redhead and came back white."

"That's me," he giggled, "I used to play with your grandpa. And I wanted to play with you when you came down my path, but the guests didn't like me to."

"You're a hospitable man . . . devil, I mean . . ." I mumbled out.

"Aye, local, aren't I?"

"And who are the guests?"

"Foreign," he pointed his woolly head northwards, "from the Prussian side."

"Devils?"

"And who else?"

Somehow, I wasn't afraid of Gmyr. I remembered grandpa and grandma, and the wintry evenings when as a nipper I used to fall asleep by the kitchen stove listening to their tales. But when he mentioned the foreign devils I shuddered as all the horrible and strange things besetting us lately came back to me afresh, and I suddenly felt like a helpless little fish in the devil's invisible but strong net, caught together with a bigger fish, even less able to escape, my major, and in this hopelessness I felt my knees going soft as wet clay.

Seeing me so troubled, Gmyr must have taken pity on me, and lowering his voice even more he murmured: "All's not lost yet, all's not lost . . ."

I held on to this line of hope:

"Tell me then, can I save my major from the evil claws?"

"Eee," he shook his mop, "you can't do much . . ."

"What are they doing to him?"

"That hellish whore is there and your major is playing with her, as he wanted . . . It's like this, if he can keep up with her till the first cock-crow, they'll give him a choice . . . If not . . ."

"They'll grab his soul," I whispered shaking like a leaf.

"Soul?" sneered Gmyr. "They don't care for souls. They care naught for God either, if you ask me. Theirs is a different need . . ."

The fear that had seized me was growing stronger and stronger, for if devils don't believe in the soul, or quarrel with God about it, then it must be such a nasty business that there's no way an honest man can get out of it.

"Come," said Gmyr and led me to the building, which at that moment changed into a factory again. Inside there was darkness, broken only by strange flashes of light flickering above the monstrous vats like fireflies on a swamp. I resisted with all my might and tried to sneak out from the devil's store but Gmyr held me tight: "Look," he demanded prodding me, "look into these vats and see what sort of mash my guests use for their elixir."

Curbing my fear I bent over the nearest vat and looked straight into a swarm of living human eyes of all colours and sizes, weltering in a disgusting, thick, bubbling tallow, and right in the middle I saw a pair of eyes, painfully familiar, though at first I couldn't remember whose they were. They looked at me with reproach, as if I were the devil's partner, until in my helpless despair I recognised them as the eyes of Prokopiuk, drowned on that balmy evening. I jumped away from the fiendish vat, feeling so sick I could hardly stand on my legs.

"What's all this . . . Why . . ." I stammered out, struggling to be myself again.

"These are their new rules," said Gmyr with a grudging grimness, "the new law they've laid."

"The old folks told me much about the devil's tricks . . . But this? . . . Never . . ."

"Well, there's never been anything like it," nodded Gmyr, and he was about to add something when a cock's crow pierced the air. The infernal will-o'-the wisps above the vats fluttered and paled, and having felt the weight that had been lying heavily on my heart suddenly lift I drew a big breath and ran out into the clearing, under the starry sky. Gmyr ran after me and we both ran onto the porch, and then to the

door in the beamed wall. The door gave when pushed, but behind it, barring the way, stood that pimp, the same one I'd seen earlier. "Pst," he hissed, warning me with fingers that seemed to have no bones in them, "Don't disturb the lovers!" and I found I couldn't move. I could have easily squashed the vermin; it was however, I realised at once, that Prussian devil.

"It's after the first cock-crow," I managed to mumble, but he only waved his hand:

"It looks like the officer hasn't had enough and has extended the bet till the second cock crows."

I had faith in the major as if he were my own father, but here, I thought, he'd overdone it, that is, if this pimp of a devil wasn't lying.

Gmyr and I backed out onto the porch, followed by that filthy guttersnipe who, piercing me with his squint, said:

"If you're bored, soldier, let's play cards for a decent wager."

"What shall I wager then? My eyes?" and I crossed myself quickly, at which he recoiled slightly, twitching his little moustache with displeasure, but went on: "Eyes? Why not? But your nerves, I see, aren't bad either, soldier – pink, nimble, haven't been used much . . . And I," he was tempting, "would stand a good foreign porter, however much you want, and as much black pudding, fresh, from today's slaughter . . ."

"Leave him alone, Herr Wrum," muttered Gmyr with distaste. "The officer will do for you, but this one's a simple lad, local, his sort are for me . . ."

"For leading astray on marshes," barked Wrum scornfully, "for scaring with hooting owls and winds whistling down chimneys . . . We turn this muck into superbeings such as the world has never seen! God cries salty tears when He sees one of them and you go on as if we were still in the Middle Ages!"

"We are not learned," admitted Gmyr gloomily, "and we can't understand your plans . . ."

"Then be obedient and disciplined!"

Gmyr opened his mouth to say something, but at that moment a terrifying cock-crow resounded again, the second cock-crow of that night, and so he stood with his mouth open while I, not waiting for more of Wrum's ranting, slipped past him, forced the door open with my shoulder and ran into a big room where I found the major lying on a bearskin, pale but alive and unharmed, and in the corner the young lady from Hell, paler than he, with tangled hair, swaying with exhaustion and embarrassment.

"Till the third cock-crow," said the major.

"No . . ." she whispered pleadingly, "please, no more . . ."

"Hey, Mr Officer!" shouted Wrum the pimp from the door. "You've dishonoured my cousin Lucy! You'll pay for it."

"I am ready," said the major standing up.

"But the deal was different," reminded Gmyr. "You were . . ."

Wrum snorted scornfully and without bothering to reply to the local devil he made a step towards the major. His white fingers, spread out and writhing like worms, were getting nearer and nearer the proud and handsome face. I wanted to rush in between them and stop them, but a strange deadness seized my limbs and I could only watch in despair the whirling of the hellish tentacles, until suddenly they curled up and fell down. Now, seeing Wrum's futile efforts to lift his arms, I realised that he was held by the same power that held me. But that was not the end for soon, apparently against his will, Wrum started backing out at a trot and at that moment I regained the power of my arms and legs. The Prussian fiend rose a good couple of feet above the threshold and, still moving backwards, barked from behind the door:

"I shall remember that, you filthy muckworm!"

"We can still turn on the old tricks," giggled Gmyr, "without the help of the new science, just like in the old days . . ."

From a distance came Wrum's voice:

"One way or the other, that which I have once reached for, will be mine! . . ."

Then the cocks crowed for the third time. I looked at Lucy and shuddered: her thick, black tresses were turning completely white and fading, her hunting dress rotted and she changed into a hideous, decrepit witch, only her eyes still burning with that unearthly glow.

I spat and ran outside into the meadow, the major following with an unsteady gait.

Day was breaking and in the pale light of dawn I noticed a winding string of footprints left by a dog, or some such beast. When I got near the first one, it burst into stinking flames, and then the rest wove a fiery path among the trees. Soon the flames engulfed a small juniper bush and before I could say three Hail-Marys the resinous pine-trees stood engulfed in a wall of fire. We flung ourselves in the opposite direction. The major was no longer tottering but in an instant regained his old resilience and orientation. We tore through the pathless wilderness of the forest, leaping over roots, holes and bushes while the fire roared behind our backs. It must have been choking on its own hate, though, for it fell further and further behind until we could hear another noise giving us a sudden breath of hope – that of a train pounding on its tracks.

We reached the tracks just as the puffing train was coming to a halt. It was that very same spot, the stop with no station we knew from the previous afternoon. I pulled open the carriage door, the major jumped in, I followed, and the train moved off, as if it had stopped there specially for us.

It would be nice if I could finish my story at this point, with the rays of the morning sun playing on the carriage windows, in the sweet greenness, and in that peace which made us doubt everything that had happened to us that night, and trust it was just a nightmare . . . Alas, it was all true, and yet to reach its gruesome end.

A week later our regiment, part of the 29th infantry division, was cutting its way through different woods – not my local ones – on the river Pilica, which was flowing red with blood. The war was on; the time of our terrible defeat. The

autumn was so beautiful you could breathe it in and in, and you'd never have enough of it, if it weren't for that calamity.

The major marched with the soldiers, wading with them through the boggy streams, without a wink of sleep, inspiring those who were tired. At four o'clock in the morning, having passed the Piotrków-Częstochowa road, the vanguard – I was there with my major – turned south towards Łódź which had already been taken by the enemy. The order came to attack. We ran across the open field shooting until we were forced to the ground by the enemy's fire. But after a while we got up again. Then the enemy attacked from behind. Before our command managed to decide anything we were attacked from the third and fourth side. We lay down, pressed flat to the field stubble, firing back in great desperation – we didn't even have time to pray for deliverance. Then I heard a terrible rumbling. I lifted my head and on the horizon I saw dark, heavy monsters, moving slowly, crushing everything in their way. The tanks were rolling in on us.

We did not surrender and kept the fire up to the end, but what could our shooting do to the thick armour-plates? When one of the tanks stopped some dozen yards from our position and one of its hatches opened slowly, the major stood up and fired his gun straight into the figure emerging from the hatch. He didn't miss but the figure kept growing out of the hatch as if the bullets couldn't harm it. I recognised that sordid moustache and the squint on that crumpled pimp's face. Wrum was grinning and shouting something which was drowned in the clamour of the fighting. The tank spat with fire and on the major's boot, just below his ankle, flowered the bloody sign of a dog's footprint. The major staggered but did not fall, took aim and fired once more. He hit Wrum again, and again didn't harm him. He was about to fire for the third time, carrying on his duel with Hell's might, but the tank was quicker. The shell exploded next to us, shrapnel stinging me in the hip, but that did not matter for I wasn't concerned about myself then. Before the pain blacked out my sight I saw the most frightening thing of my life – a pair of eyes gouged clean with red-hot iron and rolling out

of the major's head like two enormous, bloody tears. I wanted to jump to his side, to prop him up . . . and fainted.

Two years later, after escaping from the prison camp I reached the forests of the river Niemen and joined the resistance. Seventeen times did we set traps for landrat Wrum, who held the district in his devilish grip; and every time he managed to slip through our net; until I made a deal with the local devil, Gmyr, and he delivered Wrum into my hands where he met his end. My soul will fry in the fires of Hell, but to me, who was with my major at the hour of his terrible death, the good old Hell of Gmyr, God bless him, holds no fear.

DRAGON

by Andrzej Bursa

I still had the rest of the afternoon and almost the entire evening ahead of me before the bus would arrive. Ready to go, briefcase in hand and coat over my shoulder, I sat in the deep grass on a slope by the roadside. The material for an article on the difficulties and problems of manufacturing traditional harnesses in the village of G. was researched thoroughly and so, going through my notes again seemed a pointless exercise. I had six hours to kill.

Luckily, the weather was warm and sunny, and I stretched out comfortably in the grass. I could see practically the whole village from here. It was big, spreading widely over the surrounding hills and valleys. In the market square, amid the ordinary, thatched huts, stood two one-storey houses built of stone and the brick building of the new bakery. Below stretched the fields through which ran a lively stream. All this was surrounded by mountains, their tops covered by spruce forest. G. was a typical mountain village populated by shepherds and harness makers. Because of its geographical position G. was cut off from the major regional centres, yet its inhabitants were relatively cultured folk, eager for education; as I was informed, even a certain recently deceased professor of the oldest university in the country was a native of G.

And so, lying on my stomach in the tall grass I abandoned myself to the contemplation of nature and the village architecture. Lazily smoking cigarettes and squinting against the sun proved also a reasonable source of amusement. Suddenly I noticed a skinny shrivelled old man who was squatting nearby. After a while the old man moved towards me holding in his fingers a short, blackened cigarette-end and

asked for a light. I offered him my own cigarettes. At first he declined politely and then helped himself to two. He lit up and settled comfortably next to me. I accepted his presence with resignation; after all, he seemed no more boring than the clouds or the mountains.

We started to chat. The old boy turned out to be a retired school teacher; he complained about his aching joints and I found this topic amusing enough. He did not take advantage of my position as a journalist by asking favours or trying to sell me village secrets. I was grateful for this and kindly listened to his complaints. We were already smoking a second cigarette when I noticed a group of people gathering in the market square. As far as I could tell from this distance they looked as if they were leaving the church after a high mass, all dressed in their Sunday best. The old man looked in their direction and stated indifferently:

"Oho, they are getting ready . . ."

"For what?"

"You don't know? . . ." he was surprised. "The 20th of May . . . Dragon's Day."

"What dragon?"

"You haven't heard of the dragon of G.? People haven't told you?"

"Nnno . . . Or maybe? . . ."

I remembered that, indeed, when I said in the club that I was going to G. one of my colleagues mentioned the dragon. At that point however the waiter brought the vodka and the conversation moved onto another track. And today, during the interview with the chairman of the Village Council, the word "dragon" was also mentioned, perhaps even the "Dragon's Day". But, as I really had learned nothing more from him, I asked my companion to tell me about it.

"Ah, it's an old custom," he said, "going back maybe even to pagan times. What happens, is that once a year, on the evening of the twentieth day of May, the bonniest lad and the bonniest lass, not more than eighteen, but no less than sixteen, are thrown to the dragon which lives in the cave by

the river. Of course the word 'bonniest' shouldn't be taken literally – any healthy boy and girl of the prescribed age are chosen by means of casting lots."

"And what do we call a dragon?" I asked amused.

"The dragon is real alright. It's a huge old lizard of unspecified kind. It lives there . . ." the old man pointed his finger towards the alder thicket on the other side of the river. "Anyway, would you like to observe the ceremony? We can join the procession which has to pass this way. You'll be able to see the whole thing, including the devouring."

I could not tell whether the old man was making fun of me or simply drivelling. He noticed this and smiled:

"Are you surprised? All our visitors are when they find out about it. But then they get used to it. It's now thirty years since the Society for Public Education organised the first campaign against the dragon, and lost. The problem was also taken up by the government and Party officials but so far they haven't taken any positive steps. You see, the authorities have to reckon with our highlander's conservatism and love of tradition, and in truth they turn a blind eye to the dragon. Thirty years ago I myself, as an activist of the SPE, spoke out sharply against the dragon and other superstitions rampant in our rural community. I even wrote an article dealing specifically with the dragon. It was called *The Monster Sucks Out Our Vital Juices*, and it appeared in our official organ *The Torch*, which, alas, died a death a good five years before the war."

"What?" I shouted, quite upset. "So every year you sentence to death two innocent people, almost children?"

"Well, yes . . . The village doesn't lose much, for the women here are broad in the hip and give birth easily, almost without pain. There's even a proverb: 'Our lasses in good health always give a painless birth'. The vicar grumbles about it because it goes against the words of the Holy Bible."

"And what does the dragon do for the rest of the year?"

"He just lies in his cave digesting the two people, doesn't ask for anything more."

"And if . . . if . . . he were refused the sacrifice . . . ? What would happen then?"

"Oh, I don't know. Nobody's tried that yet."

"And if the monster were killed?"

"It's not that simple. It seems to me that such a rare creature must be under some kind of protection. After all he's not as dangerous as you may think . . . You'll see."

Meanwhile, the procession was moving down the road. It was led by the chairman of the Village Council, accompanied by two men whom I recognised as the secretary of the local Party and the well-known "people's artist", the local wood-carver Lelek. A few metres behind them two elderly women, wearing starched skirts and beads, led the boy, who, despite being no more than eighteen, was tall and broad-shouldered, like a fully grown man. His brow was furrowed by a deep, horizontal frown. He walked with a rope hanging around his neck but apart from that there were no other signs of force, except maybe for the two women who held him lightly under his arms. The boy's face was covered in sweat and his jaw trembled. Further on two old men in black suits were leading the girl. She was dressed in a silk dress and high-heeled shoes, and sobbed all the way. Time after time she reached into her white handbag for a handkerchief, loudly blowing her nose, putting the handkerchief back into the handbag and taking it out again. Behind them, like a river, flowed the crowd of peasants – men, women and children.

The old man and I stepped off the grass onto the road and joined the procession. The crowd parted and gave us a place at the head, just behind the girl. The procession waded on through the dust of the hot dry road; people sighed and wiped sweat off their brows. After a half hour march we reached a small footbridge on the river. Here the girl became hysterical. She threw herself on the ground, wailing spasmodically and grabbing people's feet. The crowd stopped to allow the attack to pass. Some lit cigarettes. After a while the girl got up, brushed the dust off her dress and obediently crossed the river. The footbridge was so narrow that it could be crossed only in single file, and so the crossing took a long time. Many took their boots off and forded the river.

The place where the procession stopped did not look any different from the remaining stretch of riverbank. Perhaps only the osier and alder thickets were somewhat thicker here. The crowd formed itself into a crescent. The chairman raised his hand and recited:

> *O, green dragon, fed with sulphur*
> *we've come to your lair*
> *come outta there, come outta there*
> *take the sacrifice.*

Something rustled in the osier bed and the dragon emerged. It was a reptile four metres long, an old, blind and mouldy beast. It could hardly stand on its weak, soft legs. .

> *Hear dragon, ye fiery beast*
> *Put ye tail to the west*
> *And ye snout to the east,*

recited the chairman again, and seeing the dragon stumbling clumsily he struck it with a stick across the back: "Shift yer-self!" he called out sharply.

The dragon snorted and positioned himself properly as told. The boy, until now quiet and composed, went green and shuffled uneasily.

"Mother," he mumbled to one of the women holding him, "I feel a bit sick."

The women took him a few steps to one side and held his head with tender care. The boy vomited and wiped his mouth quickly. The women then led him to the dragon and retreated. The boy knelt down, crossed himself, and trying to sound like the chairman, mumbled out:

> *Good bye my family*
> *and ye pretty lass*
> *and ye bright sun*
> *and ye green fields.*

"Amen," answered the crowd.

The dragon came closer, sniffed the boy, swept him under its belly and tore him apart. He swallowed him in three long gulps. Now it was the girl's turn. She was not crying any more. She kneeled down, wiped her nose and recited the formula. The dragon dealt with her in two snaps of his teeth.

The chairman said:

> *Hear, ye dragon,*
> *ye took what we gave,*
> *now go back to yer cave.*

The dragon stood up with great effort and disappeared into the bushes. The chairman intoned a song. People sang lazily, in fact no one even bothered to sing the last words. The crowd began to disperse. It was time for me, too. My bus was leaving in twenty minutes.

THE GOLDEN GALLEY

by Jacek Dukaj

More or less at the same time as the chief of the Earth's Intelligence Service was sweating before the President, trying to explain why he had still not come up with any solid data, and while the neosatanist Michael Condway was celebrating an imash, the Golden Galley was floating majestically on the outskirts of the Earth's empire. In the headquarters of the Blessed Legions – a skyscraper reaching three kilometres into the sky and hovering five hundred metres above the ground – the Archangel Charles Radziwill strolled the length of the panoramic windows of his office, waiting for the directors of the third and fourth Departments.

First arrived McSonn, who indeed had good reason to be officious; for the last four days he had been trying, in vain, to complete a job for which the Blessed Legions had already been paid fourteen million. For the last hundred and four hours the Department of Governmental Commissions had been labouring ceaselessly to carry out even his most idiotic instructions.

McSonn slipped noiselessly into the Archangel's huge office and sat in one of the armchairs hovering around the old fashioned four-legged conference table. Without saying a word he fastened his eyes on the crucifix hanging above the door and grew still. His friendly spirits informed him of the imminent arrival of Colloni, adding that Radziwill had already dispensed several excommunications today and was in a foul mood.

The Director of the Special Task Force arrived attired, as usual, in the period garb of a hippie. In contrast with the rest of the Blessed Ones who dressed to dissolve in the crowd, he wore clothes that attracted attention, were weird to say the

least, thanks to which no one ever suspected him of belonging to the Legions. As a hippie he was a sight to behold: long red hair falling in dreadlocks onto a faded green jacket which, out of necessity, was always open as it had no buttons, nor a zip, nor other fastening. Under the jacket showed a hairy chest with a tattooed cross into which Colloni had locked by way of a magic spell all his powers, a clever trick in as much as anyone wanting to divest him of those powers would have to skin him as well. Freezing one's supernatural powers was very convenient and despite the ban all the Blessed did it. The holster for the controls was hidden in the macramé covering his trousers. On his left ear dangled an enormous earring where Colloni carried his Jewel of the Friend.

He was an odd fish and no one in their wildest dreams would have guessed he was the deputy Archangel of the all-powerful Legions.

"God bless you brothers . . ." muttered Colloni, seating himself in an armchair.

Radziwill mumbled something in reply and without further ado gave out his orders:

"Colloni is taking over from you, McSonn. As of now. We have three days left before the deadline." He bit his lip and looked at his fingernail. He was clearly in a hurry. "You do understand, Colloni, what failure would mean for us. The Blessed Legions always deliver. You have priority. Take all the men you want, do what you want, but remember the deadline. Three days, Colloni, three days!"

Day One

They waited till Radziwill's friendly spirits left the room and all gave a sigh of relief.

"Where has he rushed off to like that?" asked Colloni, taking out a brown leaf of dajerr.

"I think he has a meeting with the chief of Intelligence."

Colloni whistled without stopping chewing, which

338

amazed McSonn. He had taken his fall from grace with the look of a devil drowning in holy water and, like Radziwill, was pissed off with the whole world.

"Stop it," he growled. "You look like a cow."

"A cow?"

"It's an animal."

Colloni shrugged his shoulders and carried on chewing.

"Well, what's up then?" He lost his patience as he started on a new leaf. "Charles said something, didn't he?"

This time McSonn shrugged his shoulders. He got up and walked to the invisible console. The room was plunged into darkness and above the table appeared a section of the cosmos with a fragment of a distant sun.

"Altair," he explained. "Ten days ago, out of the blue, there appeared . . . this."

Into the field of vision drifted the bows of a ship. A sea ship. She shone with yellow light, shimmering from the top of her masts to the rough planks of her underside.

"What the hell is this?" Colloni pushed himself off the table.

"The Intelligence has paid fourteen million to get the answer to that question. Paid us. And we still don't know." McSonn shook his head sadly.

Above the table now glowed an enormous galley in its full glory. Such floating craft must have sailed the seas in the past. The three sails fluttered in a non-existent wind and on top of the middle mast, like a small sun, beamed a red lamp. Under the bowsprit, there was a figurehead.

A bird's eye view: the empty deck, the wind-filled canvas of the sails.

"Is this some kind of a joke?" snarled Colloni.

"A joke? If it's a joke it's a very expensive one. The galley measures three thousand kilometres in length. And it's made of gold."

"How much is it worth?" mumbled out Colloni.

McSonn tapped himself on the forehead.

"Are you all there?"

Colloni pulled himself together.

"A galley, you say . . . and the oars?"

"According to the latest calculation there are about six hundred billion of them."

"Eh?"

"Six hundred billion. The thing is that while the ship is built to an enormous scale the oars are natural size. It's hard to see them."

"Hallucination? A curse? A spectre?"

"Sorry, old chap," sneered McSonn and looked at his fingernail. "It's late. Got to go. I have a flight to Lalande in two hours. Blessings."

"Blessings . . . Blessings . . ." muttered Colloni. He had a bitter taste of failure in his mouth. He spat and walked out of the room.

In the corridor and in the lifts people got out of his way. News spread quickly here. Especially bad news. He reached the level housing his section, marched straight into Stadochi's office and ordered him to cancel all arrangements for the next few days. Then, having shown enough of a foul mood to be left in peace for several hours, he locked himself in his dark little room, checked the latest on who was after his soul and logged in to the Brain.

The information on the Golden Galley gathered by McSonn was scarce. Thanks to three automatic satellite probes, orbiting at a safe distance from the ship, it had been photographed to the last detail, measured and weighed. No one knew where it came from, for it had appeared suddenly, but it certainly didn't come out of the anti-Cosmos. Could it be teleportation? It had no means of propulsion, or at least nothing that had been identified. The galley was drifting on the outskirts of the solar system of Altair at literally a pedestrian rate, that is, it was practically stationary. It was composed, down to the last particle – including the sails – of gold; the experts swore by that. The lamp on top of the middle mast was indeed a small sun, locked in a cage the shape of a pyramid, which by some miracle did not melt. This masterpiece was built precisely to the original medieval design, which, if one took

340

into account the ALIENS variant, gave a lot of food for thought.

Twenty four hours after the appearance of the galley, when all attempts to communicate with it had failed, they had sent two raiding ships with Special Task Force troops on board, which had approached the galley to a distance of a million kilometres. Soon after, due to the loss of contact – although the communication system was working perfectly – the ships had to be recalled to base by remote control. The men were alive, but they were in a strange torpor from which they still had not awoken. Except for one man who had gone mad. Colloni logged in to the STF's secret brain and checked the madman's files. One thing that struck him as unusual was the man's extreme religiousness. Apart from that he was like billions of others.

After the failed landing mission they had tried their luck with automatic unmanned craft. The ships reached about half a million kilometres from the galley and, hard as they tried, would not move an inch further. The machines simply refused to obey. For six days the Intelligence had struggled with this devilry, until in the end they coughed up fourteen million and passed the buck. It so happened that the buck had landed on McSonn's shoulders, but his legs had buckled and so it had ended up in Colloni's lap.

It was half past two when Colloni finished studying the documentation. At the end he found information that had arrived just minutes before. It came from the satellites observing the Golden Galley. It said that the Galley was increasing her speed to 45km/h.

Then, Colloni checked the list of McSonn activities and half the points, together with his own comments, copied onto another grain, were sent to Stadochi with an order to repeat those operations. Stadochi, who had no idea about the existence of the Golden Galley (the information was top secret) but knew his boss was in trouble, didn't bother to be surprised. He carried out the order but there were no revelations. One had to hand it to McSonn – he had done all he could.

At 15.15 hours Colloni decided to consult his Friend.

Miskialiatol appeared amidst the glimmering of an unearthly mist, surrounded by a sapphire glow and the web of his silver hair that reached to the ground. The brightness of his white robe was dazzling. The mist scattered and Miskialiatol raised his wrinkled face, looked at the dispirited Colloni and sadly shook his head, just as McSonn had before.

"Well, tell me – what am I to do? Not a single point of reference. Nothing. Absolutely nothing." Colloni spread out his arms in a gesture of helplessness.

The Friend, who was informed of everything via the Jewel, sat in the armchair at the other side of the desk.

"Take a closer look at the stem of the Golden Galley," he said in a tired, old man's voice. "I've noticed something disturbing in that hologram. Niej always said you don't pay enough attention to details. The figurehead . . . there's something strange about it."

Colloni rocked in the chair for a while consulting his friendly spirits, then sighed and called up the hologram. He enlarged the image of the stem and there it was: the huge golden figure, gleaming against a background of vast darkness.

"Doesn't it remind you of something?"

"Christ!" Colloni hurriedly switched off the image protecting himself against the automatic spell.

"It's Satan!"

"So it is." The Friend got up. "If it has anything to do with the Accursed, you know best what to do," he said, and disappeared.

Colloni rubbed his hands in glee.

At 17.45 his plan was ready.

At 18.08, having given relevant instructions, he got into his strat and flew off.

At 19.05 there came information that the Golden Galley had markedly increased her speed.

At 20.40 she was speeding at 79 thousand km/h towards Earth.

At 22.30 Archangel Radziwill returned to the headquarters

of the Blessed Legions and ordered an immediate search for Colloni. The search proved futile.

At 24.00 the speed of the Golden Galley reached 134 thousand km/h.

Radziwill stomped around his office sputtering curses.

Day two

The Middle-European Natural Landscape Reserve covered a wide area and without a special map it would be difficult to find the lodge where lived the forester, one Mr Rosen. In a hurry, or through neglect, Colloni had forgotten to take the map with him. Of course he could have logged in to the Legions' Brain, but that meant being localised by the Blessed anxious about his whereabouts. The nearest town was half an hour's flight away, which with the return made a whole hour. Circling above the Reserve, Colloni had no intention of going back; it was silly to lose sixty precious minutes. The programmed auto-pilot that searched for any warmer points in that wilderness, led him to three illegal bonfires. Apart from scaring off the tourists, the nocturnal flight above the woods brought Colloni no joy. Having lost his faith in science, he placed his trust in instinct. He switched to manual controls and after twenty minutes' wandering in the darkness, at 01.27 hours his strat sat gently on a small landing pad, next to the forester's lodge which hovered in the air some six metres above the ground.

Colloni put on the strat's piercing alarm signal, which probably woke half the Reserve, including Mr Rosen.

The dark cube suddenly burst with light. The invisible speakers wheezed:

"What the hell is going on out there?"

Not wanting to be outdone, Colloni shouted through the air-tube into the shadowy expanse:

"Mr Rosen! . . . I want to talk to you! Now!"

"Go to the devil! It's half past one in the morning!"

"It's urgent! I have come here specially from Sydney! I'm from the Blessed Legions!"

343

"What!?"

"From the Blessed Legions!"

"Er . . . Can you show yourself?"

Colloni, regretting he had not changed, got out of the strat. The low-power, wide beam laser pins sought him out in the dark.

"You . . . You're from the Legions?" The forester almost choked with surprise.

"That's what I said! I have to talk to you. Now."

"Er . . ." Rosen clearly couldn't make his mind up. "And the Sign?"

Colloni took the Legions' badge out of his pocket. He held out his hand and somehow survived. Rosen was finally convinced.

From the building descended a small platform; Colloni hurried towards it, afraid the suspicious forester might change his mind. The spectacular illumination suddenly vanished. For a fraction of a second Colloni lost his sight but he soon regained it as his brain adjusted his eyes to the darkness, and then back to the light as the platform noise-lessly slipped inside the lodge.

Mr Rosen was exceptionally mistrustful, waiting in the hall hung full with archaic antlers, a rusting laser gun in his hand. He was not trying to hide; it would have been difficult anyway, given the size of the antique. He led Colloni to a small room full of furs, faded as the jacket of the Blessed One, and sat down in a cosy chair, shooter at the ready.

"You wanted to talk to me about something," he opened the conversation.

"Indeed. A year and a half ago you placed an order for the removal of one neosatanist."

"Oh, yes. All this time, the devil take you, no one showed up!" He banged his huge fist on the armrest which creaked dangerously. The forester was a little self-important man with large hands and an earthy complexion. He looked like a gnome annoyed with the whole world. "Is that the way you treat your clients?!"

The queues for the Blessed Legions were always long, and

344

despite a steady intake of new recruits the Legions were constantly behind schedule. They were unable to keep up with the demand; it could not be helped.

"Mr Rosen . . ." said Colloni reproachfully. "But you see I've made an effort, I've come in the end, haven't I?"

"I pay you for it! Made an effort! In the middle of the night . . ."

"Mr Rosen!" Colloni lost his temper. "I haven't come here to listen to your complaints. Either you help me or I'm off to do something else."

Rosen looked at him suspiciously.

"Help? What do you mean?"

"Well . . . I need to know where he's hiding, if he has any chums . . ."

"Ah, that . . . that I can tell you," the forester calmed down. "But . . . You're not going to hunt for him at night, are you?"

"And why not?"

"Er . . . right. Right. You go south from here till you get to a little river, then to a little valley, than another river and then a stream. Follow the stream till you get to the hills, fly over them and on the other side there will be a big meadow, you'll see it. It's the north end . . . that's where I see him most often."

"Most often? Does it mean he can be found somewhere else?"

"Er, no. No."

"Are you sure he's alone?"

"I've never seen anyone else."

Colloni rose from his seat.

"Thank you. I'll try to let you know as soon as I'm done with him."

"May I ask, how much is the fee?"

"The fee?"

"The fee." Rosen licked his lips.

"We'll send you the reckoning grain."

The forester scratched his head, shrugged his shoulders and followed the Blessed One who was already in the hall.

"Forgive me for asking but . . . do you all go dressed like this?"

"Sure, all of us."

Colloni descended gently, leaving behind the appalled Mr Rosen standing in the square of light. He jumped off before the little platform reached the ground and ran to the strat.

Following the forester's directions he lost his way several times but in the end he found the big meadow. It was six minutes to three.

Colloni sat his strat at the eastern side of the meadow and immediately jumped out of the machine. He hid behind a large oak tree and from there observed the dark and silent machine. He waited a few minutes and ordered his friendly spirits to search the surrounding area. They returned after a while, having found nothing more disturbing than the corpse of an old werewolf left untouched by the animals. Colloni sniffed the air; he could smell a faint scent of burning klassz. Just as Rosen had said, it was coming from the northern end of the meadow.

The Blessed One crossed himself and sprinkled himself with holy water from a little silver flask, even though he was risking scaring off the neosatanist if the former had completely gone to the devil. Then he placed his friendly spirits around himself and set off walking north along the edge of the wood. The wind blew in his face, carrying ever stronger wafts of klassz. Colloni pulled out the controls, checking with his fingertips, as if from habit, the positions of individual switches.

He reached the place at 03.35. The fire was out, the hut half destroyed by the recent storm, but the neosatanist was apparently in no hurry to mend it. He was a primitive and inexperienced worshipper of evil. Colloni detected no barriers or conditional curses. Only a little dried-out clot of new born babe's blood protected the hut. In one well practised move, Colloni stripped the muscles off his left hand and from his fingernails shot silent laser beams, converging on the lump of blood. Thus the Blessed One burnt his way through. Ghost-like, he advanced on the hut.

But the neosatanist would not be taken by surprise. He crawled out from under the pile of branches at the other side of his hut and with his ancient but effective launcher hid behind the trunk of a felled tree. Colloni still managed to point his laser finger but only burnt the bark off the tree. The satanist answered in turn with a long salvo. The wood boomed with echoes.

In the same nanosecond Colloni's sympathetic nervous system took over the functions of the central and peripheral ones, and his brain, which was partly a machine, turned the Blessed One into a robot. Overloading the muscles and the blood-vascular system, Colloni performed a sequence of unimaginably fast movements. At that point ten missiles capable of blowing a 20th century bunker off the Earth's surface came flying straight at the Blessed One but each hit the neutralising blade of the Sword, which at a touch of a button, had unfolded instantly to a length of 92 cm. Luminous ricochets whizzed off into the darkness of the woods.

Taking advantage of the moment's peace that followed, Colloni folded the Sword and hid on the other side of the felled tree-trunk. Then, as he rose, he kicked away the launcher aimed straight at him and grabbed the satanist by the throat. Writhing, kicking and scratching with his long sharp fingernails, the wretch howled like the damned that he was, bared his teeth and tried to bite the Blessed One, who tightened the muscles in a skin-pouch placed under a wrist bone and, opening his right hand, caught an ejected dagger. He squeezed it hard till the blade glowed red hot before the satanist's eyes. The spectacular effect made the captive calm down.

Colloni took out his silver flask again and sprinkled holy water over the satanist. The poor devil gave out a terrifying roar, tautened like a string, then grew strangely limp, went green and flopped senseless on the ground. The Blessed One suspicious of trickery, waited till the friendly spirits had made sure the captive was unconscious. He slipped the dagger back into the skin pouch and looked at his fingernail:

it was 03.50. Then he bent over the satanist and after a close examination declared him not fully satanised.

Colloni saw no point in prolonging the exhausting concentration of his powers. He straightened and put his mind in order, just as the infernal muscle pain that began to spread through his body knocked him off his feet.

It was already daylight when Colloni got up from the wet grass. After long actions the period of convalescence could last several days. The Blessed One stretched himself and ordered the Friend to fetch the strat. Ten seconds later the machine landed a metre from Colloni. He tied up the satanist and threw him into the boot. Ignoring the light requesting immediate contact, he launched the strat in a vertical blast-off, straight as a candle, that rammed him into his seat. He did not even bother to switch on the air conditioning, despite the unholy odour with which the devil-to-be polluted the atmosphere.

At 11.16, the sight of Colloni pulling the satanist out of the strat made the section flight controller freeze in his tracks. He almost choked on the katalla, then turned around and ran off like a madman. Colloni shrugged his shoulders, summoned the goods platform, threw the prisoner onto it, tapped in the destination room and without bothering with the lift went off for a bite to eat. He had not eaten for twenty hours.

Radziwill finally tracked him down just as he was finishing his meal.

"Colloni . . . !" he started off with a threat in his voice. "I can take a lot. I've swallowed your scheming with the aliens, I've swallowed the assassination of the Lodestar, I've swallowed your insubordination during the mission in Hell, I've turned a blind eye to your illegal spells, but this . . . You won't get away with this. I'm taking the mission out of your hands. And all your privileges. This time you've gone too far."

Colloni sighed, pushed away the old fashioned food receptacles and looked with contempt at the Blessed Ones scurrying out of the refectory. In less than twenty seconds the room was empty. He turned his eyes on Radziwill, looked at

him as if hesitating, got up and asked in a conciliatory tone:

"Why all this shouting? There's nothing to get so het up about, Charles. That I disappeared for a few hours? It's not the first time and it won't be the last. You know full well I always work on my own and don't give a toss about your privileges. You can take them. As for our business, you're making a grave mistake. Time is running out and I don't think you'll find anyone who in two days will do the job McSonn couldn't do in four."

"Do you mean to say two days will be enough for you?"

"One. If everything goes according to plan, by tomorrow morning I shall know everything there is to know about the Golden Galley."

"Now I'll tell you something. The Galley is advancing in our direction at a speed fifteen times that of light, pushing in front of her a time mound that stretches for three parsecs. She's coming straight at us. That coward Glas announced an emergency alert for the whole Navy. The chief of Intelligence doesn't come off the line. Curious like hell. Tell me, Colloni, what was I supposed to tell him all those thirteen hours when I didn't even know if you were dead or alive?"

"You told him something though," remarked Colloni, not without justification.

"Out!" Radziwill rarely shouted like this. "Out! Get out of here! Take your stinking devil out of here and get out! You are no longer a Blessed One. I'll make sure the Pope excommunicates you before Sunday!"

Colloni left the refectory with an ironic grimace on his face. It was not the first time the Archangel had excommunicated him from the Legions. Usually two, three days later he had a visit from Radziwill's go-between who would shyly ask him to return to the fold. It was a matter of hours before it was clear to everyone how indispensable Colloni really was. The Department simply could not function without him, which was partly due to the efforts of his faithful staff and partly to his own. So there was nothing to worry about.

Colloni, smiling apologetically to his staff, climbed up the emergency stairs onto the next floor. In general, Colloni always smiled when he was not alone. Just as he wanted, the satanist was in room 657938, still in shock. The Blessed One took him, together with the platform, to the parking for private strats, bundled him back into the boot and departed for his fortress.

It stood on a finger of land jutting into the ocean, wholly protected by the curse AIDS IV. Coming out of the gentle curve of a turning, the strat flew straight into the cave on the face of the cliff towering above the stormy sea. The security life probes recognised the configuration of atoms that was Colloni and let him through, lowering the barriers. He left the prisoner in the care of a Guardian whom he instructed to take him to the Penitence Hall, while he headed for the communication room. Putting a smile back on his face, he called out the mist of LottIna. He did not wait long. Soon, out of the billowing clouds in front of the console, there emerged the figure of Kaa.

"Ah, it's you, Colloni." For some reason he was always called by his surname . . . "Have they given you the sack again? You really are incorrigible."

"Radziwill told me that half an hour ago."

"I'm not surprised. Well, I don't suppose you've knocked on my door to moan about your character."

"No, I haven't. I've got a problem. I need a conditional curse. It's your speciality, isn't it?"

"One could say that . . ."

"Very good. It must be a permanent curse, extra-temporal, written into an object, automatic with injunctions. For a soul. Something special. I'll configure conditions myself. To be more specific, I need a shell curse with executive powers, general rules and punishment. The punishment . . . The conditioning must be strong, the accursed is going to be a neosatanist."

"Are you all there?" snapped LottIna, playing nervously with her purple hair.

"McSonn asked me the same question yesterday."

"Apparently Radziwill isn't the only one with something like a brain."

"Perhaps," Colloni waved his hand. "When will you have the curse ready?"

"I don't recall having agreed."

"When will you have the curse ready?"

"Are you serious?"

"Christ! I'm so serious you'd be surprised if you weren't enough already."

"You can be trusted to come up with something weird."

"Well?"

She got up from the waterbed and started pacing the room. The mist surrounding her showed glimpses of her dwelling.

"The devil take you, Colloni. Do you always have to spoil every weekend? All right, for you – four days."

"I'm sorry Kaa, I need to have it by seven at the latest."

"By seven when?"

"By seven tonight."

"You need treatment."

"I've been telling Radziwill that for years. If you won't do it for me do it for money."

"Ha, ha, ha."

"I'll be honest with you."

"At long last."

"Shut up. The situation is this: Five days ago the Intelligence offered the Legions a deal. In return for a considerable sum of money the Blessed are to try and explain a certain problem. I know they won't, at least not before the deadline. The deadline is tomorrow night. If you fix me that curse I'll get what the Legions can't. What do you think the Intelligence will do then with that pretty sum?"

"How pretty?"

"Like fourteen million."

LottIna swallowed.

"M . . . million?"

"Million. We'll split."

Kaa sat down on a sofa.

"You'll have your curse. At seven tonight."

"God bless you," said Colloni.

He switched off the mist and sighed. After a while he noticed his own hand wiping sweat off his own forehead. Tough old Colloni was growing nervous with age.

The neosatanist, still unconscious, was lying on a marble rack, already undressed, washed and disinfected. Colloni hacked into the Brain of the Blessed Legions, by now off limits for him. He identified his captive as one Michael Condway: thirty years of age, successfully avoiding periodical consecrations; wanted by the Legions as well as by the police. His record showed few offences but even those would earn him a death sentence. An average worshipper of Evil, except for being a loner.

The friendly spirits established he would come round in seven hours. Of course, Colloni could try to revive him earlier, but there was no guarantee the patient would survive the cure.

Colloni instructed his spirits and had a nap.

At 18.50, the spirits awoke him. He got up, had something to eat, looked through the indigestible information service (not a word about the Golden Galley), and washed it down with Sardway 2086. Then he went to the post room situated on the top floor of the fortress. He was proud of his hideout. In fact, he would not be alive without it. According to his latest poll, his death would give pleasure to over six thousand people.

The packet from LottIna arrived at 19.17. It contained a nickel ring with an inscription: "35%". Colloni smiled at it and began configuring the curse. The procedure gave him a headache. When he finished, he slipped the ring into his pocket and floated down to the Penance Hall, or to be more precise onto the gallery above it. The floor, the walls and the ceiling were covered with a complex system of mirrors focused on the marble rack. Wherever he looked, the man lying in it saw himself; himself, his torturers and what they would be doing to him. Fear was an indispensable part of the penance.

Condway woke up at 19.37. A bit late. Colloni immediately switched on the air tubes.

"Welcome, welcome, Michael. Did you sleep well?"

The neosatanist only hissed in reply. His body was covered with hundreds of electric needles and with every move each of them increased the torture.

"Very well, very well, we've had a nice chat, now let's get down to business."

Condway chose to remain silent.

"You know very well that your life is in my hands. I can kill you whenever I feel like it and they'll thank me for it. Were I for instance to strangle you now you would undoubtedly go straight to Hell, but not as a devil. I have bad news for you: You haven't yet satanised completely. Do you understand what that means for you?"

Silence.

"The third level. For ever. It's not what you were wishing for, satanising yourself all these years, is it? Luckily, luckily for you, my heart has suddenly gone soft. I can save you."

"How?" groaned Condway.

"There is such a thing as penance. Of course, normal penance won't do you any good anymore. But I, with my extra-special papal dispensations . . ." Colloni lazily switched on the lights in the Penance Hall. "Do you see those instruments?" Disregarding the electric needles, Condway was looking around nervously. "With their help I'm sure you'll make an excellent atonement for your whole life in just a few hours."

Condway shuddered.

"I'm not doing it out of pity. It's give and take. When you've done sufficient penance, I will kill you. Thanks to these instruments, you won't be dragged to Hell, at least not outright. Now, listen carefully. Immediately after your death you will fly straight to the star Altair, I'll graft the directions onto you under hypnosis. Once you get close enough, you will find for me a certain thing, you'll have the description grafted into you as well. You should find the thing without too much trouble, as a soul you'll be able to find smaller things. You will inspect it thoroughly and find out all there is to know about it. You must do it within three hours. If after

that time you don't return and pass all the information to my friendly spirits . . ."

"Then what?"

"Have you heard of conditional curses?"

"It can't touch me as a soul."

"As a soul – not, but if you have an extratemporal condition installed now, you may activate it after your death. In this way the curse will act on you the man – the living, material being – and thus modify you the soul."

"It'll do me no shit."

"You think so?"

"I think so."

"Well, imagine then that the penance doesn't take place, or rather hasn't taken place at all. You're automatically pulled down to the third level. By cancelling a few hours beforehand the penance you had as a man, I thereby change your future as a soul."

"What's the guarantee you won't reconfigure the curse after I've done the job?"

"You just have to take my word for it. But you should know it's the word of the One Blessed by the World. Will it do?"

"It'll do. But . . ."

"But?"

"I don't understand what good is a penance which is not desired by the penitent?"

Colloni smiled.

"And you don't desire it?"

Condway opened his mouth, and shut it. He said not a word more.

Colloni switched off the air tubes and checked exactly how far Condway had already satanised himself. Tricky. Michael was on the verge of complete satanisation. Bad. Even with the most intensive programme of torture the penance would not be over before three o'clock.

Colloni switched on the brain controlling the tortures and went to bed. Just before he fell asleep he sent a spirit to check if Radziwill was ready to apologise. Radziwill was.

The Last Day

The friendly spirits woke him up at 02.30. He took a shower, had something to eat, said a prayer, looked at several registered mists with hypocritical messages of sympathy and floated down to the Penance Hall. The instruments and hypnotisers had already carried out their work. Condway looked more like an android after an exercise autopsy than a live human being. By normal standards he should be unconscious but thanks to his faith in Satan, or perhaps his pride, he was aware of everything that was happening around him.

When the lights dimmed, he called out in a weak voice:

"Hey, you, Blessed, are you there?"

"What's the matter?"

"I thought about what you told me and I've come to the conclusion it's all crap."

"Oh, interesting." Colloni was flabbergasted by the stamina of the man.

"As far as I know, all the Blessed Ones have their friendly spirits and Friends. Why haven't you sent them to that bloody ship?"

"You are well informed. As for the Friend, he is a material being, though temporarily bodiless, charmed into an object, usually a precious stone. In practical terms he would have the same chance of getting to the Galley as any other man. As for the spirits, they live with me in a kind of spiritual symbiosis. If I sent even one of them further than sixty two kilometres it would cost me my life. I'm telling you this, for I know you won't talk to anyone. Ever. At any rate, now you understand why you've been so lucky."

Condway grunted something in reply but despite various voice amplifiers Colloni did not understand a word of it.

He shrugged his shoulders and switched off the machinery.

Michael Condway died quickly, with no moaning or dramatic scenes.

The smile faded from the Blessed's face. Suddenly, he felt strangely vulnerable. He cursed and went for a drink of

Sardway 2086. Meanwhile Condway, free at last and bodiless, liberated from pain, rose towards the starry and hospitable sky.

The cool air permeated him like an invisible smoke. The space that surrounded him was familiar as if all his life he had done nothing but observe every blade of grass, every stone, every hill and every tree. When he closed the eyes he did not have, he was able just as easily to fly above the earth, knowing well the way he would only now embark upon. He could just as easily listen to the hum of the night's silence, for he no longer had ears. And all the scents circulating above the over-crowded planet, he could smell with the whole surface of his body. The body he no longer had. Which he did not want to have.

He wanted to free himself from that cumbersome, mind-restricting burden. He stretched out, grew slender, like an eagle in flight following its prey; the urge to fly, for fast, sense-numbing flight, rose within him like lava inside a vol-cano. And when it burst out – with great heat, with breezy coolness, with fountains of colours never seen before by his dead eyes, with cascades of sound never heard before by his dead ears, with all this which he had never experienced during his whole damned life . . . If he could, he would have cried for the universe, senseless though it is.

And as he circled around the sun, just two seconds after his death, into his memory burst the foreign, grafted image of the majestic Golden Galley. Condway froze in the middle of his glorious dance of praise and mourning, his heart that was his mind, his body, his thought and will, grew still. Michael Condway the neosatanist died his second death.

Humbly, like a pilgrim, Condway mustered his feelings raging in a whirl that spread for miles around. Humbly, though the hatred he had been learning for years like a cat-echism blazed on and burnt him. Oh, how he hated Colloni! He hated him for depriving him of the chance to become a devil, for humiliating him for the first time since he'd taken the Oath, humiliating him and getting away with it. He hated Colloni for forcing him to do something which now,

as a soul, Condway feared, which he did not want to do. He hated him for making him clean as a devout Christian and not as a worthy worshipper of Satan. Finally, he hated him for the powerlessness of his own hatred.

Filled with this hatred, he threw himself into flight and followed the slippery path to the distant star. He knew when and where to signal his good, and where to show his ill will. He knew and this knowledge of the path was to him as hateful as Colloni himself.

He flew and flew and flew . . .

And then he wanted to stop but did not, for the intention had already overtaken that point in space. He lost his sense of time which should however drag very slowly; he sped on, entangled in its retro-progressive loops. And then, or was it before and after, everything ended and only the Golden Galley remained in that strangely familiar natural and ordinary emptiness.

Condway turned and glided along the ship's side. His heart protested, but what is a heart if the whole world is against it? Fear gripped Michael, as powerful and visible as he himself.

Splinters that stretched for miles glistened in the black void, the red sun shone in the distance, far, far away. The silence and turbulence of the void were driving the satanist mad.

Suddenly he detected a movement right next to him. He directed the intention of a glance upwards and saw uncountable rows of enormous oars, moving rhythmically, pushing the ship towards Earth. The stars flashed in the rhythm of the rowing, the sails fluttered, and so did the terrified soul of Michael Condway. Something foreign, alien, reeking with evil, invaded the field of his awareness.

Overpowered, frozen, imprisoned in his second existence Michael was engulfed by Satan. He was engulfed by all that he had desired all his life and what only now revealed to him its true face unspoilt by a good-natured grimace, so different from what he had imagined. The armour cracked under the pressure of evil. In a hundredth of a second, Condway was astounded by Satan's power, he was terrified by his own faith

and the real devil. He was astounded and terrified for sud-
denly, and completely against his will, a voice cried out
within him: "Save me, O Lord!"

Satan laughed, dragging him first up, onto the deck, then
down below, where the oarsmen were. Michael fought to
free himself, squirming and writhing, but the will to resist
was slowly dying away in him.

Condway was panting with fear in Satan's strength-
sapping claws, listening to the drum beating louder and
louder, and to the terrifying roar:

"One . . . two . . . One . . . two . . ."

At the same time Colloni was receiving a mist from Radzi-
will's messenger, who mumbled something about the sense
of duty.

The Blessed One took a good swig from the bottle of
vintage Sardway and waved his hand impatiently.

"Enough. Radziwill knows very well I'll come back.
You'd better tell me," here he smiled bitterly, "how you're
getting on with the Galley."

The messenger was obviously informed of the matter, for
he only sighed and cursed.

"Mmm . . ." Prodded by Colloni, the messenger did not
know how to begin. "Radziwill is dealing with it now. Waste
of time . . . So far he's found something in the Lodestar's Book
of Prophecies. He got stuck at it and for the last few hours
hasn't made any progress."

"The Book of Prophecies, you say?" Colloni became inter-
ested. "All right. Buzz off."

The Blessed One duly buzzed off.

Somewhat upset, Colloni put away the ancient bottle and
floated up, to the library. All the books he had were in the
traditional form, which with the years cost him more and
more. He walked up to a huge bookcase and took from the
shelf a slim, leather-bound volume of the Lodestar's Book of
Prophecies. He sat down in a deep antique armchair and
began to leaf through the book.

Half an hour later, at 03.40, having come across a certain

passage, he jumped to his feet, threw the Prophecies in the corner and rushed to the strat.

In the machine, flying at top speed towards Sydney, he calmed down and through his friendly spirits got in touch with the Brain of the Blessed Legions. When connected, he immediately recalled the file of the trooper who had escaped the strange torpor but who went mad after the encounter with the Golden Galley. And it frightened him even more. Taking the trooper's parameters, he established the personality type and extrapolated it onto the general characteristic of Humanity. The result was staggering: no more than fifty million people had a chance of survival.

"... *And it shall come to pass that looking up towards the Heaven ye shall see the accursed ship bearing at you from the skies, the Ship of Doom. And ye shall do naught but wait and see the Satan take His due. He shall come through ye mighty Kingdom like a fisherman's net and the few that shall slip through the net's eye shall be scattered in the Wilderness lost and terrified, and shall never find each other . . ."*

In the headquarters of the Blessed Legions no one was surprised to see Colloni running like a madman, though many were surprised to see his shaking hands and the terror in his eyes. The director of the Special Task Force charged through his department and floated up, onto Radziwill's floor.

"Charles!" he screamed running into the Archangel's office. "Charles . . . !"

"What's the matter?" Radziwill was busy doing calculations on the Brain and Colloni's sudden entry, though announced by the spirits, irritated him. Colloni never behaved like this. "What's the matter?"

"What is the matter?" The Blessed One echoed with bitter irony and slumped on one of the hovering armchairs. "The end of the world is nigh, Charles. The end of the world!"

Radziwill shrugged his shoulders.

"Not for everybody. There will be some who will survive."

"How can you be so cool about it?"

"And what do you want me to say? Besides, it's not certain yet."

"Eh?"

"If you read that passage carefully I'm sure you've noticed that the Lodestar also mentions a ship which will probably overtake Satan's ship but will only put the fear of God into people."

"You reckon? And what about those troops?"

"They're human too and may constitute a part of the terror ploy."

"Listen . . . I've sent a spirit there, on a mission . . ."

"You bloody idiot!"

"No, not my own friendly spirit. The soul of a man who died an hour ago. I told him before he died to find out what's what and return."

"Where on Earth did you find a dying man?"

"I killed him myself."

"Just what could be expected of you."

"He was a neosatanist. I caught him last night in Europe."

"Are you sure he'll come back?"

Colloni took out the ring.

"It's a conditional curse. If he doesn't return by 05.58, the penance I put him through will be revoked."

"If it's Satan's ship, he doesn't have a chance in hell."

"Exactly . . ." The Blessed One hid his face in his hands. His fingers were trembling though he was trying hard to keep calm. He shook his head, his hair flogging the palms of his hands. He hid his face because it had become white as if he was about to faint. His lips whispered something nervously and tears, which he had forgotten years ago, were filling his eyes.

Radziwill knotted his eyebrows.

"Calm down. The situation is not so tragic."

"Not so tragic?!" Colloni laughed out hysterically.

The Archangel got up and began strolling along the panoramic window. The twilight on the other side was from time to time lit up by passing strats. Their position lights smudged

into misty multi-coloured spectra as they sped by. The brightness of the exhaust gases dazzled the eye. The building's power field flashed with small explosions as drivers taking over manual control of their strats charged recklessly, practically rubbing against the air-borne colossus. The security lasers of the nearby cosmoport probed the darkness while some space monster blasted off, cheekily escaping gravitation with its millions of tonnes. The long, caterpillar convoys hurtled past at supersonic speed in the purple chutes of nongravitational tunnels that disappeared along with them. The gigantic air lilies, beautiful in their dignified though alien force of life, drifted below, just above the ground, separating the noisy life from the nature given back to the surface of the planet.

"I do understand," said Radziwill in a low quiet voice. "It's terrible. For thousands of years we build a great empire, billions of people are happy. They want to live. They know they are still threatened by Satan but we protect them against Him. And suddenly . . . We are helpless. We cannot prevent what is going to happen. The only survivors are going to be those who lived according to the great Conscience. Perhaps I'm an egoist but we'll survive, so there's no particular reason for despair."

Colloni shook his head, slowly, as if his strength was leaving him. He was shaking all over even though his well known smile was still on his face; it looked frightening.

"We'll survive, will we?" he tried to laugh.

"Well, we have lived according to the Conscience."

Colloni's face stretched in an even bigger smile. He jumped from the armchair, opened his mouth, closed it again, sat down, gave out a soundless giggle, again stood up, threw his head back and down his stubbly cheeks trickled two glistening tears.

Radziwill came up to him and put him in the chair like a doll.

"Sit down," he said in a hard voice. "Sit and wait."

Then he looked at the crucifix hanging above the door and said:

"Maybe you still have a chance."

And so they waited: the motionless Colloni and the gloomy Radziwill stared at the glow of the city. The Golden Galley hurtled towards Earth faster than the fastest craft ever known on Earth. It was taking its harvest from Mald, from Katio, from Jeonast IV, from Ratton, from Bed-tan . . .

At the stroke of six, the digits on their fingernails changed and the ring lying on the table shattered with a dry crack. By now, souls in the Solar System were leaving their bodies. Caught unawares, they sped through Space – men, women and children . . .

Those billions of human souls who thought they were leading good lives, wonderful lives, were now shackled by the power of their evil to the golden oar . . . the thoughts, pushing with all their might . . . pushing the golden oar . . . and pulling the golden oar . . .

There was only the roar of Satan's voice, the sound of the drum, the creaking of the oars . . .

"One . . . Two . . . One . . . Two . . ."

And suddenly, Colloni's body slumped on the floor. His glassy, unseeing eyes stared at the brightness spreading above the city, at the great rising sun. The Legions' headquarters filled with screaming and wailing. Someone cried out in terror: "Jesus Christ!"

Radziwill was about to thank God but his lips froze shut, his hands gripped the armrests of the chair, and his soul departed from his body.

July 1989

ABOUT THE AUTHORS

BARSZCZEWSKI, JAN (1790–1851) – there is very little information about his life; the son of an impoverished yeoman in the eastern provinces of Poland (now Bielorussia), he was educated in a Jesuit college in Polock. He settled in St. Petersburg where he moved in literary circles and where he met Adam Mickiewicz and Taras Szewczenko, the leading Polish and Ukrainian romantic poets. Throughout his life he collected stories, legends and folk songs. The story "The Head Full of Screaming Hair" comes from his most popular work *Squire Zawalnia or Bielorussia in Fantastic Stories.*

BURSA, ANDRZEJ (1932–57) – poet, writer and playwright; he studied journalism and Slavonic languages at Çracow University and then worked as a reporter on a Çracow paper. He died at the age of 25 of heart disease; his *Poems* appeared posthumously in 1958, and his collected works *Poetry and Prose* in 1969. His early death amidst rumours of suicide, together with the tone of disenchantment, cynicism and spiritual desolation of his writing, combined in establishing him as a cult figure of the artist as a rebel. His novel *Killing my Aunt*, dedicated "To all those who stood terrified before the dead perspective of their youth", is *Crime and Punishment* taken a step further, where a Raskolnikov figure commits a premeditated but deliberately pointless murder. "The Dragon" is a grotesque story of a reporter who in the middle of the new communist reality accidentally discovers an ancient ritual of human sacrifice involving a live dragon.

DUKAJ, JACEK (1974–) – writer, literary critic of sciencefiction, one of the most promising talents to have emerged in

Polish literature in recent years. He made his debut at the age of 15, while still at school, with the magnificent "Golden Galley" – an astonishing feat of artistic maturity and literary craftsmanship for such a young writer. The story, a futuristic vision of the end of the world ruled by a highly structured, powerful organisation that seems to be KGB, CIA and the Society of Jesus rolled into one, is a doomsday tale constructed with elegant surefootedness, blending elements of science fiction with subtle yet penetrating reflection on the current political situation and the prevailing moral atmosphere. Written in 1989, at the time of Poland's emergence from under the communist rule and the increasing role of the church, "Golden Galley" is not only a reflection on the universal theme of the struggle between Good and Evil, but also a timely satirical commentary on the on-going struggle between the earthly powers for the rule over the human soul. In his later stories Dukaj, fascinated by the moral ambivalence of human aspirations, develops further the satanic theme, especially in "The Prince of Darkness Must Die" and his latest collection *Requiem for Satan*.

GOMBROWICZ, WITOLD (1904–1969) – one of the greatest, most influential Polish writers of the second half of this century. Born into a wealthy landowning family, he studied law at Warsaw University and later, briefly, philosophy and economics in Paris. He made his debut with a collection of short stories *The Memoirs from the Time of Immaturity* but it was *Ferdydurke,* his masterpiece published in 1937, which established him, together with Schulz and Witkacy, as one of the leading writers of the Polish literary avant-garde. The outbreak of the Second World War found him in Argentina where he remained for over twenty years working in almost total obscurity. In 1958 Julliard published the French translation of *Ferdydurke* which opened the road to recognition in Europe. In 1963 he returned to Europe and settled in France. In 1968 he was a winner of the International Publishers' Prize (Prix Formentor).

GRABIŃSKI, STEFAN (1887–1936) – the classic of Polish fantastic literature. One of the few serious practitioners of the genre in Poland, Grabiński raised it to a very high artistic standard. After studying classics and Polish literature at Lvov University he worked most of his life as a teacher. He made his debut in 1909 but it was only in 1919 that he was noticed and appreciated both by the critics and the reading public with his third volume of short stories *The Demon of Motion*. In the following ten years he published another four volumes of short stories, three plays and three novels, all within the fantasy genre. His writing is full of the prevailing intellectual fashions of his day – the paranormal, pathology, the unconscious and theosophy; he was also a serious student of Nietzsche, Bergson and James. His artistic ideal was Edgar Allan Poe but apart from being a master of the short story himself Grabiński was unusual in his systematic treatment of different themes like "motion", "fire" or "passions" around which he built his collections of stories, often by the carefully studied, realistic depiction of a social or professional milieu (i.e. the railway in *The Demon of Motion* or firemen in *The Book of Fire*).

HUBERATH, MAREK S. (1954–) – the pen-name of a scientist working at the Institute of Physics at the Yagellonian University in Cracow. His disturbing story "You've returned, Sneogg" took the first prize at the Fantastyka's II Literary Awards. "The Greater Punishment" bears all the hallmarks of Huberath's vision and philosophical interest. Both texts speak of extreme situations and take the side of the weak and ill-treated, showing both the angelic and the devilish side of human soul and condition. It is probably the first such distressing vision of Hell in contemporary Polish fantastic literature, with a dramatic addendum to the noisily inconclusive debate on abortion currently taking place in Poland. Huberath writes rarely and reaches for his pen only when he feels he has something to say. Apart from literature he has another dangerous hobby: mountaineering, sometimes with ropes.

IWASZKIEWICZ, JAROSŁAW (1894–1980) – novelist, poet, playwright and translator, one of the greatest Polish writers of this century, often described as a Polish Thomas Mann. He was born in Ukraine and educated in Elizavetgorod and Kiev where he studied law and music; after 1918 he settled in the new, independent Poland. He worked as a diplomat and was a member of Skamander, an influential literary group of post-romantic and modernistic writers and poets. A prolific writer, in most of his works he dealt with a theme of individual and artistic alienation, evoked through realistic settings of historically and culturally different contexts. His writing is suffused with eroticism, often with a touch of demonism. One of his best works, "Mother Joanna of the Angels" – a historical novella set in 17th c. Poland – is a subtle, moving psychological study of a priest-exorcist who comes to exorcise a group of convent nuns and, out of love for the Mother Superior, allows the demons to take possession of his soul.

JASIEŃSKI, BRUNO (1901–1937) – poet, novelist and playwright; born in a provincial town, son of the local doctor, between 1914–1918 Jasieński lived with his family in Moscow, where he attended Polish schools and where he came into contact with the revolutionary literary avant-garde. After his return to Poland in 1918 he studied briefly at Cracow University and became very active in the Polish literary avant-garde. He was one of the originators of Polish futurism, writing influential programmes and manifestos. Persecuted by the police for his communist sympathies, and disappointed with the critical reception of his work, in 1925 Jasieński left Poland for France. There, he became an active member of the French Communist party. In 1929 he was deported from France for dangerous political propaganda (that year he wrote an anti-utopian novel *I'm Burning Paris* describing the outbreak of the plague during a social revolution in Paris, the idea closely resembling the famous novel by Camus *The Plague*). Reluctant to return to Poland, Jasieński emigrated to the Soviet Union where he was welcomed as a

hero and given high positions in the literary departments of the party and the Soviet Writers' Union. He began to write in Russian ("the language of Lenin" whom he so admired). However, in 1937 he was arrested and died soon after on the way to GULAG. Jasieński's early Polish writing is a characteristic mixture of the sentimental and the decadent, of traditional verse and outrageous, grotesque imagery. His story "The Legs of Isolda Morgan", written in 1923, is a fine example of his own theory of avant-garde prose.

MAKUSZYŃSKI, KORNEL (1884–1953) – poet, literary and drama critic, the most popular Polish writer of literature for children, with many of his novels children's classics. Studied Polish and French literature at Lvov University, until 1918 he lived and worked in Lvov and Kiev, then moved to Warsaw. Represented a lighter side of Polish literature of the time; a master humorist, he wrote stories and novels about bohemian artistic life and in 1916 published his collection of fantastic stories *Very Strange Tales*.

MICIŃSKI, TADEUSZ (1873–1918) – poet, playwright, novelist and translator, he was one of the most original figures of the Young Poland artistic movement. Studied history at Cracow University and philosophy in Leipzig as a pupil of Wundt, and in Berlin. He spent 1897–98 in Spain where he developed a life-long interest in Spanish mysticism. His works represent the characteristic mixture of Manichaeism and a catastrophic view of history written in a highly stylised, expressionistic language. At its best, his poetry goes beyond the expressionistic mannerism and contains some of the best verse of Polish modernism, while his novels such as *Nietota, Mené-Mené-Thekel-Upharisim!* or *Father Faust*, push the boundaries of the literary genre and blend Western expressionism and symbolism with Eastern mysticism, bringing them together in a vast historio-philosophical panorama of peculiarly Polish decadence. An ardent believer in the union of Slav peoples, during the Balkan War Miciński worked as a war correspondent in Bulgaria and in 1915–18 in Russia,

where he also joined the Polish Legions as an education officer. Returning home after the war he was murdered by a rioting mob.

MIRANDOLA, FRANCISZEK (1871–1930) – writer, poet and one of the most prolific translators in Polish literature. Born Franciszek Pik, the similarity of his surname to the name of the famous Italian poet Picco Mirandolla inspired him to adopt the pen-name of Mirandola, or Pik-Mirandola. Educated as a pharmacist, he also studied philosophy in Heidelberg and travelled in Germany and France. He made his debut in 1898 with a volume of poetry *Liber Tristium* in the expressionist style of Young Poland. In 1916 he published a volume of short stories *Tempore Belli*, an atmospheric yet naturalistic picture of the First World War, and in 1919 *Spoors*, a collection of fantastic stories exploring the theme of the paranormal. His writing is imbued with a characteristic quiet, often moving lyricism, and it is in his prose, rather than poetry that he gave it its best form. He translated 200 volumes of French, German, Scandinavian and English literature, among them Baudelaire, Mallarmé, Verlaine, Maeterlinck, Schiller, Goethe, Novalis, Hamsun, Defoe, Kipling and Tagore. For most of his life he lived in poverty, dividing his time between his pharmacy and literature; only towards the end of his life was he able to support himself with his literary work.

MROŻEK, SŁAWOMIR (1930–) – playwright, writer, satirist, one of the most popular writers in post-war Poland. Mrożek made his debut in 1950 as a journalist. He worked in various journals and newspapers, writing a satirical column, and in the experimental student theatre *Bim-Bom*. His sharp satirical writings – a pastiche of official and colloquial jargon painting a grotesque, absurd picture of reality – gained him notorious popularity. Between 1958–64 he published a number of plays, among them *The Police* (1958), *The Turkey* (1960) and *Tango* (1964) in which he also pictured the grotesque yet uncomfortably familiar world of primitive

narrow-mindedness breeding ideological mythologies, the world of phrase, of highly stylised comic – and brutal – rhetoric. These plays established him as one of the most intelligent, penetrating and funny satirists of the Polish way of life, culture and traditions – i.e. Polish romanticism, and especially of the way they functioned in the context of new, two-faced communist reality. His later plays, *The Slaughterhouse* (1973), *Immigrants* (1974) and *Vatzlav* (1979), deepen the theme of individual alienation in the world of mad rhetoric. In 1963 Mrożek left Poland to live in Italy, and from 1968 in France. He won many Polish and international literary and satirical awards, among them *Prix de l'Humeur Noir* (Paris, 1964) and Franz Kafka's Award (1987, Klostenburg, Austria).

REYMONT, WŁADYSŁAW (1867–1925) – journalist and novelist, winner of the Nobel Prize for Literature in 1924. Son of a village organist, he received only a basic education; he worked as an apprentice tailor, a railway worker, an actor in a small touring company and a journalist before committing himself fully to a literary career. His early works were influenced by Dostoyevski and combine naturalistic observation of social and psychological phenomena with an expressionistic manner of style. One of his best novels, *The Promised Land* is a dark panorama of an industrial city at the end of the 19th century – a Moloch-metropolis which breeds and devours its decadent, greedy children. His masterpiece *The Peasants*, compared at the time with the popular works of Knut Hamsun, won him international recognition and later the Nobel Prize. He had a life-long interest in spiritualism, the occult and the paranormal though it resulted only in a handful of stories and a novel *The Vampire*.

RZEWUSKI, HENRYK (1791–1866) – writer, journalist, publisher; born into an impoverished aristocratic family, Rzewuski was famous for his stories and anecdotes about the bygone era of the pre-partitioned, 18th century Poland. The literary legend has it that it was he who, with his gift for conjuring up colourful pictures of the old days, inspired

the great romantic poet Adam Mickiewicz in creating the background and some of the characters in the latter's epic poem *Pan Tadeusz*. Apparently, encouraged by Mickiewicz to write down the stories he had learned and remembered from childhood, Rzewuski wrote several books extolling the virtues of the old way of life in "the noblemen's democracy". "I am Burnin'" is Rzewuski's classic, its title and the character of Mr Pogorzelski long established in the everyday culture.

SCHULZ, BRUNO (1892–1942) – writer, literary critic, translator and graphic artist, one of the greatest and most original writers in Polish literature this century. Born in Drohobycz, a small, provincial town in the eastern provinces of Poland (now Ukraine), into an assimilated Jewish family. He was educated in Drohobycz, studied architecture in Lvov and painting in Vienna, then taught art in Drohobycz' local schools for the rest of his life. He was murdered in the Drohobycz ghetto by a Gestapo officer. Schulz started writing probably in his early thirties and made his debut in 1933 with a collection of short stories *Cinnamon Shops* (in English translation published as *The Street of Crocodiles*), which originated as postscripts to letters to his friend, the poetess Debora Vogel. The book was an instant critical success and in 1937 Schulz published another collection of short stories *Sanatorium under the Sign of the Hourglass*. Apart from his literary criticism the two collections contain the bulk of his literary output (though there are persistent rumours about the existence of his novel *The Messiah* buried in the depths of the KGB archives); the story "The Comet" was published in 1938 outside these collections in a literary magazine.

SIEMIEŃSKI, LUCJAN (1807–1877) – poet, novelist, literary critic and translator. Born into a landowning Polish family in Galicja (south-eastern Poland) and brought up with the ideal of independent democratic Poland, he took part in the November Uprising (1830–31) against Russia. After release from captivity he joined a political conspiracy and

was active in the literary group *Ziewonia* whose programme propagated the common heritage of Slav cultures, with an emphasis on ethnic tolerance. He translated numerous Russian and Ukrainian classics, collected folk tales, songs and poetry, and wrote his own stories and poetry in their style. Arrested in 1837, he escaped to France and spent the next 10 years in exile. In 1848 he returned to Cracow where he lived till the end of his life, working as a literary editor and translator (his crowning achievement translations of Michelangelo, Horace and Homer).

SZCZYPIORSKI, ANDRZEJ (1924–) – journalist and writer, at first sympathetic to communism but later a dissident who was interned in 1981 during martial law; in 1989 he was elected to the Polish Senate on the Solidarity ticket. In his early novels Szczypiorski dealt with the ideological conflicts and existential crises of the war generation; in a historical novel *A Mass for the City of Arras* he wrote about the persecution of the Jews and heretics, analysing the mechanism of mass psychosis which destroys individual rights and lives. In 1988 his novel *The Beautiful Mrs Seidenman* won him world-wide critical acclaim. He also wrote lighter detective and fantastic stories under the pen-name of Maurice S. Andrews.

WOROSZYLSKI, WIKTOR (1927–) – poet, writer, journalist and translator. Born in Grodno (now Bielorussia), Woroszylski studied literature in Łódź, Warsaw and Moscow. At first committed to the communist ideal, he became disillusioned with the system after the turbulent "thaw" of the mid 50s, and although he never denounced his socialist sympathies, in the late 1970s he became the editor of a dissident periodical and in 1981 was interned during martial law. An expert on Russian and Soviet literature, author of biographical works on M. Saltikov-Shchedrin, W. Mayakovski and S. Yesienin, Woroszylski is a leading translator of Russian poetry; he has also written a number of popular novels for children.

THE EDITOR/TRANSLATOR

Wiesiek Powaga was born in Poland in 1958 where he trained as a film make up artist and studied psychology. In 1981 after martial law was declared he settled in London. He had a great variety of jobs, including working in restaurants, on building sites and as a carpenter before reading philosophy at London University.

For the past few years he has worked as a commercial and literary translator from English into Polish and Polish into English, as well as being the London correspondent for several Polish music magazines.